Hope Springs Maternal

Revised and Updated Edition

Hope Springs Maternal

Homeless Mothers Talk About Making Sense of Adversity

Revised and Updated Edition

by

Jill Gerson, DSW

Gordian Knot Books

An Imprint of Richard Altschuler & Associates, Inc.

New York

Hope Springs Maternal: Homeless Mothers Talk About Making Sense of Adversity. Revised and Updated Edition. Copyright© 2007 by Jill Gerson. For information contact the publisher, Richard Altschuler & Associates, Inc., at 100 West 57th Street, New York, NY 10019, RAltschuler@rcn.com or (212) 397-7233.

Library of Congress Control Number: 2007933884
CIP data for this book are available from the Library of Congress

ISBN-13: 978-1-884092-71-8
ISBN-10: 1-884092-71-3

Gordian Knot Books is an imprint of Richard Altschuler & Associates, Inc.

Cover Design and Layout: Josh Garfield

Printed in the United States of America

Distributed by University of Nebraska Press

Dedication

This book is dedicated to the 24 generous mothers who spoke with me, and to all those who work to support their hopes for a better future.

This book is also dedicated to the memory of Donald Joseph Shanley and Hannah Rubinson Powsner. They were outspoken and courageous friends and professionals who imparted both a profound respect for all human beings and a belief that fighting for a just future is a necessary and worthwhile endeavor.

Contents

Introduction

The "homeless" in America have been the topic of many books published over the past several decades. Most are based on statistical data, either obtained from the U.S. Census Bureau or surveys administered to individuals without homes at a given point in time. A recent, notable statistics-based report on the homeless is the "Annual Homeless Assessment Report," issued by the U.S. Department of Housing and Urban Development (HUD) (2007), which estimates that about 754,000 people are homeless on any given night.

While such publications are helpful in tracking trends and developing policy, it is clear that their findings and conclusions have not led to the alleviation of homelessness. Apparently lawmakers are not concerned with these rich data. While quantitative studies can convey valuable information about things such as the prevalence and demographic characteristics of the homeless, they cannot begin to convey *who* homeless men and women are as *people*, or how public policy leaders should address the phenomenon of "homelessness" and specific problems that burden individuals without homes.

That task of understanding who homeless people are as *human beings* falls to qualitative studies, especially the in-depth interview study. Such studies often reveal complex meanings and contexts that are, at times, contradictory, and thus imply "nonstandard" solutions to "the problem of homelessness."

Compared to quantitative works, far fewer books have been written about the homeless based on interviews, especially extensive interviews, such as those presented in *Hope Springs Maternal*. Through in-depth interviews I conducted over the past

decade with 24 mothers living with their children in New York City homeless shelters, this book allows readers to "enter into the world" of homeless mothers. It probes their hearts and minds, and enables you to understand how they experience the world; think about themselves and others; their pathways to homelessness; their lives in shelters and on the streets; and their dreams about life beyond the shelter system—as parents, workers, students, friends, members of extended families, and men and women who want to contribute to society.

This book allows you to experience the "living reality" of the homeless mothers and their children, in their own words, or "voices." Through extended excerpts from interviews, you will experience the cadence of their speech and their unique and colorful vocabularies. In addition, you will learn about both their personal pain, related to social location and interpersonal relationships, and times of triumph and comfort. The narrators are forceful and articulate about their hopes, and worry about both themselves and their children. The effect of hearing the homeless mothers speak in their own voices is moving and profound, instructive and emotional. I believe you will find that their cumulative testimonies help you to compare your own assumptions with theirs, in a most realistic way, and to refine your understanding about women and families without homes. In addition, the personal stories in this book provide a powerful literary experience, as well as a valuable document for politicians, public policy leaders, social workers, and academicians interested in understanding and solving problems related to homelessness in America.

Although this book focuses on 24 homeless mothers in New York City, it is important to keep in mind that they—like homeless individuals everywhere—are part of a social system. That system includes many elements. Among the more salient

are housing options, including emergency shelters, transitional living quarters, and permanent subsidized housing; laws and public policies; attitudes and philosophies about the "homeless," held by both policy makers and the general public; and the economic environment. This system also encompasses how authorities generally treat, provide for, and view homeless individuals as potentially productive citizens.

So that the reader can have a background and context for best appreciating the specific case studies of the mothers presented and analyzed in this book, the remainder of this chapter discusses "system factors," at both the national and local levels, especially for New York City.

Some Basic Terms and Concepts

What or who is a "homeless" person? What is a homeless "shelter" or "transitional living accommodations"? How are people defined as "homeless" assigned to temporary housing, and what rules govern where, when, and how long they can stay there?

Homeless Person

Most generally, the federal government defines the term *homeless* as follows, in accordance with 42 U.S.C. 11302.

> For purposes of this Act, the term "homeless" or "homeless individual or homeless person" includes—(1) an individual who lacks a fixed, regular, and adequate nighttime residence; and (2) an individual who has a primary nighttime residence that is: A) a supervised publicly or privately operated shelter designed to provide temporary living accommodations (including wel-

fare hotels, congregate shelters, and transitional housing for the mentally ill); B) a institution that provides a temporary residence for individuals intended to be institutionalized; or C) a public or private place not designed for, or ordinarily used as, a regular sleeping accommodations for human beings.

As can be seen from the above, the *original* concept of a "homeless" person or individual is, by definition, linked to one's residential status, especially as regards a "nighttime residence." Most important for our purposes, if a person either "lacks" a nighttime residence or resides in one designated as a "shelter" (of some kind), then that person is defined as "homeless."

More recently, however, leading researchers and policymakers have considered a broader definition of who should be defined as homeless (HUD, 2007; Shinn, Baumohl, & Hopper, 2001). For instance, should we include those who are "doubled up" or live in abandoned buildings, i.e., "squatters," as "homeless?" HUD's recent report (2007, pp. 1-2) acknowledges, "Public debate has revolved around how widely to view the scope of 'residential instability' and how to target scarce resources to address it. In general residential stability can be divided into two broad categories of people: those who are 'literally homeless' and those who are 'precariously housed.'

> • *Literally Homeless.* These include people who for various reasons have found it necessary to live in emergency shelters or transitional housing for some period of time. This category also includes people who sleep in places not meant for human habitation (for example, streets, parks,

abandoned buildings, and subway tunnels).
These 'street homeless' people may also use
shelters on an intermittent basis.

- *Precariously Housed.* These are people on the
brink of homelessness. They may be doubled up
with friends and relatives or paying an extremely
high proportion of their resources for rent. They
are often characterized as being at imminent risk
of becoming homeless."

In this book, all of the homeless mothers interviewed had
lived in shelters as defined in (2) A) above, including four who
had been "literally homeless" and 20 who had been "precari-
ously housed." Although several of the mothers had experi-
enced psychiatric care as a result of trauma, it was not my im-
pression that any of them were acutely mentally ill at the time
of the interviews. The narratives of two mothers, however,
seemed to me to be scattered and diffuse; and it was clear that
several mothers were wrestling with significant depression, and
would benefit from both a validating relationship and mental
health services.

Out-of-Home-Care (or "In Care")

In this book, the phrase "out-of-home-care" (also often short-
ened to read "in care" or "placement") refers to mothers who
had been in the care of either foster parents, a congregate or
group home, or residential treatment, at some point in their lives
prior to the interviews. About half the mothers had been "in
care" and about half had never been in care. At times in the en-
suing chapters, I will refer to comparisons between mothers
who had been in care and not in care, regarding such things as
their number of residential moves prior to entering the shelter,

their parenting experiences, or how they coped with stressors in the shelter.

Emergency Shelter

Any facility, whose primary purpose is to provide temporary shelter for the homeless in general, or for specific populations of the homeless, may be defined as an emergency shelter. These are often congregate or barrack style facilities, and in New York once were called Tier One shelters.

Transitional Housing

Any facility whose primary purpose is to provide temporary housing with services tailored to family needs, with the ultimate goal of assisting families to move into permanent housing in the community, is transitional housing. This type of housing once had been called Tier Two. A community-based, religious, or other type of public or private organization may provide it.

The homeless mothers I interviewed lived in one of two transitional shelters in New York City. In this book, they are respectively called the "The Arche Shelter" and the "The Lincoln Family Residence," to protect the anonymity of the actual shelters. The Arche is located in the theater district of Manhattan and The Lincoln is located in a working class neighborhood in Brooklyn. Details about these shelters are discussed in Chapter 3.

Department of Homeless Services (DHS)

DHS is the New York City governmental agency responsible for administering the shelter system to individuals and families that are both defined as homeless and meet the official criteria

for service eligibility. In New York City, the site of the current work, the mission, history, functions, and new initiatives of the DHS are described on the City's official website, as follows:

> The mission of the Department Of Homeless Services is to overcome homelessness in New York City. DHS prevents homelessness wherever possible and provides short-term emergency shelter and re-housing support whenever needed. These goals are best achieved through partnerships with those we serve, public agencies, and the business and non-profit communities. The Department of Homeless Services was established in 1993 and made an independent agency, reporting directly to the Mayor, in 1999. Since its inception, the work of DHS and its nonprofit partners has primarily focused on providing safe shelter, outreach services and, over the last few years, helping individuals and families transition to permanent housing. All of these areas continue to be central to the agency's day-to-day work. In June 2004, Mayor Michael R. Bloomberg released *Uniting for Solutions Beyond Shelter*, the city's five-year action plan to end chronic homelessness. With the release of that action plan, the Mayor committed to reducing the number of individuals and families in shelter and on the streets by two-thirds in five years. These ambitious goals have required DHS to place greater emphasis on interventions that solve rather than just manage homelessness. These interventions include eviction prevention services, mediation, rental assistance, and a

range of services and referrals to community based agencies . . . to name a few. The action plan also acknowledges that DHS cannot solve homelessness alone. The agency is committed to continuing to build strong partnerships with our clients, various public agencies, and the non-profit and business communities.

Homelessness In New York City: A Statistical Portrait

In 2007, homeless individuals and families in New York City are at all-time highs and the shelters are pressed for space. As a result, "homelessness" has not received so much publicity in many years, with stories regularly appearing in newspapers and on television. In March 2007, the Coalition for the Homeless released its eighth *State of the Homeless* report, an annual assessment of homelessness in NYC based on data from the city's Department of Homeless Services (DHS) (2007a). Overall, the report finds that more families than ever before are entering New York City's shelter system, primarily because of three factors: increasing housing costs, low wages, and shortcomings of the city's Housing Stability Plus program.

In this context, it should be mentioned that the phrase "homeless families" usually refers to a homeless mother and her children in her care; and that although families enter the shelter system, this may have little effect on the number of families that live either on the cusp of homelessness or under circumstances that might be remedied by adequate housing. In other words, the "cueing process" only re-orders the cue, not the numbers (O'Flaherty, 1996; Shinn, Baumohl & Hopper, 2001).

The 24 mothers I interviewed for this book may be considered a representative sample of a relatively large segment of the population of New York City who find it necessary to seek refuge in an emergency shelter at any given point in time. To help put these mothers and their children into a useful perspective, a few seminal statistics about homeless families and individuals in NYC are presented below (New York City Coalition for the Homeless, 2007a). Until very recently, city officials and the Coalition for the Homeless would have argued about how to interpret these statistics, but today they are in agreement about the severity, prevalence, and growth of the problem. Specifically, for New York City, during the past year:

- The number of homeless families in shelters increased by 17.6 percent (to 9,190)
- The average monthly number of homeless families reached a modern record high in February 2007 (since the city began counting in 1982), with 9,287 homeless families in the shelters—about 2,000 more than Mayor Bloomberg's projected number of 7,400 homeless families
- The number of new homeless families entering shelter increased by 22.9 percent
- The number of homeless children increased by 18.1 percent (to 14,219)
- The total number of homeless New Yorkers in shelters increased by 11.1 percent (to 35,113)
- The number of homeless families moved to permanent housing fell by 11.0 percent

In addition to the above, one can gain an even greater appreciation for the entrenched problem of homelessness in NYC by considering the following statistics for the past several dec-

ades on (1) the number of homeless mothers, (2) the number of homeless children, (3) the total homeless population, and (4) the cost of caring for the homeless (New York City Coalition for the Homeless, 2006; DHS, 2006; Kaufman, 2007).

- Between 1998 and 2005, the number of homeless families sleeping in New York City shelters, purchased hotel rooms ("welfare hotels"), and scatter site housing increased by 95 percent, from 4,429 families at the end of January 1998 to 8,640 families at the end of February 2005; and the homeless shelter population increased by 72 percent, from 21,100 people in shelters each night to 36,200 people per night.

- During 2005 the number of homeless residing in NYC shelters each night reached the highest point in the city's history. In February, some 36,200 individuals were sleeping each night in the shelter system, including 14,900 children, 12,600 adult family members, and 8,700 single adults. Thousands more sleep on city streets, park benches, and subway trains.

- The average stay for homeless families in the municipal shelter system nearly doubled over the past decade, from 6 months in 1992 to nearly 12 months in 2006.

- During the eight-year period 1987-1995, 333,482 different homeless men, women, and children utilized the municipal shelter system in New York City. This represents nearly 1 of ever 20 residents. During the five-year period 1987-1992, nearly 1 of every 10 black children and 1

of every 20 Latino children in the city resided in the homeless shelter system.

- Permanent housing for homeless families and individuals costs less than shelter and other emergency care. In 2005, the cost of sheltering a homeless family in the New York City shelter system was $36,000 per year, while the cost of shelter for a homeless individual was $23,000 per year. In contrast, the cost of a supportive housing apartment with services was as little as $12,500 per year, and the cost of rental assistance with support services for a family costs was as little as $8,900 per year.

As the above data show, a significant problem of homelessness has characterized New York City for several decades, and the problem is growing worse for both individuals and families, including women with young children. The mothers whose stories appear in this book are but a tiny fraction of the number of homeless individuals nationally in any given year, which is estimated to be between 2.5–4 million, including nearly 1.5 million children (National Coalition for the Homeless, 2007).

Why Do Mothers with Children Become Homeless?

In this book, you will learn how and why the mothers I interviewed became homeless, in their own words. While each mother has a unique narrative, characterized by the specific circumstances of her own life history, the basic reasons they became homeless are consistent with what other studies have re-

vealed to be the major causes of homelessness in America. Over the past several years, various researchers (Bassuk, Rubin, & Lauriat, 1986; Friedman, 2000; Smith et al., 2005; United States Conference of Mayors, 2004) have conducted studies on homeless individuals and families in an attempt to develop a portrait of the root causes of homelessness. Essentially, there are four basic, interrelated categories of explanation for homelessness among families with children: (1) legislation, (2) economics, especially poverty, (3) housing, and (4) lifecourse factors.

Federal Law Regarding the Homeless

Many programs to address problems associated with homelessness were created at the beginning of the Reagan Presidency, administered at the local level. In the view of that administration, states and local jurisdictions were best equipped to handle their own homeless problems. A federal task force on homelessness was created in 1983 to provide information to local governments and other interested parties on how to obtain surplus federal property.

Between 1980-1988, during the Reagan Administration, the commitment to government-funded housing and housing subsidies decreased drastically. The budget for The Department of Housing and Urban Development (HUD) was cut, and the subsidized housing budget allocations dropped by 88 percent. In addition, the amount of Section 8 vouchers decreased by 47% (Stegman, 1991).

With both diminished housing resources and increased gentrification in urban neighborhoods, the number of families without homes increased and became a visible, public problem. Press coverage, active protests by advocacy groups, and interest

by policy practitioners exerted growing pressure for government to address the problem in a substantive way (Bogart, 2003).

In 1983, the first federal legislation that provided funds targeting homelessness was passed. This legislation provided $100 million to the Emergency Food and Shelter Program, charged with providing temporary relief to homeless individuals and families. After an intensive advocacy campaign, along with accumulating research on the growth of homelessness, large, bipartisan majorities in both houses of Congress passed the McKinney-Vento Homeless Assistance Act in 1987, commonly called the "McKinney Act" after its chief sponsor, the former Republican Representative Stewart B. McKinney. In 2002, the McKinney Act was reauthorized, and contains a range of titles and funding streams. Of particular note for this book is that the Act focuses on the well being and education of homeless children.

The McKinney Act originally consisted of 15 programs providing a range of services to homeless people. The provisions of this act funded programs for health care, drug and alcohol rehabilitation, mental health services, and job training, as well as transitional housing and shelters. In 1990, an amendment to the McKinney Act broadened provisions of the original act to diminish barriers to education for homeless children, and developed provisions to spark interagency collaboration for public school staff.

In 1993, the Clinton Administration attempted to pass more expansive legislation, entitled "Priority Home," designed to prevent homelessness, help homeless persons find affordable permanent housing, encourage coordination and cooperation among local housing agencies, and create jobs for low-income adults. This proposed legislation, however, failed to become law (Danzig, 1997).

New York City Laws and Policies

The New York City shelter system has been uniquely shaped by a variety of forces, including the New York State Constitution, judicial decisions, the efforts of advocacy groups (e.g., Coalition for the Homeless), poverty law organizations, and press coverage. New York is one of the few states (along with West Virginia) to have identified the right to shelter within its constitution (Stoner, 1995). The Callahan consent decree, an important legal precedent, made New York the first city to shelter the homeless on demand. A decade ago, the city spent over $7 billion on social services, which exceeded the entire budgets of 21 states. Approximately $500 million went towards housing homeless people. According to Stoner, "The New York City strategy of litigating for a right to shelter on demand was unique and the results of the consent decree have rendered the City a laboratory of homeless policy and advocacy for all cities."

For over a decade, the shelter system had been under the aegis of judicial oversight, primarily with respect to the provisions of services to families requesting assistance through the Emergency Assistance Unit. In 2004, under Mayor Bloomberg's Administration, a collaborative agreement relieved DHS of this ponderous judicial oversight as well as expensive litigation.

As mentioned above, in New York, the city is legally required to provide a place to sleep to all who request it. For much of the last two decades, homeless services have meant just that—offering shelter and not much more. Some observers claim, however, that the city's shelter system has improved and expanded, so that it now includes social services as well as shelter. In June 2005, the Department of Homeless Services released a plan that expands the agency's scope beyond basic services to include prevention and a wider range of housing op-

tions. According to city officials, the city also hopes to create new rent assistance programs, new supportive housing initiatives, and ways to help people maintain permanent housing.

Economics

Generally, for the United States between 1980 and 2005, poor and low-income people were caught in a vise-like squeeze of stagnant or decreased income and benefits, plus an escalating shortage of affordable housing. These adverse conditions resulted in both an increased number of families without homes and more requests for emergency housing assistance. Families who become homeless are very poor; and the poor have become poorer in the last 25 years (Bassuk et al., 1997; Cowal et al., 2003; Friedman, 2000; Johnston, 2007; United States Conference of Mayors, 2004).

Nationally, during the course of the past 30 years, decreases in employment resulted in less opportunity for young men with limited education to offer financial support to their families. This situation also tended to discourage the formation of traditional two-parent families (Edin & Kefalas, 2005; Wilson, 1987). Single parenthood creates further financial hardship (Haveman & Knight, 1999). The erosion of income maintenance subsidies and insufficient increases in housing grants that failed to keep pace with rising rents resulted in eviction and/or families being doubled-up in overcrowded housing, with either other family or friends (United States Conference of Mayors, 2004).

Federal legislation called "The Personal Responsibility and Work Opportunity Reconciliation Act," passed in 1996, allowed New York State to place a 5-year time limit on the receipt of Aid to Families with Dependent Children. AFDC subsequently

became Temporary Aid to Needy Families (TANF). The 5-year time limit occurred in 2002, leaving public grants lower for some families. While this 1996 Act assisted many women to enter the labor market, most of their jobs were entry-level (De Parle, 2004). Even when their employment created more income, the women often lost public benefits, such as eligibility for healthcare and housing subsidies. Wages and benefits loss frequently meant that families, especially those headed by single women, could not afford market rent or rental increases. To make matters worse, many economic centers moved into the suburbs, where housing, and often commuting, was unavailable to low-income families wishing to move up a career ladder (Center on Budget and Policy Priorities, 2002).

In New York City, Markovic, Flores and Smith (2005) found that about half of all eligible homeless families in 2004 came from 10 community districts. The districts were primarily located in the Bronx, central Brooklyn, and northern Manhattan, and represented only 17% of all districts in the city. Sixty-four percent of eligible entrants to the NYC family shelter system were headed by single adults with children; 21% were two-adult households with children; and 10% were two-adult households without children.

Several neighborhood conditions were associated with high levels of homelessness. The number of people receiving public assistance in a particular neighborhood was the strongest indicator of the number of neighborhood families that entered the shelter system. Shelter use from a particular neighborhood was also associated with the number of families living below the poverty line, the percentage of African American families, and vacant housing units in that neighborhood. In the 5 years before they entered shelter, 79% of shelter users had been employed.

More than half of household heads who entered the shelter system had at least a high school diploma.

Sheltered families struggled to maintain stability in the face of a range of destabilizing life events, closely related to their economic condition. The most prevalent were loss of both jobs and public benefits, but also prominently included eviction (informal or formal) and domestic violence. These events increased the likelihood of a family entering shelter within the same month as their occurrence (Smith, Flores, Lin & Markovic, 2005).

Housing

In the past generation, our nation has managed to decrease or end many of the low-income housing programs available for poor families. Nationally, the current and growing shortage of affordable housing is leading to increased homelessness. In 1970, there were 300,000 more affordable housing units available than there were low-income households in need (Daskal, 1998). In 2001, however, there were 4.7 million more low-income households that needed housing than there were affordable housing units (Alexander, 2003).

The Federal retreat from investment in low-income housing during the past 3 decades has added to the shortage of low-income housing. Although the number of housing subsidies had increased during the early 1990s, the increase could not be offset by the growth in the number of poor renters eligible for such subsidies. Poor renters living in unsubsidized housing spent as much as 75% of their income on housing (Friedman, 2000).

New York City Housing and Section 8 Vouchers. McChesney (1992) compared the housing prospects of poor families to a game of musical chairs; the players are poor and

low-income families, the chairs are safe, affordable housing. The truth of this analogy continues to be reflected in the ongoing housing vacancy rate of 3.09% in 2005 for New York City, which is lower than the legal definition of a housing emergency in the city, which is 5% (Lee, 2006).

In New York City this situation has been attributable to a complex of factors acting simultaneously, including the policies of the Giuliani and Bloomberg Administrations, between 1990 and the present time; the faltering economy; and most of all, perhaps, the city's failure to create affordable housing. In the words of Joe Weisbord, staff director of *Housing First!*, a coalition of affordable housing advocates, "The city needs a larger policy to deal with the fundamental issues of housing costs and housing supply, which are at the root of the crisis."

In New York City, one way the administration of Mayor Michael Bloomberg hoped to move families—such as the mothers and their children discussed in this book—into subsidized housing was with Section 8 vouchers. These are federal subsidies administered by HUD, allocated to local governments. The vouchers are intended to help low-income families to bridge the gap between what they can afford to pay for rent and market rent. However, the federal government has sharply limited the number of Section 8 vouchers available. Nationally, such housing subsidies had been the crucial factor in helping about two million householders rent modest but stable homes in the private market. These subsidies often kept downwardly mobile families out of the shelter systems, and their children out of the foster care system (De Parle, 1996).

In response to the decrease in Section 8 vouchers, the New York City Human Resources Administration (HRA) and DHS developed "Housing Stability Plus" (HSP) grants. These grants were not only to compensate for the diminishing supply of Sec-

tion 8 subsidies but also to encourage financial independence among poor heads of households. Currently, HSP subsidies are only allocated to families receiving public assistance. It serves as a shelter allowance supplement with a 5-year time limit. The supplement is reduced each year by 20%, and the recipient is expected to make up the difference.

Although numerous studies have discovered that rent subsidies are the key to stable housing (Cowal, 2000; Fischer, 2000; Rog et al., 1995) vouchers are not a cure-all. For one thing, with New York City's tight housing market, landlords may not readily accept them. In addition, most families wait nearly a year in the shelter system before they receive vouchers. In New York City alone, for example, there are nearly 250,000 families waiting to be put on the Section 8 list to receive vouchers toward rent payments.

New York City Housing Subsidy Policy. Housing stability Plus (HSP) was one way of replacing, or weaning homeless families away from, dependence on Section 8, which had become less reliable and available to all local districts. HSP had many critics. Among them were homeless parents as well as service providers and advocates for the homeless. While Housing Stability Plus was intended to move families into permanent housing quickly, and to assist families moving to self-sufficiency, three aspects of the program were counterproductive. For one thing, the needs-based criteria, which stipulated that eligible families had to be receiving public assistance for the subsidy, ignored the fact that many families who had used the shelter system wanted to work. This stipulation, therefore, was a disincentive to their goals. When the head of a household did return to work, the employment often compromised other benefits being received, such as health insurance and food

stamps. In addition, many families were precipitously removed from the welfare rolls and lost any sort of subsidy.

HSP also ignored the basic fact that thousands of working families often face the perilous choice between paying the rent and having adequate nutrition. In addition, the 20 percent annual step-down in the subsidy created a fiscal balancing act that did not account for emergencies, illness, or many other daily demands the mothers faced. HSP also did not account for rising rent increases and was accompanied by a five-year time limit. This contradicted solid research that indicated a stable subsidy without time limits was the best solution for stabilizing families.

To its credit, DHS launched a new housing subsidy in 2007, "Work Advantage." It allows individuals who had been on public assistance to work for income and not lose the benefits they had received, such as Medicaid, food stamps, and child care vouchers. The amount of the Work Advantage subsidy is more generous than HSP. However, it has a two-year time limit. The subsidy is designed for families, both to increase their self-sufficiency and create capital accumulation, by matching city dollars to dollars saved by the family. "Work Advantage" also includes services that are more accessible and individualized to help heads of households find employment.

Many advocates have identified flaws inherent in this new subsidy, such as that the program assumes the central problem is individual self-sufficiency rather than the absence of affordable housing. Recipients of the subsidy have to find jobs paying $15 to $20 per hour to afford an apartment when the time limit arrives. If they cannot, then they are forced to move to housing in poor condition and make other untenable choices.

The longtime, chronic shortage of low-income housing in NYC (Jackson, 2002) has recently been addressed by Mayor Bloomberg, who announced a plan for affordable housing called

"The New Housing Marketplace." It is a 10-year plan to create and preserve 165,000 units of affordable housing, intended to house approximately 500,000 New Yorkers by 2013. This plan includes the New York/New York III agreement between New York City and the State of New York, which declares the commitment by both city and state to build housing for chronically homeless individuals and families.

Life Course Factors Associated With Homelessness

In addition to legislation, economics, and housing, the fourth major category that explains homelessness in America is life-course factors. In this section they are subdivided into childhood antecedents and current life circumstances.

Childhood Antecedents. My review of studies on the relationship between frequency of adverse childhood events and subsequent living situations yielded valuable insights. Recent research has focused on the effects of childhood adversities on increasing vulnerability to homelessness (Koegel, Melamid, & Burnham, 1997; Passero, Zax, & Zozus, 1991; Piliavin et al., 1991; Susser, Streuning & Conover, 1987; Summerlin, 1999) and heads of families without homes (Bruckner, Weinreb, Browne, Bassuk, Dawson & Perloff, 1997; Roman & Wolfe; 1997; Zlotnick, Robertson & Wright, 1999). Among the risk factors most relevant to this study are those related to events that affect individual development and well being and often shape a person's perceptions of self, place, home, interpersonal relationships, and hopes for the future. These experiences sometimes compromise personal relatedness, social support resources, and economic self-sufficiency, and thus ultimately may compromise adult functioning.

The disruptive childhood factors in these studies include living in foster care or a group home at some time before age 18, running away from home, living on the streets, physical and sexual abuse (Shinn, Knickman &Weitzman, 1991), and parental substance abuse and out-of-home placement (Bassuk et al., 1997). Other antecedents cited in the studies include having a female as the primary financial provider, poverty-related housing experience, housing distress, homelessness as a child, family troubles, and physical and sexual abuse (Koegel, Melamid & Burnham, 1995).

Physical and Sexual Abuse. Early victimization has been found to be closely associated with poor adult behavioral outcomes (Browne, 1993). Childhood sexual molestation and physical abuse can have a long-term effect on emotions, self-perceptions, interpersonal relationships, psychological well being, social functioning, and a sense of safety and good self-care. Adult women who had been sexually victimized as children were found to be more likely to manifest clinical depression and extreme emotional distress than women without such a history of trauma (Browne, 1993; Goodman, Saxe & Harvey, 1992).

Goodman, Saxe and Harvey (1992) suggested that trauma is a perceived severance of secure affiliative bonds, which damages the sense of trust, safety and security concomitant with the loss of having a safe place to retreat, either within or outside of oneself, to deal with frightening emotions or experiences. Such trauma also shatters the sense of connection between the individual, caretaker, and community. Comparison studies of sheltered mothers found that shelter requesters reported physical and emotional abuse in adulthood at almost twice the rate of their housed counterparts (Bassuk & Rosenberg, 1998; Browne

& Bassuk, 1997; Knickman & Weitzman, 1989; Wood, Valdez, Hayashi, & Shen, 1996).

Violence experienced in childhood was predictive of violence experienced from intimate partners later in life, even when all other variables were controlled (Browne & Bassuk, 1997). Homeless custodial mothers experienced a higher rate of childhood physical and sexual abuse than their housed counterparts (Bassuk & Rosenberg, 1998; Knickman & Weitzman, 1989), and such trauma began at an earlier age for homeless than housed mothers. Although Goodman (1991a) found no difference between homeless women and housed respondents in regard to the prevalence of either physical or sexual abuse when they were children or adults, she did find that all but 11 percent of the total of both groups had experienced victimization.

Imle and Anderson (2001) found that both homeless and never-homeless women were comparable in regard to family abuse history, transience, and loss. The never-homeless women, however, had support from an extended family member who provided a connection, role model, and love. This was not the case for the homeless women. These findings certainly merit much concern and consideration.

Out-of-Home Care. Many studies note that children who had been in out-of- home care are over-represented in the shelter population as adults. Childhood placement in foster care was found to substantially increase the length of a person's homeless experience (Piliavin et al., 1991); and homeless women were found to be more likely to have experienced foster care (17 percent) than men (10 percent) (Winkleby et al., 1992, cited in Roman & Wolfe, 1997).

Findings of comparative studies (Bassuk et al., 1997; Goodman, 1991a, 1991b; Homes for the Homeless, 1993, 1998; Shinn, Knickman & Weitzman, 1991) have demonstrated a cor-

relation between out-of-home care and shelter use. Out-of-home placement and drug use by the primary female caretaker was the most salient childhood predictor of subsequent family homelessness (Bassuk, Bruckner, Wienreb, et al., 1997).

Two studies (Roman & Wolfe, 1997; Zlotnick, Robertson & Wright, 1999) directly focused on the relationship between out-of-home placement and shelter use. Roman and Wolfe (1997) found that 75 percent of mothers who used the shelter and had a history of out-of-home placement had at least one child who was currently in foster care. In contrast, 27 percent of mothers who both used the shelters and had no history of foster care currently had a child in out-of-home placement. The only study that differentiated the categories of out-of-home care (Zlotnick, Robertson & Wright 1999) found no indication that mothers who had been placed had more health or psychosocial problems than other homeless women, and that differences between the categories were related to the quality of caretaking rather than the biological relationships of the caretaker to the child. Research also has shown that mothers whose children were not living with them in the shelter were likely to be at least 35 years of age, have older, school-aged children, and be concerned with absenteeism related to frequent moves.

Clustering of Factors. Comparative research findings related to single persons and families without homes suggest that both a clustering of negative developmental stressors and an uneven distribution of early family disruptions may contribute to homelessness. In a study (Koegel, Melamid, & Burnham, 1995) of 1,563 adults without homes in California, the researchers found that the participants' rates of negative childhood experiences were higher than the rates in the general population. The researchers also found that 64 percent of the respondents

reported two or more major problems during childhood, and more than two-fifths reported problems in three or more areas.

Multiple and cumulative problems have been found to lead to shelter use at an earlier age (Koegel, Melamid & Burnham, 1995). According to Knickman, Weitzman and Shinn (1990), a single disruptive childhood experience increased the risk of a person becoming homeless by seven percent; two such experiences increased the risk by almost 12 percent; and three or more child and adult disruptive experiences increased the risk by 15.6 percent.

Current Life Circumstances Associated With Shelter Use

Experts agree more about structural and economic risk factors than about person-centered risk factors. Identifying the latter, however, is important for both understanding the life course trajectories of homeless individuals in general and appreciating the subtle meanings in the testimonies of the mothers I interviewed, presented in the following three chapters.

Race and Ethnicity

Minority status increases the risk of people becoming homeless, independent of other explanatory variables (Bassuk, 1992, Friedman, 2000). Historically, people of color have sustained steeper erosion of income related to the poverty threshold than have other racial and ethnic groups (Shinn & Gillespie, 1994). Although the racial composition of families without homes varies at local and regional levels, on the national level families of color are over-represented among the homeless population (HUD, 2007; Rossi, 1994; Shinn & Gillespie, 1994; Smith &

North, 1994; The Better Homes Fund, 1999; U.S. Conference of Mayors, 2004).

In the central cities, persons without homes are most likely to be minorities, as well as older and disabled. Although the HUD (2007) report to congress underplays attributing the disproportionately high representation of homelessness and poverty to racial factors, it cannot avoid implying the connection between these variables. Specifically, the report says that 59% of the sheltered homeless population and 55% of the poverty population are members of minority groups, yet blacks, Hispanics, and other minorities compose just 31% of the U.S. population. African Americans alone compose 12.5% of the population, but they represent 45% of persons without homes.

The HUD report, which used well-conceived measures of both the homeless and shelter utilizing populations, offered the following information about shelter use: Single parent families in shelters are less likely than unaccompanied individuals to be white, and they have a minimal financial cushion to absorb the impact of unexpected crises that result in loss of tenure.

The report by the Vera Institute of Justice (Smith et al., 2005) also cites the concentration of risk factors, including race, that are present in the community districts (CDs) where families seeking sheltering services previously resided. Shinn et al. (2001), Homeless Services United (2006), and Burnham (2001) substantiate how changes in public benefits have adversely affected very poor families, and ways public assistance payments to families often are peremptorily dispensed and/or discontinued so as to create further stress. Withdrawal of needs-based income, for example, has had a general destabilizing effect, most prominently increasing levels of both food insufficiency and housing insecurity.

Gender, Race and Ethnicity. Race and gender are inextricably embedded in current life circumstances for women using the shelter system. The hard choices women have had to make regarding paying for utilities, rent, and food has increased their stress levels, especially among the unemployed. Mothers who have made the transition into paid work found they incurred increased costs associated with participation in the labor force, such as a reduction in food stamps, which meant that getting food and feeding their families became more precarious.

Burnham (2001) reported that poor women in the U. S. faced housing crises long before the implementation of the Personal Responsibility and Work Opportunity Act of 1996. This was especially so in the many states where women were at the mercy of the private housing market. In New Jersey, for example, 50% of former tenants who were not working reported food insufficiency for themselves and their children. Furthermore, Burnham reports that when one is either homeless or living in a shelter, both obtaining and retaining a job are especially difficult. In addition to disguising the fact that one is homeless, the difficulties include seemingly mundane tasks such as going for interviews, locating childcare, and arranging for transportation.

Although the Personal Responsibility and Work Opportunity Act was designed to be "race neutral," it is not so in its implementation. Nationwide, for example, a higher proportion of whites than nonwhites reported that their workers were helpful in steering them toward jobs. In addition, the application process for Temporary Aid to Needy Families (TANF) benefits has had a chilling effect on women, particularly for new immigrants such as Latina women (Burnham, 2001).

Pregnancy

The most salient factor leading to shelter use today among young women is pregnancy (da Costa Nunez, 2004), and this has been the case for the past several decades (Knickman & Weitzman, 1989; Wood et al., 1996). Comparison studies of mothers supported by AFDC have indicated that pregnancy and recent childbirth were independent predictors of their shelter seeking. Bassuk et al. (1997) found that pregnancy was a component of the causal chain leading to shelter use, although it was not an independent predictor of shelter use.

Explanations for increased shelter use by young pregnant women or young mothers with children under one year of age include mounting stress from having to adjust to the needs of infants and young children in already crowded or strained living arrangements (McChesney, 1992; Weitzman, 1989); protection offered by greater access to social services and subsidies; and priority placement in transitional housing provided for pregnant women and women with very young children (Berlin & McAllister, 1994). The shelter system also offers parents an escape route from street life or malnutrition (Dehavenon, 1999).

Parenting and Households Headed by Single-Women

The preponderance of survey research indicates that single-women headed households with children under 18 years of age have constituted the major users of transitional sheltering services among families without homes (Johnson, 1999). For the past 20 years, researchers have found that homeless sheltered mothers had typically been accompanied by two young children, ranging from 1.8 to 2.4 years of age (Bassuk, Rubin, & Lauriat, 1986; Knickman & Weitzman, 1989).

Age

Younger people are at special risk of becoming homeless because they have accumulated scant financial resources. According to Shinn, Baumohl and Hopper (2001), however, in a review of homeless prevention literature, youth *per se* was not a risk factor, but it became a risk factor within the context of other variables. This finding suggests that youth are at greater risk of homelessness because they have less access to the housing market.

Women under 35 years of age appear to face unique risks for homelessness, which may reflect their having young children or the instability of their support networks (Lehmann et al., 2007; Siefert et al., 2007; Smith et al., 2005). Young women also head most families without homes. Figures for the 1990s show that, nationally, their average age was between 26 and 30 years, whereas single, homeless individuals overall had an average age of 36 years.

In New York City, the Department of Homeless Services reports that over the past 15 years, from 1988-2002, roughly 60% of household heads in the family shelter system were between 18 and 29 years old. This segment of the shelter population declined in 2002, to 55%. The population of those over 40 years of age also increased 10%, by 2002. The DHS's Department of Policy and Planning attributes the change in the age demographic, in part, to the fact that people are aging within the system. There has been an increase in the number of children between 6 and 11 years of age compared to the age of children in the shelter system in the 1990s. The family shelter system is now accommodating far more school-aged children than ever before (Emerging Trends in Client Demographics, 2006).

Education and Employment

Brooks and Bruckner (1999) found that 60 percent of poor housed women either had a GED or high school degree, compared to 50 percent of parents without homes; homeless heads of households who worked during the five years prior to shelter use were employed in entry-level or service jobs. Barriers to employment include limited supply of affordable childcare and limited education (Brooks & Bruckner, 1999).

Although welfare reform literature and feminist-based studies generally conclude education is the key to improving individual "human capital," the assumptions about mothers without homes have been that they need "capital improvement." A study by Lehmann, Kass, Drake, and Nichols (2007) found that education, in fact, was not a sufficient protection against becoming homeless, and neither was employment. Their control group study also surprisingly revealed that first time homeless women were more likely to have had college education than a matched sample of housed women. The researchers further found that personal risk factors that precipitated women's sudden need to use shelter services were an amalgam of prior life changes, such as separation from a partner, eviction from a residence, and relocation to a new area. For some women, unemployment and relocation gradually shifted into a downward spiral to homelessness.

Even a full year of college may not provide women access to the kinds of jobs that enable them to be self-supporting, especially if they are simultaneously faced with calamities. Any single protective factor, such as education, associated with individual daily reality or social processes is unlikely, in itself, to decrease the risk for homelessness. Based on this finding, the researchers concluded that programs that address only one risk factor will not limit homelessness. Some risk factors require

community action directed towards housing policy and income supports. In this regard, Lehmann et al. (2007) recommend that women facing eviction should be targeted for emergency prevention.

Although no one knows the number of college students who are homeless or whose education has been disrupted by extreme residential instability, my experience as a college professor has furnished ample anecdotal evidence that there may well be a small epidemic of *"education interrupted"* because of housing factors. Media—including campus papers and magazines across the political spectrum—have documented stories of homeless students living in cars, friends' dormitory rooms, libraries, and shelters where there is no opportunity to study.

Social Supports

The critical role of social supports during life transitions is well documented (Bitonti, 1990; Eckenrode & Gore, 1981; Gore, 1995; Snow, Anderson & Koegel, 1994). The number, severity, and sequencing of life events, and the significance of longer-lasting, stressful conditions, are important for understanding the meaning of adversity to the mothers in this study. Several studies (Bassuk & Rosenberg, 1998; Wood et al., 1996) contend that heads of families without homes are more isolated than housed families, and assume that un-housed heads of families have less capacity to form trusting, supportive relationships than do housed single mothers. One implication of such studies is that a fragmented social support system and social isolation are precursors to homelessness.

Other studies (Goodman, 1991b; Knickman & Weitzman, 1989), using different sampling frames and measurements, found that sheltered mothers had similar, if not more, contact

with their families than did a comparable group of housed women. Prior to entering the shelter, their families and social network members provided a great deal of instrumental and emotional support to the mothers. Goodman (1991b) also found that these sheltered mothers expressed less trust and willingness to request assistance than housed mothers. Goodman suggests two explanations for this finding. The first is that sheltered mothers perceived their relationships with others to be less trustworthy; the second is that homelessness itself disrupts individuals' social relationships and creates a sense of aloneness, insecurity, and loss of trust.

A case study by Gerstel, Bogard, McDonnell, and Schwartz (1999) of 340 heads of families without homes also found that relational networks matter, but that families often had used up their resources in their social networks and declared themselves homeless in order to access resources in the shelter funding stream. Programmatic requirements of some shelters interfered with continuity of both contact with social networks and processes important to sustaining sources of social support, according to the researchers.

Among the situational characteristics most relevant to the women I interviewed was the quality of their interpersonal relationships and social supports. These components of their daily living may have both mental health and human and social capital implications. Lehmann et al. (2007), in a study of women who entered the shelter system for the first time, found that those who had relatives living in the same state prolonged the amount of time they stayed out of the shelter before entering. Siefert et al. (2007) found that, among poor African American women, instrumental support was related to a reduced risk of depression. The tangible supports included a loan during a crisis, the availability of help with childcare, and transportation.

Such supports also significantly reduced the effects of poverty-related risk factors and the odds of maternal depression. Consistent with previous research on the general importance of material support for mental health, the researchers believe that timely provision of instrumental aid may prevent escalation of a crisis into a catastrophe, and keep an event from becoming a chronically stressful condition.

The Vera Report (Smith et al., 2005) found that when support resources were stretched to the limit (i.e., severely compromised), such as when doubling up with friends, which results in extreme overcrowding, then conflict arose and families sought the shelter system.

Fram (2003), using social and human capital concepts defined by Bordieu, examined differences in mothers' access to functional social supports; how such supports relate to social position, indicated by social, individual, and economic capital; and ways the supports moderate relationships between mothers' resources and parenting practices. A functional social support is one that buffers stress, provides access to scarce and necessary resources through mutual aid, and generates opportunities to help people share their frustrations, solve problems, and cope with the challenges of daily life (Stack, 1974).

Fram (2003) also examined the characteristics of neighborhoods in which parenting and social ties functioned. Mothers with low levels of support were found to be broadly disadvantaged in important ways e.g., educationally and economically, relative to mothers with moderate and high levels of support. Mothers with moderate support, however, had the highest levels of stress among the three groups, and they also reported the highest levels of perceived neighborhood danger. Mothers with high levels of support were the least likely to live in public housing or in neighborhoods they perceived as dangerous.

These findings fit "well with other analyses (Belle, 1983; Coulton, 1996), which indicate that unsafe neighborhoods and those with high proportions of low-income households may inhibit the formation of trusting social ties," according to Fram (2003, p. 34). Fram goes on to say, "Although such relationships may provide crucial mutual aid and pooling of resources, they are likely to involve high costs in terms of expectations of reciprocity, as well as exposure to counter-mainstream norms, illegal activities, or even violence"

Mental Health

Various researchers have established the correlation between high rates of both poverty and psychological distress (Brown, 2002; Brown & Harris, 1978; Brown & Moran, 1997; Culbertson ,1997; Siefert et al., 2007). Siefert et al. (2007), for example, report that depression is highly prevalent among low-income mothers of young children, especially African American mothers, who are overrepresented among the poor. These researchers also cite the well-documented association between maternal depression and negative effects on parenting and child development. Both chronic and acute stressors are often the result of people residing in unsafe neighborhoods, which usually also have high rates of unemployment, inadequate food, insufficient housing, and problems involving transportation. As Siefert et al. found from their study, "Significantly more depressed than non-depressed mothers reported household food insufficiency and poorly maintained housing" (p. 117). Such factors decreased access to goods and services that can mediate stress.

While these risk factors associated with poverty and depression have been clearly identified, Siefert et al. (2007) also sought to find out more about the effect of discrimination on the

mental health status of poor African American women. They note that racial discrimination has consistently been associated with poor mental health status, and may exacerbate the effects of poverty, housing instability, and food insufficiency. Research suggests that people's generic perception of unfair treatment, not the objective reasons for discrimination, is what adversely affects their mental health. Siefert et al. cite other research that demonstrates that routine and continual stress, like that associated with discrimination, is more damaging to individuals than episodic events. They found in their study that everyday discrimination increased depression. The explanation for this association has not been fully articulated, but the researchers speculated that not being able to meet basic human needs sufficiently, e.g., for food and housing, "captures mothers' appraisal of their global quality of life as impoverished women in a potentially racialized setting" (p. 119).

In this context, Bordieu's concept of *habitus* is especially germane. As he explains, "*Habitus* is a set of dispositions (perceptions) that individuals develop through their personal histories of self-reinforcing experiences of their social location. A person is born into a particular social location and the material, social and cultural conditions of that location teach the individual what is possible. Each piece of learning reinforces the behaviors and preferences that will keep the individual locked into that social location" (cited in Fram, 2004, p. 559).

As regards the prevalence of mental health disorders among homeless mothers, there is a debate in the literature, though findings from recent studies do provide nuanced descriptions of such mothers' psychological functioning related both to their role as mother and contextualized in the rigors of daily life.

In addition to the racial and ethnic disparities homeless mothers chronically experience, the gender discrimination to

which they are exposed exacerbates their sense of social rejection. Siefert et al. (2007) suggest that when exposure to such indignities builds over time, it can have enduring adverse mental health consequences and greatly increase the likelihood of maternal depression. "Such an interpretation is consistent with Brown's finding on the role of humiliation and entrapment in the etiology of depression" (p. 120).

In general, researchers have found that both mental illness and substance abuse are less prevalent among families without homes than in the single homeless population (Burt & Cohen, 1989; Fisher & Breakey, 1991; NYCHH, 1990), but more prevalent among sheltered mothers than poor housed mothers (Bassuk & Rosenberg, 1986). Although substance abuse and recent psychiatric hospitalization were found to be predictive as risk factors for homelessness, only a small percentage of homeless women were found to use substances (heroin and alcohol) on a regular basis, and only a small number indicated they had used psychiatric inpatient services. This finding suggests that only a limited segment of women in research studies were vulnerable to homelessness on this basis.

A qualitative study by Kulkami (2001) identifies the effects of cultural stigmas and stereotypes in the lives of young, unmarried mothers of color, and discusses the contradictory contextual and social narratives that young mothers of color must resolve. In general, women of color, compared to Caucasian women, are more likely to parent their own babies than place them for adoption. They must, therefore, come to terms with the societal (canonical) expectations and goals for young adults and older adolescents, especially as regards increasing their economic self-sufficiency through education and employment.

Young unwed mothers often are doubly sanctioned as they navigate normative adolescent conundrums around romance and

sexual relationships. First, they are sanctioned for breaking rules about appropriate sexual behavior, and second, they are sanctioned for violating societies' preference regarding the formation of traditional families. Findings from Kulkami's study indicate that young mothers feel less judged when they are in exclusive committed relationships, regardless of the degree to which the relationships are safe and healthy. Losing their virginity narrows their options, i.e., they either stay with their sexual partners or risk a bad reputation. The pressure of these standards affects both the development and self-image of adolescent girls in far-reaching, enduring ways, e.g., others treat girls with a "bad reputation" poorly. Rather than seeing themselves as victims of a sexual double standard, they accept humiliation. It is within this socially constructed narrative that young mothers often choose to remain committed to their partners, even when they are unfaithful. The need to be valued can allow romantic attachments to push aside doubts. "You and me against the world. . . ."

Mental health and Social Support. The importance of social ties is a prominent focus in much of the mental health research (Burnham, 2001; Fram, 2003; Padgett, Hawkins, Adams, & Dacos, 2006; Siefert, et al., 2007; Smyth, Goodman, & Glenn, 2006). Social support can reduce the negative effects of poverty and discrimination (Siefert et al., 2007). Timely provision of instrumental aid may prevent both a crisis from escalating into a catastrophe and an event from becoming a chronically stressful condition (Burnham, 2001; Siefert et al., 2007).

Instrumental support for homeless mothers to purchase goods and services that satisfy basic needs, such as food for the household, protects them from despair at not being a provider of necessities for themselves and their children. Siefert et al. (2007), for example, reported that household food insufficiency

more than doubled the odds of maternal depression. In addition, homeless mothers sometimes compromise their own nutritional intake to feed their children, which can lead to a lowering of serum concentration of several critical nutrients that affect mental health (Siefert et al., 2007).

Obstacles to Mental Health Treatment. Several authors have identified important obstacles to the delivery of mental health treatment to poor mothers. Siefert et al. (2007) and Burnham (2001) note that many mothers devote their material resources and emotional energy to their families, and may feel guilty about taking time to attend to their own mental health needs. The researchers also note that clinical bias and stereotyping contribute to the diminished quality of mental health treatment that minority individuals, including homeless mothers, often receive.

A study by Gerstel et al. (1999) reported that service-intensive programs for homeless mothers often presumed that mental health problems are part of the causal nexus of family homelessness, and that mental health services were thus provided indiscriminately. Large, service-intensive shelter programs encourage sheltered mothers' isolation from other shelter dwellers as well as from their own support systems.

Goodman et al. (2006) note similar concerns about the fragmented implementation of mental health services. They point out, for example, that specialized services that focus only on a prescribed issue or constellation of issues rather than on the person-in-her-situation bifurcates internal psychological dynamics and external material conditions, by treating them as if they were discrete realities. These specialized treatment approaches often demand that women eschew important relationships and attachments in their lives, without offering a surrogate to replace them.

Such fragmentation also can undermine a woman's development of a consistent sense of self, which depends on the individual being rooted in a cultural and geographic community. This propensity to focus on diagnosis rather than context can undermine mental health treatments for marginalized women with a dual diagnosis (Padget, Hawkins, Adams & Dacos, 2006). When the delivery of mental health services demands that homeless mothers abandon social ties for treatment, and asks them to make choices without understanding the value of available social ties, then this situation merely replicates other power differentials in the women's lives that rob them of the benefits of meaningful social relationships and community.

Organization of the Remainder Of the Book

With the above as background and context for better understanding the general situation of the 24 mothers and their children I interviewed, whose actual stories you will read about in this book, the remainder of the chapters are presented as follows.

Chapter 1 presents profiles or "biographical portraits" of each of the mothers interviewed, and serves as a reference point for you to return to as you read about their lives, including excerpts from their narratives, in the subsequent chapters.

Chapter 2 focuses on the mothers' "pathways to the shelter," including their upbringings, more recent circumstances that led them to be homeless mothers, and their perception and assessment of the shelter system as the best, most rational option for the well being of both their children and themselves.

Chapter 3 focuses on the mothers' "present lives" while living inside either The Arche Shelter or The Lincoln Family

Residence, including discussion and analysis of the multiple stressors they faced and the creative methods they often devised to cope with the stressors.

Chapter 4 concerns itself with the mothers' "future lives," or how they envisioned their futures beyond the shelter, for both their children and themselves, including their plans, expectations, hopes, and dreams about their occupational, residential, family, and personal lives.

Chapter 5 concludes the book with considerations about the future of mothers without homes and policy recommendations, including my answers to the following questions: Are the homeless mothers interviewed essentially different from or the same as other poor mothers? Were the mothers "homeless" because of their personal failings, shortcoming of the social system, random chance, or a combination of these factors? Did the mothers' decision to enter the shelter system represent a rational choice—even the best choice considering the alternatives available to them—or was their choice essentially an act of desperation? While in the shelter, what social services will help the mothers fulfill their future hopes? What are the chances the mothers interviewed will have the opportunity to grow as human beings outside the shelter system, in the near and more distant future?

Following my answers to these and related questions, I provide recommendations regarding how social policies and laws should be formulated so as to take into account the true nature of *who* the "homeless" are as individual human beings, and, based on this, how to best solve the problem of homelessness and address the current and future needs of homeless populations in America.

Chapter 1
Profiles of the Mothers

The purpose of this chapter is to present biographical profiles of the 24 mothers I interviewed. The profiles both provide a point of reference, as you read about the mothers in the ensuing chapters, and encapsulate essential background information about each mother and her children, especially the family situation that led each mother to view and choose the shelter as the best alternative to the accumulating risks she had been experiencing. The names of the mothers in the chapter are arranged alphabetically, for ease of reference. In addition, the names of the mothers, their children, and others are fictitious, to protect their privacy. Following each mother's name is a brief "motto," composed of a sentence and quotation, which I felt reflected an essential quality of each mother.

At the end of the biographical profiles, selected demographic information about all the mothers combined are summarized using descriptive statistics, including data about the mothers' chronological age; age at birth of first child; number, sex, and age of children; race/ethnicity; educational attainment; marital, employment, and financial status; number of residential moves; and length of time in the shelter system at the time of the interviews.

Alicia

Taking matters into her own hands. "This is the first thing I will have done for myself. I feel that I'm doing a pretty good job."

Alicia, a 25-year-old Hispanic mother, lived in a spacious, 2-bedroom apartment room at The Lincoln with her four sons:

Eduardo, Jr., 8 months; Carlo, 4 years; Ernie, 5 years; and Victor, 6 years. The family lived here for 6 months. Although sparsely furnished, family photographs and other small personal items were part of their temporary home. Alicia's two younger sons had severe asthma, so that a nebulizer was part of the family equipment. Alicia had her own espresso maker and shared strong coffee with neighbors and her sister Wanda, who also lived at the Lincoln, with her husband and two children.

Alicia is the second youngest of 12 children, ranging in age from 45 to 21 years. She spent the first 9 years of her life in rural Puerto Rico, where her father, a hardworking, unskilled laborer, supported the family. In Puerto Rico, there was also a large extended family to care for her, as well as her siblings and cousins. She described her parents' marriage as stable. Both parents were firm believers in the Seventh Day Adventist faith. A strong family and caring for children were valued more than educational attainment in this family.

At 16, Alicia came to visit her older sister in New York City, and decided to stay, and then met the father of her three eldest sons. Their relationship lasted for six years, and then he abandoned his family shortly before the birth of Carlo. Deeply hurt by his abandonment, with few social supports or financial resources, she decided to join her sister in Chicago, and then moved near a third sister who lived in Milwaukee. There, she worked as a waitress, but experienced discrimination against Latinas, and decided to return to New York City, where she still had retained the family apartment.

She then met Eduardo, the father of Eduardo, Jr. Soon after her return to New York, she was evicted from her apartment. The family moved into an apartment that Eduardo shared with his mother, who had little tolerance for young children. Because of stress created by the criticism of her children, she decided to

enter the shelter system. Alicia's goal was to become an Emergency Medical Technician (EMT).

Charlotte

Safe from hurt and unwilling to pay the price for a relationship. "At least I go someplace safe to go."

Charlotte, age 22, and her 4-month-old daughter, Whitney, lived in a small, overheated room in The Arche Shelter. There was just enough room for Charlotte's bed and a small crib. Charlotte and her daughter spent much of their day nestled together on her bed, using the crib for storage. Charlotte moved slowly, and the effort to move seemed a reflection of the effort it took for her to move forward with her life. Charlotte came alive when interacting with Whitney. When I met Charlotte, she had been at The Arche seven months, and had been in the shelter system for almost a year.

The eldest of four siblings, Charlotte grew up in an urban area of Aruba. Her mother always worked hard to supplement the father's wages, and thus Charlotte was often left to care for her brothers and sister. From ages 9 to 16, a male neighbor sexually abused Charlotte. When she came to the states at 16, uncles with whom the family temporarily resided also molested her. The result of this chronic abuse was, in Charlotte's own words, "I have low self-esteem. Very low self-esteem. I never thought people would like me for what I am. I used to always figure, you know, if there was somebody who likes you, you gotta go to bed with them. Maybe if my family had heard what I had to say they could have stopped the situation that was going on [repeated sexual abuse], but they never care to listen, so it kept going on and on and on."

Despite many obstacles, she completed high school and had been accepted to nursing school. Prior to entering the shelter system, Charlotte had been living in her family's home, in an environment laden with parental conflict. She briefly moved to the apartment of Whitney's father, who also was emotionally abusive, and finally pushed her down a flight of steps when she was in her first trimester of her pregnancy. The abuse was the precipitant to her seeking safety in the shelter system. In fact, Charlotte had been trying to escape her family home for many years. As a young girl she dreamed of becoming an airhostess so she might "fly away."

At the end of our time together, she had located and was proceeding to move into an apartment in her home borough. This would be the first time she had lived on her own. She was scared, proud, and looking forward to living alone. Charlotte wanted to be a nurse. She worried, however, that she might not be able to attend nursing school right away, because there would be no one she could trust to look after Whitney.

Connie

The optimistic fighter. "I don't consider myself handicapped, though I am handicapped. So to me, I don't want to be somebody I feel sorry for. I don't want to feel sorry for anybody, and I don't want anybody to feel sorry for me.

Connie, a 29-year-old woman, had a 6-year-old daughter, Savannah, and a 3-month-old daughter, Margaux. She and her children had been in the shelter system 8 months, 6 of which had been at The Arche. They occupied one of the larger rooms at the residence, cluttered with clothing and infant equipment. Although Connie has a hereditary, degenerative eye disease and is legally blind, she functioned well in her space, and seemed to

know how to find items for daily use. She said of her adaptation to her disability, " Maybe I can't see you too well, but I hear what you are thinking. These are the only eyes I've ever had, so I've had to deal with it. Whatever has happened, I have dealt with it so far," she said with remarkable lack of self-pity

Connie identified her race as black and her ethnicity as of mixed heritage: southern black, West Indian, and American Indian. Connie was a bold woman, sure of her opinions. Her straightforward and self-confident manner set her apart from many of her peers in the shelter—a fact of which she was aware. Connie came to the shelter system after a conflict with Margaux's father, Leland, who then evicted her and her daughters. "The worst time for me was when I left Leland," she said of that time. I didn't know what was going to happen from day to day. But today I know I'm gonna be here tomorrow and I know what I'm here to do. Look for my apartment."

Connie is the younger of two siblings. Because of neglect and parental conflict, she and her brother were placed in foster care, from 18 months to 3 years. When she was 3 years old, her paternal grandparents moved her from care and took custody of Connie and her bother. Connie was not fully aware that her grandparents were not her birth parents until a family court hearing, when she was 10. The family lived in a home on Long Island, where Connie remained until she was 17, when her grandmother died. Connie was her grandmother's favored grandchild. "My grandmother spoiled me," she said. "Things were never the same once grandma died."

Although uncertainty was a hallmark of her life, because of her confusing parentage and degenerative eye disease, which was certain to increasingly incapacitate her, she remained optimistic, saying things like, "Beautiful things can grow out of shit."

Regarding her daughters, on the one hand Connie was proud of Savannah's bold style. On the other hand, she had not been able to develop an understanding of the consequences of some of her daughter's behavior, such as "getting negative attention" (especially at school). Nor was she able to empathize with the issues that sparked her daughter's aggression.

Connie assessed her parenting style as follows: "I'm not a hugging, kissy parent. I don't yell for everything. It'll take time to build up. Then I'll scream. Nothing I won't scream about. Then I'll start joking. But I basically am talking, joking. She [Savannah] doesn't pay me no mind, She thinks I'm the funniest person in the world."

As for life in general, Connie was compelled to be philosophical. "Moving around didn't effect me," she said. "To me, it was part of life. Sometimes some people have it easy, some people have it hard. You can't dwell on all that, and you can't base your life on that. OK? I'm going in and out and everything. You see things changing for the worse, you can see them change for the better."

Delila

Finding her way in relationships. "I consider myself lucky, because people here help me when I need it, and everything like that. But I don't like depending on no one else cause I like to do things on my own. If you close yourself to everybody, you don't trust and then when you need somebody they are not going to be there for you."

Delila was the 23-year-old Latina mother of two daughters, Alexandra, 5 months, and Maria, 17 months. Delila was a large woman, with prominent "heavy metal" tattoos. Delila's swagger, forceful demeanor, and layered clothing communicated "You had better not mess with me!" She spoke clearly and

forcefully, a woman of definite and sometimes radical views about life and politics. She saw herself as an original, and sometimes an oddball—a persona she cultivated. She had a wry sense of humor, was lucid about the facts of her life, and related her story in a clear way. She had spoken to groups of foster children, legislators, and board members about her experiences growing up in child welfare.

She, her children, and a male friend—with whom she had a longstanding, nonsexual, instrumentally reciprocal relationship, lived in a 3-room apartment on the third floor of a half-vacated city-owned building. The building lacked both basic safety features, such as an entrance security system, and was in need of basic repairs. Her apartment was located on a block in which much of the housing had deteriorated. Delila had reluctantly moved into this apartment with her husband, in order to leave the shelter system.

Delila, the eldest of two children, was a high-school graduate, and had completed 18 months of higher education at a Technical Institute in upstate New York. She spoke of her heritage, in part, as follows: "I was placed in foster care when I was 2 months old. I was told that my mother was a prostitute, so from what I can really tell, my father was one of her customers. That I will never know who my father is makes me mad." The latter point was of great concern to Delila, because she suffered from severe asthma, as did her older daughter, and she wanted to know about her health heritage.

At 5 years of age, she was placed in the care of The Almost Home Agency, where she lived until she was 21. Delila had one half-brother, Valentin, who was 2 years her junior. She had not seen him since she was placed in the care of Almost Home Child Caring Services. She recalled that her mother left both her and her brother alone for several days with no running water

and food. With a history of early psychiatric symptoms, Delila was provided with a range of services during the 16 years she remained at Almost Home, including casework intervention, psychiatric treatment, educational support, and independent living skills. Moving among various units of this well-staffed, multi-service child welfare agency, Delila was first placed at A Child's Place, a group home. She lived there from ages 5 to 16. Then she lived at Cottage School, a residential treatment facility in the New York suburbs, where she remained almost continuously for the next 11 years.

At Cottage School, she repeated ninth grade, although she was always a good student and graduated junior high school with honors. She recalled, "I graduated from junior high school, with honors, in foster care, and never had anybody to go to my graduations. I always had a social worker, but I never had parents to come and say, 'Wow, you really did good, I'm proud of you.' I had the most awards in eighth grade. I got cash and trophies. Nobody except my social worker, Ann, was there to share that joy with me, and it was hard for me."

After graduating middle school, Delila attended a top suburban high school, in a mostly Caucasian, upper-middle class suburb. There, she felt out of place, as one of the few students of color coming from a group home.

The Almost Home Agency valued employment preparation, and so from the age of 14, Delila had worked either part- or full-time while attending school. Almost Home also supported post-secondary education for youth in its care. Thus, after graduating high school with a good grade point average, Delila completed 2 years of auto mechanic training at a well-regarded technical institute in a rural community. Missing the diversity and excitement of New York, however, Delila re-

turned to NYC, and lived in a young adult residence sponsored by Almost Home.

In October of 1992, she was encouraged by the staff at the youth residence to plan for living independently in the community, as the law required that she had to leave the care of Almost Home when she became 21, which was in May of the following year. Delila was angry and frightened. She felt she had been "stuck out" there, unprepared to live on her own. Shortly before her 21st birthday, she found that that she was pregnant, and went briefly to a shelter for homeless, single women, at 21 years of age.

She then married Marcus, the father of her child, and the couple went to live at a Tier Two transitional shelter, where they remained for a remarkably brief 3 months, before accepting the apartment in which she was living, at the time of the interviews.

After Maria's birth, Marcus became depressed and left Delila and Maria. Then he briefly returned to live with the family, for one last year. Delila became pregnant with Alexandra. Her relationship with Marcus remained cordial, and he began to work as a messenger, which enabled him to provide his family with a modicum of child support. He visited his daughters occasionally.

Delila was active in the right-to-life movement. She also participated in a group for young mothers who had left care, sponsored by the Almost Home Agency. She maintained close contact with several of the other women in the group, one of whom was Alexandra's godmother.

She expressed the hope of completing her college education, rather than going to work at a low-paying job with little possibility to support her family in the future. In college, she

said she wanted to study political science, and eventually become a lobbyist.

Dionne

The hard struggle for family and respect. "I'm trying to be a better person."

Twenty-year-old Dionne and 22-year-old Amhal, both self-described as "black," lived with their daughter, 18-month-old Danala, and their 3-month-old son, Luke, in a 2-bedroom apartment at the Lincoln Family Residence. Like several other women in the study, her early experiences included psychological adversity (ADHD, depression), and being raised by a single mother who was the sole parent after a denigrating husband abandoned her. The family then moved to the grandfather's house, and remained there until her mother remarried. Her mother's high and unrealistic standards, in regard to expectations of her children's behavior, meant that Dionne was isolated from both peers and other adults who might expose her to unacceptable behavior.

Dionne spoke of herself as a peculiar child, who was aggravating to teachers. She believed this aggravation was the factor that led to her placement in care when she was 10 years old. Her stay in care was characterized by frequent moves and angry self-isolation. She was so angry and sad that she contemplated suicide, and wrote a journal she called "The Silent Cry." During her stay in care, her mother remarried and did not visit frequently, leaving Dionne lonely and despairing. She came to believe that her mother's leaving her alone was justified, however, because she was so difficult as a child.

At age 14, Dionne and her mother were reunited. During Dionne's stay in out-of-home placement, her mother remarried

a man of whom Dionne became fond. Soon after reunification, her stepfather was diagnosed with cancer, placing a heavy burden of care on her mother. Within two years, he passed away. Her mother then focused on Dionne and became more rigid, religious, and controlling. The conflict between Dionne and her mother became painfully intense. At age 16, Dionne ran away from home. She moved among several adolescent facilities, including Portal House, a youth residence with services, and homes of young men she met there. Dionne also lived on the street. Then she became involved in a period of high-risk behavior. At eighteen, Dionne enrolled in the Job Corps. The year spent in the Job Corps gave Dionne both a period of growth and respite from the potential harm of living on the streets. It was then that she met Ahmal, who was "nice and caring, outgoing and real careful." She became pregnant and left the Job Corps, gave birth to Danala and, with Ahmal, moved among serial doubled-up living arrangements.

Eventually, her investment in the roles of partner and mother brought her to the shelter system. She hoped that entering the system would lead to the family becoming "settled." The new roles changed her priorities. As she said, "I can't think about me no more. Like a long time ago, I wanted to end my life, I wanted to kill myself. But when I gave birth to Danala, everything changed. I coulda gotten into a lot of trouble, but I was, like, 'Think about your children,' and I stopped being selfish, and I started thinking about the other people in my life."

Dionne had no plans to complete her high school education, and hoped that Ahmal, who was trained as an auto mechanic, would be able to support the family. She dreamed of a house with a white picket fence, and a family life, with the help of God. As she expressed her dream, "I want my family to be love, um, I want them to be tight, you know. You know, just Mom

and Dad. Uh, but I just hope that God put a lotta love in this family and keep us together."

Eartha

A vulnerable survivor. "I don't know what it is to be a parent a loving parent. I know I still have some kid inside me. So I'm going to do the best I can."

Eartha was a 24-year-old black woman, who was six months pregnant with her fifth child, when I interviewed her. She had been living in the shelter system for four months when we first met, including her then-current 2-month residence at The Arche. Eartha's four other children, a daughter 6 and three sons, ages 4, 2, and 1, were living in kinship foster care with their paternal grandmother. All four children had been removed from Eartha's custody because of neglect and maternal substance abuse.

Eartha is the middle child of three. Her early years were characterized by a chaotic home life, which included severe domestic violence, to which Eartha was a witness, and maternal substance abuse. A maternal grandmother and aunt, who provided occasional care and supervision for the children, were the only people who protected Eartha during her childhood and youth.

Eartha grew up in Queens, New York, a shy child who was placed in special education classes. Chronically exposed to witnessing not only the violence inflicted against her mother at home, but also her mother's deterioration and humiliation as a result of her drug addiction, Eartha began to use crack/cocaine at age 15. Three years later, her mother entered rehabilitation, which left Eartha in charge of the family apartment. Severely

addicted and with few employment skills, she was unable to manage her adult responsibilities.

As a result, she lost custody of her eldest daughter, and was soon evicted from the apartment. Without a home, Eartha's subsequent years involved serial high-risk survival strategies, including continuing substance abuse, prostitution, and involvement with an abusive paramour who abandoned her to the streets. It was during this time that she gave birth to her three youngest children, who were placed in the care of the paramour's mother.

Eartha had been living on the streets for several years when she met Sidney, though a friend. Sidney, an older man with a stable life, took her in, and when she became pregnant, he stood by her. The relationship and subsequent pregnancy changed her life. She wanted to sustain her connection with Sidney and have his child, and so entered the shelter system.

As she said of her life at that time, "I was just this woman who kept sneaking around, and kept trying, going from house to house. I didn't know what I was gonna do to help us to be together. So I figured going into the shelter, you know, because its gotta be a 2-way street. You know, he's helping me and I'm not helping myself. I had to do something for myself, and I decided to go into the shelter."

She stopped using drugs during the two months she was in the shelter system. She accomplished this, she believed, with God's help, rather than through substance abuse treatment. Beyond Sidney, her support system consisted of her increasingly frail grandmother and her mother, who continued to work on her hard-won rehabilitation.

For the first time, Eartha was hopeful about the future. "I can't wait to have my baby and my new apartment," she said. "I want to do so much, I don't think I wannna work, don't know

what I would do. I want to be a wife and mother and take care of the apartment." She also was aware of fragility of her plan, saying, "You may think you got it so good now. Watch out, something is going to happen to you."

Elyse

Reality is events not people. "When I am going along a straight road, all of a sudden my life takes a left turn and I'm traveling along the same road again. I take two steps up the ladder and then I am pulled back one step."

Elyse was a 25-year-old, petite, energetic, and intense African American woman, who spoke with feeling and with her whole body. She was both incisive and reflective. Elyse was the only child of Lily and Samuel, who were killed in an auto accident when Elyse was a week old. She grew up in the household of her maternal grandmother and grandfather. She occasionally wondered about her biological parents, and had to wrestle with conflicting family stories about her mother.

I met Elyse and her son, Oliver, when they had been living in a tidy, well-organized, drafty room on the fourth floor of The Arche for 9 months. She and Oliver had been in the shelter system for almost a year. Elyse was an eager participant, and believed that she gained perspective on her life in telling her story. She was able to express anger and frustration about the people and events that stood in the way of her getting her apartment and her education; and was dismayed when staff was critical of her parenting. She also differentiated herself from many of the other 30 parents in the shelter, and was aware of her "outsider status," a familiar role. Although frustrated by her long shelter stay, she had completed a rigorous course to qualify as a home daycare provider, and had taken the initiative to register for the

new college year by the time she and Oliver were moving into permanent housing.

Elyse was a woman who could manage complex feelings. She could tolerate resentment that her grandfather's disability curtailed her adolescent prerogatives, and also express love and gratitude for his generous heart and family pride. The latter was especially evident as she recalled his altruistic act of taking her in after the death of her parents.

After her grandfather's death, when she was 13, her older cousin Gwen became Elyse's guardian, and she went to live with Gwen. Gwen was authoritarian and physically abusive. Elyse could not concentrate on her studies or enjoy a social life. Feeling that she could no longer live with Gwen after Gwen assaulted her, Elyse approached her high school guidance counselor for help. She was removed from Gwen's home and placed in a group home.

It was a private house, where the childcare staff was firm but kind.

> There, if you showed them you were a good person, you could earn freedom. I was a good person when I was living at the group home. The rules were straightforward and sensible. I stayed on the elite level the whole time I was there. It wasn't even like my home. In my own home, I was very limited. The other girls would try to bring me down. Whenever we would get in a disagreement or something, I would stay, like, away from it, or whatever.

Because she was a good student and avoided trouble, she was isolated from the other girls, but received a lot of support from the house parents. She traveled over an hour a day so she

could remain in her Manhattan high school. She remained in the same group home from 14 to 18, graduated from high school, won a scholarship, and attended an elite state college in a rural community. Here, she first encountered racism among the students. She found attending school in a rural setting difficult, and had only one close friend. After completing 3 years at a state university, Elyse transferred to a bachelor's nursing program at an urban university in the Midwest, where she had won a partial scholarship. Elyse had not anticipated the cost of housing nor the extreme isolation created by moving to a city where she had no support system. She had to work to pay for room and board, and could not find a parttime job where she could make enough to survive. Finally, she decided that she would have to delay her education until she was more secure financially. She found a well-paying job as a meat wrapper in a supermarket. She met Alford, the father of Oliver. His persistent pursuit at first troubled Elyse, but finally, out of loneliness, she allowed him to move into her apartment. She became pregnant and tried to have an abortion, but was unable to locate a clinic that would perform one. With the pregnancy, Alford became abusive, finally assaulting her late in her pregnancy. He was incarcerated. Elyse called Gwen, the only person on whom she could rely for help. Gwen came to help Elyse, and brought her back to live in her apartment in New York.

Living with Gwen and Gwen's 13-year-old son was a situation rife with present conflict informed by past experience. Once again, Elyse felt that she could no longer live with her cousin, because of Gwen's controlling and abusive behavior. Elyse, then pregnant with Oliver, viewed the shelter system as her only viable option.

The shelter system provided her with a chance to find her own place to live her life, and to create enough distance be-

tween herself and Gwen to preserve the relationship. Elyse supported herself until she returned to New York, at which time her only income came from Aid to Families with Dependent Children (AFDC).

Jana

Starting off new. "It took me a while to get it together, but it's better to start off fresh, you know. Leave the old stuff, in the past."

Jana was a 24-year-old African American woman. She and her 3-month-old son, Leon, were living in a small room at The Arche when I met them. She had been living in that shelter for 5 months, and had been in the shelter system for 9 months.

Until the age of 9, Jana and her younger brother lived with their mother in upper Manhattan. Jana never had contact with her father, and the only information she had about him was that he had been incarcerated. She attended parochial school until sixth grade, and described herself as a poor student and slow learner, especially when compared with her bother, who was a good student. Her mother was an immigrant from the Caribbean and supported the family. She owned a dressmaking and tailoring shop in the neighborhood. Jana described her as a caring parent and a good homemaker, while Jana was a small child.

When Jana was age 10, her mother met a man, moved the family to the Bronx, and soon they married. Jana was distrustful of her stepfather, did not like his distant manner, the favoritism he showed towards his younger children, and his verbal abuse. She began to stay away from home, and at age 13, as a result of increasing verbal abuse from both parents, she ran away.

"I felt ashamed," she said, "because I didn't have to go through this. My mother always said I had a place to stay, but I had such hatred of my step father, I couldn't go home." Her

mother filed a Person In Need of Supervision (PINS) petition, and finally Jana entered a group home.

In the initial group home setting, she was isolated, depressed and ate little. "I kept so much inside, me," she said. "I couldn't trust my mother, so why should I talk to these people in the group home? I didn't trust them, or believe that they will love me, and I was thinking, 'Oh my mother don't love me, she put me away."

When she was transferred to a second group home, she was able to develop extremely positive relationships with both childcare staff and her social workers. These relationships changed the way she felt about herself. "At about 16, I began to feel I was just as good as the next person. You're not just this girl in the group home and you're not a bad person."

She remained in the second, stable group home for 5 years, participated in an Independent Living Program, and left the group home at 21 years of age. She did not want to leave because she felt unprepared for young adulthood and was frightened. After leaving care, she moved often, living among boyfriends, counselors, friends and the street.

Although Jana had completed her General Education Degree (GED) prior to leaving care, and was able to work at a clerical, low-paying job, she led a hand to mouth existence. At age 23 she became pregnant. The father was a young man she had met at the group, who abandoned Jana.

With his departure and her inability to return to follow-up care in the child welfare system, she entered the shelter system. Though frightened and often at odds with and suspicious of other mothers, Jana spoke in a lively manner, was playful with her son, and often seemed optimistic and joyful at the prospect of an adult life and an apartment one day. "It's going to be fun," she said. "It's going to be ours."

Kathleen

Pulled in many directions—doing for self or doing for others. "If I don't benefit from it, I don't need it, that's going to be my song and I mean it."

Kathleen was a 27-year-old woman of Hispanic heritage, born in The Bronx, New York. When I met Kathleen and her two sons, Charles, Jr., age 4 years, and Eli, age 14 months, they had been at The Arche Shelter for 6 weeks, and had been in the shelter system for three months. The family lived in a spacious, well-organized room, with two beds. Kathleen had stored the family belongings carefully, and found enough floor space to allow both sons to move around the room and create play space.

Kathleen and her husband, Charles, Sr., the father of both sons, had been living in an apartment in Brooklyn, until he was incarcerated for robbery. Kathleen was 7 months pregnant with Eli at the time, and could not work and pay the rent. She briefly moved to her mother's overcrowded home, and then entered the shelter system.

Kathleen is the middle of three sisters, and her parents' relationship was more stable than that of most of the mothers I interviewed. Her father, a chef and restaurant owner, supported his family, but was openly a philanderer, and was cruel to his wife and children.

Kathleen loved school, was a good student, and had very positive memories of the parochial school she attended. After leaving school, she continued to have contact with high school friends. When she was 16, her father developed a life-threatening illness, and her mother devoted herself to caring for him. Kathleen left school in her junior year, and went to work to help support the family. She continued to support her mother for several years after her father's death. He passed away after a

long, disfiguring, and painful treatment for lung cancer. The family stuck close together and had much support from extended family and friends, both during and after the father's illness and death.

Kathleen continued to work and live with her family. When she was 20, she married Charles, Sr., whom she had known since high school. She described him as a young man of great charisma, whose own childhood experiences undermined his adult functioning. Kathleen and Charles had a strong relationship for several years, when he supported the family well as a laborer. Charles became involved in selling drugs, however, and was arrested several times. She stood by him, but became increasingly angry at his irresponsibility, always hoping that he would do the right thing in protecting and caring about his family. Although both boys missed their father very much, Kathleen was conflicted about allowing them to visit him in prison or even have contact with him. She has maintained a close relationship with her family, and stayed close to his extended family. In the shelter, Kathleen had been able to make connections with others, especially Sabina (see below), who cared for her children on occasion.

Kenya

On her own and frightened. "One step at a time."

When I met Kenya, she had been living at The Arche for two months, after having been in the shelter system for five months. She was the 19-year-old African American mother of 1-month-old Cynthia. Kenya was a small, young woman with large, expressive eyes that often captured hesitation about speaking to a person she did not know well. She was one of the mothers in the study who was not comfortable with use of the tape recorder,

and spoke in a soft voice, with long silences part of her conversation.

Kenya's participation was clearly an act of courage and, perhaps, curiosity. She was the eldest of 5 children, and grew up in the Bronx, in a large, public housing complex. Her maternal aunt also lived in the same building, and Kenya and her cousins were good friends. The aunt also provided support for her mother.

Among this family group, Kenya was the quiet one. "A lot of people didn't know that I lived in the building." Kenya had little contact with her father, who had been incarcerated. "I can't remember the last time I saw him," she said. "I would want to know why he walked out on my mother." Her mother worked at a clerical job, and Kenya was frequently given much responsibility for the care of her younger siblings.

She did not socialize much beyond the family group until she was 17. A year later Kenya became pregnant. The father was a young man involved with the justice system.

When she became pregnant, Kenya's mother believed that there was not enough room in the home, so Kenya lived briefly with extended family. Then she decided she needed a place of her own. Early in her pregnancy, she attended school while in a shelter, commuting from Brooklyn to the Bronx.

Kenya was concerned that her daughter be brought up right, but worried that it was not going to be a good world for her. She expressed her concern, in part, as follows:

> Things are getting badder and badder, more people are dying and more accidents are happening. It's gonna be a harder world for her. I want to be a good and responsible parent. I can wait to have fun till after she is grown. I want to be a teacher. I want to finish school. My mother will watch

her while I save my money. It will be hard though, because I will go to school and my mother will watch the baby. And then I have to take her home, and she will keep me up, and I'll be bone tired, and then I have to take her back to my mother. But lets see—it'll be one step at a time.

Linsay

This was the white picket fence that was. "I miss the children running in from the outside and jumping in my lap and bothering me—little faces and bright eyes. I miss the christening dresses and ceramic mementos that were for the girls. They were family heirlooms."

Linsay, a 39-year-old African American woman, 5 months pregnant with her fourth child, had been living in a room at The Arche shelter for 6 weeks when we met. She had been in the shelter system for almost two years. Her three older daughters 12, 10 and 9, were living with their paternal grandmother in kinship foster care.

Linsay was an elusive interviewee. She was the rare mother who was not reliable at keeping appointments, and I found it difficult to follow her chronology of events. She refused to use the tape recorder, and when I reviewed my notes, it took much effort to reconstruct her narrative. I suspected, along with the staff at The Arche, that Linsay was using drugs. That suspicion was not confirmed, but if true, might explain her missed appointments, bad manners, and largely incoherent narrative.

With Linsay, a forced cheerfulness of manner accompanied a sad telling of events. I believe that her narrative was an idealized version of her life; and when we were speaking together, I sensed she might well have felt she had to construct her pleasant

reality for my benefit. Linsay maintained an argumentative stance with the staff. To me, her battles with staff seemed child-like. They often seemed to center on minor infractions and smaller slights. She dismissed common courtesies needed to conform to quotidian rules, and was often dismissive of the common graces needed for reasonable relationships with others.

Linsay grew up in Coney Island, the youngest of 9 children. Her parents were divorced when Linsay was 2 years old. She described a halcyon childhood in Coney Island, living in a stable, low-income community. Her mother supported the large family with her salary as a nurse. Linsay was devoted to her maternal grandmother, who was the matriarchal organizing force in her birth family. When Linsay was 13, her mother began to use drugs, and Linsay went to live with her grandmother, at her mother's urging.

Linsay was an adept student and graduated high school. She then went to work in the food industry, beginning as a waitress and then becoming a manager for the restaurant chain. At 22, she married a career Marine, and they moved to the South, living near a military base in a comfortable home. Three daughters were added to the family. The oldest was born with cerebral palsy, which confined her to a wheel chair. The family lived together until 1990, when Linsay discovered that her husband had been unfaithful. She confronted him about his infidelity, and he became abusive.

Linsay and her three children returned to live in Brooklyn, in late 1991. In 1992 the building in which they were living burned down, and the family entered the shelter system, moving among three units within the system. During her stay at the last transitional shelter, Linsay frequently left her children alone, and they were removed in late 1993, because of neglect.

Linsay was forced to leave the family transitional shelter, and then lived among friends. During this period she met Andrew, the father of her yet unborn child, and she entered the shelter system.

Her future plans included permanent housing, where she dreamed of living with Andrew and her child. Linsay described her future residence as having "lots of plants, and some of my old furniture—I used to have lovely furniture."

Lucia

The mobile hoper. "I bounced from here to there, and back to here. I been bouncing my whole life."

Lucia was 19 and lived with her two children, Faith, 3 years old, and Rolando, 6 months old, and her husband Salvatore, 32, the father of Rolando. They lived in a chaotic 1-bedroom apartment at The Lincoln Family Residence. The family had lived there for 20 months when I met them, and they had been in the shelter system for almost 2 years. Before entering The Lincoln, Lucia had moved within the shelter system 4 times. The present stay at The Lincoln was not only the most stable she had experienced in the shelter system, but was the longest continuous residence Lucia had experienced in her adolescent and young adult life. When we added the number of moves she had experienced during her lifetime, we approximated that Lucia had lived in 23 different places in her 19 years.

Her early development was characterized by extreme residential instability, a mother with a psychiatric illness, a surrogate father with a substance abuse problem, and no support from either maternal or paternal extended family. Loss and disappearance of caretakers, chronic neglect, periods of physical

abuse by substitute caretakers during the time she lived apart from her "adopted father," and loss of educational opportunity, as a result of frequents moves, were hallmarks of Lucia's childhood, adolescence and young adulthood.

Mr. D, whom she credited with early caretaking efforts, was one of her mother's paramours, to whom she had no biological tie. When her mother abandoned Lucia and her two brothers, he took them to the home he shared with his mother, rather than put them in the care of strangers. She empathically remembers his attempts to provide for her, memories made more poignant by her recollections of his substance abuse, which limited both his employability and ability to provide basic needs such as clothing.

At age 14, after the shooting death of Lucia's brother, her caretaker, Mr. D, became aware that he could no longer care for an adolescent girl who needed a woman's guidance and consistent rules. Her guardian then placed her in foster care. Over the years, she was placed in 7 different settings, far away from the scant family she had known. Longing to return to her guardian, she engaged in high-risk behaviors, including suicide attempts, premature sexual activity and promiscuity, and substance abuse, and was hospitalized in a psychiatric institution.

At age 16, Lucia was placed in a structured group home, where she got the individual attention she needed. She became pregnant that year, however, and eloped from her stable, group home and lived on the streets with her infant daughter. At age 17, she entered the shelter system with an older paramour, who abandoned her. Lucia was required to leave the shelter because she was under 18. She again lived on the street, until she was 18 and could enter the adult shelter system. During the second shelter stay she met Salvatore and became pregnant.

At The Lincoln for the first time, she had the interest of her caseworker and a housing specialist necessary for her to stabilize her life, develop pride in her role as a mother, and take needed assistance from this stable milieu.

Maria

A determined grandmother. "Life is life, you bring them up and you don't quit. I don't like to start something I can't finish."

Maria was a 51-year-old Latina widow living at The Lincoln Family Residence with her 17-year-old granddaughter, Eloise. The kin care pair had been living at The Lincoln Family Residence for 7 months, and had been in the shelter system for 8 months. Although the apartment was sparely furnished, it contained several small plants and sewing supplies.

Maria spoke with a pronounced Spanish accent and was not comfortable with a tape recorder. As she told her story, the narrative was clear, and she was tearful as she spoke of her parents' death. Her recollections of her youth were animated, with many details about family celebrations. When we met, on the days she traveled to her old neighborhood, she was weary; and when she spoke of her path to the shelter, she lowered her face and voice. Eloise attended high school during the day and was only present during one interview.

Maria's path into the shelter system began four years prior to her shelter use, when she left New York City to care for her dying mother in Puerto Rico. After her mother's death, she stayed to care for her frail and grieving father. Her daughter, Jeannette, with her three children, Eloise among them, moved into her public housing apartment, where Maria had lived for 30 years.

When Maria returned to New York, Jeannette had assumed the lease, and she could not return to the apartment because it was overcrowded. The pregnancy of Eloise created conflict between mother and daughter. The family decided that the overcrowding and conflict could be addressed if Maria, along with Eloise, moved to the shelter system. They were accepted because Eloise was pregnant.

As Maria explained the impact of her mother's decline and death, "All my life changed when my mother became ill. Before I left, I had all my own things and used to be independent. When she died my life got turned around, mostly because I lost the apartment. I have no furniture, no nothing. I left all my furniture with my daughter. I wasn't planning to come back from Puerto Rico. When I came, then, I found myself without anything."

Maria grew up in rural Puerto Rico, living among a large, extended family. She was a woman who spoke with affection of her childhood home. "I liked that house, I liked the place I grew up. I lived in a big family, and it was my grandfather's farm. He used to grow his own food and his grandchildren used to work. I liked that house. It was a beautiful life. My mother was a strong person who taught me to respect others. It was a beautiful life, I don't have any complaints."

Maria married at 18, but when she was 20, she came to New York with only her young children, after leaving her first husband, a poor provider, in Puerto Rico. With pride she remembered, "I came here by myself, I didn't speak English. I learned English from the TV when my son was 6 and I couldn't tell the doctor what was wrong. I taught myself English to take care of my kids and defend myself. I am very proud of myself for taking the GED in Spanish."

After she came to New York, she met her second husband, raised her family, and finally left him because of domestice violence. At 40 years of age, she matriculated at a community college, studied early childhood education, graduated, and worked in an early childhood setting for several years, before the onset of her mother's illness.

Along with cumulative losses, Maria had many health problems at the time of the interviews, including a difficult menopause, which brought with it a range of physical symptoms and depression. While at The Lincoln, she attended clinics twice a week, traveling an hour-and-a-half to get to her old neighborhood.

At The Lincoln Maria had worked hard with her case manager, who she said is a "beautiful person. She helps me, she cares about me." Maria had developed friendships with two other Latina women at The Lincoln, and was an active participant in the sewing group. She created several sets of hand-stitched towels, which were sold at the street fair sponsored by the residence.

Eloise continued to attend high school in Manhattan through her pregnancy Although hurt by and angry with Jeanette, Maria spoke with pride of her seven children, who remained a central part of her future."All my children will finish school," she said. "I will take care of Eloise's baby, so she can finish school. It's my fault that they are here. I don't like to start something I can't finish. The most important thing for me is my kids and my home."

Marion

The singular resolute achiever. "You have to be strong and tell yourself this. That is what keeps me going, I am a strong person, I can do it, I can do it, I'm strong, I did it with no family, with no one around for any support, and I could do it on my own."

Marion, a 23-year-old Caribbean born woman, lived with her 2 year-old son, Zach, Zach's father, Kareem, and the family cat, in a 2-bedroom basement apartment of a 2-family house in a working class neighborhood. The landlord provided minimal services. The sound of leaking pipes accompanied everyday life. Although the family had lived in this subsided apartment for almost a year, the living space was Spartan, with few personal items. The home looked and felt temporary. Marion planned to move when the subsidy expired.

Marion's daily life required that she fulfill many demanding roles. She was a mother, part-time student, and cared for her Kareem, while attempting to supplement her small income with as much home healthcare work as possible. The stipend that Marion received for participating in the study was allocated to paying for repairs on her second- hand automobile, which she needed for work.

Marion was a slim young woman who moved restlessly to get many tasks done before the end of each day. She spoke of her life matter-of-factly, with occasional intense outrage at her mother's cruelty. She was a coherent narrator, as I was left neither confused nor in doubt about the quality of her relationships with others. Her voice was soft, often muted and sad, with a trace of a Jamaican accent. Kareem was an imposing man of few words. Marion and Kareem related to one another efficiently, as though they were business partners. Zach, who was often in day care, was a timid toddler, a 2-year-old who, without complaint, followed his mother's wishes on the first request.

Marion, the second eldest of five children, grew up among an extended family in Jamaica. Her parents came to the states to seek financial opportunity. In her native country, she moved among the homes of relatives often. "They didn't know what to do with us, so we moved back and forth," she said. She thought of her mother as "The lady that came for the day and gave us gum and things from America. She was my mom, but we expected her to leave."

When Marion was 7½ years old, she and her older sister joined the family in Brooklyn. The family had grown, with the addition of triplets (4 years younger than Marion), and an infant brother. Her hardworking, ambitious parents had little time or tolerance for the needs of their children, and Marion recalled frequent verbal and physical abuse, particularly by her mother. In a photograph taken at her sister's birthday party, Marion is a petite, thin, little girl standing with fists clenched, large dark eyes staring at the camera. (She, too, was surprised at how sunken and dark her eyes appeared.) Her distant, substance abusing father did nothing to prevent the abuse. "He wasn't like a father, he was just known as that label," she said.

When Marion was 10, she and her older sister ran away from home to escape the abuse. They stayed with friends, occasionally, and survived on their own for several weeks, by staying awake to protect each other and selling flowers, to earn enough money to eat. At age 10, Marion was placed in care briefly, and then returned to her mother's custody. The abuse continued and escalated. During the same year her father had a stroke, and her parents separated.

When Marion was 11, her mother remarried, and her stepfather moved into the family home. He soon began to act inappropriately towards Marion, and she confronted her mother about the abuse. This led to further abuse. Finally Marion

sought protection from her stepfather's inappropriate attention and her mother's continued abuse from a school guidance counselor. After repeated child protective service investigations, she was finally placed in care. During the time when protective services failed, however, to substantiate abuse, Marion saw no remedy and attempted suicide. As she recounted, "And I was thinking, 'Why am I not dead? If I were, I'm not gonna get anymore beating. I'm gonna die. No more beating'."

When child protective services removed Marion from her mother's custody, she was evaluated and then placed at Almost Home Children's Services. "This was the best place I ever could be," Marion recalled. Gradually, with support and understanding from staff, she formed important relationships with the other girls and staff. Her stay at Almost Home was a time Marion recollected with fondness, as being the most peaceful and growth-promoting time in her young life.

Before she entered Almost Home, she said, "I had no one else around me actually to think, to know, what's right and wrong. No one ever taught us that. This is the way that a person was meant to be. Almost Home exposed us to a lotta things, different things, different situations. The group home was a regular life, a regular teenage life, adolescent life. I was able to complain about petty stuff. It was just good, I loved it. I mean, today, I think that was freedom, living in a group home, rather than having my son and being on my own. It was just freedom." Her social worker, especially, "made me feel really good about myself." Marion began to do well in school, and aspired to become a psychologist.

When she met Kareem, at 18, she was drawn to his kindness and his family's respectful treatment of one another. Finding herself pregnant, she had regrets, saying, "I think we should have gotten to know each other before the child." With the

pregnancy, she moved in with the family, but worried about depending on Kareem, as she had no green card, and thus no route to financial independence.

Given these worries, she believed that a solution would be to enter the shelter system. She was correct. There, she was able to finish a home health aide course, apply for a green card, and obtain a housing subsidy, thereby taking control of her life. She continued to struggle with fears about closeness, intimate relationships, and balancing her own needs with those of her son. She hoped to continue her studies at the City University of New York (CUNY) and become a psychologist.

Milagros

The same old story. "You go through another day here. It's just another day that you could get certified, so that you could go look for your apartment. Sometimes I just stay in here and cry. Cause it hurts me that I am still here."

Milagros was a 20-year-old Latina who had been in adolescent and adult shelters for almost three years, when I met her. She had lived at The Arche for 9 months, along with Kenny, her 3-year-old son, and Marina, her 4-month-old daughter. Her room was spacious, but chaotic. When we met, Milagros was often dressed in a nightgown, looking tired, sometimes annoyed, and always sad. Her childhood experience and a trudging depression instilled in her the inevitability that life would go on just as it had. "Well, you come in here to get out, and everybody comes in here is alone, and you leave alone," she expressed her feelings of solitary existence.

These statements reflected her earlier experiences with caretakers. Milagros grew up in The Bronx, the middle of three children. At 5 her father died. When she was 6, her mother re-

married her uncle, and the blended family moved into a larger apartment, with his three children. Her mother infrequently recognized or met her children's needs; and she failed to protect Milagros from sexual abuse by her stepfather (uncle), which resulted in the placement of her five children when Milagros was 10 years old.

Three brief placements and the incarceration of both of her parents, separating her from her siblings with whom she had shared experiences and fears, followed the removal. Two years spent in a fourth foster home provided Milagros with a brief feeling of safety and closeness with her foster mother. There she experienced belonging to a family, community, as well as acceptance and excellence in her school.

She was unwillingly reunified with her mother at age 15, with little preparation. Milagros's mother soon introduced a new man into the home, who was verbally abusive to her mother. After an attempt to express her feeling about the abuse was rebuffed, and her mother, again, chose a man over her well being, she left the home, went to Portal House, and became pregnant. Her second pregnancy resulted in her having to leave the mother-child program at Portal House. She then lived briefly with a friend and finally went to EAU when she was 18.

Milagros was left with the feeling that she was an adult before her time, saying "I feel older than 20." She regretted having no one with whom to speak about her experiences and feelings. "But it would have been, you know, easy for me to talk to somebody after my stepfather did what he did. 'Cause I was in foster for a year and a half. So it should have been easier for me to talk to somebody. But then I had so many different workers."

Milagros said that one day she would like to be a social worker for teenagers, and work with computers as a hobby. She also wrote poetry, and gave me a copy of one poem still in her

possession. She promised to send others when she could find them among her dispersed belongings. I await these.

Nodica

Looking forward. "Now I'm living my own life. It feels different to make my own decisions."

Nodica was a 23-year-old Puerto Rican woman in her last months of her pregnancy when we met at The Arche Shelter, where she had been for 3 months out of her 5 months in the shelter system. She gave birth to her daughter, Vienna, in April, and moved into her own apartment shortly thereafter.

Nodica was a heavyset woman, with a sense of sadness as she recalled her painful relationship with her mother. When cradling her newborn daughter, however, she was peaceful, and spoke of her future with calm anticipation.

Nodica was the younger of two sisters. Until she was 4 years old, she, her mother, and her sister lived alone in an apartment in Brooklyn. When Nodica was 4, her mother remarried, and 2 years later gave birth to a girl, Nodica's half-sister. Nodica's life was then characterized by emotional abuse and scapegoating. Her stepfather made it clear that she was not as "lovable" as her younger sister. Nodica felt that she could never live up to parental expectations. That belief was reinforced by the difficulty in learning she encountered when she started school, at the age of 6. She was the "black sheep" in the newly formed family. In both parents' minds, she was associated with her devalued, darker skinned father, whom Nodica had never met. Her stepfather both insulted her intelligence and beat her. Her mother failed to intercede. "It made me feel that they would be better off without me," Nodica recalled.

When she was 18, Nodica's mother told her to leave the home, and she went to live with her older sister. After a short-lived stay with her sister, who exploited her, Nodica decided to join the Job Corps, where she remained for a year developing childcare and clerical skills, which enhanced her eleventh grade education. When she returned to New York at age 19, she worked at a variety of clerical and service jobs. During these 3 years, she moved often, temporarily living with friends and briefly returning to live with her sister, until she became pregnant and entered the shelter system.

"At one point, it looked like nobody really cared, what I was doing," Nodica said. "I was scared and worried all the time." She had a mutually supportive relationship with Vienna's father, whom she admired for his intelligence, kindness and persistence. "Roy, he's a hard worker. He's not afraid to show his affection toward me; he's not afraid to cry in front of me. He teaches me a lot of things. He knows about the solar system, he's very smart. He could teach our child a lot. He doesn't tell me what to do." Nodica looked forward to developing her employment skills and getting her own apartment. "The most important thing is my baby, Roy, and my apartment."

Natalie

I am the boss of myself. "I want something of my own where nobody can come and say what they want me do."

Natalie was a 22-year-old African American mother of 3-week-old William, who had been residing in the shelter system for seven months, and had been living in a small, dark room at The Arche for five months. Natalie was a reticent participant, somewhat sullen, though expressive about her anger about the complex, often draining demands on the life of her now young

family. She was wary of having the conversations taped.

Natalie was an only child for 12 years while growing up in Brooklyn. She never had any contact with her father, and knew little about him. Early in her childhood, her maternal, extended family often functioned as alternative caretakers for her mother, a human service worker troubled by episodic alcoholism.

When Natalie was 11, her mother remarried Mr. "B," and her half-brother was born. Mr. B cared for both children, as Natalie's mother was unable to function in a care-taking role. He passed away after a struggle with AIDS, three years after they were married. Both Natalie and her brother reacted emotionally to his death.

Her brother was finally in need of residential psychiatric treatment. During late adolescence, Natalie moved among the homes of her extended family and friends, and then returned to live with her mother. Natalie completed high school and enrolled at a public college in Brooklyn.

At 21, Natalie became pregnant and, at about the same time, her half-brother was discharged from care and returned home. When her brother returned from residential treatment over the summer, Natalie believed that the house would be too crowded.

She planned to continue her college education at a school where there was more diversity, and wanted to become an obstetrician, in part as a reaction to the "ghetto" medical care she experienced during pregnancy and post partum.

Rayette

The privilege of respect." If you respect me like a woman. You will get my respect."

Rayette was a 21-year-old African American mother of James, 9 months old. They had been living in very small room at The Arche shelter for three weeks, and had been in the shelter system for three months when we met. The room seemed smaller than most for several reasons. James was a large infant and Rayette was an imposing woman, who had accumulated many possessions.

Rayette was assertive, and had developed confidence to ask that her needs be met. This was a modus operandi that was often successful. Her narrative of recent events was bigger than life and, at times, seemed apocryphal; and Rayette, herself, was "full of life." At times imperious, she was engaging, with a hearty, infectious laugh. Her energetic style included a penchant for changing the subject, skipping from time period to time period, so that the plot of her narrative was difficult to follow.

Rayette was one of 4 half-siblings (including a brother and sister, who were 10 years older, and a half-brother, who was 16 years her junior). Until age 6, Rayette and her parents lived together in Brooklyn. Rayette's maternal grandmother, who lived near the family in Brooklyn, was the family matriarch, loving and imperious, with high expectations of family members.

Her father provided well for the family through illegal activities. Her parents separated when Rayette was 7, and her mother began to engage in high-risk behavior, including prostitution and substance abuse, and that same year was incarcerated for attempted murder. Rayette was placed in kinship foster care with her godmother. Rayette's mother served a three-year sentence and, when Rayette was 10, she and her mother were re-

united. When Rayette was 12, her mother gave birth to her younger brother, Lawrence. Shortly thereafter, her mother began working, leaving Rayette and the extended family with much of the responsibility for Lawrence's care.

As an adolescent, Rayette was extremely obese and underwent surgery to help her lose weight. She recalled being argumentative and assertive in high school, but completed high school with good grades, and had an active social life. She planned to go to college, but took a job as a bartender to support herself and help her mother financially. Rayette spoke with conflicted feelings about her relationship with James's father. She was especially concerned about his inattention, and worried that while she was in the shelter, he would be seeing other women, which hurt her very much. She longed for respectful treatment from both her mother and James's father, and it was important for her to be respected by her son and become an educated person the world could admire.

Roberta

The independent optimist. "Something good will come of this. I know I got enough to be on my own."

Roberta, the 23-year-old self-identified black mother of 9-month-old Donald, lived in a small, crowded room at The Arche shelter for 4 months, and had been in the shelter system for 15 weeks at the time we first met. Roberta was a large woman who was arthritic, and at times, movement was painful for her. The demands of a rigorous childcare course and the multiple appointments she kept did not diminish her humor, energy, and hospitality. She was consistently devoted to, playful with, and delighted by her responsive son.

Roberta was the third eldest of four children. She said about growing up, "It was a nice childhood. My mother Lena raised me. She was a very soft-hearted woman, you know, so I could get away with a lotta stuff." Her parents separated when she was 2 years old, because her father "loved women too much." The separation was amicable, and Roberta and her brothers retained close relationships with their hard working father, who always provided child support.

Growing up in the safe housing development in the West Bronx (her only residence during her first 18 years), she had an active social life and loved school. At age 14, she began working at her father's vacuum repair shop. She continued to work in retail through adolescence, obtaining positions with increasing responsibility. As a result of her competence and maturity, she became a manager of a large chain store, a position she accepted because of the good pay and benefits. However, the decision came at the cost of completing high school.

Three years later, the retail chain was bankrupt, and Roberta was laid off. For part of that time, she had been living independently, but could no longer afford her own residence. She considered returning to her mother's apartment, but did not wish to jeopardize Section 8 (discussed in the Introduction). When her child was born at that time, she decided to enter the shelter system and apply for public assistance. " I don't just like sitting back, and I've always been independent," she said.

She worked hard to retain her close relationships with both her parents and Donald's father, with whom she planned to live when she had permanent housing. She cherished her son, saying, "That's my heart. He's a trip, you know. He gives me inspirations, cause everything I do now is basically for him, you know? Oh, he's a wonderful child."

While Roberta was at The Arche, she took an active part in shelter life, joining in many activities. She also completed her GED and began a childcare course. Her longterm plan, to which she had given much thought, was to enroll in a business course, so that she could own a clothing store for large women that carried well-made, fashionable attire. "Unlike Lane Bryant," she added, to make her point.

Her optimism about the future was rooted, in part, on her philosophical perspective about life. She said, for example, "You have to go through bad things before good things happen. You know, you usually take a step back before you take a step forward. And you figure, uh, this stuff happened. It can't happen again, once you have learned from it. You get stronger and you know what not to do, and what to do to keep going. So you won't get back in the same situation. You try to get something out of everything that happens to you."

Roseanne

Changing for her family and changing her family story. "I want to break the chain."

Roseanne, an 18-year-old African American mother, and her husband, David Sr., 27, lived in a 2-bedroom apartment with their two children, Danielle, 3 years old, and David, Jr., 2 years old. Roseanne and David had lived in the shelter system for 16 months, and at The Lincoln for 5 months, when I met her.

Roseanne entered the shelter system to "save her family." She was worried that she would lose her husband and that her children would loose their father to drug abuse. She believed that a different environment from the housing projects in which they had been living would make a difference in her ability to prevent her family from disintegrating.

Roseanne, the middle child of 5 siblings of three different fathers, endured multiple and cumulative risks as a child, including extreme residential instability. As a child, her family lived in the shelter system twice. She experienced severe maternal physical abuse and neglect. Self-mutilation, suicide attempts, and psychiatric hospitalizations were the sequelae of her mother's failure to protect her from sustained sexual abuse by her stepfather. When Roseanne was 12, she and her sister ran away from home, and she entered the child welfare system. Initially she was in a residential treatment facility and then in group homes. She experienced serial placements while in care.

With all the trauma, Roseanne still recollected two periods in her childhood when she experienced an age-appropriate secure, carefree, hopeful, sense about her world and her self. These were experiences she wanted to ensure for her children on a sustained basis. The first was when she lived in stable, community housing, in a cohesive neighborhood on Staten Island, from age 5 to 7 years. The second was her first group home experience, when she felt that she belonged and was valued. As she described that experience, "The staff listened. There were 6 girls, and they just took me in. I mean, I was their sister. You know, everybody was just so close. The home was so in order, you know. There was a certain time to do things, you know, and then the allowance you used to get for cleaning up. That's the first time I ever lived somewhere where it was everybody did everything together and then stuck together. They always had something for us to do. They always kept an eye on us, kept us busy. I like strict places. They were the best counselors. I was in the middle of all the other girls. I felt love. That's the best."

Roseanne was transferred to a second group home after 8 months—a change she regretted. With that change, she became

withdrawn and very compliant—for which she was given "The Best Girl Award" by the agency. However, her compliance masked a depression, from which Roseanne longed to be free. " I called out for help so many times," she said. "I hoped that therapy would set some goals in my life, that I would have somebody to confide in. Help me know right from wrong."

At age 14, Roseanne met David and stayed with him, violating the group home curfew a number of times. As a result, she was discharged from the group home. Because her mother was, again, living with the man who had sexually abused her, Roseanne believed that she had no other choice than to move into David's apartment.

After the birth of her children, her suicidal ideation diminished, and she did not attempt suicide. She hoped to distance herself from the multigenerational pattern of sexual abuse, single parenthood, and early childbearing that had been part of her family story.

Sabina

The journey of a practical dreamer to find a place in the world. "I think I have a place in the world where something good is gonna happen. It might not be now; it could be in a few years from now."

Sabina had been at The Arche for six weeks, and in the shelter system for three months, at the time we began our work. She was a 21-year-old self-defined "Negro" woman, who was 6½ months pregnant. She gave birth to a daughter, Serena, near the end of our meetings together. Sabina was a statuesque, dignified woman who, even at the end of pregnancy, moved with grace. She spoke clearly, taking care to use moderate language. Her small room was a good example of "making a silk purse from a sow's ear." With few possessions to call her own, she purchased

items from a discount store and used push-pins to create storage, thereby adapting her tiny space to her growing size and changing needs.

Sabina was the third youngest of 7 siblings (from 4 different fathers), but was closest to her sister, Teshina, who was 2 years her junior. She grew up in Brooklyn public housing. Her mother was a vulnerable woman with a history of substance abuse and domestic violence, which Sabina witnessed. Because of both the mother's limitations and the lack of involvement by the extended family, the siblings had a close bond with each other, and the older siblings cared for the younger siblings.

When Sabina was 11, her mother died after a fall during a physical altercation with a boyfriend. From the age of 11 to 16, Sabina and sibling pairs lived among maternal great aunts and uncles, who often were abusive, both physically and verbally. At 16, fearful of molestation by an uncle, Sabina spoke to her school guidance counselor and was placed in foster care. She adapted poorly to each of the 9 foster homes in which she was placed during her 3 years in care.

At 19, she eloped from her last foster home, where the foster mother exploited her. For a time she lived with her oldest sister, with friends, and finally on the street. While living in a mall where she was employed, she met the father of her child and briefly moved into his family's apartment. At about the same time she discovered she was pregnant, the father of he child was incarcerated for a felony. Realizing that she could not safely survive on the streets, and wanting a healthy child, she decided to enter the shelter system.

Although Sabina had worked from the time she was 15, education had always been the route out of her difficult life circumstances, and school often was the place she felt most at home. There she found vital validation for her talents and intel-

ligence and enjoyed support from teachers and guidance coun-
selors. Her entire high school class was the recipient of a phil-
anthropic endowment, which provided full college scholarships.

Sabina was one of the few mothers interviewed who had a
role model, Oprah Winfrey. Knowing about Winfrey's early life
gave Sabina inspiration to think about future success. Sabina
believed that her present or past environment had failed to rec-
ognize her worth. With this sensibility, she distanced herself
from those whom she felt might devalue her. She and Kathleen
(see above) formed a close and mutually helpful and satisfying
relationship.

Sabina aspired to use her choreographic and photographic
interests to one day run her own business, perhaps in the fashion
industry. She also wanted to use her college scholarship to
study liberal arts. She hoped that, along with her infant daugh-
ter, she would be able to provide a stable safe home for her
younger sister, Teshina.

Soliel

*Back and forth, carrying her memories and future with her. "I didn't
have my mother around. I took care of myself, I fought."*

Soliel, 22, was a tall, striking, self-identified African American
woman. She entered the shelter system 4 months prior to our
meetings, and had been at The Arche for 6 weeks. She and her
17 day-old daughter, Deja, lived in a tiny, well-organized, fifth-
floor room at The Arche. Two items dominated the space.
These were Deja's sleep monitor and a large, plastic box con-
taining photographs, correspondence, and newspaper clippings
about family and friends. Among the clippings were articles
about her high school, the death of her mother, and three close

family members, which had occurred within a short period of time, when Soliel was 12.

Soliel spoke deliberately, emphasizing important points by repeating the last words of the sentence. She was optimistic, warm, and had a buoyant sense of humor about herself and others. "My grandmother is a def comedy jam," she said. "We was a comical bunch. My mother, she loved to have fun and she loved to dress."

Soliel was the eldest of 3 sisters, and part of a close knit extended maternal family. She had no knowledge of her father. Her mother was murdered when Soliel was 12. None of the maternal family could take her in because of lack of room, so she and her next eldest sister were placed, first, in serial foster-care boarding homes, and then in residential treatment.

Comparing her experience before the death of her mother with that in foster care, she concluded: "I didn't let anybody take advantage of me. I didn't have my mother around. Otherwise I wouldn't have gone into foster care or group homes. I took care of myself, I fought."

At 16 years of age, however, with the help of an aunt, Soliel enrolled in Liberty Preparatory School, an alternative high school. There, she thrived for several reasons: the intimacy of the small school; she was among adults who could provide her with individual attention and concern; and she was exposed to a core, multicultural curricula that enhanced both her consciousness of racial and cultural issues and pride in her cultural inheritance. At the Liberty School, she also developed close relationships with other students, and remembered the individual and collective faculty members with fondness. After graduating from high school, Soliel enrolled in college, which rekindled an earlier interest she had to work in the area of juvenile justice.

Soliel had health problems, including a heart murmur and asthma. Deja was a fragile infant, born prematurely with apnea and respiratory difficulties. Soliel recognized how important she was not only to her daughter's development but, more significantly, to her literal survival. With both pride and concern she observed about her daughter, "When she was first born, I could not leave the room. She started crying. She could smell me, if I'm not in her eyesight where she can see me. I make sure she can hear my voice. I like that, and she knows her mom and I like that now. When she gets of age, I'm going to let her be her own person."

Soliel's future plans included attending a bachelor's program in the field of criminal justice. She also planned her home down to the color of the towels she would buy, and looked forward to spending time there with her sisters and nieces, and caring for her daughter.

Talia

The disappointed stranger. "Well, when we came here, I thought my Mom was going to support us and buy us clothes. Cause back in Jamaica, you watch movies about America and you think about how it would be to come here."

Talia and her 1-month-old daughter, Collette, had been living in the shelter system for 4 months when we met. She was one of the few mothers I interviewed who breastfed her infant. She is tall and capable of appearing either elegant or in disarray.

Talia's vivid account of her recent life on the street was coherent and moving. Her narrative about her earlier life, however, especially her description of her mother, was more puzzling, perhaps reflecting her inchoate childhood recollections.

About her mother, she said at one point, "I don't know why she went and why she comes back."

Born in rural Jamaica, the middle of 5 siblings, with twin sisters 3 years younger, Talia lived with her parents and extended maternal family in large family house. As a child, both of her parents worked. Her father was a teacher. Her mother was an ephemeral presence in Talia's life. She would leave with no apparent explanation, and then come back when something happened. "She's the kind of person who likes to be by herself," Talia said of her mother.

Growing up, Talia witnessed many marital disputes, and her parents separated when she was 10. She remained living in the family house with her father, whom she described as nurturing but strict. When her mother asked that she and two younger twin sisters come to live in New York, she uprooted herself, at age 17, from her native Jamaica and her caring father. Eager to see New York, she complied.

Talia entered the shelter system several months after being ejected from her mother's apartment, because she could not make enough money to give to the household. Before that, Talia and her only companion in the states, Jeffrey (Colette's father), a young Jamaican man also ejected from his family, lived in a series of vacant apartments and the subway. Confused, and with shattered trust, Talia remained isolated at The Arche. She was frightened that she did not know enough to get along there, and was worried about who she could trust. She turned to her maternal role, with her infant daughter as a source of stability in a confusing world. As for the future, she had some optimism, and wanted to own a cosmetology shop one day.

Vanessa

Forging a new life from a confusing past. "I didn't say I missed out on, you know, a lotta things, but it was like with my son, I grew up too fast for my age. This is a start for me. This is a step out into the real world."

Twenty-one-year-old St. Thomas-born Vanessa had been living with her 8-month-old daughter, Diane, at The Arche for a year, and had been in the shelter system for 16 months, when we met. She was also the mother of 4-year-old Gavin, who had lived in kinship foster care with her sister for 2 years.

The youngest of 4 children, Vanessa grew up with her mother and her mother's extended family on St. Thomas. Her father was employed by a British company and spent much of his time in England, visiting family members over the Christmas time. When Vanessa was 7, she, her mother, and 2 siblings were traveling to the states, and her mother passed away on the airplane. "I had a fairy tale life, and then after she died, it was shattered," Vanessa recalled. Her father then stepped in and brought the daughters to New York, where he had moved. Her brother stayed in the Caribbean. "I didn't know him," she said of her father. "A month after my mother died, a month later he married someone else. He just enrolled us in school here."

Vanessa could not form a relationship with her stepmother, and she was consistently exploited and insulted by her new stepparent. At age 14, her older sister, who had offered some protection from the stepmother's abuse, moved away from the city.

Vanessa became pregnant when she was 16. She then moved in with her older sister, who was then married and had her own son. Vanessa cared for her son and niece while her sister and brother-in-law worked. Vanessa's son, Gavin, was re-

moved from her custody after his father burned the child while giving him a bath. Gavin remained in kinship care with Vanessa's sister, and Vanessa returned to the city to live with her brother. There, she had to double up with friends, and always felt she was only welcome on a time-limited basis.

When she became pregnant, Vanessa knew she needed a stable place to live with her child. She then entered the shelter system. With all the disruption, she completed high school and obtained a certificate as home health aide. She was very proud of her training, as well as having completed a parenting course while in the shelter.

Vanessa looked forward to one day having her own apartment, where she would not have to experience rejection, and would have her son and daughter to care for. She also wanted to build on her home health aide experience, because she felt significant gratification caring for older people.

Summary Statistics for the 24 Homeless Mothers

In this section, selected demographic characteristics of the 24 mothers interviewed are summarized using descriptive statistics. The demographic characteristics include their (1) age, (2) age at birth of first child, (3) race/ethnicity, (4) marital status, (5) educational attainment, (6) employment status, (7) financial status, (8) number of residential moves, and (9) length of time in the shelter system at the time of the interviews. In the Appendix at the back of the book, a table summarizing the major characteristics of each mother interviewed is presented.

For the 24 mothers interviewed, their mean age was 24.2 years, and their median age was 22.5 years. The youngest

mother was 18 and the oldest was 51. Their mean age at birth of a first child was 20.2 years, and their median age was 21 years.

The most prevalent racial group in the study was "Black," with 70.8% (17) of the mothers identifying themselves as either "African American" (50%) or "Carribean-American" (20.8%). Latinas represented 20.8 percent (5 members) of the total sample. The remaining 2 women in the study (8.3%) identified themselves as of mixed race and ethnicity.

At the time of the interviews, 66.7% (16) of the mothers were single, 20.8% (5) were married, and 12.5% (3) were divorced. As regards education, 25.0% (6) of the mothers had attended college, with the range being 1 semester to 3 years. Almost all the mothers either had never been or were sporadically employed. Only 12.5% (3) mothers had been able to obtain steady employment in positions where there was opportunity for advancement. With the exception of Roberta, all the other mothers' employment had been at entry level, leaving them vulnerable to economic changes.

All of the mothers were receiving some form of income or rent subsidy at the time of the interviews. A shelter allowance was paid directly to the shelter provider, and the mothers received an additional subsidy in the form of direct cash grants, food stamps and WIC, based on federal and state formulas, according to family composition.

Before the age of 18, the 24 mothers had an average of 6.6 residential moves. Of note is that the mothers who had been in out-of-home placement moved more than three times as often as the those who had not been in care before the age of 18 (an average of 10 times compared to 3.2 times). At the time of the interviews, 75% (18) of them had spent less than one year in the shelter system, with their average stay being 9.5 months.

Chapter 2

The Mothers' Past Lives:
Understanding Pathways to the Shelter

A common view of shelter use is that it is a solution of last resort for those unable to help themselves. Much research linking childhood risk factors with homelessness has reinforced the notion that shelter use is, to a degree, the result of a combination of developmental affronts. It is notable in this study, however, that the mothers also displayed active, logical behavior in choosing and fighting for shelter placement. Their narratives consistently revealed their will to develop as individuals, a process that was reliant on, but not necessarily hindered by, shelter use. These narratives challenge the thinking of much recent research, and bring into question prevalent trends in policy that aim both to limit shelter admission and move people out of the shelter into community housing without adequate community resources or economic supports.

A discussion of the past lives of the mothers in this study must inevitably address the concepts of choice and personal development. It is within a risk/resiliency perspective, in which shelter use can be understood as a viable alternative for people with limited choices.

Most of the mothers believed they had few choices in living arrangements other than shelter entry. Although the mothers often described more than one reason for shelter use or an extended sequence of events that led to shelter use, the following discussion is intended to describe their perceptions of the primary reason they entered the shelter system.

For a third of the 24 mothers, the shelter was not a survival choice but was related to their developmental and relational needs. Their words give a fuller understanding of their feelings and thoughts regarding their choices. The women's words reveal that they were neither taking advantage of a system nor admitting failure, but were using the shelter as a means of improving their life chances. The mothers' narratives revealed that their seeking to use the shelter system was an active solution to an amalgam of longstanding and/or proximal psychosocial stressors. The following are the major reasons they gave for entering the shelter system.

For My Child

Pregnancy or recent childbirth was the most cited change that led the women to consider and choose shelter entry. The themes associated with pregnancy and recent childbirth and shelter use varied, and their narratives identified other longstanding stressors, which, when combined with pregnancy, gave fuller meaning to the women's perceptions of choice. Some of the women recognized that having a child meant a change in status that required new living accommodations. As Soliel explained,

> Well, the only reason I came here [the shelter], if I had been by myself I would have survived. But I had something besides me that I was going to take care of. Something that was going to make a better life for myself—and that was my daughter. That's another reason I came here. Um, I knew I was pregnant and I didn't wanna stay with nobody else. You know, I wanted to be on my own, and that's what I had to do. I had to do it in order

to get, you know, to do what I wanted to do, you know, get my own apartment and stuff. It was something I had to do.

Roberta had a similar story to tell, involving her child.

I was going through this with my child, you know, he won't remember this in time, you know. I had everything and now I don't have anything, though it's not my fault. It just happened that way, you know. And, um, that's why I feel it's just like rock bottom; the main reason that I am going through this was for my son. "'Cause you know," I said, "I can't be going from place to place dragging my child around until something comes along," you know. Of course, you can't find a job when you have a child that you're dragging around.

Roberta also explained that she did not want to continue to be a burden to her family.

I figured I couldn't go back to my mother's house (after unemployment) 'cause there's not enough room there. I have a little half-sister and brother. It's only a two-bedroom apartment, and you know they need the space. My mother's on section 8 and it would interfere with the rent; they always increase it. And I didn't want to get her in trouble. So I figured that I was used to living on my own. So I guess this is the last resort, you know.

Dionne, too, expressed her parental concerns about her new daughter that led to her shelter use:

They [the owners of the apartment in whose parlor Dionne and her infant daughter had been residing] were fighting over the baby's head, and my baby was crying. She was getting aggy [nervous]. I didn't want to subject her to that kinda abuse and the screaming. They figures 'cause I was living in their place they could treat me any kinda way they wanted to. Because they feel they have authority to do that. And I was always a strong-minded person, you know, you not gonna do me and my daughter the way you want to. I just hope that God just put a lotta love in this family and keep us together. 'Cause we been through a lot right now. Keep us together forever, you know. Right now she [her daughter] doesn't realize by going place to place, but she doesn't realize, you know, what's going on and why Mommy's doing that. But when she become a certain age, I really want, I want to be settled. 'Cause the worst thing in the world is just travel around, and be little shelter children going in shelters, after a while rootless. I mean, how they, they never been stabilized all their lives. So they don't care, you know. They're not gonna know how to take care of anything they have or get anything in life, 'cause they're always moving.

The women's knowledge that pregnancy meant priority status for gaining access to transitional shelters, and then permanent housing, figured into their decisions. The choice between either continuing to live outside precariously or remaining pregnant gave definition to their decisions.

Sabina, for example, decided that the shelter system was better than continuing to live outside in a mall, where she had slept after the father of her child had been incarcerated and her two sisters had ejected her.

> Well, it's like, I'll be thinking about when I came out of high school that I should have just went to college [she had been guaranteed college tuition from a foundation program] instead of having a baby. The baby situation is like, I'm in a different situation than a lot of women here because I really kept the baby, because I didn't have a place to stay; and that if I kept the baby, I'll have some place clean to sleep, and where I can shower, you know, and a warm place to sleep every night. You know, the baby wasn't really planned, but I'm gonna do my best, you know, when she arrives. Had I had a place to stay, I don't think I would have made that choice [to continue the pregnancy]. But, you know, under the circumstance, you know, that was the choice I had to make in this part of my life.

Sabina, exhibiting a political consciousness, went on to equate the condition of homelessness to powerlessness. "People become homeless," she said, "because they have no power and no way to voice their opinion and get an answer. A lot of people don't want to be bothered, but I deserve better than this. Power is the point in your life when you can call the shots, where you can be listened to by others who are in higher positions."

Delila, who had been in the care of The Almost Home Child Welfare Agency since age 6, had started college. When she was about to turn 21, she decided to enter the shelter sys-

tem, and was thankful that her pregnancy created the opportunity. As she explained the events that led up to her entry into shelter system:

> Then I dropped out of college because I decided that I didn't like it up there anymore. . . . I missed New York City, so I came back and stayed at Youth House. And I started to work full time. I was 20. And then they said to me, "Well you're going to be 21 in May," and it was already October. "What are you going to do with your life?" I became pregnant in April. I was supposed to leave in May and could no longer remain at the Youth Residence. I had a lot of emotional problems thinking about, you know, I was going to be 21 soon and that I was not gonna have any place to be; I didn't have any money. I didn't have a place to be, you know, I didn't have any career goals. I mean, all I had was just the college, and I could not continue to go to college for the rest of my life. I was thinking, I have no family to go to, I don't have any apartment set aside. I don't have anything. So if I go, I'm gonna become homeless. But then I guess it was kinda lucky that I got pregnant and decided to have the baby. Because the city's more sympathetic to homeless women who are pregnant. They're more sympathetic to them than any other people in the system, you know? So I ended up being breezed through the system, you know. I got pregnant. I mean, I found out about a month before I turned 21 that I was pregnant and I was like, Oh good, well at least I won't have to stay

in the street 'cause they're gonna feel sorry for me anyway, and find a place for me to be, so it was kinda good that I ended up pregnant.

For Vanessa, pregnancy was also a way into the shelter system. She felt unwelcome and barely tolerated living with her family, friends, and the father of her children. Eventually, she decided that the shelter system was the best option for both her and her children.

Uh, I lived with my girlfriend, I lived with my baby's father, my brother and my sister, and then I came into a prenatal shelter; and that's five places, and then this place is six, and seven is finding my home. It was like every time I go to live with somebody, in the beginning, it's all nice and they will tend to me. You know, they're caring and everything. But sometimes people feel when you live with them they have the right to tell you, 'cause you're in their house. And I don't feel that's right, because, you know. It's okay in the beginning; they would cook food for you and then, as you're not working or giving them money or, you know, things is hard on you. . . . They know you don't have any money. . . . They start taking, you know, their soap, their lotion, their personal things that before you used to share; and these are just little things. So from that you get, you know, a hint that you, you're not wanted here any more. It's time to move on. And a person can just keep moving on and move on for so long before they get tired. And like me, I just tired and said, you know, when I found I

> was pregnant, and I was like, I gonna keep this
> baby, because this is a way for me to get my life
> together, and my education together, you know,
> get everything done when I'm out there, a roof
> over my head. By the time, you know, my
> daughter is an age where she could go to babysit-
> ter, she's on a schedule, you know, this is just a
> start for me.

Vanessa knew a viable pregnancy was a requirement for
shelter eligibility. That is why, when she learned her pregnancy
was medically uncertain, she felt desperate and thought through
available alternatives.

> I was like, oh my goodness. And I was in the
> prenatal shelter and once you're outta there, I
> was like, I will have to go to a single woman's
> shelter, and then what's gonna become of me? It
> was like a second breath of fresh start, because
> like suppose the doctor already took my baby
> from me, you know? It's just like a miracle, and
> I didn't have to go to the single shelter. I came
> here and I don't feel homeless.

Autonomy and Independence

Some women chose to enter the shelter system as a way to
change the valence of power in their present living arrange-
ments. To remain in a pre-shelter living arrangement meant ex-
periencing themselves as powerless and dependent. Rayette ex-
pressed these feelings, and also her desire for autonomy and in-
dependence.

When I decided to go to the EAU, I told my mother I can't come back. I'm old enough to be on my own. I'm gonna get my own. The next time you see me, it's gonna be in my own apartment. And that was it. When I told her, she was upset. But I said to her, "I just want my own for me. Like when you got yours," and she started crying. She was like, "I'll help you. If anything goes wrong. I don't give a damn, come home." You know, it wasn't like I just got kicked out. I'm glad it wasn't like that. She used to depend on me for a lot. I mean, especially when it came down to my little brother. She depended on me for almost everything. When I bought his uniforms, I paid for his school. I was making good money being a bartender. And I could always take care of myself. Though she's independent, she's also dependent on me. I depended on her too. When my son came also it was different, and I had to fend for myself and him.

Nodica echoed the same desire for autonomy, after being in a situation in which she felt powerless. "I'm just glad I'm out of that situation," she said, and continued to explain:

I look back and I waited for these days to come, and when I would grow up and get out of the house. I'm having my own child and I'm glad that I'm in this age now. So I don't have to be in her house, her telling me what I should do. There are rules here [in the shelter], but you don't have anybody really coming down on your back. You don't have anybody constantly on your back. I

can go in my room and close the door. I didn't have any privacy at home; she would go in my room and search through my drawers. I had to be careful. No privacy at all growing up. I'm a woman now. I'm glad I left. 'Cause I wouldn't have anything if I was there. I wouldn't have a boyfriend and about to have a child. In a way I'm glad I'm here.

Elyse also had a similar perception and need for freedom, only in her case it was freedom from her older cousin. Referring to her cousin, she said,

But she was trying to talk to me like I was a child. I'll try to explain it to you. Like I was her son, and I'm not. And you can't inflict that on me, you know what I'm saying? And she would do things like not let me use the phone if I had to call the Domestic Violence. I was in a bad situation I just had come out of. Why would you try to do this? In the first couple of weeks it was okay. But then, I don't know. She would come and be like, you can't cook dinners and da-da-da-da. You don't do nothing. And I was like, man, I gotta get outta this. It's like when I was an adolescent, when I had to deal with her. I said, how did I get into this? Why did I come to her? I can't wait till I get outta here. And so I said, gotta get outta here, I gotta get outta here, and I ain't never taking this route again. It's like when I said I was a kid, when I had went into the group home.

Two mothers I interviewed worried they had become too dependent on the men in their lives, and that the only way to change their situation was to claim something as their own. The shelter met this need. As Marion said,

> When I was coming up in the group home, I actually taught myself that, you know, you are by yourself. You know that no one is gonna help you. But when I first met Kareem, I started leaning on him for moral support, and I broke down my wall. So when, you know, I thought he was gonna be there for me or something, I mean, I became a less strong person at that point, when I moved in with his family. And I allowed them to make decisions for me. So after that, things started getting bad. I said, "What the hell am I doing? I have to do things for me." 'Cause Kareem started changing. I went into the shelter because I began to worry what would happen to me if Kareem left me and I didn't have a job. And I have no green card, even though I have been here since I was seven. If Kareem leaves me, how would I live? Since I couldn't go to school, I went into the shelter system. I had to do something to make myself feel stable. Get on my feet and make myself happy. Kareem didn't want me to go into the shelter with Zach [their child]. What would I do if he leaves me, you know? I don't have a job, I'm not from this country, so I don't have no papers and I need a place of my own.

Eartha described her relationship with Sidney, and how it made her feel dependent. She also perceived the shelter as a path both to retain an important relationship and, at the same time, support her autonomy.

> This guy in Flushing, I was living in his apartment. He threw all my stuff out in front of the door and said I have to leave the apartment. I was walking around with a duffle bag, a big laundry bag of clothes. Then I went and slept in the park for a while. And then I met Sidney, from a friend of mine and his. After the friend had no place, I was sleeping in Sidney's car at night, and then I would go out and come back and sleep inside in his bed, in his mother's house. Then maybe I'd go to Chantelle's and her mother let me take a shower and stay with them some days; and then I'd wait for Sidney to come home from work. Go upstairs with him, go to the car, and sometimes back and take a shower. So I guess I really wasn't homeless. But then I found out I was pregnant and then Manny [the father of her other three children] came back from Michigan, looking for me to get back together. But I loved Sidney by then, and decided to have this baby and go into the shelter system because I wanted to have Sidney's baby, and I wanted to have a relationship with him, and I didn't want to have Manny find me or mess up that relationship. So then I decided, I couldn't stay outside in the car any more, and I loved Sidney. So I decided to go into the shelter system. So I did, and it turned out for me. I'm in a nice place. I'm go-

ing to get an apartment and Sidney is sticking with me. So look where I am now. I have a baby and Sidney is still sticking with me.

Roseanne sought residence in a shelter to protect her children and stabilize her family, which basically meant "saving her husband" from drugs so he could be a functioning father to their children. As she said,

> I wanted to leave the projects because my husband was continually exposed to drugs. And, also, I wanted my kids to have a father. So I felt I was obligated to do it for my kids. There wasn't really nothing stable, you know; the most stable thing was the other B shelter. But before I went to the EAU, I had his apartment. And we all lived there. Why I really had to get out of that apartment was we were living in public housing and my husband was on drugs. People would just come up to me and say, "You're married to him?" Didn't want to put my kids through that, you know? I don't know. So I figured maybe if I can get him outta there, outta the projects where he grew up all his life, you know, he could stop and we could get help. I felt like I was belittling myself, but I had to do it. I took him outta the projects and then I went to live with my mother. But she was too money hungry, so I went to the EAU and from there, and . . . um, he stopped doing drugs for a while, but when we got back to the B shelter, he started again. But now he's in NA [Narcotics Anonymous]. I seen a change in him now; he doesn't come in late or anything.

The Shelter as the End of Living Outside

To some of the women, shelter entry meant an end to exposing themselves to an extended period of living on the streets, either while pregnant or with their young children. For Lucia, who had been in out-of-home placement, the shelter meant an end to living with danger from the elements, predators, and paramours. She perceived shelter use as the end to a long period of accumulating risk, including risk to her life, as evidenced in her testimony.

> I did so good when I was in the last group home. I mean, I was an angel, I didn't even do nothing bad, you know? But when I got involved with the wrong kinda people, I started hanging out again, started drinking. I started smoking weed again, I started doing everything all over again. Sometimes I would have to sleep with people just to feed my daughter, 'cause when my daughter was born, you know, I couldn't even feed myself. I would have to go around, guys would pay me to just sleep, just to, to put food in my mouth, because I used to live in the streets. 'Cause when I was in a foster home, um, I ran away from the foster home, that was far away in the boondocks. When I was in that one, I ran away with this girl. I used to always say she was my cousin. We got kicked out, and we slept in the streets; we didn't have nowhere to go, nowhere, nowhere, nowhere. I was almost raped; but we slept in the streets, it was cold, it was three of us. We stayed in the streets, we didn't

> eat nothing, we was walking all day. Yeah, and
> then we did something bad and had to just sleep
> in a hotel for us to lay our head on a bed and
> food. We stole money from a bum and he was a
> cop! Dressed as a bum! He started chasing us
> and we ran and hid and they couldn't find us.
> You know, it was terrible, my life was real terri-
> ble. I went through so much, so much. I was
> mentally abused.

Finally, she entered the shelter system, even though her
first entry was short-lived. That led, however, to a longer stay at
a shelter.

> Then I lived with an ex-con who I met in a GED
> class. But then I got pregnant and his mother
> kicked us out. Then we went to the J shelter, the
> second day he left me in the shelter. Since I was
> a minor, since I was seventeen years old, I
> wasn't allowed to stay in the shelter. So they had
> to kick me out the shelter. I went back on the
> streets, had an abortion, and then lived with a
> friend. I did not have a choice. And then she
> started taking advantage of me, taking my food
> stamps, and then I went back up with that guy
> again. And he got mad and he threw me on the
> train track. I fell inside the car; if it wasn't for
> that, I woulda been dead to this day. Then I went
> back to live with another friend, but she also
> took all my money. I went into the shelter sys-
> tem. I was eighteen by then.

Talia emigrated from Jamaica to live with her mother,
whom she had not seen for 5 years. She hoped to start a new

relationship with her and a new life as a cosmetologist. Prior to their reunion, her mother's mental illness became more acute, her behavior harsher. Suddenly her mother said to her, "By Saturday I don't want to see you here." Then the following events happened, according to Talia:

> So I left and it was wintertime. So I just, you know, I just be sleeping in buildings all the time. It was terrible, terrible. Pretty much we [she and the baby's father, who had also been ejected form his family's home] used to like, we used to just walk around in the daytime looking for somewhere to stay at night. . . . Sometimes we used to go, when we know there's a certain apartment to sleep in there that night, and be out early in the morning before the superintendent came. And I didn't know I was pregnant. So I was tired and I was hungry 'cause, you know, you wanna eat and then you wanna sleep. And I was cold. Sometimes I couldn't walk 'cause of my feet, they got so frozen. I couldn't move and you had to walk. And sometimes we'd have to go on the subway and say "Can I have a quarter? And they said they didn't have it."

Finally, Talia went to an emergency room, her pregnancy was diagnosed, and a social worker intervened. That led to Talia's entry into the system, which she explained as follows:

> Well, when I first came into the system, I didn't have an idea of what I wanted to happen 'cause this is like, I didn't have no choice. I didn't know about all this. It's like I just went. Like in April, 'cause I was living in the streets, and then I got

pregnant and the social worker told me about Portal House, and so I went there. So I figured like, I'm just going to spend the night. But when I went there, it was like, they sent me to East Street [a prenatal shelter] and I ended up here. So pretty much, I couldn't say I want this or that, it was like having, you know, my apartment, talking like other people, saying they're getting their apartment. I can't really picture it, you know. I don't know what would have happened if the social worker didn't tell me about the shelter.

Forced Independence

The young women who had been in "out-of-home care" felt that shelter entry was yet another decision they had to make during a series of sudden changes that forced their premature independence. Jana, 21, left care and then lived in a series of temporary doubled-up situations. Shelter entry meant stability to her, in the midst of fear and uprooting. As she said,

Whew, it was like I was scared, happy and sad all at one time. I was scared because it was like, well, you're grown. You're going out in the world, you know. I don't have that net to hold me. I have to make decisions on my own, and it was sad for me. 'Cause it was like, I'm leaving all the people that I would love, before I'm ready. It's not like I'm going to see them on a regular basis, you know. Now I have to start my own life, my own independent living. Doing things for myself which I was doing there. But, it's not like I could walk to the next room and be,

> like, "Well, what do you think if I do such and
> such?" And I was happy because I was out. I
> thought I would be out on my own, you know, at
> that point I thought, I'll be starting my life, but
> then it didn't work out like that.

For some of the mothers, their instability and conflict were
exacerbated by the poorly planned and sometimes peremptory
discharge from care to their families. They were not yet pre-
pared to meet changes involving both placement and the devel-
opmental needs of young women. Pregnancy further destabi-
lized their opportunity for a degree of family permanence. They
were forced to leave the homes of parents whose caretaking re-
sources were burdened, even prior to their pregnancies.

Milagros, for example, had established an admiring and
trusting relationship with her foster parent, foster siblings,
school, and neighborhood. Those responsible for planning her
discharge did not consider the consequence for Milagros of the
loss of substantial attachment to person and place when the fos-
ter care agency returned her to her biological mother and her
household. This loss soon led to conflict, and her entry into the
shelter system. As she explained:

> Well, let's see. My mother's boyfriend started
> living with us, and I didn't agree with the way he
> was treating her and us, either. So I had a social
> worker like, with teenage kids, 'cause I was a
> teen-ager when I had him. She told me that if I
> wanted, she could find me a place to live if I
> didn't want to stay there, because there was al-
> ways arguments at home. He wouldn't hit her or
> nothing, but he would always use abusive lan-
> guage with her. To me it made her fall down,

like she was nothing. And I didn't agree with that. And I told her about it and she told me that if I didn't like the way he was treating her, I knew where the door was. And I said "Okay," and a couple of times she said "Okay." So I finally told the worker that I wanted to get out of there, especially with my son being there. He would be cursing and he wouldn't know what he was saying. So then I told my worker, and she brang me to Portal House.

Some mothers found they were forced to use the shelter when their mothers chose the needs of the men they were involved with over the needs of their teen daughters. Like some women who had been in out-of-home placement, these young women lived in situations dominated by the needs of parents rather than the needs of all family members. The young women were powerless to chart their own course into independence, which left them feeling uncared for, frightened, and angry.

Nodica explained,

Finally my mother said it would be better if I left. She always said that, you know, my life would be so much better if you leave. I guess she needed to be with him more than she could care for me. She needed to feel loved and she needed him to help her out. But me, I wasn't ready to leave. I was scared. It felt like nobody cared at all what happened to me. I went to live with my sister, then the Job Corps, then when I got kicked out, I went back to my sister's, because my mother wouldn't let me come home.

Inadequate Living Arrangements

For the youngest women living with families, conflict within the household coupled with inadequate housing contributed to forced independence. Often, pregnancy was the "final straw," as Kenya's testimony illustrates.

> I didn't tell her [her mother] I was pregnant. I gave her the piece of paper that's saying that I was pregnant, and she was like, "Is it true?" And I would say, "Yeah." She was, like, "What you gonna do?" I said I was gonna keep it. And she didn't say no more, and then she told me to leave; and there was no more room, and anyhow, we weren't getting along too well. We were arguing anyway, and she wanted me to clean up. I didn't want to leave. I didn't know where I was going. It was about June, and first I went to her sister's house. I thought I might stay there for a while. They were arguing too much. And then I went to my Godmother's house, but after a while I couldn't stay, there were too many children. I thought I'd be able to stay. I thought my aunt's house was gonna be home, at least until the baby. But it wasn't. Her boyfriend was hitting her. And then some one, a friend, told me about EAU, but she didn't like it, so she went back to her mother's house. I ain't had no other choice, so I tried it anyway.

Natalie also spoke of a problem involving both her pregnancy and mother. "I had been living with my mom. My brother came home in July; he had been upstate. It was too crowded with my expecting a baby. I stayed with a friend for two or

three weeks, and then I went into the system. I called my worker at the center and she gave me a referral to EAU."

Escaping Violence

Of the 24 women interviewed, seven experienced personal violence during the year prior to entering the shelter system, yet only 2 of the 24 identified domestic violence (as well as pregnancy) as the primary precipitant of shelter use.

Connie and her boyfriend, Leland, had been involved in a relationship filled with conflict that sometimes exploded into mutual physical attacks, which led her into the shelter system.

> The worst time for me is when I hit Leland back after he hit me and he finally threw me out. I didn't know what was going to happen from day to day. That's the time I felt a little upset. I came to the city and didn't know which way to go. But today I know, I gonna be here tomorrow, and I know I have to start looking for my apartment. What makes me mad is really, the thing is, nobody really has a choice. Yeah, I say, yeah, it's really my choice to bring my newborn home to a shelter. It was such a joyous occasion.

Charlotte also entered the shelter system to escape violence and protect her pregnancy. As she explained,

> One reason I couldn't stay there [her parents' home] was because of domestic violence. My father would come in drunk, he'd start arguing in the middle of the night. And between you and me, I thought I might have a miscarriage. Everybody said the best thing to do was go live with

Anthony [the father of her baby], but then Anthony started fighting with me and pushed me down the stairs. I thought I would again have a miscarriage. I went to the hospital after he threw me down the steps, and the social worker told me about the shelter. And I said, but the best thing about it is, I can get an apartment out of it and everything is cookies and cream after I decided to go; and then Anthony told me he'll see how things work out, and he wouldn't mind coming to live with me. I'm not gonna take that chance. He'll do anything so he don't have to pay bills or rent.

Expectations of Residential Stability

More often than not, the women who had been placed in out-of-home care perceived the shelter system as an extension of never having had a home. Lucia said, "Let me tell you something. I've always been homeless. This is the first place I ever lived so long. I told my husband, 'You is the first person that I ever lived with for so long.' Cause I used to go through men like goin' through pants."

Sabina recounted the following about her sense of not belonging:

There isn't any place I call home. No place is home. There wasn't any, there wasn't any place I called home, and this is another part of not having a home. I haven't had a home or a place I could call home since I was thirteen. 'Cause sometimes when you know the truth, it does hurt and you pretend that you belong; but if you

know that you really don't belong there, it becomes a problem.

As Dionne explained:

Well, like I said, since when I was 10, I was going from place to place, and then I went back to my mom and I didn't have those problems. Then when I left my mom's again, I was going from place to place, back and forth, Portal House to the boy, Job Corps to Portal house to the shelter. I mean, I was like, you know . . . or where you look at group homes as a shelter. Shelter is a place where you're homeless [chuckles], and I couldn't go home, so basically I was homeless. Homeless at 10 'cause they wouldn't let me go back there [her mother's home]. I couldn't go nowhere, I had no life. I had nothing, and then, because I was peculiar, I had no friends. I was different. I consider myself homeless, sort of, because this isn't my home. This is someone else's home, sort of. But I don't look at myself like that. But I mean, what is a shelter for? Be realistic. Shelter is for people who are homeless, they don't have their own home. I've accepted this.

Elyse expressed her lifelong futility, saying,

Well, I feel like I'm on my own, but I feel more like every time I try to get on the right track, something jumps in to push me off the track, you know. I've been trying to go up the stepladder, you know, and things been jumping in and push me down. I went through all of this with his fa-

ther and my family, and I just totally in this mudhole; and then I get put in shelter. Sometimes I start to think, there's no end to this. I'm serious.

Women who had not been in care believed that shelter use was an aberration, a brief interlude or even a step forward. Roberta said,

> 'Cause you have to go through bad things before good things happen to you. You usually take a step back before you take a step forward. And you figure, uh, this stuff happened; it can't happen to me again [chuckles]. And once you've learned from it, you get stronger, and you know what not to do, and what to keep doing so you won't get back in the situation. Get something out of everything you do.

Talia said,

> When I went to cosmetology school, I never thought about living on my own. I was always going to live with my family in the same house, because that's the way my mom lived all her life till she came here. I thought it would be the same. You come here, you learn to be more independent, you learn you can't trust much of anybody.

Alicia took pride in her ability to sustain herself and her family through their time in the shelter. She said:

> I never thought this would happen, that I would end up bringing my kids to a shelter; but I think I'm doing a pretty good job. I have to get the

> furniture by myself, and it's hard with the little bit of money that I get from welfare. I'm doing great. I'm doing a pretty good job, 'cause right now, if I get my own apartment, I gotta furnish my whole apartment by myself.

Maria also expressed the same sentiment. She said, "They are helping me here, even though I could never imagine myself or my family here. I've always had my own home, my own things around me. And I know I will again. We will be leaving this behind soon."

Conclusions About the Mothers' Shelter Use and Rational Choice

In general, the mothers' wish for an adequate home in which to raise their families was no different from that of other mobile Americans, who move to acquire adequate housing to meet their changing family needs (Rossi, 1980). In addition, most of the mothers understood that Tier Two Transitional shelters were just that, a transition in housing, family, and social status, when other avenues to change were not available. Yet, at the time of the interviews, the general public usually accused "the home-less" of taking advantage of taxpayer generosity, by using the shelter system to "get housing" (Bernstein, 1996)—an interpretation reminiscent of "blaming the victim." Despite often highly negative options, the women's choice to use the shelter was complex, as well as pragmatic. Like other marginalized groups mentioned in Gordon's (1989) historical study, they asserted "the power of the weak" (p. 288), actively using their right to shelter to meet their survival and life course needs.

The strength of each mother's resolve to find a home must be measured by her awareness of the stigma connected to declaring herself and her family "homeless," which also implies being rejected by friends and family. Though aware of derogatory public attitudes, the mothers viewed shelter use as part of a goal-directed plan that might provide family stability and a chance for them to give their children what they themselves missed while growing up. Even with this awareness, the mothers had not anticipated the degree to which shelter living might either dismantle their self-esteem or limit their agency. Shelter life would prove to be more difficult than they imagined.

Chapter 3

The Mothers' Present Lives:
Making Sense of Adversity While Living in the Shelter

Just as the mothers described their common and unique reasons for shelter use, they also recounted their shared and distinct experiences associated with shelter living *per se*, and with life in general during the time they were living in the shelter. These experiences are recounted and analyzed in this chapter. In the first section, the focus is on the stressors the mother experienced, and in the second section, the focus is on ways the mothers coped with the stressors, especially so as to maintain self-esteem, manage conflict, and carry out tasks of daily living. The chapter also includes accounts by relevant shelter staff and my own observations of the shelters, intended to deepen the reader's understanding of the mothers' lives while they were shelter residents.

Financial Stressors

While the mothers and their children lived in the shelter, their room and board expenses were paid directly to the shelter operator. At both shelters, the women received food stamps and a small stipend for living expenses. Women at The Arche received a smaller grant than those at The Lincoln, because the mothers had no cooking facilities, and breakfast and dinner were provided by the shelter and served communally. At the time of data collection, only one of the mothers was employed, as a home health aide. Families were eligible for several kinds

of subsidies, including public assistance, food stamps, the Women's, Infants and Children (WIC) supplemental nutrition program, and Medicaid. Carfare for apartment searches was provided, as well as a stipend for living expenses beyond room and board. Two of the mothers, Lucia and Maria, also had SSI supplementation, because of medical disabilities; and only two others, Kathleen and Rayette, could count on their biological families for additional funds in an emergency.

Each mother interviewed spoke about the financial stressors associated with shelter living. Specifically, I discerned three categories of financial stressors: (a) The gap between needs and income, (b) Difficulties establishing eligibility, and (c) Humiliating contact with income maintenance workers, and the erosion of self-esteem related to loss of financial independence.

For 12 (50%) of the mothers, their entitlements proved elusive at some time during their shelter stays. They reported problems either establishing eligibility, calculating a correct budget, or with both of these matters. Administrative "churning" (i.e., administrative procedures that automatically close a percentage of cases across the public assistance rolls) meant that their survival funds were cut off without reason or warning.

Sabina, for instance, had no source of income for the first several months of her stay, and she was thus forced to depend on donations for clothing, toiletry items, and travel expenses. Her struggle was resolved with legal advocacy.

Alicia recalled,

> They closed my case 'cause they said I didn't show papers for child support. I never received the letter they said was sent from Family Court for child support, so they closed my case. Even though I didn't want to report their father, I didn't want the case closed. And I had to go do

everything all over again, and it took like six
months for me to do that. I had my youngest son
September 1st and they closed my case in June,
something like that. And I didn't have nothing
for the baby, and nothing, nothin' at all. Every-
thing I did after the baby was born, everything
their grandmother bought for him. She gave me
everything.

Sabina commented that the physical conditions and the
treatment at the income maintenance centers "just makes you
just want to go all over yourself." Connie, Milagros, and Lucia
provided details in their narratives about what is involved in
battling the "churning" to get enough money to live adequately.

According to Connie, the following occurred when she fol-
lowed through on matters regarding her eligibility requirement.

I went to the cash machine and there was no
money. I didn't have any money. Um, I had to
speak to Ms. N [an income maintenance worker].
She quit, fired or whatever; she's not there no
longer. So I asked to speak to her supervisor
[Ms. Q]. I was speaking to Ms. Q, she told me to
bring in my paper work, so I did. I called her on
Monday, and she told me to bring my identifica-
tion papers in Tuesday. I said, um, I wasn't able
to do it, because I was supposed to go to a hous-
ing thing. So I went in Wednesday. But she for-
got to tell me that she needed the one paper
about the school identification number [for Sa-
vannah]. I brought that back Thursday. She says
the processing is going to take three to five days.
She said wait for the week. I checked three days,

I checked the five days and then I checked the week and the day after the week, which was yesterday [Wednesday]. Still no money; I called there. Now Ms. Q is out. I called to speak to her supervisor. Her supervisor says, "Gimme your PA number, she'll check it." She checked it. "Oh your case is closed." I ask, "For what reason?" She don't know, because Ms. Q is gone. I called again to speak to the head supervisor; the phone was busy all afternoon. So I gave up. Yeah, that's what happened. Now I'm down to my last twenty in food stamps and that's it. That's all that's left. Until whenever they decide they wanna, um, give me some money. I told my counselor, and she said she didn't talk about nothing but the decrease in money for food stamps. That's all she talked about.

Another description of financial stress in life within the shelter system came from Lucia.

They put in the computer that I'm receiving three meals a day here, and I said, "That's impossible, I cook my own food; how the hell I'm receiving three meals a day from these people?" So my welfare worker said it's gonna take two weeks to straighten out my budget. They're gonna change my whole budget. I'm depending on that money to feed my family.

Mothers who had been financially independent were embarrassed by their dependent status within the shelter system, which was exacerbated by the derision they suffered from income maintenance workers. Roberta, for example, remembers

feeling, "We need this money so bad. That's terrible, you know, that's terrible. Okay, I mean, we need it, you know; it's like, you shouldn't treat us like crap because we need it. The same workers that doing that to you can be in the same position a year later."

Health Stressors

Homelessness can exacerbate minor illness in both children and adults. Residential mobility diminishes continuity of medical providers and access to medical records, and also complicates preventive health maintenance, health management, and treatment (Bassuk et al., 1991). When mothers without homes enter into communal shelter living, they often find that this situation leaves their young children, who often are un-immunized, vulnerable to contagious diseases.

At both The Arche and The Lincoln shelters, for instance, upper respiratory and ear infections moved among the families quickly. Several mothers also were alarmed by the high fevers associated with ear infections in their young children, and they were also frequently concerned by gastrointestinal distress, particularly diarrhea and colic, that afflicted their infants. Mothers of six toddlers and preschoolers were constantly concerned about their children's asthma, and three mothers used emergency rooms or inpatient hospital treatment for their own asthma.

Alicia described how asthma affected both her and her 4-year-old son:

> When he has asthma, and I give him a treatment,
> the coughing stops for like about four hours.
> Five! I gotta give the treatment three times a day.
> I'm tired and worried and he always says "Why

do I have to do it?" And he's only four years old. He sits there so quiet, and they're doing their homework, but then after a while he can't hold still. In the clinic today they changed the medicine that they give for asthma; it gets them hyper, and he's hyperactive already. I still don't have Medicaid. So my case is a mess. So right now, what they'll do is, they give me the prescription and they give me this letter. I take it to the pharmacy and they give the medicine. I don't have to pay for it. They'll pay for it. They give me Tylenol, they gave me antibiotic for the kids, they help you out a lot here.

Because the mothers interviewed were living far away from their regular medical providers, when their young children developed high fevers in the evening, the mothers either stood vigil over their infants through the night or took them to emergency rooms, often waiting there into the early morning hours. These events left both the mothers and their children exhausted, causing them to sleep through the day or attempt to function with diminished frustration tolerance. Natalie, for example, while describing the stressful situation she encountered after her infant son developed a high fever, fell asleep several times during the interview, because she was both physically and emotionally exhausted. Her still-restless infant son, however, kept moving about. She described her experience in the hospital as follows:

I was in the emergency room all night. He [her son, three weeks old] had a high fever and I was scared. He was so sick and I was so scared. I thought "Did I do anything wrong?" I was pac-

ing and pacing. I had to go to Brooklyn Hospital and then finally the triage nurse told me it would be three hours before they could see him, so I took him to County Hospital. I was so scared. This Metro Plus plan is a ghetto health plan. I'm scared what will happen now with welfare and Medicaid. Those politicians are greedy and thieves. I was scared and up all night. My son is the most important thing, and I was scared. He was so sick.

Another health stressor on the mothers resulted from their own gynecological and dental problems. As a result of their moving often from home base to EAU to assessment center, and then to transitional housing, they chose to travel long distances to reach familiar providers. For instance, Maria left the apartment twice a week to travel 1½ hours from Brooklyn to northern Manhattan, to her mental health therapist and gynecologist, who treated her for symptoms associated with both depression and menopause. Women who had recently given birth worried about reliable and accessible postnatal care; and pregnant women worried about both the unfamiliar hospitals into which they would be admitted, and what would happen when they gave birth.

Sabina had no income and thus no regular source of food to eat during her pregnancy. "I've lost weight," she said. "I haven't gained weight since I was pregnant [she was in her eighth month]. So I'm really depressed about that also." She went on to explain,

As far as our health goes, when I have this baby, I don't want them to say, "Oh, she's underweight, she has to stay in the hospital," because

the hospital . . .what you know, I watch the news, so that, what goes on in these hospitals . . . you really wouldn't want the child to stay there an extra day without you. So they'll make you leave to give the bed up to somebody else; but they'll keep your baby, and then I don't think there's enough safety system. You know, where people is coming in and out of the hospitals. I don't want to be separated from her after the delivery. I worry about it every night before I go to sleep. I think that what can I do tomorrow that'll help me, you know, gain weight. What can I do tomorrow to make it a better day. Especially with a child, because what happens to you involves the child. Because this is someone that you're responsible for and, you know, you have to be there one-hundred percent. So, you know, you have this person, this little person that's depending on you. And there's so many ways things can go wrong.

For many of the mothers, the physical environment of the shelters added to their stress related to both chronic health conditions and parenting a child with special medical needs. Soliel, for example, didn't want to go back to the "nasty" EAU, so she stayed at The Arche. In an extended narrative, she described the environment and its relationship to stress and the health of herself and her child.

When I came here, when I first came and they told me where my room was, I was like, well where's the elevator! There was, like, there's no elevator; I was like, I'm ready to leave. I'm

pregnant and I have severe asthma attacks. I carry my asthma pump everywhere I go. Especially these stairs. They'll kill you. It's a doozie. These stairs, it's a doozie; and I have to carry all her stuff and my stuff upstairs, and no elevator. And I thought, "Should I sit or go back to that nasty EAU?" Yet, they know I was in the hospital for palpitations. They know that. So when I went to the doctor I told my doctor and he sent a note. They still didn't move me from off the fifth floor, and um, they were supposed to call and talk to the people in the office about moving me to a lowered floor. So now I've been here for three months. I just have to wait. I'm worried about my health. That's why I try not to go up and down the stairs unless I really have to. Usually what I do is if I, um, I'm not going nowhere. I have my book bag full of everything that I need. I have my jug of water in there and everything that I need so I won't have to come back upstairs, till it's time to stay in the evening. I stay downstairs and don't come back upstairs, 'cause these stairs, phew! Outrageous! And then I gotta carry Deja, and, um, my book bag, with all her stuff and her monitor. Then if I take her, she gotta be in the chair [the baby carrier]. It's not light. She weighs nine pounds and twelve ounces.

Privacy, Autonomy and Having a Say

The mothers' reactions to living with shelter rules varied. In part, their differences were related to the reasons they came to the shelter. For instance, women who came to the shelter for safety (e.g., fleeing violence) felt safe, as if they had control. As Charlotte explained:

> People's telling me to get out for years, so I feel it's time, my time to say get out. I couldn't tell him to get outta my mother's house because, you know, it's not mine, so it's not the same. It feels really nice to say it. When I get my apartment, there's lotta people that cannot come in here. They could come only one time to see where I living if I allow them to. Like my family, the first time they're gonna come is probably gonna be Christmas. This year, you know, invite them for Christmas dinner. That's gonna be the first and last one. The father not gonna be welcome.

For several mothers, the shelter was more comfortable than home. As Nodica went on to explain:

> I got comfortable here [at The Arche shelter] because when I come in the door and I lock the door, I don't have to listen to nobody talking to me, when I don't want to be bothered. So the comfort's over here, and I like it here, because I don't have to listen to my mother nagging and none of my brothers or my sister or my father. So it's like I've been comfortable here.

Some of the mothers felt the shelter was a respite from lack of permanency. As Talia said, "I don't feel homeless because I have a key to my door, which is like your own apartment. You have a key to your own door, you have a place to sleep, you have a roof over your head, and you have food in the fridge, and you have running water. And I can stay until I leave for my own apartment."

The women who felt the shelter offered them stability and/or protection from the violence in their lives naturally feared losing their safe havens. As Vanessa explained,

> But it's not having my son here with me, and then I have to make it [curfew] and leave him at 11 o'clock to make it here for 12 o'clock curfew. That already takes a lot out of me, because it's like, to come in is, like, violating my privacy, in a way. I know this is temporary and you must have rules and regulations to follow, but its like, if it's 12 o'clock, and if you call and say you can't make it, you still get a violation; and this leads to one violation and then two and then three and then, after the third one, you get kicked out; but you know, its like you're not breaking the rules or anything like that. But that's what happens, you know, you live in a system.

Many of the mothers also expressed fear of being ejected, either for violating rules or engaging in unacceptable behaviors, such as repetitive, loud arguments or fighting. If ejected they would either have to start shelter processes all over again or, worse, live in the streets. As Rayette said, "If I get thrown out for any reason that I feel like it was unjust, they gonna have to fight me in court. 'Cause number one, I'm not gonna be home-

less in the street with my ten-month-old son. I want them to fight me in court. I wanna know why they threw me out, you know."

Fear of Loss of Custody

While the mothers interviewed said they worried about loss of custody of their children, those who had been in placement expressed worry more often. For them, having their children placed in foster care was tantamount to breaking the vow that they could and would do better for their children. The mothers also were concerned for their own futures if they lost custody, because that would mean they would no longer be eligible for residence in the shelter.

Lucia expressed her concern about losing custody, saying, "I'm not letting my kids go into foster care. Won't ever let my children go into the foster system. Some of them [foster homes] are good and some of them use you, just to take your money. Some do abuse kids, some are very good to kids, but most of them not. I will never let my children go into foster care."

Roseanne simply expressed her fear by saying, "The BCW [Bureau of Child Welfare, which encompasses child protective services] is not playing anymore; they're taking babies from people." Connie took a paradoxical approach.

> When Savannah falls out, I say, "You know what? Go downstairs and sit in front of the male counselor and let them see, you know, and then they can call BCW on me. I'm tired of your falling out when you don't get your way. And tell them what your mom did to you. Tell them I spank the crap out of you. Tell 'em to call BCW,

and when you get there, tell 'em your mommy cleaned your ear piercing with alcohol." Savannah is very dramatic. I tell her, "Your Academy Award is in the mail."

Delila indicated her fear about loss of custody, saying, "I worry that if I can't buy Pampers, they will take my kids away." Vanessa, whose older son had been removed on charges of child abuse, felt the child protective agency had judged her and not acknowledged her motivation or capacity to care for her son. She said:

> CWA [Child Welfare Administration, which encompasses child protective services] see me as a bad child, but I have matured. They don't see the things that I have accomplished with my parenting skills class. I went out and found counseling. When I came here I didn't have to tell them about my son. They just kept making me do more things. I participated in the prevention program and I am very proud of the fact that I completed the parenting classes. They said they would return my son; they kept telling me that my case was closed. Then later they kept telling me that I was gonna get my son back. They never told me that I had to go to court or that I needed to go to another program when I left the shelter.

To prevent loss of custody, the mothers almost always tried to show that they possessed good mothering skills and were concerned about disciplining their children. When they felt their children ignored them, for example, they vowed to teach the youngsters to respect and listen to them. Eartha said, "I expect

them to listen and not do it no more. I know a child is not gonna listen all the time, but I don't want the child to be disrespectful. I will need to be patient, but oh Lord, I am not a patient person."

Milagros worried that Kenny no longer respected what she had to say.

> I wouldn't want my kids growing up here. He's been in the system a year-and-a-half now, and he's picking up things he's not supposed to pick up. [Kenny, in the background said, "You ass."] I don't want to hit him because I been through a lot of that when I was young, so I don't think hitting is going to do anything. So I used to threaten him with hot sauce. He used to be a lot more respectful. Now I feel I've lost control over him.

Self-Esteem, Self-Worth and Stigmatized Status

Each mother was aware of her devalued status in multiple domains of social life. One of the most persistent themes in their narratives, therefore, was that shelter use also reflected loss of social worth. The mothers were aware that their histories differed from more conventional life stories. Although heads of households understood that the use of the shelter system was a either a physical necessity, relational choice, or bridge to autonomy, the mothers were acutely aware that these explanations for shelter use were often seen differently by most other people.

The similes the mothers used to describe the physical location in which they resided reflected a social representation of an institution designed for women to live together who were separated from their family and community. They often described

the shelter in which they lived as either an "institution" or a "prison." For some of the women, such as Roberta, the time in the shelter system was the lowest point in their lives. The mothers' awareness of how many people in the general public devalued families without homes is clearly evident in the following excerpts from their narratives. Sabina said, "People generalize about us, just because we're homeless. We're not stupid. People try to keep you in your place." Connie said, "People think we are stupid. They actually think that we came outta the bottom of the gutter and crawled here, looking for a place to stay. We're homeless. We'll take anything. This place is run like a prison for profit."

Elyse said,

> We have morals and we have standards. We're not something you could throw in a corner somewhere, which is what I think they think. Down to this hair-cutting thing. Recently they had a hair-cutting thing. All the women who went said they didn't treat them well at all. And I wonder does that have to do with why they're homeless? Also working with black women's hair, and you're running a salon for white people with white products.

Rayette voiced similar thoughts when describing her day of looking for an apartment, after she had waited three hours for the rental agent to appear.

> I thought, man, if they treat people like this, you know, I wanna know what they treat their tenants like. I couldn't believe they sent me over there. They made me waste my money, and this apartment look like garbage, really. It looked like

> somebody just moved out, and it was in a sham-
> bles. And I was like, how, why would you show
> me this?

Vanessa reflected on shelter use, and what others had said
to her about shelters.

> I sometimes think it's a mistake, but it's a learn-
> ing experience from that mistake, because with
> my situation of being homeless, people always
> say, "Oh, you come from such a good family,"
> and you know, "How could you go into a shel-
> ter?" It's dirty, it's this, you know, they have
> their own, you know, blindness to a shelter be-
> cause they have their own house, and you know,
> they be like, "Why you?"

Roseanne directly connected the shelter experience to her
self-esteem.

> I suffer with very low self-esteem. Whenever I
> go out I try to gather enough self-confidence,
> you know, to be out there dealing with things.
> Because for a while I was kind of afraid to be
> outside, and I was afraid to be around people.
> Going through the shelter system really made it
> even worser, because to see how people act and
> the things that they do, thinking about it makes
> me so fed up.

Dionne was more willing to accept social expectations, and
struggled humbly to improve, based on such assumptions.

> I'm trying to change, you know. I'm trying to be
> a better person, a better mom. Every day I work
> at it. I'm really trying to become a good person,

and sometimes it's so hard, and people look at you as a person taking taxpayers' money. I'm just living everyday, you know, I try to get, to have pride of, how can I explain it? I try to have some type of respect for myself. I don't want to take from nobody else. I want my own, even if it means working at Burger King or McDonald's.

Stigma Associated with Being Young or Single Parents

Younger mothers spoke about their awareness of the social worth of young, single parents, both indirectly and directly. Roseanne, for example, said:

I tried to register to vote at eighteen [an active assertion of her right to exercise her power as a citizen]. The lady looked at me and was surprised that I was the mother of two children. I do get a lot of discrimination for that. Like when I was in the hospital, I overheard a nurse making nasty remarks about another woman who was under twenty and had two kids. "She did not have the right to have them so young. Did she know who she even slept with?" I was furious and was ready to get out of bed and say something. I decided to ignore it, to prove the point that I was a better woman than to pick a fight. And now I see a lot of what they are saying about the homeless in the papers. It's a lot of discrimination out there.

The mothers interviewed had internalized the stigma associated with early childbearing, and sometimes tried to distance themselves from being identified as very young mothers. They felt that at least they had waited until they were 19 or 20 to bear children. As Jana, 20, said, "I was lucky to have had my son so late. You know what I'm lucky of? That I didn't have him like at 14, 15, 16, 17, or 18. I had my son when I was almost 20. That's what I thank God for. Maybe that's still too young, but it's much better than when them girls had 'em so young, 16, 15, 14, 13, 12. So I guess I'm good."

Soliel and Rayette both expressed the sentiment, "At least I'm not a teenage mother;" and Dionne thought, "If you 12 or 13, you have done had a baby and you done messed up. You done messed up big time."

Marion felt disappointed in herself, and anticipated criticism from her social worker, who had been an important part of her life in the group home, and might otherwise have remained part of her life. She explained,

> I never called my social worker. I wanted to and she gave us her number and she said we could call her anytime. I wanted to. But I have never called her. But then again, I felt like when I got pregnant, I felt bad that I did, because she always say, um, finish school. Go to school and stuff and I felt disappointed. I felt like she was going to be disappointed, too. But I had to realize that she's not like that and stuff. So that's why I actually stopped calling her and stuff because she might say, "You should use protection and don't have a baby now." And it's hard, you know? I felt, really, that she was gonna be disappointed in me. So that why I stopped calling.

Dionne felt that marriage would legitimize her social and spiritual status. She described her own near-marriage as follows:

> We had planned to go down to city hall and get married by Ahmal's birthday. He wanted to do that, so I respected that. Hopefully when we are married things'll ease up for us. My mother also said that God truly respects a person that's married . . . Because the worse thing in the world is to shack up. God respects a marriage, a married bed. Ahmal thinks the same. He wants to be marrying. Before my life was so tangled up and so was his.

For all the mothers, particularly those with older children, the shelter system hurt their own ideals of themselves as good parents and violated their own norms of care and protection.

As Alicia recalled:

> The oldest one [Victor, 6], he's the one that understands more, and he used to cry. He used to, he was telling me that the first day that we got there [EAU], "You lied to me, you told me there was a bed in here. I don't like this Mommy. Why everybody gotta sleep on the floor? Mommy, what happened with our house?" He got me real depressed. I didn't wanna put my kids through that. And I know that affects them. And then they got problems because their father don't wanna come and see them, so all that together. I would . . . I would like to give them the world, but I can't. So what I wanna do is get my apartment, go to school and give them a better life.

'Cause I know there's a lot of things they want, they ask me for, and I can't give them. That hurts me a lot, you know?

Kathleen noticed how her 4-year-old was more withdrawn in the shelter. "At first, I was scared," she said, "and I worried about how it would effect my kids. It's not something I would ever have expected myself to do. The kids were scared and they were worried. The staff scared my son, too, and that affected him."

Both Alicia and Kathleen found ways to recover self-esteem and provide a good enough buffer for both their own stresses and those they understood their children to be experiencing. They understood their own potential both to help their children feel more secure and protect them from excessive fear and devaluation of their own mothering.

Kathleen was sometimes understandably authoritative with her oldest son, Charles, as she felt she must protect him from others who might criticize his behavior. She understood the importance of her presence. As she explained:

But you know, I think it's because I'm with them, you know, definitely [chuckles]. They feel safe and all right. I bring them things from my mother's house that they know and they feel more comfortable. His [younger son] blanket and books for Charles. So it's all right, they kinda handling it. I think kinda well, and I don't know if it's because they little and they know; and, like I said, 'cause I'm with them, you know, just motherly, motherly worry.

Awareness of Racism and Its Impact

Considering that the mothers were women of color, it would not be surprising to learn they had experienced racism in their lives. Although few of them directly linked shelter use with gender or race, 10 of the 24 spoke about their experiences with racism. Connie was, perhaps, the most direct. She related her reply to another resident about a racist remark, saying, "She just looked so shocked at that remark, 'What you acting so black for?'" and I said, "What, you 20 years old and never had no form of racism? Girl, you can't tell me that. Maybe till now, you never paid attention to it. And now at 20, you're shocked that someone would make a remark like that."

Alicia remembered her experience of a racial incident while living in a large Midwestern city near a sister.

> Everything was around where I used to live, but the only thing that, where I used to live, was only white people. And over there they're racists. Forget it. When my neighbor . . . she was forty something years old and she used to talk to me nice and everything until I told her that I was Puerto Rican. When I told her that I was Puerto Rican, she never talked to me again. She didn't want her kids to play with my kids, and I was like, "Oh my God!" Well, I ain't lying about it. I had a birthday party for my son and she called the cops on me 'cause the music was loud and it was Spanish music. It's too different than over here. Everybody here is pretty friendly, but everybody over there looked at you with a face, like where you come from? What are you doing

here? I felt so uncomfortable, and I didn't like it, so I said, I'm going back to New York.

Soliel also had some instructive ideas for workers she did not experience as genuine, saying,

> Um, and I guess what I like most about that particular group home was that all the staff was black. White staff could not really relate to black children. Until y'all have walked in those particular shoes, then y'all will never understand. Nor can you say, uh, "I really sincerely feel. . ." or "I know what you're going through," or "I've been there, I've been there," you know what I'm saying? And we used to hear a lot of that, you know. "Oh I know what you're going through," you know, from the social workers and stuff. But with the black counselors, um, we never had to hide our character, more or less, you know; we was always able to be our self and, uh, and have a honest relationship with some of the staff. We didn't have to hide sexual things.

Rayette explained how she was first introduced to racism, and what it meant to her.

> Until I went to high school in Queens, I seen some kind of all nationalities in that school. Chinese, Asian, Dominican, Puerto Rican. Mixed. Really, wow! It's always been blacks, whites and Puerto Ricans. You know. I think it's a shame that school can't teach about other than Caucasian's history in school. You know, I don't think they should exclude the history of the Dominicans, West Indians, Black, and Hispanic.

Sabina offered her views about the influence of race on her sense of her place in this world, and her personal resistance.

> Well, society plays a big role in my life, because that's what I move around. It's shady sometimes because you have to, you know, bend for certain people, you know, like in here. The rest of my family, I think they are afraid of society. I think that's what it is, I think, they're just afraid to be out there, when you be put down so much by people for being black. And I'm, like, why don't you go on The Million Man March? It should be about what you got achieved, um, what skill you have; It's not gonna be about color. That's what I'll be trying to tell people. I mean this is my world too. They let these top-notch people, you know, sit up there, the white Caucasian guys in these fancy chairs and intimidate the But when I get there, they're not gonna intimidate me. Because, um, I'm gonna have to go after what I am trying to achieve. I mean this is my world too. You know, I have some say-so in this world. And it's all about being educated and knowing what you're talking about in order to get up there.

Natalie remembered her mother's deep suspicion of Caucasians like this:

> Growing up with my mother, she believed that so many things had been done to us by the Caucasian people, that basically she didn't trust them. She doesn't want us to depend on them, you know. As far as her life and our life was

concerned, and the way in which we are living. She didn't want us to be kept in a place where we couldn't progress, you know? She always used to tell us, "Get your education and you will not have to depend on the white people."

Educational Stigma

Although many of the mothers had completed high school and 25 percent had attended college, as a group the women reported a low sense of self-esteem and self-worth because of their educational backgrounds. Those without a high school education, in particular, felt embarrassed by their lack of accomplishment in this area. Although they were only in their early 20s, they thought they were too old to return to school.

Some of the mothers felt fearful about going back to complete their high school education, while at the same time they realized that without the degree, they faced a bleak economic future. Roseanne expressed her thoughts about education this way.

> If I could have stayed with her [her mother], put the children in a day care and then just went back to high school I could have finished. My school was a short walk, a little bus ride. But then I said no, because I think about going back to high school, and I say I couldn't deal with it because of the kids. I would think they would be kinda immature. And basically I'll be in the eleventh grade and they'll look at me [chuckling] like "Ain't you kind a old, you know, to be in the eleventh grade?" But then, after all, maybe they

won't bother me at all because of what I have accomplished at eighteen.

Lucia spoke about the frustration and embarrassment she felt when thinking about going back to school to complete her education. She read at a fourth-grade level, and wished to finish her high-school education and become a guidance counselor for teenagers. She said,

> I noticed it when I went to school. I started going to school not in kindergarten but in first grade. It was because, for me, being bounced around from so many places, being in and outta school, I never had the time to learn. I was hyper when I was a kid. I can't concentrate to this day, and I know there's a problem, but nobody wants to believe me. They just say I don't want to concentrate. I try to concentrate. I'd get F's on my papers. I'd just sit there and do my work. I never understood in school. Only reason I got good grades is that I did extra work. I couldn't pass Regents. Because I don't understand what I read. When I do answer a question, I get it wrong. And I'll be knowing it. I know the test and I still get it wrong. My husband had to sit with me and do my homework when I was in school, when I was pregnant. It makes me feel real stupid; because the kids, since I'm so old [nineteen], they made me seem like, damn, she really is stupid. I was afraid to go to school, too, because I used to stay home, not go to school, 'cause I used to be embarrassed to go to school. I would sit behind the class so I won't have to be asked questions. I

don't think nobody is going to help me. Why waste my time? They won't believe me.

Eartha, who left school in ninth grade, said,

Yeah, you know, I'm thinking like it's gonna be hard for me. And I don't wanna be no dummy, you know. I do wanna go back to school, but I just keep thinking, I don't, I don't know if I wanna go through this, you know? I keep thinking, "Yeah, I'm gonna go to school." 'Cause what am I doing? I'm not doing anything with my life. I'm just sitting here on my butt all day. You know, my life's boring here, it's not, it's not, I mean, it's exciting when I'm with my boyfriend, my new man, my boyfriend. Now, it's exciting, yeah, but it's not everything. I can't be chasing behind him all the time, going to see him. I have to do something's gonna benefit myself and then my future and my life later on in life.

Mediators of Self-Esteem

In this section, I describe 5 major elements that mediated the mothers' self-esteem: (1) the physical environment, (2) relationships with staff, (3) social ties with friends, men, and family, (4) relationships with others in the shelter, and (5) the future and children.

The Physical Environment

Three aspects of the physical environment in the two shelters created somewhat different reactions to shelter living among the

residents. The first was the different arrangement of physical space at the two shelters, including space for interaction and staff offices. The second was the presence or absence of men. The third involved "service delivery," that is, the staff's understanding and perceptions of the residents, and they ways they enacted their role in relationship to the residents.

The fully-equipped apartments of The Lincoln Family Residence afforded families privacy, boundaries, and the ambiance of a home-like niche. At The Lincoln, large room size, adequate storage space, and private kitchens and baths meant that a parent taking responsibility for the care of the apartment and the preparation of meals had control over family life, including the family routine and privacy.

More often than not, the women at The Lincoln felt more positive about their living space than the women at The Arche, and were thus more inclined to make their separate spaces "homey." Maria, for example, had a small plant growing, which had begun from seed; Alicia had pictures displayed in her room, and she and her sister, Wanda, enjoyed strong coffee together each afternoon; Roseanne exhibited pride by taking much care in preparing dinner each night; Dionne was elated by having her own pots and pans for the first time in her life, the result of a gift. She described the night she received her gift, upon her arrival at the shelter.

> That was a hard night when we first got here. Oh man, she [her daughter] yelled and yelled and cried. And me. I was so happy. At first, 'cause they gave us the pots and pans, they gave us sheets, they gave us everything to come in and use an apartment, um, I was like a little child when I first came here. I couldn't believe this was all mine and they were giving it to us. And I

was like, "Do I have to give it back?" They was like, "No."

In contrast, at The Arche the small single rooms and shared common spaces, minimal storage space, and five flights of stairs were sources of complaints and conflicts among the mothers. Shared bathroom, dining, and recreation space at The Arche, in particular, contributed to stress related to privacy and boundaries. These differences affected many aspects of shelter living for the residents.Rayette described her living situation as follows: "My room is a little cramped, but I just try to keep it as neat as possible, you know? But sometimes I can't get around the crib to get what I need and that is a problem; and I can't clean like I used to."

Kenya was sensitive to the slamming doors. "The other women slam the doors to their room at all different times," she said. "What kinda respect is that? My baby's sleeping and the doors are slamming. And it's frustrating."

Elyse, who lived in a cold basement for a time growing up, was frustrated by what she had to go through to regulate room temperature for herself and her child. She said.

> When you bring, I brought it to, um, the director and she tells me, "Oh, we can't do nothing about it." I said, "Oh. So it's okay for me to wake in the morning and be freezing and I have to wash my child up and it's freezing in the room," and stuff like that? She's like, "Well what do you want us to do? It's a wiring problem. It takes money and time." And I like say to myself, "It's easy for you to sit there because you ain't gotta live with it. You can go home to your own bed every night. You know?"

The personal reality of a crowded and less than private daily life, marked by diminished control over their environment, reinforced both the mothers' perception that others held them in low esteem and their own feelings of being stigmatized.

The physical environment of the office space was different at the two shelters. Staff offices at The Arche provided little privacy. The case managers shared office space, so that privacy for meeting with clients was limited, interrupted and often negotiated. At The Lincoln Family Residence, in contrast, a social service suite was located near the building entrance, so that families or individuals could drop in, which they often did. Each case manager and housing specialist had his or her own, personal office space, which ensured both respect for the worker's role and his or her convenience and privacy.

Men. The second factor that distinguished the physical environment of the two shelters was the presence of men at The Lincoln Family Residence. The Arche sheltered only women and children; men were not allowed above the first floor. Women received guests in the front reception area directly in view of the staff office. Sometimes the women entertained their guests on the outside stoop during milder days. Sexual intimacy was relegated to weekends, when the women had overnight passes. Often male companions were also living in crowded conditions, which limited chances for couples to be alone with one another. Sexual needs were never spoken about directly by the staff or the women, as if they were not a part of adult life.

Service Delivery: Staff Roles and Perceptions. The third element that made a difference in the mothers' reactions to shelter living was the degree of understanding the staff had about the needs of families, which informed their theory of help and guided staff interventions. In particular, the staff's empathy towards the women, their judgment about the etiology of home-

lessness, and their reactions to the needs of the women were influential in how individual staff members viewed themselves and the women. The staff's understanding of the underlying causes of homelessness differed at the two shelters, and affected the behaviors and attitudes of the residents. One difference between the workers at the two shelters was in the emphasis they placed on the causal factors relating to homelessness among families. Generally, the staff at The Lincoln believed that the interaction of social, familial, and individual factors lead to homelessness. One director of social services, a graduate social worker at The Lincoln, opined:

> Homelessness is a very complex problem; there are many layers and causes. I think that one cause is a long life of shattered dreams. Having a dream is not part of many of their lives. They have had little inspiration. They got burned out at school, by a second-class education system. They never were inspired there. The shelter may be their chance. The depths of deprivations have robbed them of hopes and left despair—a hole in their moral base.

When I asked the social worker what would address her definition of the problem, she responded,

> It's a difficult problem, calling for solutions at many levels. Certainly, here we could use someone who could work with issues of domestic violence and mental health problems including, of course, substance abuse treatment. A much more thorough program after they leave the shelter is needed. I would like to have therapy available on the premises.

Other workers at The Lincoln recognized the complexity of the situation for mothers without homes, variously emphasizing factors such as housing, education, familial background, and interpersonal relationships. Most workers also included racism and gender oppression as causative factors, and one worker added lead poisoning to the list. One worker made this hopeful statement: "Even though this is temporary, this is their home. Even though a mother is homeless, she can make her children feel safe. Home is where the roof is." For workers at The Arche, on the other hand, a shelter was usually viewed as impermanent, not a place one could call home. "It's a temporary home," one worker said. "I don't think they [residents] should feel too comfortable here, because when they have to leave they get scared."

In general, the case managers at The Arche most often used person-centered explanations to explain homelessness. The Director said, "Homelessness is a symptom of other problems. I now see less substance abuse and more mental health problems among the women." Another worker at The Arche compared the experience of his clients with his own experience: "My wife was in a shelter, she got out in five months. I don't know why they can't."

The general difference in perceptions and understandings of the workers at the two shelters affected the way they performed their role, although the role of workers at both shelters was to support families so they could successfully move into the community. One worker at The Lincoln described some aspects of his role as follows: "When a client moves out, it's a victory. I think adversity with supports helps to build character. My job here is to help families build a foundation for living in the community."

Another worker at The Lincoln spoke about the way she engaged clients: "I recognize their anger when they come in. I

let them speak about it. I help them to counter anger at being abandoned, that they feel less worthy than others, unloved, rejected and sometimes hopeless." Still another worker at The Lincoln said,

> The greatest thing is to enable families to do things on their own. When they come in, they are very angry. They don't want to see you. You get to know the family, respect what they are dealing with and feeling, and then they can work with you. Seeing them move ahead makes me feel real good. When I send them to see a home, they are excited and then I am excited for them.

At The Arche, in contrast, one case manager said, "This is a baby shelter. Anytime I want, I can get a baby fix; no matter how grim things are or how much work there is, I can always go outside and hold a baby." She then added, "When a baby cries for more than three minutes, my ears perk up."

In an attempt to be a good model for her workers, the director of The Arche saw her role as collegial:

> I do everything that my staff does here. I like it that way. There are no absolutely clear boundaries here. No clear roles. We don't put boundaries between the women and us. We really like the women, we try to make women feel more comfortable here, so they will be more open. We provide an experience here. Many are afraid to let others know about their limitations. I think we need a really good GED program with child care.

Social Stigma and Conflict with Staff

Mothers who had been in foster care were particularly sensitive to staff attitudes that reflected devaluation. They fought the stigmatization and the staff retaliated. For Elyse, for instance, being treated civilly—as an adult, with respect—was important, not because she had a different set of needs from the other women, but because she disliked being dismissed, treated as if her needs were less important than those of others.

Elyse recounted her desire to be treated as an adult and to include the value of the "Golden Rule" in her thinking.

> Not to say that I'm a problem person, 'cause I'm not that at all. It's just that I think I'm pretty open-minded; but if you do something to me, I'll close my mind [chuckles], that's just how I am. 'Cause I done been hurt too many times and I don't need to, you know, experience it. Um, I'll give you an example. They tell you when you first come in here, if you need us to help you with the baby and the stroller. And it's hard to take both down the stairs and we understand. But it turns out real different. I had hurt my leg on a nail, and this time I needed help to take the stroller. I came into the office and asked them. And the person in the office [there were five people in the office] said "No!" And I couldn't understand why she having that tone of voice. I came very, you know, um, good, you know, I came in and asked nicely. In my mind, I thought she was joking; and then she says, "I said no!" And I was like, whoa, you know; and then it kind of made me upset. It's not the fact that she didn't

want to do it; it was the way she expressed it over to me, like as if I was a little kid. If I give your respect, I want it back from you; and once that happens, then I'll think it over.

Linsay expressed her upset at how the staff sometimes disrespected her, when talking about donations she received.

Like if they donate stuff and they use it for they taxes or whatever, you can tell the people that do stuff from their hearts. Some people send dirty stuff. Some people send stuff that can't be used, like if, like I got a rain jacket that I seen downstairs, 'cause I didn't have anything to wear if it rains. And it couldn't be used because it had snaps broken. That's pretty insulting. So and then you look at the staff here, and they say "Well, you better be grateful," and, and I'm looking at them like, "You one paycheck away from homeless, and you telling me, I better be grateful?"

Sabina and Elyse did not fully accept such devaluation, questioned the contradictions regarding power differentials and perceived double standards between the staff and residents, and valued doing things "by the book." In the following narrative, Sabina vented her concerns about these matters, defined where she "was" at the time of the interview, and expressed a fantasized scenario of the future in which she is the owner of the shelter.

Well, during the two-and-one-half months that I've been here, I've seen pretty much of the staff, who is very professional about certain things that goes on at the agency. Things are not done like

supposed to be ran. And I think a lot of the rules and regulations are swept under the rug. Because I seen "No Smoking" signs in the building and I see girls smoking. So I went to my counselor and I said, "Why are staff and clients smoking here?" So he goes, "Oh, that's because the director smokes." So, you know, and I said, "That doesn't have nothing to do with how the program is supposed to be ran. 'Cause of the director smokes and she has an office or there's outside. But this is a building where there's pregnant women and young children. I don't think that should be allowed at all," and he said, "Well, the director smokes and so that allows the women to, to follow her footsteps." So I don't really agree with that, and I'll never agree with that. And I say, one day I might be able to buy this building and I'll have it ran differently, and I'll have, um, I'll have the staff checked up on. Anybody just can't work under me, because they'll be representing me.

The staff labeled both Elyse and Sabina "angry" and "uncooperative," because the women were outspoken. One staff member spoke about how staff viewed women such as Sabina and Elyse, who had their "own voice."

Sabina is one of the angriest clients and so is Elyse. Sabina is constantly angry with staff and those at income maintenance. She expressed her anger directly and therefore she don't get what she wants. If you express your anger at the IM [income maintenance] worker, they can keep

money off the budget; although they are not le-
gally supposed to do this, they often do. If she
doesn't make peace with the reality on some
level, it alienates staff from wanting to help.

The staff member went on to compare Sabina with another, less assertive and more "likable" resident, Sally, "who asks for help with many things. Everybody wants to help Sally. She asks for help and she gets it. People don't want to help Sabina; that's why she is having so much difficulty with her welfare case. You want to help Sally, not Sabina, who acts as if staff is lazy."

The mothers interviewed in The Arche more often felt infantilized by and angry with their workers than the mothers interviewed in The Lincoln, Vanessa, for example, said "My worker was just mean. She wouldn't give me a token to get to the doctor; and I met someone else from the shelter who bought me a token to get home when I was pregnant."

Nodica expressed a somewhat balanced view of the staff, even as she expressed her discontent.

Rules and regulations and stuff. Some of them
are, some of the rules are fair and others aren't,
but that's the rules. You know, and they're pay-
ing for you, that's how they feel. You gotta run
underneath our rules and do things as we say,
you know. And I'm not saying that's totally
wrong, but you know, you should consider that
we are adults and we do have our own lives. But
that's not according to um, what you would
probably call shelter life.

Natalie also expressed her feelings about her sense of powerless, how it felt to have no control over others. She said,

I have to wait on somebody else, and the way they go about it is, it like you're unimportant. It's like, yeah, this is a person, she's in the shelter, you know, or whatever. She got time to kill; that's not right with me. I don't have time to kill. I want to get on with my life. This is just what I see as a transitional state. You know, to get me back to where I need to go. But they are taking a very long time. And you can stay on their back and they will still take a long time to do things. And, um, then there's the side tricks, which are when you wait this long, you know, just to get the paper work done. You gotta go through all this stuff to try to get an apartment, like that, and they give you hell and make you wait again.

Personal Ties

Mothers who maintained ties with their families or friends felt they had entered the shelter system with the support of others, i.e., they felt they could speak to and be understood by important others, and thus they were more at ease in developing relationships with other women in the shelter. Roberta, for example, was able to sustain her close ties with both parents, and found that she could buffer the egregious conditions at the EAU by finding other women with whom to pass the time; and Marion and Delila, who had instrumental and emotional support from boyfriends and husbands, as well as service providers, were able to weather the rigors of the EAU and eventually quickly move on to their own apartments.

Mothers who maintained their support systems also could both acknowledge their need for others and sustain relationships

in which they had to consider the interests of others, while negotiating a way to meet their own needs. In other words, these women could accept and express the relational aspects of themselves. They also believed in their own efficacy, and felt they had the internal resources to give to others. These beliefs, and the actions that followed from them, were less related to whether or not the women had been in care than to the trauma they had experienced and the degree to which the trauma was subsequently addressed.

More often the mothers who had not been in placement maintained ties with their families and friends. They felt they could escape to family or friends on weekends, and thus manage to get away from the regimentation of daily life in the shelter, with its interpersonal hassles. Some of the women, e.g., Roberta, Kathleen, and Soliel, were also able to rely on their families to spell them from solo parenting.

Roberta described the difference she perceived between her life at the shelter and at her mother's home. As for the shelter, she said, "Like over here, just me and him, and the girls here, and then, you know, the gossip in the lounge; and there's been too many problems down there. I stay away from there; just a lotta 'he say, she say' going on." In contrast to her life in the shelter, where Roberta experienced her relationships as precarious, she said her mother's home was a place where she felt safe connections to people.

> Even though there's always a lot of people at my mother's house, it's still the place I'll always be welcome, no matter how many people's there. So now I wanna come find a home for me, so my mother can get away from everything, come relax. If she wanna go in a room, lay down, you know, come and have supper, come and talk to

me, come see Donald. 'Cause like I said, she was always helping me with my son. She needs a break, too. So I'm going to do it like that.

Roberta also explained how Phil, the father of their child, Donald, was an active part of her support system, and therefore very important to her. Roberta went to great lengths to involve Phil in Donald's care, and her comments are replete with observations about the mutual pleasure father and son took in one another's company.

He [Phil] wanted a child for a long time but wasn't ready, 'cause he wanted to make sure he was gonna be there and do the right thing for this child. So when Donald came along, he was ready and making sure of that. When I first came home from the hospital, you know, he stood in that kitchen with me and he learned everything from scratch. I didn't even have to bring, call him in. I came home [from the hospital], he said, "Okay, you getting ready to make the milk. Show me how to make the milk."

The mothers who had been in placement were more likely to have had multiple moves throughout their lives. They lost, never had, or severed connections with their family, community, or both. Thus, they had fewer housing choices to avoid shelter use, and they had fewer chances for respite from the daily life of the shelter. As Sabina said, "I didn't have anyone to back me up a hundred percent, so it was difficult to do. I don't want to leave important people in my life behind. My extended family didn't help when they should have."

When I interviewed Lucia, she described her feelings of abandonment and defensive withdrawal from personal relationships as follows:

> He [her husband] makes me jealous 'cause his mother's still in his life. His mother calls, he speaks to his mother, he speaks to his family, and I don't have nobody to speak to. I don't speak to my father, I don't speak to my brothers, and he has so much attention from his mother, his mother is there for him. His mother supports him. My father don't even support us. I don't have friends. If friends were around, I guess I wouldn't be here. When I move, I don't want no visitors. Nobody. Nobody couldn't ask me for nothing. I'm only saying that since I was homeless, nobody gave me nothing.

Interpersonal Coping

If the mothers could not control many of the external stressors in their lives, they could choose to enter into or avoid relationships with others. The way they perceived the value of others and chose to negotiate relationships with them could thus mediate self-esteem. In part, relationships were shaped by the difference in shelter populations and living arrangements. The residents at The Arche, for example, were living only with their children and no other adults, while three mothers at The Lincoln Family Residence were living with the fathers of their children, one was living with a granddaughter, and Alicia's sister, Wanda, was living at The Lincoln with her husband and two young children.

Within both shelters, while some of the ways the women managed interpersonal relationships could be traced to differences in both the physical arrangement and populations of the shelters, other ways were associated with the women's earlier interpersonal experiences and resources available for developing personal ties.

In general, the more the mothers had experienced positive relationships in the past, the better they were able to negotiate relationships in the present. This process may be seen in the testimonies of Marion and Roberta. As Marion said, "When I was at the EAU I got comfortable. I brought my backpack and Kareem would bring us clean clothing and food every day. I got to know other people. We had a card game. People would look out for my things and I would look out for theirs. I kept in my little corner and felt sort of safe."

Roberta explained,

> The EAU, it was terrible when I first walked in there. I was scared to death; I said, "Oh my God, it cannot be this bad" [chuckles]. And I went in the corner. The only thing that was okay was when you met a couple of girls and you talking to people, conversating. Everybody seems to have the same problem you have, and so you don't feel as bad as you should, you know. And you hear these problems is worse than yours. And you hear these problems. At least I have a relationship with my mother. Most of these girls couldn't even go home to their mother.

The mothers at The Arche spoke about friendships they developed there. Sabina and Kathleen, for example, developed a close relationship. Sabina often cared for Kathleen's two chil-

dren during the day, allowing Sabina to fill her time while waiting to deliver her child and providing Kathleen with relief from looking after her two active sons, both of whom became quite attached to Sabina. As Kathleen was departing for permanent housing, she gave Sabina some of her prized possessions to use during her remaining stay in the shelter. She said of her relationship with Sabina, "Me and Sabina stick together and she is my only real friend here. We get along. She knows what she wants to do and I know what I want to do."

Some mothers formed alliances based on similar ethnic backgrounds. Women who had recently emigrated from the Caribbean Islands, such as Vanessa and Talia, for example, formed an alliance and spent time together. Vanessa moved into permanent housing and left the shelter just as Talia had become certified for housing. Talia missed her friend and became more isolated as well as suspicious that staff had delayed her housing application because of negative feelings about immigrants.

Milagros had severed ties with her family, and did not know the whereabouts of her closest sibling, Andrew. In the following excerpt, she first speaks of the gossip she encountered (of which her son was often the subject), and then how her alliances with friends buffered the hurt she felt from the hearsay.

> Everybody here gossips. I don't see no meaning to it, but they gossip. I don't say everybody, but a lot of people do it. People here do gossip, they talk about people, then they're nice to them. So I don't get it. But hey, that's their way of doing it. I'm close to a couple [of girls]. There's like two girls that I'm very close to. We hang out, we do everything together. The girl across the hall, we conversate. We're good friends and, you know, there's only three people I let come in here. Her,

and the two girls I was talking about, because we're all like good friends. But with everybody else, it's like a hi-bye thing. "How you doing?" And this and this and that. Just a little conversating thing. You know, they [staff] say, "Don't share your problems with nobody," but whenever I have problems or they have a problem, we go to one another, so it's a pretty good relationship.

Unexpected alliances also developed among the mothers. Connie, for example, a flamboyant resident of The Arche, had been the victim of a knife assault by another resident, which left lasting scars. She spoke of the assault, and yet sometimes she saw physical struggle as a preferred way to resolve conflict. She provoked and denigrated other residents—often hurting their pride—creating a wide gulf between herself and her victims. Nevertheless, Connie had one close shelter friend, Raquel, whose honesty she had tested by leaving money in her room while Raquel was there alone. Raquel's honesty soldered Connie's trust. As Connie said, "I don't trust too many people. I learned to trust Raquel. Other than that, I don't trust nobody. To me, everybody I tried to trust, it's like they did something wrong in my book, so I just left 'em alone, and when I move, they won't know where I move."

Spousal Relationships

For some of the mothers interviewed, relationships with their spouses were reassuring to their self-esteem. Roseanne, for example, felt important to David, but was also quite concerned that he would relapse and begin abusing drugs if he became too anxious or discouraged; therefore, she felt she must stay with

him. As she described the effect of that helping behavior on her sense of self:

> I'm glad my husband doesn't start trouble with others. I'm glad my husband is like that. 'Cause most guys, they look for trouble. I know him so well. I know what he's gonna say before he says it, and that's what I like about him, you know? 'Cause he, anyway, he's real simple and easy to figure out. But it's like, somehow, in a way, you know, like I said, I'm a very strong believer in God, and in a way I felt like it was meant for me to help him because he didn't have nobody there, you know? He don't, especially after his mother died.

Dionne felt encouraged by Ahmal, who helped her during a "down" time. "When I came there" [the Job Corps], she said, "I was a bum [chuckles]. And he [Ahmal] took me shopping. He helped me, you know, to get my self-esteem back together when I was up there. So, you know, that's why I guess I'm with him so long and I don't mind having his children, but I wanna be married, you know? He gave me encouragement. And he still does." She went on to describe a boat ride the two of them took, which was sponsored by the shelter. "At first I was worried," she said, "because we had never left the kids without one of us for so long. But we had such a great time. We laughed and we danced and I can't remember the last time that we did that."

Lucia took pride in the longevity of her marriage to Salvadoro.

> I don't know why I picked Salvadoro. He was a bum. He didn't have nothing, so I guess it was meant to be. I always went out with people that

had money, but it was like we were meant to be. When we saw each other, and we asked each other to marry each other, people didn't think it would last. I was too young. We been together almost two years. I think that's long enough for me, 'cause I never have been with somebody that long. He been with people that long, but not me. It's a long-lasting relationship.

Intimidation, Comparisons and Gossip

Some mothers used fighting or the threat of force to make their point and feel powerful. Rayette, for example, indicated this approach in her narrative, saying, "I can handle talk, but hit me or dare to touch my son. Gonna be a real problem, He can't defend hisself. So I'm gonna have to defend him."

Connie said, "My rules are, if you fuck with me, I'm gonna hurt you, point blank, I'm gonna hurt you mentally, physically, emotionally, or as the counselor says, spiritually. Leave me the hell alone. For one, I'm too old to be playing with these little girls. If they got an argument, let them go outside and duke it out." Connie also bolstered her self-esteem by "put downs." For instance, she stated, "I'm like Ray Charles, when somebody asks me something sometimes, I say, uh huh, uh huh."

Many mothers interviewed compared themselves with others in the shelter. Through this strategy, they were able to mitigate the full effect of perceiving themselves as part of a demeaned group. Linsay, for example, described how she both legitimized her need for the shelter, and thus her social worth, and at the same time agreed with beliefs that women without homes were taking advantage of the system.

Sometimes I think that because some people in here don't have to be here, and they let it be known sometimes. "Oh, I got this, I got that, I don't have to stay here." So then other people think they're not really homeless, they just want to get somewhere. But they make it hard for people that really need it, like me. I don't have a choice. It's either this or back on out on the streets, you know?

Sabina salvaged a sense of self with an altruistic stance. She wished to guide others, even though she often distanced herself from others and perceived herself as an "outsider." She said,

I'm not supposed to be here. I'm the type of person that, I'm supposed to be helping people in a situation like this, you know? Come into visit different shelters, talking to different women about things, about how precious life is and how they should not take one day for granted. I'm the kind of person that would help someone out in a bad situation. I would help somebody in this situation not be helpless.

It is possible to understand many of the women's coping strategies within the shelter, such as gossip, "put-downs," and comparison, as efforts to mediate self-esteem and regulate self-castigation. Soliel's reaction to gossip provides an example of a philosophical approach to coping with this verbal behavior, which was shared by many mothers.

Every place where there's a lotta women, there's gonna be some gossip, even though this is a shelter or a residence. There's some women that

have more than others, you know, because after all, you don't know what predicament they were in. You don't know. But like whenever there's a lotta women, there's always gonna be like, she's this or that, and he say and she say. This is the way it goes. Stuff like that. I suppose men gossip sometimes. So it doesn't matter where you at, you just try to stay out of it, you know, and I don't go by what everybody say, but it still gets on my nerves. I feel like this. They should come to you and ask you if they don't know.

Distancing and Isolation

For some mothers with a limited history of protection from physical and verbal abuse, who suffered constant damage from the abuse of important others, isolation was an alternative coping mechanism. Charlotte, for instance, the victim of sexual abuse and familial relationships that disallowed any form of support, spoke about her isolation.

> I have low self-esteem. Very low self-esteem. I never thought people would like me for what I am. I used to always figure, you know, if there was somebody who like you, you gotta go to bed with them. Me and Linsay, we used to sit and watch TV. We were associated, and as we were watching TV, we had conversations and got close. But after we had a disagreement over the Walkman, she stopped speaking to me. Now the others see me downstairs and they talking to me. But I know that they're talking about me. And I'm telling myself if they don't like me, why do

they talk to me. I know they talk about me when I'm not there, and I'm telling myself, "If you don't like me, why are you in my face?" And that goes on here every day. That's an ongoing thing. That's how come I stay in my room, because I'm always so, so . . . don't talk to nobody no more. I'm just here in my room with Whitney [her infant daughter]. I stay away from the other women now.

Talia explained her reason for isolation this way. "I get upset with the gossip. I do have one friend here. So mostly I stay to myself, watch TV, do her laundry, pretty much play with my baby. Sometimes I go to Queens or something like that."

Eartha described her life, marked by much isolation.

No, I don't have any friends. I don't have nobody else. I have nobody else. I don't want to be bothered with nobody else, except Sidney. I don't have any associates here and I don't have anybody else I can talk to. I spend time in my room or I go to Queens on the weekend to see Sidney and his family. I don't have any friends or any associates either. Maybe I could talk to my aunt in Virginia. Oh, she's in Kentucky. I think, "No I don't have nobody."

Elyse wrestles with her isolation, saying,

I just wish that the atmosphere here was a bit more pleasant, like people wouldn't get in your business. I don't care, you know. I wouldn't care so much if you gossip, but stay out my business. Don't say the wrong things to them. Don't say what you feel 'cause, you know, you're not spar-

ing other people's feelings. I was noticing last night I stand out. I was looking at my son last night and, you know, we went to this group session downstairs to do a hair thing, right? And I went into the room to look at my son. Right? And Oliver is way over on the other side with the other kids. He didn't pay any attention to all the other little babies. And I said "Guess who that reminds me of? Me!" I'm always the one outside the crowd. I'm the one outside doing my own little thing. No, I don't mind, but I do mind in a sense, because it's lonely; it doesn't leave you a lot of friends or conversating with people. Sometimes I think my son is a lot like me, 'cause remember, I am his parent and he copies off of what I do. So he might get an insight from me.

Children Mediate Self-Esteem

Even though the mothers interviewed agreed that being a single parent without a permanent home for their family diminished their social worth, most felt that becoming a mother, parenting, or both was a most stable source of self-esteem. In particular, the women perceived themselves as actively shaping the early years of their children's lives, and that living temporarily in a shelter was part of this goal.

Children were a central part of the mothers' internal world and day-to-day life in the shelter. In general, children were a source of hope and companionship, and many mothers wanted to make an emotional investment in the growth of not only their children, but also in their own maturation. Roberta, Delila, and

Natalie considered their children to be "miracles." As Roberta explained the "miracle" of motherhood:

> Oh my gosh, it was a miracle that I had a baby [because of health problems]. They [friends] were, like, I can't believe it. But that's the one thing I was really happy of. He's my heart. You know, I'll just sit up there and have a conversation with him, you know. Sometimes I think he knows what I'm talking about. I'll just sit up there and have a conversation with him.

Nodica expressed the same sentiment, saying, "I always wanted a little girl, and so God blessed me with a little girl. After all the things I been through, it seems like a miracle." For Jana, her son "is the best thing that ever happened to me; he was my birthday present." Natalie said,

> When I found out that I was pregnant, I was happy and told the father. He said, "For real?" All I wanted to do was to have my baby. It seemed like I was pregnant for a year. There were no problem in pregnancy. My mother was upset 'cause I was in college. I saw my friends having kids, so it wasn't . . . I wasn't trying to get pregnant. I never told my friends. I continued in school till the end of the semester. Now I can't do the things I used to do before the baby was born. I could go out anytime I wanted to.

Children were a source of self-esteem for these mothers, in that they confirmed they were worthwhile women. Dionne said:

> That's my children. That's the one thing I did give the world—not the world, nature. I always

heard that it takes a special woman to give a man a pair like that, you know. That's when you know you're really ready for that; that a man and a woman really belongs together. It's a lot, I don't know if it's a myth or whatever. But they say . . . 'cause a pair, a boy and a girl, that's everybody's dream.

For other women, motherhood meant "womanliness." As Sabina said, "I'm going to love this child extremely; and I'm gonna thank God that I'm able to create, you know, another human being. Um, because, a lot of women is not that fortunate, you know, so this was a gift to me, and I think that really everything happens for a reason."

Delila explained motherhood and womanliness this way:

I expected myself to be single my whole life and I didn't want any men in my life. I didn't want children. I just wanted to be single and rich. No children, nobody, no responsibilities. I thought I was invincible. It was weird, because I wasn't too delicate that way. For a while, I was questioning myself as a woman. 'Cause I was always a tomboy and I guess that's why in my mind I wanted to have kids. It made me feel good and womanly when my kids were born, to see something come out of me. A little part of me.

Undermining Parental Authority And Identity

On the one hand, the children were a source of hope and pride to the women and supported their motivation to persevere; on

the other hand, children were a source of worry. Parenting exposes flaws and thus can be a threat to self-esteem (Benedict, 1959). In the shelter milieu, behavior of family members is often public and open to scrutiny. Shelter environments are places with unsure boundaries in regard to privacy. Often in shelter environments, temporal order is external, and continuity of family patterns that orient time and space are controlled by others. With the disruption of family rhythms and routines, and with few belongings to mark continuity, the mothers interviewed needed to infuse stability and control, to help their children trust in their physical and social worlds.

Because poor women of color disproportionately use social services, their parenting capacities are observable by social service providers. As a result, the providers' expectations of "good enough" parenting for them are higher than for more privileged mothers (Cowal et al., 2002; Friedman, 2000).

Mothers in shelters worried that living in close quarters with strangers exposed both their children and themselves to harsh language and behavior that was different from their own expectations. They felt they had a limited say in creating barriers to such stimuli. The women were acutely aware that others could censure both their child-rearing practices and their children. Such rebuke was taken very personally, and the women responded contentiously.

Kathleen expressed this problem, with regard to mealtimes, saying, "All the time when we go down to eat, women are always commenting on how your kid dresses and what you are feeding them." Jana said, with regard to the privacy issue:

> Now this recently happened. I'm downstairs [in the dining room] minding my business, and I get up to walk out the room, and I hear somebody talking about me and my son. How I don't feed

> him, and he's starving and I should feed him,
> and why I come downstairs and put him in the
> high chair and don't feed him. And I'm like, why
> do people just sit around and think they know
> what's going on?

Furthermore, the mothers often had to hear judgmental statements from the staff, based on the latter's person-centered explanations of homelessness. For instance, one Arche shelter worker said, "I think that these women are a product of the care-free sixties generation, who believed in sexual freedom. Having children was something to do." Some workers understood, on the other hand, that "a lot of the women hadn't been nurtured or had the opportunity to hope for better." Other workers assumed the shelter mothers were less than adequate with regard to their child rearing practices and knowledge of the "mothering science."

Still other staff members connected poor child-rearing practices, adult social problems, and assumptions about child protection (which de-emphasized the importance of the child's connection with his or her primary caretaker). They believed it was in the families' best interests to offer advice. To the shelter mothers, however, the "advice" felt, at best, irrelevant or self-interested, and at worst, it seemed like a threat.

Kathleen, for example, felt undermined by staff norms. She recalled, "When Charles [her 4-year-old son] heard the program director threaten that mothers would get into trouble for letting their children cry too long, he told me. And then the staff always says to kids, 'Behave your mother or I will call the cops.' It scares them and gives the kids a lot of power."

Connie expressed a similar sentiment in recounting a situation that involved Savannah, her 8-year-old daughter.

I have no control here. I have no control. And Savannah know it too. She didn't get to be a pain in my ass till we moved here, and the counselor be killing me with this, um, "You need to spend more time with her." And I say, "Okay, count from 4 p.m. to 9 a.m." And then my counselor said, "You should be more hugging and kissing with her." I'm not a hugging and kissing person. Then, the other day I was carrying Marguax [her infant daughter] in from the outside. And a male counselor was, like, "Why are your carrying that baby that way? You show the baby no love." They tell me that I have to hug Savannah when I pick her up from school. It's corny, mad corny, and she would know that too.

Elyse recalled how she stood her ground when a staff member called her own efforts and competence into question.

He [Oliver] had a bad case of gas, okay. And it was just something that I had to deal with, and they didn't know how to deal with it or take it for what it was. Um, as a result they get on my nerves. And I didn't like that. I didn't like it because, its enough I was dealing with, trying to figure out in my mind, "What can I do to soothe him? What can I do here? What can I do there?" And then, to top it off, they comin' on my shoulder. Ahhh, "You need to get the baby to the doctor, there's something seriously wrong with him. Babies don't do that." And I'm like, would you get out of my face?

Cognitive Coping: Making Sense Of Adversity

Inherently, the presently recalled life story can reframe the present, manage past and present adversity, and support realizing personal goals; it can also justify self-defeating standpoint. An important way mothers interviewed made meaning in their narratives was by trying to make sense of their firsthand knowledge. Many of them often repeated the conviction that troubles create challenges and then growth. Seeing their troubles as part of a reality with which they had to cope was useful to them in various ways: gaining perspective, pride, and distance from self-depreciation. Looking at both their relationships with others and the social forces that had dominated their lives as personal challenges served to reduce their burden of lifelong devaluation and loss.

Several themes in their story plots were patent. Taking a longer view helped mothers who had experienced fewer disruptions and could remember previous challenges and successes. Maria said, "When I came to New York, I didn't speak English, but I got my GED and I learned English. Everybody was proud of me. I worked hard. Now after I get out of here, I am going back to a community college to finish my degree. Some things come easy, some things come hard. I like to finish what I start, and I will."

Roberta illustrated the benefit of taking a longer view, saying,

> 'Cause you have to go through bad things before good things happen to you. You usually take a step back before you take a step forward. And you figure, uh, this stuff happened, it can't happen to me again [chuckles]. And once you've

> learned from it, you get stronger and you know what not to do and what to keep doing so you won't get back in the situation. Get something out of everything you do.

In contrast to women who could optimistically take the longer view, those who had been in care, and for whom disruptions had become a norm, lent a pessimistic caste to their narratives. For some, recognizing a lifetime of disruptions and troubles added up, at best, to realistic pessimism and, at worst, to helplessness. For women who had experienced multiple disruptions in regard to place and interpersonal relationships, narrative was a natural way for them to find perspective on the cumulative adversity they had faced.

Acknowledging a lifetime of stress provided them with a way to look at coming into the shelter, their relationships with others, and the social forces that had dominated their lives as an adaptive challenge. Both viewpoints lent complexity, courage, and realism to their narratives.

On the one hand, Elyse felt pride in overcoming poverty, as evidenced in the following narrative.

> Money was one less obstacle to jump in the way. 'Cause as the obstacles came in, it started getting more concentrated, meaning that one problem piled up to the next, to the next, to the next, like what I go through here. Like I don't only have just one thing to think about, getting outta here; I have other things to think about, like school, storage and other little things that pop up. Now I think of myself as being poor, you know? I've reviewed this in my own mind. If I wanted to, if I had to be rich, would I be happy? I don't think

so, cause, just like, I've also reviewed in my mind, if you did not have, say . . . if you had some problems, but not a lotta problems in you life, would your life be better than having no problems at all? The answer to my question is "no," because through problems is how you grow, and how you learn to deal with things. Without it, you come to a standstill and, you know, you . . . how can I say this? You kinda get stumped; probably wouldn't know how to deal with time, because you know, you haven't been in the kinda atmosphere for dealing with problems. And it is how I think some kids grow up that be like dependent on their parent, until they're thirty and stuff like that. They don't ever learn.

On the other hand, Elyse acknowledged her sense of futility.

Well, I feel like I'm on my own, but I feel more like every time I try to get on the right track, something jumps in to push me off the track, you know, more or less than anything else. Um, I try to think through things to see what possibly could happen, but the impossible happens. It's not impossible, but what I don't expect, right, happens? And I'm like, huh? And it not something that I can always just clean up real quick. It's always something that's a long process, and like, okay. I've feel like I've been doing my half, it's just like little things been jumping in. I've been trying to go up the stepladder, you know,

and things jump in and push me down. It just
pushed me back further and further. I'm trying to
get over one heap and little things with that heap
is getting in the way to stop me from getting to
the next heap. And it's a nightmare. I wonder
when I will wake up.

Marion described the genesis of her effective but some-
times inflexible "solo act" as follows:

Trouble makes you strong. When I was coming
up in the group home, I actually taught myself,
that just, you know, you're by yourself, and you
have to be strong by yourself. No one's going to
help you but you. And when you break down,
there is no one else. You don't wanna depend on
anyone. You don't wanna think there is someone
there to pick up the pieces because it's so much
easier to fall apart. So you have to be strong and
tell yourself this; and that's what keeps me go-
ing. I am a strong person. I can do it.

Connie's plant analogy captures a complex blend of opti-
mism and pessimism to make sense of her situation, as when
she said,

So that's the story. Always something good will
come outta shit. Believe it or not. Like a plant, I
look at it this way: With a plant, put fertilizer on,
and that's some terrible stuff, but look at the
plant you got, you understand? And that's how I
look at my situation all my life and now. This is
pure shit to me.

For Soliel, adversity promotes confidence.

All these troubles and moving around so much will help me better understand my daughter—when problems occur in different situations—how to handle it and stuff, from living with different people. I think each time you go through something or the same thing more than once, if a situation like that occurs again, I know how to handle it, and I am more outspoken about it than when I was younger.

Dionne, too, struggled to make sense of adversity, saying,

People who had it easy won't be able to survive when bad times creeps upon them. They wouldn't know how. They'll drown. I used to have everything and maybe God doesn't want it to go to my head. Always to remember where I came from. Look, I remember when I used to be in the shelters. I remember when I didn't have any food.

Spiritual Beliefs and Adversity

Some of the mothers turned to religious beliefs to help make sense of adversity. Spiritual beliefs and traditional religious practice provided a potent set of buffers to help these women cope with both the experience of shelter living and lifelong distress. Of the 24 mothers I interviewed, 15 spontaneously spoke about the ways their religious beliefs had provided both an explanation for their adversity and helped them avoid an even more terrible fate, by playing a part in influencing their actions that led them to the shelter.

The women who remained with their families and incorporated family traditions were the most likely to use religious practices in specific situations, rather than in general, to explain what had happened to them. Bibles or religious symbols from their own traditions often lay beside their children's cribs. Vanessa, for example, relied for comfort on the Bible, as her religious education provided a range of apt readings. "When I have problems," she said, "I read Proverbs, the Twenty-third Psalm when I am scared, and the Song of Solomon to gain wisdom."

The mothers who had the most disruption in their lives, the least experience with safe-keeping patterns of secure attachment, and the least connection to place and persons were most apt to put their faith in a protective higher power, to help them explain what logic could not. Believing that "someone" was with them, watching over them, guiding their actions, helped some of the mothers contend with fear and aloneness. They believed that a caring, available, and reliable God would help when no one else would. In essence, their faith held that God provides meaning, concern and forgiveness. As Dionne expressed these beliefs that helped her cope:

> God really watched over me and, I think, I don't know, everything happens to a person for certain reason. Some things that help make me a strong person. I think it was determination and my belief in God. It's something that I could hold onto; I needed. Belief in God was one of the main things that helped me. Because, if it wasn't for Him and His love and care, I could be dead anywhere.

Lucia believed that faith overcomes anxiety and her prayers bring fiscal miracles:

> We pray every night, and we just have faith the Lord, you know, because when we don't have food, outta nowhere we get money, outta no apparent reason. Outta no apparent reason, when we don't have food, my husband goes out there and gets money. He makes money off the streets, he'll, if he has to pick up cans just to support us. When we don't have food, for no apparent reason, my husband will find money on the streets and we'll get food; and we thank the Lord for that. For, you know, providing food and you know, I have faith in the Lord.

.Eartha expressed how her religious beliefs help her cope with lifelong patterns of unstable and exploiting relationships:

> God knows my future. I thank God that I have a chance to make my life better. I can't depend on a man; men come and go. Once he's gone, God will always be there for me. He will be there for me and that is who I am going to depend on for the rest of my life. He is my Father. He loves me. Nobody can ever change His feelings. I know that God will always love me with all his heart.

Roseanne also described how her spiritual beliefs enabled her to cope with adversity:

> I prayed so many times. I didn't know what to do [to help David get substance abuse treatment]; and that day I had to go see my social worker [at the shelter]. And she asked us, I am a very strong

believer in God, you know? And when she asked us if there was any history of substance abuse in the family or anyone on drugs now, I looked at my husband, and he said, "I'm on drugs right now. Is there some way you can help me?" So the same day he went to detox. Now it's getting better and better and better. Even though it's stressful, but it's not as stressful as being in all the other places where nobody, it seemed, like nobody would help, you know? God and my social worker set us on the right track.

Religious belief also provided the mothers with a structure for moral decision-making and behavior. Religious belief helped them to establish a personal meaning system and to help support societal standards of behavior that, to some degree, were a part of becoming both an adult and a mother. Although Eartha had not yet felt ready, when interviewed, to join a substance abuse treatment program to address her addiction, and shame about her past actions, her religious beliefs gave her great strength and guidance. In addition, reading the Bible helped her practice rudimentary reading skills, ameliorate the dread of returning to drug use to soothe her fears, and develop a way to nourish new behavioral standards consonant with being a parent.

The following extended passage from Eartha's interview well describes the connection between thinking, feeling, and acting that is tantamount to self-soothing as well as self-forgiveness.

Yes, because the baby is moving around all crazy, and if I'm upset, the baby must be all upset, so I have to stop doing that [being upset].

Distract myself and stop worrying. By my having these worries, I'm not going to let it set me back and start doing the wrong things; that's something I refuse to do. But the other day, I got a serious craving to go and get high. The day we had the interview, I was sitting there thinking, actually conniving, 'cause the next day I get my check. Actually thinking, what am I going to do? I caught myself. I started thinking about my baby and the promise that I made myself and what it done for me. I got up and did something to distract my mind. I read my Bible. That's what I did and, distancing my mind, the feelings went away. The thought went away, the evil. That's what it did. But actually I was conniving. I'm going to do this and I'm going to do that. I caught myself and I said, "What are you doing? Do you realize what it's [crack, cocaine] done to you? What it's taken away? What it's made your life?" And I think of all these things, and I read the Bible and it all went away. I felt it going away and it felt so good. This was actually conniving, actually planning to go and do these things, and then I go and want more and more and more and more. So I'm glad I caught myself when I did. I haven't thought about it since then. So I will read my Bible book every day from now on.

For Lucia, too, the Bible and religious morals provided a behavioral structure that helped her to control her impulses and allay her anxiety. Reading the Bible improved her literacy, and the Ten Commandments furnished her with values that she

could integrate into her everyday life. As Lucia described religion's role in her life:

> I never knew what religion all about until I met my husband. He was the one who told me all the sins and not the sins. I don't know nothing about that. It made me better, you know? I used to bounce around from guy to guy. I used to just leave 'em, that's how I used to be. Now with my husband, this is where the "doing unto others." I don't cheat on him. I don't think twice. I don't wanna go to Hell, that's why. I feel that if I cheat on him, I'll sin, because I'm married. That's a sin. It's in the Bible. You read it in the Bible, and giving to children first.

Shelter Living and Dissonance

The interviews revealed both similarities and differences in the mothers' adaptations to shelter. Those who sought shelter for safety felt as if they had more control over place and person than they had when living either in the street or with potential violence. Very mobile women who had never had the chance for a stable environment, in which they could consider what they needed, were relieved by the chance to ask for help.

Though the mothers perceived that shelter use was a rational choice on their part, given the alternatives, their self-esteem was eroded by the cognitive dissonance described by Breakwell (1980) between, on the one hand, their subjective evaluation of themselves—as competent parents and people with a measure of expertise and knowledge about life tasks—and on the other hand, the negative representation of their character as needy, immature, shelter residents. Such dis-

sonance underscores how generalized use of normative, cultur-
ally constructed definitions can lead to feelings of personal fail-
ure: for the women to use the transitional shelter, they had to
declare themselves dependent and alone—and they had to do
that at a time when a normative, developmental schema held by
society expected individuals to move toward self-sufficiency
and committed adult relationships (Ashford, Lecroy, & Lortie,
1997; Saleebey, 2001).

The dissonance between the mothers' self-descriptions as
competent mistresses of adversity who chose shelter as a *tempo-
rary* situation that would lead to independence often clashed
with service providers' representations of them as persons who
would *always* remain "dependent," that is, if they were not
"motivated" and "changed." The women re-experienced present
denigration as a reflection of personal failure. For some, com-
pliance was humiliating, but they considered it a fair "tradeoff"
for the stability, protection, and help they were receiving.
Mothers with higher levels of self-confidence resisted shabby
treatment or expressed anger. Service providers, who had much
control over the integrity of the women's families, reacted by
labeling outspoken women "trouble makers" and "complain-
ers."

It is clear that the physical environment affected the moth-
ers' adaptations, especially by either creating or alleviating
stress, a finding consistent with other qualitative studies (Beatty
& Boxhill,, 1990; Dail, 1990; Fogel, 1997; Friedman, 2000;
Lindsey, 1997), which have described adaptations to the physi-
cal and institutional aspects of a single shelter. Data collection
for the current study occurred at two different shelters, which
provided an opportunity to describe how differences affected
families living in each. Mothers who lived in an apartment-style
shelter felt more as if the space was their own. They had more

control over their family lives, and could fulfill the role of homemaker, including being a cook—tasks consonant with their motivation to use shelter.

Women living in the rooming-house-style shelter arrangement had less authority in establishing family routines and rituals, which lessened their capacity to fulfill accustomed or anticipated parts of their role. The women's self-esteem associated with parenting was very vulnerable to social context and oversight. The challenge of shelter parenting for all women was significant, in part, because of limited space and lack of privacy. The mothers believed their behaviors with their children were sometimes misinterpreted, and they felt diminished confidence in their capacity to parent. This finding is consistent with that of other studies (Beatty & Boxhill, 1990; Dail, 1990; Hausman & Hammen, 1993; Molnar et al., 1990). The degree to which the mothers interviewed perceived unsolicited advice about parenting as attacks on their parenting competence seemed determined by their investment in the social worth mothering afforded them.

Mothers who had limited alternative models for parenting and negative identifications with their own parents were particularly vulnerable to perceiving themselves as disrespected. They were also more liable to feel less trusting about sharing mothering with others, including using services like day care. Even women who felt confident about their parenting began to feel less effective. For some mothers, self-esteem rested on their children behaving well, and it was difficult for them to accept their children's behavior as developmentally appropriate, or even as a reaction to small spaces, noise, stresses of the shelter, or anxiety related to uncertainty about what would happen next.

The mothers also were worried about being characterized as inadequate. Some felt that asking for assistance left them

vulnerable to losing custody. This concern was intensified during the interviews because of public sentiment, which demanded that child protection authorities become more active about removing children from their homes to protect them against parental abuse, as well as other negative social representations about persons without homes. These trends, combined with the race and class of the mothers, left them vulnerable to state intervention, especially the loss of their children, who were such an integral part of their present and future sense of social worth. Therefore, when threats of loss of custody from staff occurred, the women responded with fear, withdrawal, and protective "privateness."

The mothers described a variety of cognitive coping strategies to mediate stress and devaluation, such as patient endurance, partializing stressors, ignoring stressors, and taking one day at a time, which have been described by other researchers (Banyard, 1995; Banyard & Graham-Bermann, 1995; Fogel, 1997). Such coping strategies also addressed the kind of threat to identity and interpersonal status described by Breakwell (1986). The shelter context and the women's prior experiences also shaped their evaluations of how to adapt and retain personal dignity.

Embedded in the women's life history interviews were stories about the ways they had managed adversity, which organized past experience to make sense of the present. This process has been described by Bruner (1990) and Cohler (1994). Some mothers sadly believed that, because they had little control in the past, the same was true of the present and future. Other mothers spoke of some successes amidst the challenges, and thus could more easily take the longer and more balanced view that, perhaps, things would not always be this way. Their experience of effectiveness led them to expect a better future, a

finding consonant with resiliency literature (Felsman, 1989; Hines, Merdinger, & Wyatt, 2005; Murphy, 1974; Werner, 1989).

In some of the narratives, particularly those of women who had been in out-of-home placement, coping with lifelong trouble was a sign of worth in-and-of-itself; it was an experience that, in fact, differentiated their stories from the canonical, usual discourses of women with fewer challenges. In the telling, they spoke about a sense of futility that, perhaps, life would continue presenting them with challenges. They were pessimistic about finding an intimate adult relationship that could end their loneliness, and predicted they would continue to "go it alone"—a narrative in which there is little room for a less isolated future identity.

The mothers' narratives revealed distinctions between fatalism ("always") and possibility ("perhaps"). Some women who had been in care and women who had been sexually abused—with no prior access to treatment—either felt they were of little importance to others or only important when they could meet the needs of others. This perspective represents an existential crisis, of having no meaning to others, except perhaps to one's children. Women who experienced multiple placements hoped the shelter would lead to stability, yet believed it was only an extension of "bouncing," or "belonging nowhere." These findings are similar to those of Meier (1965) and Bryce and Elhert (1981).

Some of the women used spirituality and religious belief as a way to ward off both despair about past defeats and present fears. They found hope in a higher power that could explain what logic could not. Faith represented a kinder value system than the one in which they felt their lives to be mired. Faith in some higher power established moral priorities for the women,

and helped them to retain hope that they could change—a vital ingredient that strengthens individual and family resiliency. These findings are consistent with those of other researchers (McCubbin, et al., 1997; Westerbrooks, 1998).

Shelter living required complex social identities and self-definitions that influenced the mothers' interpersonal relationships. To be part of the community of heads-of-households without homes, one had to be legally and socially defined as "dependent"; yet to identify with this devalued status meant that one suffered a further self-denigration. This conflict was not lost on some of the mothers in the shelter.

Within the shelter context, the mothers utilized interpersonal coping strategies to retain self-respect and power. Strategies such as comparing themselves with others, scapegoating, and gossiping seemed designed to make them feel, albeit fleetingly, that they were better than their peers without homes. They willingly could choose to enter into or avoid relationships with others. Although several women developed friendships in the shelter, none experienced the shelter community as a "second family." A few, however, developed connections with other parents they felt would last beyond their shelter stay.

It is possible to understand the mothers' avoidance of others as related to limitations imposed by daily survival stresses. However, some qualitative studies have described sheltered parents' capacity to identify, cooperate with, and feel empathy toward other parents in the "same boat" (Fogel, 1997; Friedman, 2000; Koch, Lewis, & Quinones, 1998; Lindsey, 1997). The mothers' strategies of disconnection from others are manifestly inconsistent with assumptions of recent theories about women's relationships that emphasize the importance of women connecting to and caring about others as qualities that enhance their self-esteem (Bitonti, 1990; Kaplan, Klein, & Gleason,

1991). For the women in the current study, it is possible that both their then-present conflicts and gossiping kept their past trauma from rising to consciousness, as hypothesized by Koch, Lewis and Quinones (1998), and required distancing from others. Mothers who had been sexually abused developed extremely self-protective plans, such as intending to shield themselves with dogs or not allowing anyone to enter their future homes. Such findings regarding isolating protection arouse concerns in regard to helping women establish connections in the community.

Chapter 4

The Mothers' Future Lives:
Making Sense of Hope

For the homeless mothers, whether their lives in the shelter represented continuity, transition, or a low point in the lifecourse, each could mediate their circumstances with hopes about what they and their children might become. These hopes, or possible futures, help one to mitigate the effect of present circumstances, and provide both another interpretative frame for self-esteem and a guide for present and future behavior.

Near Future

The mothers interviewed had a variety of hopes for the near future. Most of them described hopes to be established in life, and thought about living in their own homes. Dionne, for example, described herself and Ahmed as one day being "settled" people. Roseanne's family would be "stable." Vanessa said, "It's been a long, hard thing, you know. My life hasn't been easy. And I just want my own place, just to make things right. You know, develop my family, you know, see what it's really like to have a family again after so many years. It's been a long time."

Some of the women planned what their homes would look like, and the first meal they would make there. Kenya wanted her home to be quiet and beautiful, with lots of colors and nice, big furniture, including a large-screen TV for the living room. "I like a lot of stuffed animals sitting around," she said. "And someday I want a houseful of kids."

Soliel described her future home as follows: "Hunter green, the bathroom will be hunter green, with hunter green towels; and I'm going to paint the kitchen a soft lavender. My first meal will be lasagna with lots of cheese." Jana envisioned "thick rugs and Mickey Mouse decorations on J's wall. I imagine myself taking a bubble bath with candles, and staying there till I'm all shriveled up."

Linsay described her future residence as having

> Lots of plants, and some of my old furniture. I used to have lovely furniture [which was lost in the moving]. I will have my rocking chair in a corner full of light, and the kids will come in from school and jump in my lap and start bothering me, like I used to love. Fried chicken and mashed potatoes . . . the girls' favorite.

Connie spoke about the family rituals she hoped to establish. As Connie said, "My first Thanksgiving is going to be nice, with my two kids and my dog, a Wiemerarner. They are good guard dogs. Probably a turkey sandwich with cranberry; probably a sweet potato pie. Then I'd be happy . . . the turkey, the salad."

Some mothers, however, especially younger women who had been in care and never lived on their own, tended to worry the most about living alone, and how they would manage daily living. Nodica, for example, said,

> I really never had my own home. I can't wait to move into my own apartment, and I will make it home. But I don't like being in the house myself [laughs]. My mother always says, "How are you going to stay in an apartment by yourself?" and "You scared of being in the house by yourself."

But now I have Serena to keep me company when I'm in the house myself. It's just scary to think about it otherwise. You hear some of everything and you don't know where it comes from.

Natalie expressed the same sentiment, saying, "Nope, I don't like being in a house alone. I'm used to being around other people. Nope, I won't like being in the house myself. It makes too much noise. When I was living at my friend's house when I was by myself or even with my son, the house made too much noise. So I left all the lights on."

Milagros worried,

I mean, people think it's gonna be easy. But, I mean, I never actually lived in an apartment by myself; so I mean, not only would I be scared, because what I mean, people in the building. But when you don't know people and you just live there by yourself, I mean, however it is. My son sleeps with me right now, and I can see when he gets his own room it's gonna be even more scarier for me. It's not the aloneness 'cause I got . . . I have a lot of friends and everything. It's just probably . . . I don't know, with all the things happened with people in their apartments and everything . . . getting killed, getting on fire, getting raped. It's scary.

Soliel said about living alone, "With me, if I'm in the house myself, I tend to keep all the lights on; and I know when I move I will make sure that I have a lot of company, my cousins, my sister, her little rugrats, and Deja. And I'm moving near my gramma, so maybe if I got scared I'll go see her."

Jana also expressed her fears about living alone, saying, "I am scared. Like, living in an apartment by myself? Uh, uh, I was always around a lot of people, so I couldn't see myself going to sleep myself, you know? Even when I was in the group home, I shared the room with somebody."

Kenya said,

> I worry, I really don't know how to cook. And the other thing is I worry that I will end up watching TV too much and not go out, and do the things I have to do. There's a lot I still just don't know about. I don't know what she [her child] is entitled to. I didn't even know I had to have a social security card for her to be on the budget.

Lucia said,

> I wonder what's going to happen the next day. Just wondering how, you know, sometimes like, I'm scared that if I end up losing my husband, what it would be just raising my two kids on my own. Living out there in the real world. This ain't your place. Nothing is yours in here. So, to me, I'm just living in lala land until I really move out in the world, and I have to pay for my bills, and I have to go to doctors' appointments on my own. When I got to take care of responsibilities, 'cause they do everything for me.

Plans and Worries About Earning a Living, Financial Independence And Education

The mothers interviewed had a range of plans for their future, including specific career goals. As Soliel said,

> I started going to college, and then I had to leave when I found that I was pregnant with her, because I was sick, and I was going to school at night. So I had to leave. I didn't even finish the first semester. Didn't finish the first semester. But I plan on going back to college when she gets a little older, a little older. I say about one year or something like that. I plan on going back. Yep! Take my corrections officer course and then the test and I'll be straight. I want to be a corrections officer for kids, not for adults though.

Kenya spoke about her future plans, including a career, as follows:

> I want to get my own apartment and then go back to an alternative high school. Something where I can graduate and know that I achieved something. I'd like to be a teacher. After I finish high school, my mother wanted me to go to college, but, um, I didn't like school. So I don't know. I know I don't want to know about no college. But I really like taking care of kids. So maybe I'll be a childcare worker or even a teacher.

Some of the mothers also recognized certain obstacles embedded in federal policy, namely the Federal Personal Responsibility Work Opportunity Act of 1996. For instance, Delila had frequently represented children in care and offered legislative testimony regarding the effects of child welfare policy. She hoped to become a lobbyist, but she worried about whether she could return to school, finish her bachelor's degree, and then embark on a career. As she expressed her concerns,

> I mean this, the system [welfare] sucks. I don't understand how a woman can depend on welfare. I mean as soon as my daughters are old enough, I want to go back to school. But with all the cutback, they're not letting anybody go back to school. So how can I get myself better? I don't understand it. They are saying "Get off welfare and get a job." They are taking away all the programs that will help us get a job and they are giving us workfare. Workfare is not a job, that's not a career goal. That's not what I want to do with my life. And they're cutting everybody off. They are firing everybody. So where's everyone going to go, to welfare? 'Cause nobody going to get SSI 'cause they were working. It's ridiculous.

Roberta had concerns similar to those of Delila. As she said,

> I'll do the day care for a while until he's [her son] old enough to go to school. But my real dream is to open up a women's clothing store, for big women. A clothing store that has really quality things—high style, reasonably-priced

clothes for larger women—not that polyester, no-style stuff they have at Lane Bryant. I've already made drawings of how I want the layout to be.

Roberta also commented on the economy and worried,

Yeah, you know, and they cutting all these jobs. And then they tell you, they want you off welfare. But they never have no jobs for us [chuckling] when we get off of it. So like I said, you have one or the other. If you're not, don't have at this present time, now is not the time to cut welfare because now, you don't have no jobs. How many people getting laid off? What's the telephone company . . . ATT? Yeah! You know, what are you doing to these people? And then you complain about welfare. Where do you think welfare comes from? People not able to get a job, you know? And then it's to the point they get lazy, and after that, they don't wanna get jobs. I can't understand your wanting to stop that, but now's not the time to cut welfare.

Kathleen also expressed her hope for a career in the near future.

I want to be a sound engineer. I've always had a good ear. Knew what sounded right together. I want to go on long trips with my kids, like to Aruba. I wanna husband that has his own status and I have mine, not a husband that's scared. If I make it I would take care of older foster girls. Charles didn't have any aspirations. Charles wanted to stay in the neighborhood.

Nodica was also hopeful about her future. Having had a work history prior to shelter use gave her confidence. She explained,

> I have skills in several areas. I have done temp agency work. Filing and light office work. I also have skills in construction, plastering, but it's hard to find work in that. I like taking care of children, especially kids between 9 and 12. I worked at a summer camp that I used to go to. I have always found my own jobs. My resume will catch somebody's eye.

Charlotte expressed a fear about completing her education, raising her child, and her relationship with the father of her daughter. She had been accepted into a bachelor's nursing program, but wanted a child badly, and so did not complete the program. Although she planned to return to the nursing program, she also worried about childcare. As she stated all these concerns,

> Well, I need to go to school. I mean, maintain a B average so that I can do the clinical part. You know, pass it. That's right. Really, I see there's one person that can help me out a lot, and I don't know how. Because I have his daughter. I don't see it happening for me, to be raising her by myself; and gotta study and go to school. I see it rough, so I'm, I'm gonna need him badly; and I think he knows this. I haven't spoken to him about it, 'cause I said I was gonna wait till I get my apartment, so I could. But I'm gonna need him.

Charlotte was certain her baby would allay any fears she might have about living alone, however, saying, "He [the father of her daughter] lives by himself and he gets lonely. I got a baby to fulfill my loneliness. I don't need him, but he couldn't understand that. I don't need anyone. I got my baby."

Elyse had already been accepted into a nursing program, and expressed her hope for, and concerns about, the future, as follows.

> I am enrolled for nursing courses in college in the fall. I think I can take everything but the clinical, but I can't do that and the day care; so I'm worried I will be in the same fix I was before, wanting to do something with no support. I can't count on my sister. A lot of times I ask for help, but people always fall through on me.

Connie, whose sight was diminished by a degenerative congenital eye disease, and took advantage of services for the visually impaired, stated,

> The doctor says at some point I will need a seeing eye dog. I'll grin and bear it. But I do want to go back to school, find something to do, just make a career. I'm waiting, though. I wouldn't mind being a receptionist. But with my vision, I will have to memorize everything or run my own business. I will worry when men stop looking at me.

Marion was partially supporting herself as a home health aide, hoping to complete her bachelor's degree, and then become a psychologist. She worried about struggling to make ends meet, living in subsidized housing (which was going to expire in a year, leaving her with a market rate rent to pay), and

college tuition, paid for by Almost Home. She also often worried about whether she would be able to have her car repaired, if the need arose.

> I think about money all the time. Money is very important. People say "Don't kill yourself," but actually I need it; and I'm tired of being relaxed, and I can't do this and I can't do that. And I worry about who's taking care of Z. Now when I go to school and have to study after work, I keep myself going with coffee. I take every little job I can, because I need financial security of some sort. When I didn't have to pay for my repairs, I just loved seeing the bank account grow. It just made me feel good. God, that's the money I worked hard for. Almost Home, they taught you to be hard working.

Other mothers interviewed also expressed hope for a career in the near future. Milagros wanted to be a social worker or a computer programmer. Talia said,

> When I was a little girl, I wanted to be a stewardess. If I stay here, I'd like to have my own cosmetology shop. I would like to have my own house. I want to make something of myself. Get my degree and become a cosmetologist. I wanna go to school and get a job. Sometimes I think I wanna buy a big house and take care of my daddy. Living in an island in the Caribbean in one big house. It would be like heaven. My father used to do everything for us. Then sometimes I think, just to have him here would change things.

Lucia expressed many of her hopes and fears regarding work and education, though she saw work as a more distant goal than many of the other women in the study. She said, "I just want to go back to school. I've asked everybody here . . . the Board of Education lady. When I get to be older, I want to do counseling with adolescents."

More Modest Hopes and Worries

Those mothers who had not been in the labor market and/or had not completed high school wanted to be financially independent, and worried about how they would enter the workforce. Dionne spoke of her profound fear of failure when she was an adolescent.

> I didn't wanna work. I was always afraid from when I was a little girl. I didn't wanna pay bills. I was scared about succeeding in life, and sometimes I think I tried my best not to grow up to be 20. The years flew by and I had nothing to show for it except for my children. Me, I'm just living everyday. Everyday I try to have pride of, how can I explain it? By trying to have some types of respect for myself. For instance, I'm using protections so that way I won't end up in another crisis and have another baby on the budget. I don't want to take from nobody else. I want my own, even it means working at Burger King or Mickey D's. Something so I could have an income. It sometimes seems so hard. It seems so hard to try to get a job without a GED, and it seems hard to try to go back to school.

Ahmal had been persistently searching for work as an auto body repair person, the field in which he was trained. Both he and Dionne felt discouraged, and she worried for him. As she voiced her concerns, "He can't find a job, but he keeps looking. It's hard for a man to live in the shelter. It hurts his pride. He could have sold drugs to keep us going, but God forbid, he woulda ended up dead. I would have ended up without a husband and a father for the children. What for? Greed?"

Eartha expressed her self-depreciating apprehension and humble hopes for the future this way:

> I guess I'm what you would call a housewife. I want to stay home and take care of my children. I just want to get my own apartment and raise my child with Sidney. I worry about money. I worry because everybody says I'm lazy, I'm lazy, I'm used to sitting on my ass. That's another problem my grandmother thinks I have. Doing things when I get ready to do them instead of when you're supposed to do them. I was in the street 'cause I didn't take care of business. If I still had my apartment, I would have been getting high. I'm very happy that I don't still have that apartment. I have problems with money now sometimes. I don't spend money correctly. Everybody has problems with not enough money. But I kinda forgot a lot of things, like how to hold a baby, a lot of different things. But I'm going to try to budget. Sidney helps me budget. If Sidney and I break up, if he leaves me, then I will go to live with my aunt in Kentucky. I'm taking my child and going to Kentucky.

For some of the mothers, worries about the future also included death. Roseanne said,

> I know what I want for the future. I know what I want them to have in the future. You know, for their future, I want them to have . . . I, I just want them to have a stable environment where they won't have to look to nobody for anything; and just in case anything happened to me or my husband, I want them to have a little trust fund or something, That's why, you know, I kinda wish that I had a career, you know. I kinda wished that I had stayed in school, but see, I got married so young.

Delila was especially afraid of dying from acquired immune deficiency syndrome. She expressed her fear as follows:

> I always say at night, "Please don't let me die of AIDS, give me breast cancer. Take my legs, take my arms, take my sight. Just don't give me AIDS." You know? I would feel so bad, because I would think, I gave it to so many people, you know? I coulda given it to my children. To my children's father. It's just a horrible thing to deal with because I wanna grow old. I wanna watch my children grow up. I wanna have grandchildren and I wanna see them. I don't wanna think I'm gonna die. It would be a tragedy. They have to suffer. I'd rather die of cancer, because I know I didn't give it to anybody, or it was something that could come to my family. If I have AIDS, I will burn eternally in hell. I would do anything to

make sure that never happens—no more sex, even!

My Children's Future Will Be Different From My Past: Changing Family Stories

Some mothers interviewed recognized the turmoil and deficits in their relationships with their parents. A frequent expression embedded in the mothers' narratives was, "I never had a childhood." They wanted their children to have not only a childhood, but also a childhood different from theirs. Often mothers were specific about what they would do differently in their own parenting role in the future. As Marion explained, "I always said I was never a kid. I can honestly say I never had a childhood. I was changing diapers when I was six. I was never a kid. I always had to figure out what was going on. I have to make sure that my son has a chance to be a kid . . . to play . . . not have cares."

When she was interviewed, Marion was working and planning to return to school, reflecting her anxiety about attaining financial security and caring for her son's needs. She was able to acknowledge the lack of physical contact and attachment with Zach, and how she could be a better mother in the future.

> I think I'm unfair. It's unfair to him because I have so much to do. I don't spend a lot of time with him at all. Sometimes I'm so tired, I'm always snapping at him. Like, "Zach, get outta here and go to your room." Then I realize, you're really being bad and mean. I don't think he will understand this. I think I better start changing something and spending a little more time with

him. I realized that when we went to this lady's
house to have dinner last week. 'Cause she was
hugging him and stuff. The kids love her. And I
was thinking, "Like, gosh, I don't treat Zach like
that, like a baby and stuff." I'm gonna manage to
spend more time with him and not make him
think that he's a little man all the time.

Natalie recalled her negative childhood, and related it to
how she would treat her child:

I didn't have a good childhood at all. It like
robbed me of my childhood. I felt that it was un-
fair and learned a lot from the years of living
there. What I will do when I have a baby. My
mother was never in my corner. I always wanted
a little girl, so God blessed me. I always want her
to feel comfortable. My mother made me uncom-
fortable, made me seem like I was crazy. I want
to be her [daughter's] friend. I want her to be
able to tell me anything she wants.

Delila talked about being treated as a traded commodity by
her mother, and how much this made her cherish her own chil-
dren:

I came into this world not out of love, but out of
necessity. I mean, they didn't need me, but he
needed sex and she needed money. I know it's
hard to be a parent and everything, but my chil-
dren are the most beautiful things in the world. I
just look at them and I feel they are the most im-
portant part of my life, and sometimes that feel-
ing makes me want to cry.

Elyse described her unfamiliarity with warm parental relationships, and what it meant for her future as a mother: "I could give him [her child], I fill him up with all the love that he needs, but I lack that in me. So, therefore, I can never find, you know, equivalent to what a parent love is. So I know exactly what to give him, but I would never be able to receive it through life until, you know, it is gone."

Respect for Women

Some of the mothers expressed a consciousness of parenting-related gender issues. They felt they had the ability to shape their children's gender-related attitudes and behaviors. Those mothers with male children wanted them to grow up with respect for women. For Roberta, self-esteem and respect were important values she hoped to teach her son. In worrying about the violence young men face, she stated, "I want to raise him with enough self-esteem that he don't let anybody bring him down. Raise him to be respectful always. I want to instill in my son, 'Be all you can be.' I want him to be a gentleman, treat women with respect, because they deserve it; because that's who brought you into the world."

Natalie said of her son, "I want him to know how to treat a woman. I want him to be a man and take responsibility. I want him to respect me." Rayette expressed her vision of her son's future as follows: "I don't want him to grow up to be a man who disrespects women, kicks women to the curb. Even though I am angry with his father, I will not kick him to the curb. And I will teach him not to just kick women to the curb, either." Kathleen thought it was important for her sons to respect her and treat women well. "I want them to respect women and know how to treat a woman. I want them to know about how to be

responsible for taking care of a family and to never betray a woman."

All the mothers felt they had to protect their girl children. The mothers who had witnessed domestic violence as children were generally the most worried about protecting their daughters. Sabina compared her own family experience, and that of the other women in her family, to the protection she felt she must give her unborn daughter. She voiced her concerns and vision in this extended narrative:

> Now I understand my mother got love for all the wrong reasons. My mother couldn't take care of us, in the ways that we needed. She wanted us to take care of her. She exposed us to a lot of cruelty. I was too young to understand that she didn't take care of us. I appreciate that they [family members] gave me a different outlook about people. They, they, they let me know when I looked at them it was like looking at a soap opera. It was like looking . . . I looked on the outside in. And I saw that this is not the type of family that I want. Um, so you know, it was kept real frank to me that, you know, I never wanted my child to go through this experience. I'm glad I'm doing this, that this is happening now and not later on. When I decide to create my own family, I know I won't do it this way, and I won't do it that way. So I know where all the don'ts are. You know, I just have to figure out all the dos. But I'm still worried about what will happen when this child gets here. I'm just gonna love this child extremely.

And I found out that it was a little girl, so it's really . . . I thought it would be much easier if it was a guy. Boys tend to role-model themselves after athletes. Your daughter, she looks so much up to you, and you have to bring her up as a little lady, you know? You have to be very precautious with a little girl. I think things are so cruel in this world. I'm not this big person like Captain America with a shield or anything, but I mean, I can protect her by giving her the knowledge that she needs to continue in the world with or without me.

Mothers who experienced sexual abuse were worried about protecting their daughters from repeating their experience. In the following quotation, Roseanne explicitly demonstrated the contrasts between her own experience and the experience she wanted for her child. "I want to break the chain," she said. "My grandmother got pregnant at 16, my mother at 13, and me at 15. Let me tell you, my biggest fear with her [her daughter], she is going to do what I did to my mother." She continued on,

My father was very abusive to her; made her sleep with other men. He died like two years ago. And I mean, why would you go on and have another baby, you know? If you know, why would you go on child number three, if you know your life is not getting right? And then I look at myself and I say, I went on child number two knowing my husband was doing drugs. But see that was an accident. I was on birth control pills, and I'm stopping at two.

Like, my mother, she had a choice. When I was at the last shelter I was pregnant going. I felt terrible, living in a shelter, no apartment. I was still on welfare with no education and I already got two kids, and no education. I can't deal with another baby. I'm barely making it now. My mother had five children. She left all three daughters in New York and moved to Atlanta with the two boys; and she didn't want to be bothered. She would try to save the two boys. She felt that we weren't going to amount to anything. I think I actually had the capabilities to really be somebody, outta all her kids. But then I think how did I end up like this then? And I say, well I was lonely. When I ran away and was staying with David. My children are what's keeping me alive to this day. You know. . . I done been dead or try to kill myself, you know? That's all I that I ever lived for and then give them, try to give then a better life. You know, what I have, everybody says that, but the way I see it, only the ones that been through a lot can actually do it.

Roseanne contrasted the above to the new family story she wanted to write: "I want her to remember me getting up and getting out the door every morning just like she will be doing, you know? I want her to know Mommy can work, can go to school, too. And Mommy knows about cooking and cleaning."

Roseanne struggles to stay connected, while giving Danielle[her daughter] a chance to grow.

Danielle is a funny, little person. I stay hugging her and giving her affection, 'cause I never got it from my mother. When my daughter started school, I cried, I didn't wanna leave her. I was like, "Can I stay?" And to this day, I still get teary-eyed because I miss her so much when she goes to school. Did my mother feel like this when I started school? And I keep saying to myself, probably not, she was probably happy.

Elyse, Kathleen, Sabina and Alicia hoped that higher education would be part of their children's future. Roseanne, too, hoped that her children would go to college, but it was even more important to her that they have only "child-sized" worries. As she explained,

At least, you know, go to college, becoming something, make something of their life. I want them to have school. I don't want them to have no worries. I don't want them to have a care. Nothing that will cause them stress. I know they will. I want them to worry about getting pimples, and stuff like that.

Elyse, speaking in the context of limited access to higher education for persons of color, said:

If Oliver [her son] wants to do that [attend an Ivy League school], then I'll explore the option with him; and I'm going to tell him the consequences of doing it. And if he wants to go ahead and do it, that's him, but I don't want him to be let down. I want him to be fully armored for what's to come, so he doesn't get knocked down of self-esteem. Because it's true if you, if you climbed

those stairs to get to the top, and the last three rungs fell off. You'd feel bad wouldn't you? Because the damn thing broke, and you didn't get to the top and because you all hurt because it broke on you.

Challenges to Fulfilling Future Hopes

I noted differences in the mothers' capacities to consider their children's psychological needs and simultaneously fulfill their own dreams for a better future. The differences appeared to be mainly related to the severity and duration of the trauma, and the degree to which their original trauma was mediated by intervening experiences with others. These intervening experiences included stable caretaking subsequent to the original harm they suffered; the availability of other significant adults with whom the child could form a corrective attachment; and the degree of social support available to each mother, particularly during times of transition and crisis. In addition to these interpersonal intervening experiences, the mothers' earlier harm was mediated by the availability of skilled mental health assessment and treatment and opportunity to build on their interests and talents.

Some mothers were able to speak about other changes they recognized that needed to be made. As Dionne explained:

I took up child care [in the Job Corps] 'cause I realized I did not want to be an abusive parent, and I knew I was having a baby and was very much interested in children and their behaviors, and I wanted to understand them. I wanted to know, if she [her daughter] hits me hard, you

know, or something like that. I don't want to use reflexes. If somebody hit me, I go pow! Now I know she was gonna do those things and I didn't wanna be, um, you know, aggressive with her. I was really rough with things. See my hands [scars were apparent]? This is from that. I was rough with other things, and I had to teach myself to be gentle with babies. I took that trade up. I wanted to be a good parent. I'm not all the way at that level yet, you know. I'll get there, if it's the last thing I do, I gonna be a good parent.

These mothers also were concerned about their capacity to meet both the demands of their children and their own needs. For instance, Eartha thought,

I will teach a child respect. I don't know if I have that much patience. I tell them one time and then I expect them to listen and not do it no more. I know a child is not going to listen. I have to have patience, and that is one thing I have to develop. I think I'm going to have problems.

The mothers who had been either sexually or severely physically abused found their wish to be better parents compromised by the decisive effects of trauma and their profound fear of being alone. For Roseanne, for instance, no mental health services or adult role model existed to buffer traumatic attachments engendered by prolonged sexual abuse. In speaking of her aborted mental health treatment after an inpatient stay subsequent to sexual abuse and self-mutilation, she recalled, "I cried out for help so many times. I hoped that therapy would help me set some goals in my life, that I would have somebody I could confide in, help me know right from wrong. Somebody

to put me in the right direction. I cried out for help so many times."

Charlotte said,

> I wanna be a nurse. I got to, I wanna be a nurse so, you know . . . I like helping people and, you know, knowing within myself that I can give my daughter the life that she deserves, one that I did not have. That's gonna be my greatest reward. You know, it's just the things that I didn't have, somebody to talk to, somebody she [daughter] could trust, you know? When she say, "Ma, can I get this?" I don't wanna say no, every time she say that. Just trusting my daughter and for her to trust me. Communication builds trust. Communication equal being able to talk to the person, you know? And know that when you just tell something it's not gonna be all over the place. Basically, that's what she's gonna need to get her through life. For me to encourage her to do stuff, whatever she wants to do is fine with me. Long as I don't see no harm she gonna do herself, I have no problem with it. Family . . . can't ever depend on my family to encourage you. The most important thing in my life is my daughter, going back to school, making a better life for myself.

Mothers who had been sexually abused, with no subsequent parental or mental health intervention, also were at risk for depression, which limited their emotional, and sometimes physical, availability to their children. Milagros, for example, found that her extended period of homelessness combined with the

sequelae of unexpressed reactions to her stepfather's sexual abuse—from which her mother failed to protect her—left her depressed and depleted. This, in turn, resulted in her limited ability to protect her 2 children, Marina and Kenny, and perhaps undermined the hopes for both herself and her family. About this, she said,

> 'Cause it hurts me that I have been here so long. I took care of him [Kenny] his whole life, but there are those days when I'm upset and he adds on top of it. I just blow up. You don't want to see me. I just go to sleep and put my head under my pillow. When she's crying [Marina was teething], I just put the pillow over my head and she's crying and he's up. I just put the pillow over my head and I make sure that he's on the bed 'cause he can get into anything. I make sure he's in bed. I can feel both of them moving, and so I try to sleep and to take a nap and let it just clam off me.

When the mothers' self-esteem was tied to their children's behaviors, their wish for changed, usually better, parental performance was compromised, Lucia became harsh, for example, when her daughter stirred-up unresolved conflicts, and she turned to her son to satisfy her need to feel valued. Misattributing motivation and acting on this error recreated her own chaotic attachment and developmental challenges, and thus compromised both her path to self-growth and the growth of her child.

Lucia explained her attachment to her daughter, Faith, as follows:

My attachment to her is fading away 'cause he [Salvadoro] got involved with the attachment. So when I had my son, she started to get more attached to him, and this reminds me of me. She has tantrums if she don't get her way with her father, just like me. She starts throwing things. She'll start hitting her head against the wall. That's how I acted. She acts real bad if she don't get what she wants. I'm gonna have a handful with her when she gets older; she gonna be real bad, that child is real bad. She don't respect me. I don't know whether she's deaf or what, but she doesn't listen to me. She listens to her father, she loves her father with a passion. You can't take him away from her. She loves when he sleeps with her; she'll put her head under his body. She loves him so much. Long as my daughter loves me and I love my daughter. But I prefer her to love her father more because . . . and to bond together. It's cute that she has both parents, especially she have a father, 'cause most teen mothers don't have a father around, and the kids cannot bond with they father. That's why I want my daughter to be close to her father; that if, God forbid, we end up splitting, she will always have her father there for her.

Envisioning the Future: Personal Meanings and Former Identities

As a group, the 24 mothers interviewed envisioned different possible futures for themselves and their families. Their plans for the near future almost always included a new home, and they imagined what it would be like to live there. To ensure

their possible futures, several women were involved in training programs they expected would lead to financial stability, while others hoped to return to school. Most often the mothers' possible futures represented a synthesis of social norms regarding self-sufficiency and caretaking, combined with a personal sense of satisfaction they would derive from meeting the needs of others, undoing their past, and establishing themselves as competent adults who could provide for their family's material needs.

Such "potential identities" have been described by Breakwell (1986) as important for changing the meaning of present, socially transmitted social definitions, and mediating the internalization of devalued social worth. Breakwell notes that, when individuals can compare their devalued identities with a planned end-state that is superior, the power of the past is diminished. Both Saleebey (2001) and Bruner (1991) assert that subjunctive stories of a hopeful self are based on optimistic assumptions that change is possible. A central finding of resilience research is that "expecting better" is associated with positive outcomes (McCubbin et al., 1997). For the mothers in this study, such a future orientation served as a powerful coping strategy that enabled them to adapt to, rather than only react to, past and present affronts to their self-esteem.

Along with their hopes, many of the mothers expressed worries about what was to come. Aware of the economic decline in some sectors of the labor market, they worried that they would be unable to find employment that would provide financial stability. They also worried about barriers created by recent changes in public assistance policy. Several women worried about school-related issues, such as their intellectual capacities or the embarrassment they might suffer if they returned to high school or tried to get their GEDS because they were "too old."

Above all else, however, the primary future plan of the mothers was to ensure that their children's futures would be different from their own pasts—a hope in harmony with the general American value of improving life-chances for succeeding generations. In reality, however, some mothers' cumulative stress, past identifications, and trauma were barriers to their ability to fully meet the needs of their children. Several mothers had been exposed to reliable, alternative role models long enough to have learned what good parents do, while others lacked role models to identify with, and thus were left to "invent motherhood" on their own.

In addition, some mothers showed high levels of awareness regarding what they did not know about parenting. They wanted to know more about the development of children, for example. Several mothers were willing to make behavioral changes they felt were needed to become better parents. Most did not want to become like their own caretakers, and vowed that their own parenting would be the polar opposite of those who cared for them. Even when they vowed to be different, however, they exhibited a pattern, described by Benedict (1959), of worrying that their children would make the same mistakes as they did, especially during difficult developmental periods such as adolescence.

Chapter 5

Hope Springs Maternal:
Considerations and Questions About
The Future of Mothers Without Homes

The mothers described in this book may have made mistakes during the course of their lives, but unlike others in society with greater resources, they received little forgiveness for their missteps, which had lasting consequences. Their "mistakes," however, occurred within an historical framework that had been all but invisible, especially to the women themselves. They did not have the perspective to evaluate their "mistakes" within the social context and time in which they were living—and this represents a missing part of their narratives. Their housing situation was a result of long-standing discrimination, the pattern of existing social stratification, and others' social expectations regarding work and family life.

It is difficult to know for sure, however, if their "mistakes" were not, in fact, rational choices. As Edin and Kefalas (2005) demonstrate, what often appear to be mistakes are actually strategies based on practical hierarchy best understood by asking the subject rather than assuming. The choices the mothers made were based on economic conditions, developmental thrusts, and social location. They also were based on their understanding about the current structures of opportunities available in the broader social world, as well as on current cultural conceptions of marriage. The feminist movement, for example, has succeeded in making marriage far less necessary for social personhood among middle class American women (Edin & Kefalas, 2005).

For mothers without homes, living in conflict with family members or others, or living in doubled-up and tripled-up situations, caused stress. The transition to a different social location, however, such as leaseholder and parent, could be anticipated to be less stressful for the mothers than the situation in which they found themselves prior to shelter use (Kubiak, 2005). In addition, their transition to a different physical location, such as from the street to transitional housing and then to an apartment in the community, seemed like a sensible path to them.

The change in "social location" could have meant only a change in geographical location and housing status for the mothers, i.e., from point A to point B. They hoped, however, to find an array of opportunity structures in the new neighborhoods that would offer services, basic amenities, resources, and investment in infrastructure required to change their "stories," or personal histories. They hoped for social and economic mobility.

Most mothers interviewed had only spare support systems to which they could turn, and they found limited understanding from those around them. Their children were growing up with similar prospects. One major difference for the children, however, was the added resources of shelters in which their mothers had fought for placement.

Considering the above, all of us concerned about homeless mothers must ask ourselves the following questions: Are the shelters giving these families the assistance they are seeking? Will shelters offer them a safe place to make mistakes and still find support as they develop and grow? Will families be able to leave the shelter system as self-sustaining individuals capable of dealing with the expensive, unforgiving, and challenging housing environment of New York City? Are we developing hous-

ing and economic policies that make productive futures and community membership possible?

Parenting, Interpersonal Relationships And Coping In the Shelter

The interviews with the 24 homeless mothers indicate that their entry into the shelter was necessitated by the pressure of two forces: the lack of affordable and accessible housing options for families, and the women's distinct housing needs related to pregnancy and motherhood. The shelter system was a resource that provided safety for the mothers and their children; and it was the only choice when women who were pregnant were living in deprived, and sometimes dangerous, situations. For younger women living in families with limited emotional and instrumental resources, pregnancy was "the final straw" that forced independent living and shelter use. Forced independence was also a theme in the narratives of mothers who had been in care, and had little say in leaving out-of-home care or family reunification. For one-third of the women interviewed, shelter use was a relational and developmental decision rather than a survival imperative.

The mothers generally experienced the shelters as difficult living environments, for a wide variety of reasons, which called into play an array of approaches. The most formidable stressors with which they had to cope were those that threatened their finances, health, privacy, autonomy, physical comfort, parental status, and self-worth.

The narratives suggest that the mothers within the two shelters, The Arche and The Lincoln, did not uniformly experience these stressors. Rather, some stressors were more or less prominent in each of the two shelters, because of their different

physical conditions, living situations, facilities, and staff. Often, mothers in the two shelters coped with stressors in ways that were more similar than different.

Overall, the mothers' stories show that they employed a variety of coping strategies related to different types of relationships. With friends, family, and other residents, the strategies included retaining ties beyond the shelter; forming temporary alliances with other sheltered parents; intimidating other residents; ignoring gossip from co-residents; and distancing and isolating themselves from others. With staff, the mothers' methods included both accepting and resisting staff's evaluations and judgments of their behavior, and/or working with staff to solve housing, benefits, and parenting dilemmas. With children, parents focused on their care and well-being, as a source of self-esteem. In addition, they coped by cognitively reframing their definition of the situation, and trusting religious belief to transcend the adversities presented by their immediate living situation.

One of the most persistent themes in the mothers' narratives was that shelter use meant loss of self-esteem. At a point in their personal histories and intersecting social identities (i.e., as homeless, single, mothers of color), when their motivations to use the shelter system clashed with values of those in more privileged positions, their motivations were labeled negatively and viewed derisively. The women were aware of the nature of the general political discourse about them, which rarely extended itself to question the causes of homelessness. Rather, it focused on society's need to control shelter use, and the behavior of the women whom the shelter system was mandated to serve.

Most of the women were acutely conscious of their devalued social worth, in at least one of the following domains: as

heads of households without homes; women of color; single mothers; workers; and educated citizens. Their self-esteem was related both to earlier interpersonal encounters and how they experienced a range of interpersonal negotiations in the shelter. The nature of these encounters either could intensify previous experiences or support strengths.

A mother's parental status and authority were central to her coping with previous diminished opportunities and self-worth. Mothers, who retained social ties and were supported by others in the community, as well as by partners in the shelter, were, for the most part, both more self-confident in the parenting role and better able to protect their children from the harsh conditions inherent in shelter living. Women who felt sure about their choices and perceptions about parenting were able both to resist staff authority and create an environment in which their children felt safe enough.

The mothers hoped the shelter would be a bridge to a stable and hopeful future for themselves and their families. They worried about both living alone and what would happen to them because of shifting social policies that might compromise their aspirations. The shifting policies included limits of The Personal Responsibility and Work Opportunity Reconciliation Act of 1996—which changed Aid to Families with Dependent Children to Temporary Aid to Needy Families—and the push toward sometimes premature self-sufficiency. These could limit educational opportunities for the mothers and, perhaps, their children, which would further erode the mothers' hopes and self-esteem. Societal expectations to promptly enter the workforce can distract a mother's focus from fully nurturing her children.

Transitional Shelters, Adaptation to Trauma, and Cumulative Adversity

The mothers' thoughts and feelings reflect important conclusions of both longitudinal studies of development and discoveries about adaptation to trauma and persistent psychosocial stress (Cohler, 2000; Werner, 1989). New milieus can alter persistent patterns of adaptation to adversity and serve as a primary source of opportunities for both action and new information, upon which individuals can draw for solutions to past negative life events. It is possible that the shelter system can provide several conditions that might revive the forward edge of development, sometimes referred to as "self-righting development" (Cohler citing Kohut, 2000; Rutter, 1995). It is often the qualities of these new or transitional environments that can further enhance "self-righting," and can offer chances to promote self-efficacy and self-esteem. Without a nonjudgmental milieu in which interaction with others can support a new definition of self, however, self-righting opportunities become limited and individuals' narratives of "possible selves" become disjointed.

Bitonti (1999) found several factors in the new or transitional experiences that can mediate a woman's identity and reduce the risk of diminished self-esteem. These factors are (1) opportunities to make meaningful connections to others, (2) the availability of social support during the transition, (3) external validation by valued others, and (4) the meaning the women make of these mediating factors.

The families living in shelters that I interviewed interacted with an array of service providers on a daily basis. For most of the mothers, feelings of unworthiness could be exacerbated by service providers' failure to validate both their choices and status as adults, parents, or both. Conflicting assumptions,

power differentials, and minimal opportunity for the women to express their ideas and emotions exacerbated their feelings of ineffectiveness. The service structure thus unwittingly reproduced the mothers' experience of power differentials in many of their earlier, pre-shelter relationships. Staff interventions, which were based on limited information and unexamined assumptions, both posed a risk to the mothers' self-esteem and limited the potential of the transition to support their positive identities.

The possible and promising meaning the women could make of their transitional experiences was often undermined by the milieu and, perhaps, exacerbated by previous abuse. Their disavowal of homelessness, represented by comparisons and gossip, lessened the bold act of shelter use. For some women, shelter use often meant further disdain rather than an act of courage. Their preferred identities as capable copers were often unrecognized, and shelter staff often reinforced their status as "homeless mothers." Staff negatively labeled women "resistant" who refused to apply to themselves the devalued label of "homeless mother," rather than positively labeling them for having the self-worth to reject devalued labels. Because of shelter policy, the way shelter staff implemented policy, and the concomitant power relationships that developed from the policy, the shelter residents had little room to nurture acceptance of either self or others.

Both Siefert et al. (2007) and Burnham (2001) allude to social service providers' preferential tendencies towards helping Caucasians. Because the women I interviewed are both non-white and dependent on service providers, they could not easily engage in political resistance that might intensify discrimination against them. This limited their opportunity to recognize the historical context in which they had been placed.

Regarding social skills, it is notable that mothers who shared physical space, similar parenting and caretaking roles, and similar status barriers often were frightened of and disconnected from one another. By holding devaluing perceptions of one another, the women limited opportunities for the shelter to serve as a setting in which they could develop meaningful connections to others and gain interpersonal and social confidence. A "negative adaptation" gave credence to many assumptions held by the mothers' strongest critics. The mothers' mutual denigration also limited their potential access to validation and support, and prevented them from considering that they, like others in similar situations, may have been worthwhile and likable.

Such pressure prevented parents from fully considering capacities and changes necessary to family life that accompany the transition both to community living and moving from welfare to work. The parents' isolation also increased their sense that they were the only one's experiencing the challenges endemic to this situation. This pressure limited their fuller opportunities to take action that might distinguish their value as persons from the problems they faced regarding housing and economic support, which often resulted in exacerbating their anger and self blame.

Parenthood

Parenthood is a transitional experience that potentially allows for personal growth. It can transform a mother's interpersonal isolation into an intimate relationship with another person, and enhance her self-esteem through caretaking and pride in her child's growth (Golan, 1981). Because parenthood represents a lifecourse transition that encompasses many opportunities for

personal growth, including a maturational thrust associated with adult status and the responsibilities of caring for another, this role complex was a significant source of self-esteem for the mothers. The fact that the mothers retained much hope that they could do better for their children represents a significant, progressive, and self-righting opportunity for them—both to undo their own earlier experience and enhance their competency. Few people acknowledge that parenthood—for poor women who need public support—can be a strong source of and motivation for change.

As Edin and Kefalas (2005, p. 206) state, based on their study of poor, single mothers, "Finally, we believe that the stronger preference for children among poor women can be seen in the propensity of the women interviewed to put children, rather than marriage, education, or career, at the center of their meaning-making activity. Presumably, people of all social classes show a deep psychological need to make meaning. Over the last half-century, new opportunities to gain esteem and validation have opened up for American women. But these new alternatives—the rewarding careers and professional identities—aren't equally available. While middle-class women are now reaching new heights of self-actualization, poor women are relegated to unstable, poorly paid, often mind-stultifying jobs, with little room for advancement. Thus, for the poor, childbearing often rises to the top of the list of potential meaning-making activities, from mere lack of competition."

Some mothers interviewed found it challenging to try to become the parents they wanted to be, and perform the tasks of empathetically attending to the psychological and developmental needs of their children. Although some parents wanted to do better, fear of loss of custody—associated, in some cases, with their own placement and, in other cases, with public dis-

course—kept the parents either from accessing help to solve parent-child problems or from understanding that such problems may be related to stressors, including those that are a natural part of family development. Often, the mothers doubted whether they could live up to either their own or "society's" expectations about their competency as parents.

Implications for Human Service Workers

It is wise for direct service workers to refrain from expressing their personal assumptions about the choices women have made, and listen as clients discuss their points of view, experiences, and hopes. Careful listening creates an amicable, collaborative relationship, in which autonomous, positive development is most likely to occur. Validation and support of strengths and self-righting capacities promote "potential identities" that are different from and represent a more accurate reflection of clients' abilities than do past identities.

Well-trained workers realize that the act of listening is both validating and indicates to individuals that their concerns and needs are understandable to another. Such a reflective stance on the part of helping professionals can both enhance "possible selves" and serve as a model for parents to mindfully respond to their children's internal states, whether of pleasure or distress (Slade, Sadler & Mayes, 2005). Inspiring change in workers' values, knowledge, and skills is a productive endeavor that requires commitment on the part of both service providers and staff. Training workers in assessment based on a lifecourse perspective sensitizes them to clients' personal resources and needs at a particular life-stage.

A strengths-based assessment can recognize women's expertise, use of adaptive strategies to confront stressors, and identify the extent to which the strategies are effective for a range of situations. In addition, this collaborative assessment can enable women to cope more flexibly. Learning to use these assessment tools, and a trauma protocol, will help shelter workers understand trauma-related behavior, so that they can develop appropriate interventions that encourage women to talk about their experiences and begin to heal.

Based on findings from this study, a new hypothesis is that the mothers' and service providers' conflicts and misunderstandings shielded both groups from recognizing a range of painful feelings and experiences, albeit at the cost of helping the mothers find new ways of coping with feelings. Supportive, knowledgeable supervision can help workers recognize the difficulties involved with both tolerating and addressing painful feelings that are part of their daily work.

Facilitating Shelter Worker Effectiveness

Unfortunately, transitional housing budgets often do not provide sufficient funding for professional and in-service training. Such additional funding would likely support workers' growth in assessment and intervention skills, increase their awareness, improve their listening abilities, and create more job satisfaction. This, in turn, would augment worker retention. However, worker support groups and group supervision are cost-effective ways to provide new knowledge, foster exchange of information, build cohesion, and model validating relationships.

A second alternative is to develop community service training consortiums that involve schools of social work and allied professional disciplines (e.g., nursing, early childhood education), in partnerships with shelter operators. Such interdiscipli-

nary training could build on service workers' experiential knowledge while providing shelter staff with more structured learning on site. Financial incentives, such as loan forgiveness and educational stipends, could help individuals to access professional education that could meet the critical need for skilled staff.

Since groups help individuals develop social skills, the shelter is a natural setting for the implementation of group projects, such as planning for holiday events, which create a sense of common purpose. Completing projects supports confidence. In the shelter, the controlled intimacy provided by the group facilitator can reduce anxiety that many women have about gossip, confidentiality, boundaries, and connection to others. Group processes enhance self-esteem, offer new experiences with social relationships, and provide new outlets for the wish to help others. Helping others, in turn, is a source of positive identity and promotes the sense of being part of a larger community.

Affirming Good Parenting In the Shelter

Because the arrangement of physical space in the shelter significantly affected the women's adaptation to parenting, it is important to provide parents living in rooming-house-style shelters with opportunities to *be* parents. Allowing them to cook meals together on special occasions, for example, or to install a microwave oven so that they can prepare snacks and light meals, would help parents, in part, fulfill the role of nurturer. Common areas equipped for mother-child interactions remind parents of what they have in common. Such a setting also provides a neutral, larger space both for parents to interact with their children, and for children to interact with other adults and children. In all shelters, programs also should address the needs and interests of the fathers. This is especially true for shelters

such as The Arche, where fathers do not live with their families. Such inclusive programming will help both parents better communicate and solve problems.

While it is important to acknowledge and sustain hope in the self-righting capacities of parenthood, it is also important to assess the psychosocial barriers that reduce hope. The permeable family boundaries inherent in shelter living both expose parents to increased scrutiny and offer staff an opportunity to observe patterns of problematic parent-child interaction over time, which they can communicate to parents in a nonjudgmental, credible way. Plausible, tactful observations, combined with attention to parents' perceptions and purposes, preserves the hope that they can, indeed, make a difference in the lives of their children. This approach also offers mothers a thoughtful understanding of their children's behavior. A collaborative relationship with shelter workers, based on mutual respect, allows reflective workers, simultaneously, to take on the difficult dual roles of controlling the effect of past experience on present parenting and supporting realistic hopes for the future.

Because parenting issues for sheltered parents are, paradoxically, similar to those of all parents, and unique to the shelter environment, both sets of concerns can be addressed by inviting experts in child development to speak to families about their concerns. I believe this conversational format is nonthreatening and relevant to the stated needs of individuals, and also more appropriate to individual and collective concerns than curriculum-driven, generalized "parenting classes."

Isolation

Of particular concern to me are the mothers who have established an "on my own" identity. While such an adaptation can protect families from exploitation and stress related to the bur-

dens of others, isolation deprives families of major benefits of living in a community. For women deprived by adversity of the hope for positive interpersonal relationships and social support, which so many low-income and poor mothers need to survive, there is an especially great concern. The complexity of human relationships and social networks needs to be better understood, because networks among the poor are essential to survival.

For women who had experienced sexual abuse and reached out for help but received little or no parental or mental health intervention, such as Roseanne, Charlotte, and Milagros, depression limited their emotional, and sometimes physical, availability to their children. For these mothers, the ability to have someone to speak with while in the shelter, even if not about their traumatic experiences, would have been a valuable beginning. They longed for someone to help them sort out what was right from wrong, to help them establish some moral order that could bring meaning to their lives.

Programs and Processes that Support Homeless Mothers' "Possible Selves" And Improve Life Chances

Programs and services that sustain new roles are among the most important ways to support "potential identities" among shelter residents. To the extent the shelter experience enables residents to learn more about adult roles and enhance their self-esteem, it is important to consolidate the benefits that contribute to the residents being more involved parents and citizens. All the mothers I interviewed envisioned the move to permanent housing as one that could lead to stability and safety. For most of the mothers, this move would be the first time they had lived on their own, and thus they would be taking almost full control

of their own lives. The experience of "having their own" while "being on their own" was both exciting and frightening to some. For women who had been in placement, their new apartment could become the first permanent place in which they might feel as if they belonged.

A full dialogue between worker and client about this life-altering future move is vital. Both workers and parents should ideally apply their enterprise and expertise to locating relevant services based on the families' anticipated daily realities, needs, and available community resources. Some mothers I interviewed who retained community and social connections needed few aftercare services. However, many mothers worried about safety and loss of familiar surroundings when moving to new neighborhoods. Without the support of extended family and community, a mother is deprived of a facilitating environment, which is vital to her being not only a good-enough mother but also the mother she wants to be.

Referrals by workers to community-based programs that meet expressed and identified needs are, therefore, vital. For this reason, if workers identify community activities grounded in parents' interests and concerns, they will both be performing a needed service and communicating their perspicacity in acknowledging parents' priorities and talents. Outreach to women at risk by neighborhood community agencies and shelter staff, through phone calls and in-person visits, will communicate that they have not been forgotten or "fallen through the cracks." Local school or daycare personnel can also invite parents to participate in programs, which will further support their status as citizens, in general, and as parents, in particular.

Non-stigmatizing referrals to local Y's and community centers, or local religious institutions that service a range of families, will normalize service use, offer opportunities for women

to experience being members of a community, and introduce them to others who know the community. In addition, knowing they can return to meet with helpful shelter staff creates a safety net for the women to lessen their loneliness.

Transitional services also should help women develop strategies needed to protect against risks associated with living on their own in poor and sometimes dangerous neighborhoods. Services should importantly include working both with new tenants and landlords, to ensure their compliance with building safety codes. Many of the apartments into which women move have been rehabilitated quickly and, therefore, the quality of repairs is sometimes inadequate. Alerting women to both risks and their rights regarding housing problems is, therefore, important. Providing parents with resources and information about how to obtain repairs, contact the landlord, access legal and regulatory remedies, and procure basic police, fire, and sanitation services are vitally important.

For mothers at high risk before entering the shelter, protective factors in the family and community that mediate specific risk should be identified. Where women are at risk for reoccurrence of violence, coordination among the parent, shelter caseworkers, and a local domestic violence service provider should begin before women exit the shelter. The same thoughtful, collaborative planning and effort must occur for women with mental health risks. Such careful approaches may help prevent shelter re-entry, a problem recently identified by the Homeless Services Administration (Kaufman, 2003; Lin & Smith, 2004).

Often, mothers for whom a parenting support service could be the most helpful are the most vulnerable and threatened. They may see a referral to a program intended to prevent placement of their children in foster care as associated with child removal, and, therefore, stigmatizing and threatening.

Cowal et al. (2000) note that homeless mothers are more likely to have their children placed in foster care both during the shelter stay and after they leave shelter than poor housed mothers. Based on these findings, the authors speculate that this may be because of the frequency of contact homeless mothers have with all service workers. In addition, they found that it is less likely for children to be reunited with their families after placement; speculate it is possible that children were removed simply because of parental homeless status; and question the objectivity of risk assessment in these cases.

Sheltered mothers often are weary of contact with social service workers, and perhaps also wary of further scrutiny. Women with infants or very young children, however, might benefit from home visiting programs that provide a range of educational and preventive health services. One such program, The Nurse Family Partnership (NFP), is intended both to help parents provide more responsive care of the child and to support parents' personal development. The program provides home visiting over a two-and-a-half-year period, and has had remarkably positive, evidence-based outcomes. These include improving the maternal lifecourse and a range of other outcomes in regard to improved infant health and development. The program also shows promise in significantly reducing the incidence of child abuse among the control group (Olds, 2005). These programs can lessen isolation, sustain parental motivation, and slowly develop mothers' interest in using a broader array of community services. For these reasons, it is recommended that home visiting services be fully utilized, especially to assist young mothers and their young children.

Making More Sense of Adversity

Two types of intervention will support mothers in the shelters to make more sense of adversity. The first is narrative practice, which should be part of an intervention repertoire for social work staff and other helping professionals. The second is coherent service delivery and implementation, especially as this pertains to program design.

Narrative Practice

Narrative practice is important for several reasons. A strong body of research suggests that when people gain perspective or another view of their life story, this can lead to their becoming more self-reflective. In addition, narratives often highlight the impact of negative life circumstances on one's identity. Thus, when one can differentiate between what has occurred (e.g., the painful memories attached to both trauma and cumulative adversity and oppression) and what is happening now, this can foster objectivity that leads to self-efficacy.

Findings of recent studies suggest that psychotherapy, at its best, replays and reinterprets each person's unique life story, and is effective because of the mutative effect in helping people move from feeling helpless to a sense of efficacy and control (Carey, 2007). The purpose of narrative parallels the reason women used the shelter system—to change a personal life story and ensure they would not repeat the narratives with their own families. The capacity to develop an identifiable life story can often occur during adolescence and young adult hood.

Telling one's story is universal and uniquely human. The construction of a personal history is an active process that is based on connection among life events that may have been both arbitrary and capricious. The capacity to maintain coherence

and continuity can foster increased self-efficacy, which enables one to more readily overcome both usual and unusual disappointments and frustrations. Narrative can, furthermore, foster a resilient self that is less vulnerable to the "stings and arrows" of how others may see one. It can help one to develop degrees of personal autonomy from the dissonance one experiences, such as the women I interviewed. Their narratives revealed that they experienced dissonance on a daily basis, e.g., they saw themselves as competent, on the one hand, and sensed that others saw them as incompetent, on the other.

People remember events and facts better when they are cast as part of a story rather than unrelated to one another. Several mothers I interviewed for this book spoke of the meaning they made, and other benefits they obtained, by being able to tell me their life stories as well as hear them spoken aloud to an interested, empathetic listener.

Use of narrative also can create coherence. As Cohler (1988) explains, an emerging sense of self, founded on the capacity for mounting a coherent narrative of experience, provides personal continuity, even if one is confronted by unanticipated life changes. The narrative, therefore, is essential for giving meaning to one's life.

Examples of Narratives

The last questions on the interview guide I used when interviewing the 24 mothers are, "How did you feel about our time together? Can you think of other things to add to the things you have said? What was the best part of these interviews? What was the most difficult part? Do you have any questions that I might answer? Is there anything you would like to say or talk about that we have no yet talked about? The answers to these

questions elicited several different categories of interesting responses.

"I Never Had a Chance to Tell Anyone." Most of the women said that they never had the opportunity to review their lives or speak fully about important life-events with another person. As Roseanne said:

> I was eager to tell you, 'cause I never actually told anybody everything. It's kind of a relief. Everyday you would leave, it was like a relief because I never sat down and said everything. Because I was so ashamed to tell my mother or I couldn't talk to my sisters, 'cause they didn't have anything [good advice] to give me. I feel much better, like, talking with you. I'm at ease a little. I know I had to get that [sexual abuse] out first, you know? It's just like, 'cause every place I been they just ask the same questions.

Eartha said, "You are the first person I talked to about the past, present, and future. It's important to talk and I just had to get it out."

Delila said, "I find it better to talk about the abuse [from childhood] than to keep it bottled up, because you may end up taking it out on your children, which is something I don't want to do."

Perspective. Several mothers said the interview process gave them a chance to sort things out. As Elyse put it,

> Actually, I like talking to you. You get my mind going and thinking and I like to do that. It's a way of easing myself. It's thinking, 'cause it gives you a way of sorting out problems, getting options, getting new ideas and stuff like that and

that's a way of like relieving tension. Because you throw out a plan in your mind. You know what I mean? It give me a sense to hear myself talk about me and understand me a little better, you know? By hearing me, even though I understand myself, expressing it opens your mind a little more. Um, I don't know whether you go through these experiences or not. If you talk out your problems with somebody, if you hear what you're saying, you're forced to think about what you are saying. It's out there in the open, not inside where all the wheels are spinning, and you worry about things that aren't even real. I do that all the time.

Talia enthusiastically said: "It's good because I really never had time to sort myself out and realize what I've been through. I think, now, I realize more. It helped me sort myself out."

Connie said, "It's refreshing, 'cause when I can talk to you, you don't have to worry about hearing it back downstairs twisted, when I tell you. Even some things I tell Rayette, she'll get it twisted. But I—it's on tape, so you know exactly what I said, so I can conversate—I don't mind conversating with you because, you might get something out of it. I feel like I get something."

"Talking Can Help Others." Many of the women felt what they said was important, and hoped that it would be disseminated and help others: Talking, in short, had a purpose. Jana said she would like to become a spokesperson for children who are now in foster care or group homes: "Jill, if you happen to talk to anybody, tell them, 'If they can help it, don't live with friends, don't live with family. Try to get yourself together, you know.' Do it on their own, they'll feel much better. It's like a

whole burden came off me. I feel free. Will this help other peo-
ple? Would you need anybody to be a spokesperson?"

Almost all the mothers I interviewed were incredulous that
another would want to listen to them speak about their lives,
and that having a wider audience understand their lives might
be helpful to others and change some social policies that had
effected their lives. Dionne said,

> I couldn't believe it, when they said you were
> going to interview us, and find out what we went
> through as a child. I never thought it would be an
> open book or a topic to talk about my life. Be-
> cause I always kept that shut in me. My mother
> used to say "Minister to other children," mean-
> ing, um, speak to them about it, you know. Let
> them know what you went through. And I could
> never tell them how I really wanted to tell them,
> like the lonely nights. It's funny because, you
> know, you were interested. This is my chance to
> let the people know how it is out there.

Interpreting and Applying Narratives

The mothers' narratives in this book address degrees of aware-
ness about the social construction of their own experience, and
the meaning race, sex, class, and "the times we live in" gave to
their present lives. Roberta and Jana, for example, remained op-
timistic about their lives, recounting strong, hardworking par-
ents; others who had significant losses, such as Charlotte and
Milagros, were pessimistic and worn out. Soleil and Delila were
most aware of the ways in which chance, race, and power
shaped their opportunities. Sabina and Elyse resisted "shabby
treatment," which often was a result of such factors, and each

thought there were ways to design services characterized by the "Golden Rule." Dionne humbly vowed to comply and do better. Enterprising utilization of such narratives by direct service staff will lead to self-reflective, collaborative practice and intervention, which could provide a lasting impact on the present and future life chances of all shelter residents.

As mentioned above, one goal of narrative practice is to have the individual focus on the impact of negative life circumstances on identity, and to construct an emerging sense of self, with an awareness of having overcome adversity. Narratives arm the narrator with a perspective about how one can overcome continuing challenges and unanticipated changes.

Given the comprehensive negative effects of homelessness and poverty on family identity, narrative theory and practice—with its particular focus on the impact of negative circumstances on identity—provides a means of expanding perceived possibilities and elevating disempowered families.

Within the family shelter system, narrative techniques have been successfully used in family groups. Fraenkel (2006), for example, describes narrative practice used in the shelter-based, multiple-family discussion group program "Fresh Start for Families." The program was developed collaboratively with sheltered families and shelter staff to support families exploring and discovering solutions to the pressures and problems they experience, both in shelter living and as they move beyond the shelter.

In particular, the practice of *externalizing*, a technique derived from narrative family therapy, helps families and individuals to locate a problem outside rather than inside themselves. It thus lifts the weight of a "homeless only" identity. Placing the problem in a story line helps separate self from the problem. As a product of both culture and history, the narrative

allows individuals, families, and groups to come to understand that their problems, with which they are coping, have been socially constructed and created over time. It allows human beings to realize that they and their problems are not the same thing. When a problem is externalized it then becomes possible to identify the particular practices (i.e., *habitus*) that sustain this problem, as well as particular practices that might diminish its influence. It thus leads to increased understanding and helps one develop incrementally flexible options for avoiding negative effects.

Placing problems, such as isolation, into a story line can begin to shed more light on how the story has come to occupy such a prominent place in one's daily life. The narrative procedure might have been helpful to Elyse and Sabina, for example, in identifying the earlier purpose served by isolation, such as getting away from danger, becoming an adept student, and looking ahead. Identifying the purpose served by isolation can lead to an exploration of how their relationships with homelessness and isolation have been shaped by gender, race, culture, class, and interpersonal power relationships. By giving consideration to these factors involved in shaping action, narrative allows individuals to create a new understanding of their lives. It may open up a range of possibilities for action not available when problems are seen as intrinsic to the self.

Groups, especially family groups, help members to become self-reflective about how their actions may affect others—particularly those with whom they wish to preserve their relationships (Fraenkel, 2006). Groups also can help diminish the demoralization and stressors due to dilemmas involving economic sustenance, employment, housing, education, daily family functions, raising children in an institutional shelter with time limits, acute and chronic health problems, experiences with

violence, and the social stigma of being families without homes, among other stressors and dilemmas. For families, homelessness can stir up memories and experiences of marginalization and oppression based on race and gender. Stories, like religious beliefs and values, can strengthen family ties, generosity, respect for others, and support for future identities.

Studies of both the life course and homeless adults have reported associations between exposure to developmental adversity and compromised adult outcomes. I question, however, the accessibility of this knowledge to the women I interviewed, who so eloquently spoke in defense of the ways they addressed lost opportunities. Often their eloquence combined awareness and angry vows to garner the resources of their "captors," and as Sabina said, to show them how service could be delivered more fairly and kindly.

Recent studies in the field of narrative theory document the power of using personal stories to account for fame, success, and misfortune. In fact, psychotherapy, and other mental health interventions accompanied by talk, historically have been enterprises that embrace listening to life stories, work with the patient-author to make sense of the story, and in many instances, to change client's present and future life story.

This particular modality is not readily available to the women I interviewed, or to other homeless mothers, and it often seems irrelevant to their lives. They typically lack health insurance to cover skilled mental health services. Poor mothers, and especially homeless mothers, must contend with multiple demands of shelter living, documented in chapters 2 and 3 of this book.

I would speculate that many homeless mothers might feel guilty about taking time to attend to their own mental health needs rather than devoting personal resources, including their

time, to attend to such needs. Siefert et al. (2007) also question the skill of many mental health professionals to provide the relevant treatment that women might accept. Smyth, Goodman, and Glenn (2006) detail the current trends in mental health treatment that allow reimbursement for only a limited number of sessions and very narrow range of prescribed issues, such as substance abuse or domestic violence.

Given this situation, therapists can rarely treat the whole person. Change, as defined by the treatment protocol, e.g., cessation of drug use or severing an abusive relationship, is the preferred outcome. Such a specialized treatment approach can further pathologize the mother by "dumbing her down," leaving other possible problems untreated and undiagnosed, and returning her to the same environmental-relational context, without offering her any positive substantive alternatives. Treatment concerned with integrating the external stress family members experience with their internal functioning targets family well-being, rather than program outcomes, and thus provides scaffolding on which to build positive outcomes in the future.

Coherence in Service Delivery

The women you have met in this book, young mothers of color, have experienced significant trauma and cumulative adversity. We must ask what services will be beneficial for them, and after we answer that question, we must ask how these services can be useful and if they will be available. While many welfare-to-work programs have sought to change life trajectories, and have been well funded, they have sometimes resulted in disappointing outcomes.

The reason often lies in the implementation of the services. One of the most common reasons these programs are poorly

implemented is that they see the client as the problem, a "target of change," and measure change narrowly, ignoring unintended consequences. In the process, they often sacrifice growth inherent in maturational processes and protective factors incorporated in the "forward edge of development." Furthermore, those who deliver these services often discriminate against young women of color, and their skills have not been nurtured. As a result, they are not yet competent to deliver the services effectively. These inadequacies are documented by Burnham (2001) and Siefert et al. (2007), who report there is discrimination toward both women of color and immigrants among direct service workers.

Racial discrimination is associated with poor mental health, as well as with poverty, housing instability, and food insufficiency. Depression is highly prevalent among poor mothers, and mothers of color are overrepresented among poor mothers. Siefert et al. (2007) found that, although both white and non-white women reported depression associated with food insufficiency, a generic perception of unfair treatment was more prevalent among women of color. It is the unjust treatment itself rather than the reasons for discrimination that adversely affect mental health.

Discrimination implies profound social rejection. When indignities build up over time they can have enduring mental health consequences, and may leave a woman robbed of self-efficacy and trapped in a context (*habitus*) of social and personal devaluation.

Several service modifications may have a bearing on helping women to secure and fully utilize services that take into account the complete interconnections of the issues that low-income mothers of color must address. Fels et al. (2006) identify the consequences of specialized mental health services that

address only discrete domains of change (such as domestic violence, substance abuse, mental illness, homelessness, or financial and housing stressors) as the focus of intervention.

Four negative consequences of such specialization are likely to occur: (1) Internal psychological dynamics and external material conditions are treated as separate issues; (2) Young women using shelters often have limited relational ties available, since the relationship with the service provider is time- and boundary-limited. This type of relationship cannot, therefore, serve as a substitute for other relationships, even those defined as problematic; (3) The woman's definition of the problem is not given as much credence as that of the provider, which reproduces power differentials in the shelter environment, including racial, gender, and class issues. This can also, perhaps, replicate a lifetime of limiting her development as a capable human being. These are themes clearly identified in narratives such as those of Kathleen, Eartha, and Sabina; (4) A fourth consequence, which is most important for our discussion of coherence, is that "such fragmentation undermines a woman's development of an internally consistent sense of self, rooted in a cultural and/or geographic community" (Fels et al., 2006, p. 493).

This fragmentation is reflected in the narratives of Kenya and Soliel, who had strong attachments to their neighborhoods, as well as Talia, Alicia, Vanessa, and Maria, who had positive memories of the places that had been important parts of their lives.

A "full frame" (Fels et al., 2006) approach requires service provisions that address both external and internal factors. An example of an external factor is the limitations on a mother's time, which affects internal factors, such as her choice to place her children's needs over her own mental health treatment. To address this problem adequately requires that service providers

respect the importance of women's extant relationships and their role definitions (especially when many other roles have been relegated to shelter providers and/or devalued). Service providers need to be flexible and accessible, respect that mothers are busy, and not see it as resistance if mothers can't keep appointments during restricted agency hours. The approach should create an opportunity that allows women to control the process of framing their own narratives and intentions, addressing concerns that emerge, and encourage a sense of belonging to a community of others larger than oneself.

Services both during and after the shelter stay must also be comprehensive, validating, flexible, and family-centered (Weinreb et al., 2007). Women must balance competing role demands with their energy and resources within the structure of the shelter system, where there may be some institutional supports. When women leave the shelter system, these competing role demands often become more pronounced.

Services that are accessible and use a family focus both as an entry point and basis of service provision resonate with mothers' expressed, unmistakable hopes for the future of their children. There is a strong relationship between the mothers' level of emotional distress and adverse child behavioral outcomes. This suggests that intervention that improves the mothers' level of stress, combined with treatment of depression or other diagnostic nosology, will positively affect parenting practices and result in improved child outcomes. Support that helps mothers to meet the needs of their children, while they manage their illnesses and multiple role demands, must be clear expectations of service goals. Mental health services must be directed toward strengthening the parent-child relationship within the context of an accurate mental health diagnosis. Services that normalize the impact of stress on mental health suggest that use

of such services is consistent with clients' goals, and thus creates a collaborative, strength-based, working relationship.

Weinreb et al. (2007) also emphasize that coherent treatment must take into account the impact of trauma on relationship issues with service providers. Educating mental health and other service providers about the importance of boundaries, redefining resistance as a fear of relationships, and reframing demanding or controlling behavior requires both in-depth training and skilled steady supervision. Standardized, balkanized service delivery approaches—given these challenges—can easily lead to perplexing, frustrating, mental health services. This, in turn, can cause disappointment for both clients and service providers. For providers, it repeats prior experiences with stressed clients, and for mothers, it repeats prior service failures with mental health professionals. If someone such as Roseanne, for example, had received services that resonated with her definition of the problem and needs, then she would have eagerly used them rather than, as she put it, "Cry out for help so many times," with no response that made any sense to her. Skilled, developmentally relevant mental health services were part of the effective experience that Delila and Marion remember as helpful, and that made a difference, both when they were in out-of-home placement and after they left placement.

It would be a glib overgeneralization to define every woman in this study as resourceful. They often had few resources, which created an increased reliance on both limited services and family and neighborhood support systems. There can be no clearer example of this than the residential "doubling up" and expectation by the DHS that sheltered women continue to live in overcrowded and stressful conditions (Vera, 2005).

Helping mothers without homes to become more resourceful can mean working with them to overcome fears and teaching

them how to make the best use of extant services. Such help requires that service providers be familiar with the resources, the ways in which they can be accessed, and the regulations—a rare combination of skills, in my experience.

I am familiar with several effective community-based organizations, such as The Child Welfare Organizing Project (CWOP) and Community Voices Heard (CVH), which are excellent exemplars of advocacy groups familiar with resources and regulations. They offer political and financial education. Also, they provide the opportunity for poor parents to become social activists and belong to a community of others that is larger than themselves. These groups also use the clients' own experiences and ideas to develop strategies. They also promote policy research and critical thinking capacities among their members. These organizations have successfully sustained their integrity via substantial private funding, and are thus less rigidly tied to the strictures of government funding, which allow them to assert their autonomy and make their voices heard. They help women become more competent and resourceful. Although they cannot replace a generous support system, such sustained grass-roots organizations have much to teach both participants and policy makers about healthy resistance and how to change services to utilize clients' solutions rather than focus on the clients as the problem.

The Shelter System

Though the shelter system was originally created to respond to a housing crisis, it had become a new and growing, seemingly permanent, social service structure (Bogard, McConnell, Gerstel, & Schwartz, 1999; Friedman, 1999). This new structure both meets basic survival needs and provides a range of ser-

vices, the efficacy of which has not been examined. In addition, it has evolved into a real estate office for the very poor (Friedman, 2000). To me, these shifts and changes suggest that transitional housing can also be viewed as a system of secondary prevention, which can promote positive outcomes by reducing stressors and interrupting further accumulating risk and trauma (Kubiak, 2005). The mothers chose the shelter system to reduce the personal impact of harmful experiences, to stop their lives from "spinning out of control," and to halt the progression of cumulative risks, which would have undermined their adult development. The shelter system functioned to reduce risk, open up positive opportunities for growth, support the determination to take control of their lives, and encourage the forward edge of development.

Temporary Tier Two shelter use provided a bridge to adulthood for the young women with children. The transitional time and space afforded by the shelter gave the women an opportunity to turn adversity into adaptive growth—supported by maturational thrusts of parenthood and young adulthood—and to integrate identity, enhance parenting and social skills, and augment self-esteem. Both the meaning the women made of the transition and the impact of environmental qualities on their internal experience of change affected their emerging adaptations, especially as regards their self-esteem, social skills, and parenting.

Social Policy Implications

Some primary risk factors associated with homeless mothers' shelter use and futures can never be altered by social policy, e.g., age, gender, race. Yet both legal precedent and social welfare policy implicitly affect how potently these biological fac-

tors converge to influence the life course, especially when there are limited family and community buffers. Social policy can, for instance, address what housing gets built, what the ratio of income-to-rent might be and, thus, what choices a family is able to make.

Values and Opportunity Structures

Although single parenthood has been and continues to be a choice for middle class women, many of the mothers I interviewed also made a choice, but it was based on different criteria. They had to calculate the costs and rewards of their choices under circumstances of less control and more uncertain future prospects. Waiting to see what might happen to the men who were the fathers of their children meant they had to order their life circumstances differently than women with more financial resources. Mothering, for them, had a different cost-benefit ratio.

They chose to have children—and were not mere "victims" of mistakes—based on a difference in values and opportunity structure. Clearly, economic and income policy can change the odds for parents, so that some of their children can have a two-parent family, access to good jobs, and a future career ladder that will support both parents as they mature.

There is substantial empirical evidence that both men and women are involved in less risk taking and impulsive behavior as they mature. Two policies that would allow children better odds for a two-parent family are employment that paid a living or rental wage and a generous tax credit program, with higher monetary return, which would enhance motivation for employment.

In addition, training and access to education for both parents, and adequate, flexible, childcare subsidies would allow parents to communicate and plan rather than argue about making ends meet. For instance, if parents like Marion and Kareem wanted to go to school at night, and work during the day, they could hire a subsidized baby sitter one evening a week.

Coherence or Fragmentation In Workforce Development Programs

A second economic, class-related issue lies in access to social networks that are more readily available to middle class families (Fram 2003, 2004). For youth with few social ties or local economic networks a job is just a job without a career path or possibility of upward mobility. For young adults without a varied social network, access to labor market connections is limited. They have few opportunities to create economic and personal capital, and less access to valued social roles.

At the present time, there are several initiatives that provide valued skills and future social roles to high school students. For example, programs funded though the New York City Department of Aging are providing collaborative three-year training at institutions caring for the elderly. Through such programs, high school students will obtain the skills and knowledge, and receive a certificate, to care for older persons—a professional role that will be increasingly valued with the graying of our population.

Many of the mothers I interviewed sought such a role, and understood that it would be both profitable and fulfilling. For instance, if Vanessa had access to such training and adequate childcare, she might have been reunited with her son and not have had to use the shelter system.

In contrast to these programs, which provide relevant and meaningful roles for young mothers based on "hands on" learning, are many welfare-to-work programs that offer both inadequate skills development and support for individual interests and abilities. Such a program is "We Care," which recently was developed by New York City's Human Resources Administration. It is charged with developing and implementing programs for public assistance recipients and applicants having multiple and complex barriers to employment. We Care spent $201,465,000 of public funds over three years to serve an estimated 45,600 persons per year! Contracts were performance based. Of those enrolled, 5.4 percent, or 2,500 individuals, obtained employment while in We Care, according to Kasdan and Youdelman (2007).

A report by "Community Voices Heard" (CVH), a grassroots organization composed of present and former welfare recipients, trained members in research protocols (Kasdan & Youdelman, 2007). The report, titled "Failure to Comply," indicates that there was a wide gap between program design and program implementation and practice. Not only did HRA heavily invest public dollars to provide meager outcomes, but the assessments of barriers to work were of poor quality. Program participants, who were categorically labeled, documented that the staff lacked both information and flexibility. Few services were specialized or individualized for persons with complicated barriers to employment. Workers were not trained and there was high staff turnover. Such a program would not have benefited mothers I interviewed who had multiple special needs, such as Eartha and Lucia.

The new Work Advantage subsidy developed by DHS that has, in part, replaced Housing Stability Plus, suffers from several gaps in program design and implementation. These short-

comings may lead to public questioning of the values of the public officials who developed newer housing subsidies. They also may lead formerly homeless heads of households to re-experience failures.

The Work Advantage subsidy requires that families have formal savings accounts, which at the end of the two-year subsidy period is matched by city dollars. It is often difficult, however, for the families to save, considering their many urgent financial needs. The subsidy is based on solid—but middle class—norms, values, and assumptions, which are not yet familiar to the families without homes.

The morality of social welfare programs designed for very poor people must be questioned by the public, which has sanctioned its dollars to be used on behalf of the poor families.

The public expectation for poor individuals and families to become self-sufficient is usually based on assumptions about the latter's moral flaws or personal weakness. It is much more difficult for the public to evaluate the ways programs are implemented by sanctioned public entities. Means tested housing subsidies related to market rents are clearly the most effective component of stabilizing families.

There are many other approaches to housing subsidies than HSP and Work Advantage. For example, a subsidy could be calculated based on the ratio of Average Monthly Income (AMI) to rents, computed on the local level. A second productive, alternative strategy, which is used in Westchester County, New York, is to increase the housing allowance for everybody on public assistance. This approach has proved successful by decreasing the overall incidence of families without homes. This is a better strategy than a policy intended to prevent shelter use by making shelter entry humiliating and psychically and emotionally taxing, and that erodes dignity and exposes parents

and their children to more cumulative risk (especially health risks). Such a policy often requires that families return to over-crowded and overextended support network resources.

Age-related subsidies would address the second risk factor, i.e., youth. Shinn, Baumohl and Hopper (2001) point out that adolescents and young adults are frequently those with the least financial resources. Providing a "starter subsidy" for this age group to help launch them into fully independent living would be wise, in that it would allow them the same supports that middle class families offer their young adult children, i.e., a family financial safety net.

Such age-related, means-tested subsidies should also be applied to students who are working with and engaging in post-secondary education, either in the form of scholarships or housing arrangements provided by university student life services. For these youth, the motivation either to work or obtain an education should be rewarded by a government that provides either a savings account or other financial reward for their desire to become self-sufficient adults.

Housing: Supporting Life Chances for Future Generations

Housing is the best indicator of living standard, when the standard is measured by both the level of economic investment in infrastructure and the quality of the amenities available. Where you live has a prominent impact on your life chances and changes. Rosenbaum and Freidman (2007) make a cogent case that the well-being of present and future generations is affected by racial discrimination in housing. Racial segregation most severely undermines the present generation of nonwhite New Yorkers, particularly those of African American descent, from

taking advantage of opportunities formerly open to immigrants of European descent, which enabled them to get ahead and ensure a better life for their children and grandchildren.

In the first decade of the 21st century, spatial stratification by neighborhood has been far more difficult to manage than for previous generations of new Americans. According to Rosenbaum and Friedman (2007), spatial assimilation is the process whereby immigrants and ethnic minorities move into neighborhoods that were formerly, for them, the next "rung up" on the socioeconomic status (SES) ladder, i.e., neighborhoods in which the housing quality, schools and neighborhood amenities are better and offer more opportunities than those in the older neighborhoods they came from. The newer neighborhoods also more readily allow for social connections with those of higher socioeconomic status. In some of these neighborhoods, a percentage of older residents who have yet to move out combine with newer residents moving in, which gives such neighborhoods both a mixed class and racial/ethnic composition.

The study by Smith et al. (2005) for the Vera Institute of Justice clearly identifies those who used the shelter as coming from under-resourced neighborhoods where the housing was substandard or dilapidated. Heads of households and their children often were trapped in high poverty neighborhoods and workplaces where others with the same educational and occupational credentials lived and were employed. According to the Vera study, in a section devoted to "shelter re-entry," it is reported that one-third of those who exited shelter in 1994 returned within 10 years, and that the risk of reentry was the highest in the two-year period following exit from the shelter. This was not true, however, for those exiting to subsidized housing—where the return rate to the shelter was low and consistent

over time. The report concludes, therefore, that subsidized housing provides the best protection against repeat shelter use.

Families who exited the shelter to mixed-income subsidized housing, under the auspices of Mitchell-Lama housing legislation in New York City, had the lowest return rate, followed by those who were in the NYC Housing Authority. Smith et al. also found that a longer shelter stay predicted a longer time until return, most likely because of the issue of cueing, i.e., those who waited for access to housing subsidies sometimes stayed longer in the shelter system. The Vera report further found that several other demographic risk factors predicted shelter reentry—even among individuals with a housing subsidy. For those with children, single-parent, male-headed families had a higher return rate than single-parent, female-headed families. The Vera report speculates that this finding may be attributable to lower income and, perhaps, also to previous trauma issues and loss (Smith et al., 2005).

Race and ethnicity also are factors in shelter reentry, with black families generally having the highest rate of reentry. While the Vera study (Smith et al., 2005) speculates that this is likely because ethnicity masks other characteristics, such as low income and employment discrimination, the report did not consider housing discrimination as a factor in reentry. Yet the findings of Rosenbaum and Friedman (2007) on housing discrimination, discussed earlier, might be relevant in this context.

When families are relocated to neighborhoods with limited housing resources and are entrapped, again, in their familiar social location, this "syndrome" serves to reinforce tenuous social arrangements with which poor parents must contend. It results in a host of limitations, including limited autonomy, options to move among different social networks, development of social capital, and capacity to build community networks.

In summary of the above, although the factors discussed do not point directly to housing discrimination, the Vera report clearly substantiates that families who entered the shelter system came from predominately under-resourced areas. This factor, along with findings related to the importance of neighborhood in determining life chances, and that Americans of African and Puerto Rican descent face greater and more permanent obstacles than European immigrants in efforts to achieve socioeconomic and housing status (Rosenbaum & Friedman, 2007), creates profound concern about declining life chances of families in the second, third and fourth generations in regard to downward mobility across generations. The housing choices presently available to them do not bode well for better futures.

One of the solutions identified by Rosenbaum and Friedman is stronger enforcement of housing discrimination laws. These concerns are well founded, in that enforcement of the Fair Housing Act has fallen precipitously since the highest level of enforcement in 1992. In fact, the Department of Justice entered into only eight legal actions related to enforcement of the Fair Housing Act in 2006, and the federal government recently has decreased funding to local fair housing organizations (National Fair Housing Alliance, 2007).

Towards Affordable Housing

Housing instability for extremely low-income households will continue until the supply of affordable housing increases. Resources relative to needs determine overall prevalence rates of stratification and homelessness. In the New York City Area, the AMI, or "area median income," refers to the median income for a family of four, measured across the metropolitan area, including the surrounding near-suburban areas. In New York City, the

AMI for family of four is $70,000. When affordable housing is created, it is priced based on the AMI, making it unaffordable for anyone with an income significantly lower than the area median income (Picture the Homeless, 2007).

In the city the current plan for developing affordable housing, promoted by Mayor Bloomberg, is called *The New Housing Marketplace*. Soaring land costs and increasing construction costs compromise it, however. Low-income housing developers can no longer purchase city-owned property for low prices, and must compete for land with luxury housing developers. As a result, construction costs for all have increased immensely (Murphy, 2007). For instance, "Affordable housing constructed in Harlem can be targeted at families making between $52,000 and $157,000 a year, although the median income for that neighborhood is actually only $26,000 a year" (Picture the Homeless, 2007, p. 16).

Thus, although Mayor Bloomberg's *New Housing Marketplace* plan proposes to create tens of thousands of units of affordable housing, the housing is not accessible to poor New Yorkers, because it follows federal guidelines in targeting households with an annual income of 90% of Area Median Income. The working poor thus have difficulty competing for affordable housing. As with child care vouchers, working class and very low income workers are perpetually competing for inadequate resources.

Despite this situation, the federal government's funding for affordable housing has declined over the past two decades. This has motivated state and city officials to attempt to develop a number of alternative strategies. Other municipalities with scarce land, such as San Francisco, have been creative and committed to developing low-income housing. In New York,

larger organizations, such as the Settlement Housing Fund and HELP, remain committed, entrepreneurial and successful.

Nationally, the most successful results have occurred in Hennepin County, Minnesota, the seat of St. Paul/Minneapolis, which has led the country in developing low-income housing. Their planning strategy used the political resources and will of multiple stakeholders, the local housing and advocacy communities, city government, the county, and the state to create the Minnesota Housing Finance Agency. It is charged with developing a program to shorten the length of shelter stay, and has developed a graduated subsidy that has led to significant progress in reducing homelessness and developing low-income housing (National Alliance to End Homelessness, 2006). New York City has neither produced a citywide count of abandoned property nor used abandoned property to develop affordable housing as other cities have done (Picture the Homeless, 2007).

Housing Trust Funds

Housing trust funds are one critical tool used by many state governments, which realize that housing is the foundation of every well-functioning, growth-promoting community. Housing trust funds dedicate public resources to constructing affordable housing rather than relying on annual budget allocations. There are now more than 38 housing trust funds in more than 35 cities. In New York City, the only such authority is The Battery Park City Housing Authority, which failed to use tax savings and profits to develop low-income housing. It is a symbol to housing advocates and low income New Yorkers of the city's failure to "walk the walk."

Given both the value and the volume of real estate transactions involving legendarily priced living space in New York

City—especially since recovery from 9/11—it is puzzling that the city has not either transferred some part of the rich real estate transfer tax revenue stream to develop such a trust fund or applied it to developing low-income housing, as other cities have done.

Tax and Zoning Policy

Tax and zoning policies can be used to help develop more low-income housing. Inclusionary zoning regulations, for example, which stipulate that new housing development dedicate a portion of new living space to low-income apartments—if the developer is to receive a tax abatement or desired zoning change—is another underutilized avenue of low-income housing production. Inclusionary zoning also serves to mitigate the effects of poverty, by giving lower income families access to better schools and job opportunities in less economically disadvantaged areas.

One cannot help but wonder why city government has allowed powerful real estate interests to control so much of the valuable real estate that everyone has to share. Is it the intention of those who have both the power to tax and dictate housing policy, i.e., city and state government, to have only one class—the wealthy—dwelling in New York City?

Social Policy Consequences

Among the mothers I interviewed, having a safe, affordable home, in which family life could develop, was the primary, expressed need that conformed to the general American value of being a good parent and householder. Housing policy, therefore, should include a range of options for low-income individuals

and families to be able to rent homes. Given the policy direction affirmed in New York's "The New Housing Marketplace," which recognizes the needs of some families for enriched services and longer stays in transitional housing, such facilities should be a specific part of the affordable housing plan.

Subsidies, such as Section 8, have proven to be the most useful form of stabilizing housing for poor and low-income families (Cowal &Weitzman, 2002; Lin & Smith, 2004; Rog et al., 1995). However, as previously indicated, the compromises that less-well-funded-and-stable voucher programs, such as HSP, represent may not only create fear of leaving the shelter (White, 2006) but eventually create the very disincentive for financial independence it was designed to promote, as women transition from public benefits to employment. Because the inspection for HSP apartments is less rigorous than that under the Section 8 plan, landlords may be less inclined to make vital repairs required for safety (Institute for Children and Poverty, 2006). Reductions in the supplements require such a delicate fiscal balancing, that one unexpected emergency expense or "maternal miscalculation" may thrust a family back into the shelter system. Affordable rents and housing are more important to the lives of poor persons than a number of other issues. When a middle-income individual spends half of his or her budget on housing, that is a life style choice; but when a poor family does so, the choice may be between adequate nutrition and shelter (De Parles, 1996).

In New York City, programs to prevent shelter use among those precariously housed (e.g., doubled-up or tripled-up, or in unsafe housing) have recently been initiated in neighborhoods with the most demand for shelter services. New York State must continue to fund the Jiggetts Program, for example, which provides subsidies to help low-income families who reside in stable

housing to meet market rents.

Housing subsidies connected with less scrupulous inspections for safety and health conditions, and that often force families to accept smaller, crowded accommodation than needed, are counterproductive. Requiring a continual annual increase in a family's share of the rent, on a formulaic basis, creates a dilemma: If a woman earns enough to keep up with the subsidy, then she may lose her public welfare; and this, in turn, will cause her to lose her HSP subsidy altogether. This rigid policy may stifle women's motivation to advance financially and professionally.

The way policies are implemented either can be a progressive force in parents' lives or an inhibiting force, which unwittingly contributes to the probability that a crisis may occur again. To the extent that failure occurs because of unintended policy consequences, we will have lost a cohort of families who used personal courage and considered logic to make changes that would have increased hope and given meaning to their lives.

Imagining the Future

If we had a crystal ball, what might we see regarding the chances for the mothers without homes to adopt approaches that sustain themselves and their families on their hopeful path? How should we understand their worries? What would it take for the mothers and their children you have met in this book to break with the past and improve their life-chances in the future?

Consider Delila's concerns, which, indeed, are real, expressed in the following excerpt from her interview: "I don't understand how a person can depend on welfare. They are saying, 'Get off welfare and get a job.' Workfare, that not a job;

that's not a career goal." With the recent governmental decree, during the Clinton Administration, to "end welfare as we know it," impoverished individuals are required to enter into work training programs to earn subsidies. In New York State, there is a 5-year time limit for receipt of Temporary Aid to Needy Families. During that 5-year period, an individual must either enter the workforce or train to enter the workforce to finally succeed in ending welfare benefits.

We know the hardships faced by women with higher incomes who try to balance work and family commitments. Performing these roles becomes even more difficult when confounded by meager public assistance grants—grants that barely cover daily living expenses, public transportation, affordable, quality childcare, and the variability of other benefits, such as medical insurance. In addition, the fluctuations in the labor market make the path to self-sufficiency stunningly precarious. Neither workfare nor welfare-to-work are programs that support motivation to develop a career path (DeParle, 2004).

As Delila said, education is the key to both job satisfaction and a living wage. Until recently, in New York State, higher education has not been as a legitimate alternative to either job training or welfare-to-work. Programs that facilitate higher education, however, are constantly jeopardized by state budget priority commitments. The recent threatened federal cutbacks in student loans and grants, plus the constantly rising tuition in public colleges and universities, threaten the ambitions of women such as Marion, Soliel, and others discussed throughout this book.

For Delila, Marion, Elyse, and Soliel—who clearly had career paths that preserved the meaning of their earlier experiences—applying their life experiences to present personal goals represented both mastery of adversity and acts of altruism.

During my recent experience as a professor and researcher, I became aware that serious educational pursuits of men and women attending City University of New York (CUNY) and other public institutions often have been interrupted by unstable living situations. Students are often doubled up and live in overcrowded conditions, including some students with children. The younger students who have needed to live at home could not attend to their studies because of family obligations. Often their educational pursuits have been interrupted, and the students made the choice to "wait" on their education. Given the pressing need for a well-trained and professional work force, this small epidemic of "education interrupted" is a waste of our nation's resources.

In addition, as Roberta pointed out, the job market for low-income workers is unstable. Public assistance rolls rise with unemployment. Considering the job market, I wondered, "Will Roberta be able to move from her temporary plan to support herself via childcare to realize her entrepreneurial dream of owning a 'chic' clothing store for large women? Will she be able to use her retail experience, talent, and drive to make a living for herself and her son, as she performs her role as a mother? Will the role model provided by her hard working father continue to serve as a guidepost for her, a woman besieged by physical problems? Will she be able to gain the business acumen needed to begin her store by joining a day care provider network, where she can build on her already sound financial understanding?"

Roberta could count on Donald's father to help, and her mother to assist her, with respite from childcare. I asked myself, however, "Will they be available in several years? Will her arthritic condition impede her from the activity needed to start her own business? Will she be able to access a small business loan

at a reasonable interest rate, given her limited experience with credit?"

I also have continuing concerns, of course, about all the mothers I interviewed. About Kathleen, for example, I ask, "Will she be able to use her talent to do something for herself? Become a sound engineer and make enough money to move her children out of the city? To what extent will her loyalty to her husband prevent her from realizing her own dreams? And will his record of incarceration preclude her from obtaining the financial aid she needs to attend technical school?" While marriage may serve as protection for some couples, married women are more reluctant to report marital abuse than unmarried women because of the ramifications in regard to economic need. Women routinely can blame themselves for the abuse leading to a decrease in seeking help and reluctance to leave the relationship, which results in poor mental health outcomes. In the case of Kathleen, it is possible that her *habitus* of considering others before her own needs compromises her ability to move ahead.

About Talia, I ask, "Will she—a new immigrant—be able to apply for and obtain financial aid to attend cosmetology school, and get the license she will need to work in her chosen field?"

Dionne and Ahmal have a strong relationship. Two-parent families are better off than single-parent families. Ahmal is still young. His attempts to find employment in his trade had yet to be fruitful. I wonder, "Will his self-esteem and frustration tolerance enable him to continue to search for legitimate work to support his family? Or will he, as Dionne fears, risk supporting his family by illegal activity?"

Jana, Lucia, Kenya, Milagros, and Roseanne had limited life experience. They were frightened of living alone; they had

been uprooted or alienated from their families, and had few others upon whom to depend. Younger women who had never lived on their own were the most scared. About such women, it is natural to ask, and even more important to be able to answer, "How will they find their way in community living? Who will they be able to count on when an emergency arises?"

Understanding Moral Hierarchy, Choices And Maturational Processes

For Lucia and Roseanne, the chains of risk, especially their choices of men, must be considered within the context of their age, maturity, and the range of survival choices each made when she eloped from care. Both young mothers are in committed relationships with fathers of their children. Edin and Kefalas (2005) note that early childbearing is highly selective among girls whose other characteristics, such as family background, cognitive abilities, school performance, and mental health status, have already diminished life chances so much that an early birth does little to reduce life chances further. Both Kulkami (2001) and Edin and Kefalas (2005) note the contradictory social stigmas and stereotypes in which the lives and "reputations" of young mothers of color are mired. They, along with Dionne and Roseanne, highlight that young mothers feel less judged when they are in exclusive, committed relationships, regardless of the degree to which the relationships may seem healthy and safe. Leaman and Gee (2006) also speculate that romantic loyalty and/or marriage may serve as a protection against psycho-emotional adversity.

If we could predict the near future, we might see that these two youthful mothers, still in the early stages of family formation, are committed to making meaning of important personal

relationships. They equated the loyalty to the troubled men in their lives with wanting to live differently from their parents, by providing their children with a two-parent family. This pledge gives their actions moral sway, though it may compromise their life chances.

We might ask ourselves, "Will these relationships, based on meaning and prior choice, borne of urgency, founder on the stressors of a transition to permanent housing?" Given the youth, family size, and instability of the economic situation of the families, as well as the limitations and significant mental health challenges of the men in the mothers' lives, how will the choice affect Lucia's and Roseanne's level of stress, concomitant depression, and lifelong residential stability?

It is notable that both women, Lucia and Roseanne, worry about the future, when they will leave the shelter. Roseanne is realistically concerned with the pressures that might exacerbate David's substance abuse. Lucia's attachment to Rolando's prowess as a teacher and provider—an attachment that may be based more on wish than reality—lessens her personal distress.

Based on my conversations with shelter providers, I learned that both women had established productive relationships with their shelter caseworkers. Neither mother had the chance to see herself as a competent, resourceful person in the world nor had the opportunity to establish a reliable relationship with a mental health provider. Both women had two stays in the shelter system, and their histories indicated they may be considered "long stayers" by DHS. Shelter providers understood that both women might benefit from longer tenure, but administrative implementation of newer shelter policies penalize shelter providers for slower discharge time.

Considering the life trajectories of both Lucia and Roseanne, we must ask ourselves a series of important questions: Is a

precipitous exit to living in the community a 'one-size fits all' remedy that benefits Lucia and Roseanne? How will they cultivate fledgling relational and personal assets when they leave the shelter? Will the support service be there in a context that enables them to mitigate their own "*habitus*" for impulsive solutions, borne of few supports and personal desperation? Will they have the time and support to develop assets and capacities that enable them to stand on their own, or have their own voice to make demands on their men to function as partners?

Will David and Rolando have access to vocational and financial resources that provide access to social value as young men of color? Or to support roles young adult males grow into as they get older? Are there opportunities and time to cultivate these assets that are more available to families in other social strata? Will repetitive stressors leading to conflict, depression, and relational strife blunt the forward edge of development established by parenthood and respite in the shelter?

Will Lucia be able to access the long-term support services she needs? Will the motivation to have her learning disabilities evaluated and addressed seriously be available, if she was not heard while in the shelter? Or will she be sent to a work program for the disabled, where the full assessment mandates of the program to help are compromised by officious and disrespectful workers or the fragmented service systems? Will specialized service staff have Lucia running from place to place without considering the transitions she is experiencing, or offer her relevant, cohesive mental health services based on her hierarchy of choices?

Will Roseanne find time to use mental health services and relevant family counseling to undo some of the trauma she has experienced in her life? Will she be able to use her considerable

artistic interests and love of children in the service of a career, perhaps to become an art teacher?

Or will Lucia and Roseanne become alarmed by the limited support they receive, by the unpredictable services, and by service providers' demands that both they and their men change on time? Will they find themselves again mired in systems (e.g., child welfare, public assistance, housing) over which they have limited control? Will they lose their children and their housing? Will they find their vows broken and their motivation to continue sapped? Will they move from "episodic users of services" to families who move among parts of the housing market, never having a stable room of their own? Will they be further labeled as "chronic, multi-problem families"?

Bogart et al. (1999) point out that cumulative stressors can largely shape one's world-view. The mothers interviewed have been deprived of a stable social location, safe socialization, and family support programs. Their ascribed social identity was often shaped by contexts and experiences over which they had limited control. Freidman (2000) points out that, as difficult as shelter life is, it does provide a sense of safety and community. Thus, mothers without homes may have a more difficult time in the general society than in the shelter, if they are not provided with adequate support systems and resources.

For women like Dionne, Roseanne, Eartha, and Lucia, the humiliation of returning to high school would seem to augur poorly for continuing educational pursuits. Each mentioned the importance of wanting to take care of others. Edin and Kefalas (2005) note that research has demonstrated that programs that engage at-risk mothers in service learning are especially effective, although experts are not sure why. Certainly constructing programs where service learning can be used to complete secondary education, and comes with a career path, would meet the

educational needs of education-shy women. Providing a range of educational opportunities that lead to careers that may lead to self-sufficiency is a worthy endeavor, as this promotes safe interdependency and is useful for society, since, for example, more caretakers will be needed in the future at both ends of the life cycle.

Supporting Life Chances

A major conclusion of the study is that the mothers' use of the shelter was not based on their individual flaws. Rather, it was based primarily on economic, political, and demographic factors, especially race, age, and gender, which narrowed the women's opportunities. Most of the mothers interviewed were young adults, for whom lifecourse needs were similar, especially as regards negotiating an adult identity and role, and assuming full responsibility for their children.

It is vital to provide a range of opportunity structures that support the goals and needs of mothers who want to become contributing citizens, but must overcome many barriers in a wide range of personal, relational, and social domains to meet this goal. When parents make an investment in parenting and identify with socially sanctioned goals that promote the optimal development of their children, society must reciprocate and support parental capacity to be physically and emotionally responsive to children.

Safety and support are pivotal factors in parents' controlling their lives. Most mothers were willing to make conscious changes necessary to move towards their aspirations, especially to form families and independent households. They were determined to be or become responsive parents, and many of them vowed to be different from the abusive or absent caretakers who

had been part of their lives. Policies and programs that add systemic attributes that capture and amplify these processes will facilitate positive adaptations. Such programs and policies hold the promise of both buffering intergenerational transmission of poor outcomes and supporting the determination of the mothers who, like Roseanne, wish to "break the chain."

Suggestions for Further Research

The methodology used in this interview study focused, simultaneously, on participants' narratives about a remembered past, actual present, and subjunctive future. A prospective longitudinal study that followed sheltered women into the community would provide a lens through which to view how they change as they move on from shelter living. It could allow one to answer the research question, "Did transitional living in the shelter serve as the bridge to residential, community and family life the women hoped it would be?"

Longitudinal research also could address another important issue germane to this study. As previously discussed, the risk to women of continuing isolation as they move from the shelter into the community is of great concern, because support networks are crucial for poor women to sustain taking care of themselves and their families. Longitudinal research focusing on the qualities of social support networks for women who become community residents, therefore, could help workers and transitional shelter staff to build in environmental opportunities that support women's acquisition of social skills, to help them make the transition from shelter to autonomous residential life and better plan for their futures.

Although this book has focused on homelessness among young mothers, two other concerns have been highlighted: op-

portunity structures and personal and family development. Three research initiatives would be useful for determining how opportunity structures could support stability and other positive outcomes, for both current and future generations. These initiatives involve the efficacy of "bridging opportunities," i.e., structures that provide paths to fuller autonomy and positive family development.

Education and employment are clearly routes that either can limit or expand a family's capacity for fuller personal and financial autonomy. One concern, however, involves ways that housing disruptions and family life stressors affect education and employment, e.g., it is most difficult for students to focus on their academic studies or for employees to routinely show up for work or perform complex activities on the job, if they are coping with housing disruptions, family life stressors, or both of these negative life conditions. Many of the mothers you have read about in this book had their educational pursuits interrupted because of an amalgam of intersecting, partially planned changes and limited resources to respond to these events.

In New York and other large cities, with a heavy concentration of both public and private institutions of higher education, a pressing need exists for student housing. Little has been done to measure this need, however, especially in public institutions, which provide the greatest access to higher education for adults with limited means.

There are many psychological and wellness programs intended to help students resolve normative issues related to managing academic stress and personal problems at public universities. Housing stability is a hidden problem. Many students are ashamed of having no place to call their own. In addition, the affordable tuition of public universities is often predicated on one having an address within the city or state where a university

is located, i.e., students must provide a local address to be eligible for, and take advantage of, low tuition.

In large cities with expensive housing, institutions of higher education must compete for both distinguished faculty and students capable of high academic achievement who will advance scholarship as well as the national prestige of the university. It is difficult, however, to recruit talented faculty and staff to New York City, from other parts of both the nation and world, when the rents are so high. Although financial aid is possible to obtain, it is limited. Both educational institutions and their students must struggle to balance high housing costs with the motivation to achieve successful educational outcomes.

For CUNY students, there has been only anecdotal information about their housing status in general, and the extent of their housing stability is unknown. Studies do not exist, unfortunately, regarding how housing affects their academic achievement. To address these pressing concerns, perhaps we should turn to universities in large, European cities, such as Paris, Madrid, and Barcelona, for alternatives to meet the needs for student housing. Many Western European universities, for example, support housing programs in which students share housing with single adults who have the room. The students often can perform necessary work for the older adults, and the latter receive a rental subsidy from the university that can supplement their income.

In order to launch such a program in New York City, or elsewhere in the United States, it is vital to determine the housing status of students and the extent of their problems in general, which can be done through survey research. In addition a qualitative study could help determine the ways that housing status affects academic achievement. The same is true of other opportunity or bridging structures that help families achieve fi-

nancial and personal independence, e.g., workforce participation.

The current, annual meeting of The National Organization to End Homelessness produced a research agenda to fill gaps in knowledge and identify solutions to end homelessness. The agenda advocated that research should accentuate intervention evaluations to increase understanding of how program components are implemented. The organization's report recommended that study designs identify key ingredients and aspects of programs most strongly related to outcomes. Weinreb et al. (2007) provide such a research model for examining holistic provision of mental health services to homeless mothers, which is worth replicating with other interventions.

Finally, the issue of the quality of both housing and neighborhood and their effects on providing opportunities for succeeding generations must be examined fully. This should be done in New York City by replicating the Vera study (Smith et al., 2005), using available data from DHS, HRA and the census. Ideally, such a study would comprise a longterm design to follow the course of future generations, and the results would help us to understand the impact of neighborhood and community characteristics on both families' relocations and the agency and social support they receive after they leave shelter.

Although this research project employed 24 respondents, which is a relatively large sample for an in-depth interview study, I recommend that the findings be generalized with caution to all mothers without homes, given that certain factors defined the limits of the study, such as that it was conducted in one city and that the mothers lived in two shelters, The Arche or The Lincoln. Other researchers, however, have developed implications consonant with this study, e.g., the shelter system as

an accessible institutional route to garner resources (Berlin & Mcallister,1994; Gerstel, Bogard, & McConnell,1999).

A larger and more heterogeneous sample, in terms of socio-demographic variables, would allow for greater generalization of some of the findings, and enable researchers to better document the meaning of individuals' use of shelter systems over a wider span of lifecourse needs. These data, in turn, would enable planners to better predict how structural pressures impact lifecourse transitions and vulnerabilities, and to answers questions such as, "Do families, as they grow, use the shelter system to gain access to more needed space?"

In conclusion, it should be mentioned that both the iterative nature and intensity of the interview protocol might have excluded women burdened by substance abuse, mental health difficulties, or histories of recent abuse. While it may be possible to minimize this factor in future research, any interview study of shelter mothers must necessarily rely on the voluntary participation of individuals; and because of this fact, it would seem that any sample will be biased towards those respondents who are more motivated, have fewer mental health problems, and believe that what they have to say is of value, both to others in similar situations and in the larger society. For these reasons, this potential source of respondent bias not only should be acknowledged by researchers, but also minimized to the extent possible in future studies.

The mothers who participated in this study not only wanted to speak about their experiences, they also wanted other women and, especially staff members—who affected their daily lives—and professional policy makers to know what they knew; and they hoped their experiences would be of help to others, especially to other parents without homes and women living in substitute care.

It may well be that the mothers in this study represent a resilient sector of women with a demonstrated sense of agency. The very fact that they chose to use social institutions to meet their needs when they had few other options, and that they sought to protect themselves and their families rather than accumulate more risk, is a tribute to their resourcefulness and persistence.

Appendix: Table of Mothers' Characteristics

▯ = None or Not Applicable

Characteristic	Alicia	Charlotte	Connie	Delila	Dionne	Eartha
Age	25	22	29	23	20	24
Ethnicity	Latina	Carribean-American	Mixed	Latina	"Pure Black"	African-American
Age/Sex of Children in Shelter	8 mo/M 4 yrs/M 5 yrs/M 6 yrs/M	4 mo./F	6 yrs./F 3 mo./F	!7mo /F 5mo /F	2 yrs./M 3 mo./M	6 mo. Pregnant
Age/Sex of Children not in Shelter	▯	▯	▯	▯	▯	4 yrs/M; 1 yrs/M; 6 yrs/M; 2 yrs/M
Placement Status	▯	▯	FC, KFC	FC, Group Home, RTF, Teen Residence	FC, RTF, Group Home	▯
# Moves Before Age 18	3	3	12+	12+	14	4
# Moves from Age 18-Shelter Entry	5	3	6	6	6	10
Marital Status	Single	Single	Single	Separated	Single	Single
Highest Educational Degree	J.H.S.	H.S.	H.S. + Secretarial.	H.S.+3-yrs college	J.H.S.	J.H.S.
Past Employment	waitress	▯	office assistant	entry level jobs	▯	▯
Childhood Victimization	No	severe sexual abuse	neglect	physical abuse	neglect	witness /neglect
Mental Health Treatment	No	no	no	yes	yes	no
Respondent Evaluation of Mental Health Treatment	▯	▯	▯	effective	ineffective	▯
History Substance Abuse	No	no	no	no	no	yes
Current Address	Lincoln	Arche	Arche	community	Lincoln	Arche
Who Currently Living With	4 sons	daughter	2 daughters	2 daughters and friend	son, daughter, children's father	self
Time at Current Address When Interviewed	7 mo.	7 mo.	5 mo.	2 yr.	2 mo.	2 mo.
Total Length of Shelter System Involvement	8 mo.	11 mo.		5 mo.		3 mo.

Characteristic	Elyse	Jana	Kathleen	Kenya	Linsay	Lucia
Age	25	24	27	19	39	19
Ethnicity	African-American	Carribean-American	Latina	African-American	African-American	Mixed
Age/Sex of Children in Shelter	8 mo./M	3 wks/M	4 yrs/M 14 mo/M	3 mo/F	pregnant	2 yrs/F 4 mo/M
Age/Sex of Children not in Shelter	▯	▯	▯	▯	12 yrs/F; 10yrs/F; 9 yrs/F (All, KFC)	▯
Placement Status	Group Home	FC/Group Home	▯	none	▯	FC/ Group Home
# Moves Before Age 18	5	6	3	2	3	20+
# Moves from Age 18-Shelter Entry	6	5	6	4	10+	7+
Marital Status	Single	Single	Married	Single	Divorced	Married
Highest Educational Degree	H.S.+ 3-yrs college	H. S.	J.H.S.	J.H.S.	H.S.+ Military	J.H.S.
Past Employment	meat wrapper	summer jobs/irreg.	retail/ steady	summer jobs/irreg.	manager	▯
Childhood Victimization	no	physical abuse	no	neglect	no	yes
Mental Health Treatment	no	No	▯	▯	▯	yes
Respondent Evaluation of Mental Health Treatment	▯	▯	▯	▯	▯	positive; but no follow up
History Substance Abuse	no	No	▯	▯	yes	yes
Current Address	Arche	Arche	Arche	Arche	Arche	Lincoln
Who Currently Living With	son	Son	sons	daughter	self	spouse & 2 children
Time at Current Address When Interviewed	7 mo.	6 mo.	3 mo.	2 mo.	1 mo.	11 mo.
Total Length of Shelter System Involvement	8 mo.	9 mo.	3 mo.	5 mo.	2 yrs.	2 yrs. (Cont'd)

Characteristic	Maria	Marion	Milagros	Natalie	Nodica	Rayette
Age	51	23	20	22	23	22
Ethnicity	Latina	Carribean-American	Latina	African-American	Latina	African-American
Age/Sex of Children in Shelter		24 yrs/M	3 yrs/M 7 mo./F	3 wks/M	3 days/F	9 mo/M
Age/Sex of Children not in Shelter	7 children over 21 years (4F, 3M)					
Placement Status		FC, Group Home, RTF, Maternity Residence	RTC, FC, Group Home			informal FC
# Moves Before Age 18	2	14	9	5	2	7
# Moves from Age 18-Shelter Entry	5	3	7	3	10	8
Marital Status	Divorced	Single	Single	Single	Single	unknown
Highest Educational Degree	H.S.+some college	H.S.+some college	GED+ vocational	H.S.+ college	J.H.S.	H.S.+business courses
Past Employment	Advocare	HHA/ stable	none	none	retail/ parttime	bartender/ steady
Childhood Victimization		emotional / physical abuse	sexual/physical abuse		emotional/physical abuse	neglect
Mental Health Treatment	yes	yes	no	no	no	brief
Respondent Evaluation of Mental Health Treatment	very helpful	very positive				helpful
Past History Substance Abuse		no	No	no	no	no
Current Address	Lincoln	community	Arch	Arch	Arch	Arch
Who Currently Living With	grand-daughter	son/son's family	son and daughter	infant son	infant daughter	son
Time at Current Address When Interviewed	7 mo.	10 mo.	9 mo.	5 mo.	3 mo.	1 mo.
Total Length of Shelter System Involvement	8 mo.	11 mo.	3 yrs.	7 mo.	5 mo.	3 mo. **(Cont'd)**

Characteristic	Roberta	Roseanne	Sabina	Soliel	Talia	Vanessa
Age	23	18	21	22	19	21
Ethnicity	African-American	African-American	African-American	African-American	Carribean-American	Carribean-American
Age/Sex of Children in Shelter	9 mo/M	3 yrs/F 2 yrs/M	1 wk/F	2 mo/F	1 mo/F	4 mo/F
Age/Sex of Children not in Shelter					4 yrs/F	4 yrs/M
Placement Status		RTC, FC, Group Home	FC	KFC, RTC, RTF		
# Moves Before Age 18	4	9	12	10+	4	5
# Moves from Age 18-Shelter Entry	4	6	19	6	4	5
Marital Status	Single	Married	Single	Single	Single	Single
Highest Educational Degree	GED	J.H.S.	H.S.	H.S.+ college	J.H.S.	H.S.+HHA Training
Past Employment	manage-ment/ retail man-agement (steady)		retail/ parttime	none	waitress	HHA
Childhood Victimization	No	sexual/phys. abuse	neglect	neglect	sexual/ neglect	neglect
Mental Health Treatment	No	yes	yes	yes	no	no
Respondent Evaluation of Mental Health Treatment		too short to help	positive	ineffective/ unnecessary		
Past History Substance Abuse	No	no	no	no	no	no
Current Address	Arch	Lincoln	Arch	Arch	Arch	Arch
Who Currently Living With	Son	husband/ 2 children	infant daughter	daughter	daughter	daughter
Time at Current Address When Interviewed	4 mo.	5 mo.	2 mo.	2 mo.	5 mo.	13 mo.
Total Length of Shelter System Involvement	4.5 mo.	16 mo.	3 mo.	3 mo.	7 mo.	19 mo.

References

Alexander, B. (2003). *The state of the nation's housing: 2003.* Cambridge, MA: Joint Center for Housing Studies for Harvard University.

Anderson, D. G. & Imle, M. A. (2001). Families of origin of homeless and never homeless women. *Western Journal of Nursing Research, 23* (4), 394-413.

Ashford, J. B., Lecroy, C. W., & Lortie, K.L. (1997). *Human behavior in the social environment. a multidimensional perspective.* Pacific Grove, CA: Brooks/Cole Publishing Company.

Atkinson, R. (1998). *The life story interview. Qualitative research methods.* Thousand Oaks, CA: Sage University Paper.

Banyard, V. L. (1995). Taking another route: Daily survival narratives from mothers who are homeless. *American Journal of Community Psychology, 23(6),* 871-891.

Banyard, V. L., & Graham-Berman, S. A. (1993). Can women cope? A gender analysis of theories of coping with stress. *Psychology of Women's Quarterly, 17,* 303-318.

Banyard, V. L. & Graham-Bermann, S. A. (1995). Building an empowerment paradigm: Self-reported strengths of homeless mothers. *American Journal of Orthopsychiatry, 65(4),* 479-491.

Barth, R. (1990). On their own: Experiences of youth after foster care. *Child and Adolescent Social Work, 7(5),* 419-439.

Bassuk, E. L. (1992). Women and children without shelter. The characteristics of homeless families. In M. J. Robertson, & M. Greenblatt (Eds.), *Homelessness: A national perspective* (pp. 257-264). New York: Plenum.

Bassuk, E. L. (1993). Service and economic hardships of homeless and other poor women. *American Journal of Orthopsychiatry, 63(6),* 340-348.

Bassuk, E. L., Bruckner, J. C., Weinreb, L. F., Browne, A., Bassuk, S., Dawson, R., & Perloff, J.A. (1997). Homelessness in female-headed families: Childhood and adult risk and protection factors. *American Journal of Public Health, 87(2),* 241-248.

Bassuk, E. L. & Cohen, D.A. (1991). *Homeless families with children: research perspectives.* Washington, D.C.: U.S. Department of Health and Human Services, Public Health Service, Alcohol, Drug Abuse, and Mental Health Administration.

Bassuk, E. L., & Rosenberg, L. (1998). Why does family homelessness occur: A case control study. *American Journal of Public Health, (78)*, 783-788.

Bassuk, E. L., Rubin, L., & Lauriat, A. R. (1986). Characteristics of sheltered families. *American Journal of Public Health, 75(1),* 1097-1101.

Beatty, A. A. & Boxhill, N. A. (1990). Mother/child interaction among homeless women and their children in a public night shelter in Atlanta, Georgia. In A. A. Beatty & N. A. Boxhill (Eds.), *Homeless children: The watchers and the waiters. (*pp. 49-65). Binghamton, NY: Hayworth Press.

Beitchman, P. (1992). *Homelessness and mental illness: An analytical and methodological review of the first decade of research.* Unpublished manuscript. Graduate and University Center, City University of New York.

Belle, D. (1983). Gender differences in the social moderators of stress. In T. Barnette, L. Bener, & G. Banuck (Eds.), *Gender and stress* (pp. 257-273). New York: The Free Press.

Benedict, T. (1959). Parenthood as a developmental phase: A contribution to the libido theory. *Journal of the American Psychoanalytic Association, 7(4),* 389-417.

Berlin, G., & Mcallister, W. (1994). Homeless family shelter and family homelessness. *American Behavioral Scientist, 37(3), 422*-434.

Bernstein, N. (1996, Oct. 12). Changing course. Giuliani proposes rent aid for homeless families. *The New York Times*, B: 19.

Bitonti, C. (1990). *The self-esteem of women during life transitions: A grounded Theory.* Unpublished Doctoral Dissertation. Graduate School of Social Work. University of Denver.

Blau, J. (1992). *The invisible poor: Homelessness in the United States.* London: Oxford University Press.

Bogart, Cynthia (2003). *Seasons such as these: How homelessness took shape in America.* New York: Aldine de Gruyter.

Bourdieu, P. (1990). *The logic of practice* (translated by Richard Nice). Stanford, CA: Stanford University Press.

Boydell, K. M. Goering, P., & Morell- Bellai, T. (2000). Narratives of identity: Representation of self in people who are homeless, *Qualitative Health Research, 10* (1), 26-38.

Breakwell, G. M. (1986). *Coping with threatened identities.* London: Metheun.

Brooks, M. G., & Bruckner, J. C. (1996). Work and welfare: Job histories, barriers to employment and predictors of work among low-income single mothers. *American Journal of Orthopsychiatry 66(4),* 526-537.

Brown, B., & Perkins, D. (1992). Disruptions in place attachment. In I. Altman & S. Low (Eds.), *Place attachment* (pp. 279-304). New York: Plenum Press.

Browne, A. 1993. Family violence and homelessness: Trauma in the lives of homeless Women. Implications for interventions. *American Journal of Orthopsychiatry. 63*(3), 385-400.

Browne, A., & Bassuk, S. (1997). Intimate violence in the lives of homeless and poor housed women: Prevalence and patterns of an ethnically diverse sample. *American Journal of Orthopsychiatry, 67(2),* 261-277.

Bruner, J. (1990). *Acts of meaning.* Cambridge, Mass.: Harvard University Press.

Bruner, J. (1991). The narrative construction of reality. *Critical Inquiry, 18*(1), 1-21.

Bryce, M., & Elhert, R. C. (1981). 144 Foster children. *Child Welfare, 50*(9), 499-503.

Burnham, L. (2001). Welfare reform, family hardship and women of color. *The Annals of the American Academy of Political and Social Science*, *577*(1), 38-48.

Burt, M. R., (1996). *Over the edge: The growth of homelessness in the 1980s.* New York: The Russell Sage Foundation.

Burt, M. R., & Cohen, B. E. (1989). *America's homeless. Numbers, characteristics, and programs that serve them.* Washington, D.C.: The Urban Institute Press.

Carey, B. (2007). This is your life (and how you tell it). *The New York Times* (May 24), F:1.

Carey, M. & Russell, S. (2002). Externalizing –commonly asked questions. Retrieved May 2, 2007 from http://www. dulwhichcenter.com/externalizing .htm.

Center for the Urban Future, Child Welfare Watch. (2002). *Uninvited guests: Teens in New York City foster care* (Monograph No. 8). New York: Author.

Center on Budget and Policy Priorities. (2005, Feb. 18). President's budget would restore some rental voucher cuts in 2005, but reduce the program substantially in future years.

Center on Budget and Policy Priorities. (2005, March 8.). Estimated voucher funding shortfalls in 2005,2006, and 2010 in New York City.

Coalition for the Homeless. (2000). *Housing a growing city. New York is bust in boom times.* New York: Author.

Coehlo, G. V., Ying-Yang, Y. T., & Ahmed, P. I. (1980). Contemporary uprooting and collaborative coping: Behavioral and societal responses. In G. V. Coehlo & P. I

Ahmed (Eds.), *Uprooting and development: Dilemmas of coping and modernization.* (pp. 19 -41). New York: Plenum Press.

Cohler, B. J. (1991). The life story and the study of resilience and response to adversity. *Journal of Narrative and Life History, 1*(2&3), 171-199.

Cohler, B. J. (1994). The human sciences, the life story, and clinical research. In E. Sherman & W. J. Reid (Eds.), *Qualitative research in social work* (pp. 163-175). New York: Columbia University Press.

Cohler, B. J. (2000). Psychological resilience and the lives of children. Presentation at The Postgraduate Center for Mental Health, New York City. April 28, 2000.

Compass, B. (1987). Coping with stress during childhood and adolescence. *Psychological Reports, 101*(3), 393-403.

Cook, R. (1992). Trends and needs in programming for independent living. *Child Welfare, 67*(6), 497-514.

Coopersmith, S. (1967). *The antecedents of self- esteem.* New York: W. H. Freeman.

Courtney, M., & Piliavin, I. (1998) *Foster youth transitions to adulthood: Outcome 12-18 months after leaving care.* Madison, WI: University of Wisconsin. School of Social Work and Institute for Research on Poverty.

Cowal, K., Shinn, M. B., Weitzman, B. C., Stonjanovic, D., & Lebay, L. (2002). Mother-child separations among homeless and housed families receiving public assistance in New York City. *American Journal of Community Psychology, 30*(5), 711-730.

da Costa Nunez, R. D. (2004). *Beyond the shelter wall.* New York: White Tiger Press.

Dail, P. W. (1990). The psychosocial context of homeless mothers with young children: Program and policy implications. *Child Welfare 69*(4), *291-310.*

Danzig, R. A. (1996). Children in homeless families. In N. K. Phillips & S. L. Straussner (Eds.), *Children in the urban environment: Linking social policy and clinical practice* (pp 191-208). Springfield, Ill. Charles C. Thomas.

Daskal, J. (1998). *In search of shelter: The growing shortage of affordable rental housing.* Washington, D.C.: Center on Budget and Policy Priorities.

Dean, R. G. (1993). Constructionism: An approach to clinical practice. *Smith College Studies in Social Work, 63*(2),127-146.

D'Ecrole, A., & Streuning, E. (1990). Victimization among homeless women: Implications for service delivery. *Journal of Community Psychology, 18*(2), 141-152.

Denzin, N. K., (1970). The life history method. In N. K. Denzin (Ed), *The research act: A theoretical introduction to sociological methods (pp.* 219-259). Chicago: Aldine de Gruyter Publishers.

Dehavenenon, A. (1999). *Homeless families : Out of sight, out of mind. How New York City created a hidden human crisis at the Emergency Assistance Unit in 1998, a synopsis.* New York: The Action Research Project on Hunger Homelessness, and Family Health New York City.

De Parle, J. (1996, Oct 20). Slamming the door. *The New York Times Magazine Section*, 52-95.

De Parle, J. (2004). *American dream: Three women, ten kids, and a nation's drive to end welfare.* New York: Penguin
.

Eagle, R. (1994). The separation of children in longterm care: Theory, research, and implications for practice. *American Journal of Orthopsychiatry, 63*(3), 421-434.

Eccles, J. S., Midgley, C., Wigfield, A., Buchanan, C., Miller, R. D., Flanagan, C., & Maciver, D. (1991). Development during adolescence: The impact of stage- environment fit on young adolescents' experiences in school and in families. *American Psychologist, 48*(2), 90-101.

Eckenrode, J., & Gore, S. (1981). Stressful events and social support: The significance of context. In B. Gottleib (Ed.), *Social network and social support* (pp. 43-68). Beverly Hills, CA: Sage Publications.

Edin, K., & Kefalas, M. (2005). *Promises I can keep: Why poor women put motherhood before marriage.* Berkeley, CA: University of California Press.

Egan, J. (2002, March24). To be young and homeless. *The New York Times Magazine*, pp. 32-58.

Emerging trends in client demographics. (2006). New York: DHS, Department of Policy and Planning.

Elson, M. (1984). Parenthood and the transformation of narcissism. In R. S. Cohen, B. J. Cohler & S. H. Weissman (Eds.), *Parenthood: A psychodynamic perspective* (pp. 297-313). New York: Guilford.

Epstein, Irwin. (1988). Quantitative and qualitative methods. In R. Grinnell, Jr. (Ed.), *Social work research and evaluation* (3rd ed.) (pp. 185-199). Istaca, Ill: F. E. Peacock.

Erikson, E. (1980). *Identity and the life cycle.* New York: W. W. Norton.

Fanshel, D. (1992). Foster care as a two-tiered system. *Children and Youth Services Review, 14*(1), 49-60.

Fanshel, D., Finch, S. J., & Gundy, J. F. (1990). *Foster children in life course perspective.* New York: Columbia University Press.

Fanshel, D., & Shinn, E. B. (1978). *Children in foster care: A longitudinal investigation.* New York: Columbia University Press.

Fein, E., Maluccio, A. & Kluger, M. (1990). *No more Partings: An examination of long term foster family care.* Washington, D.C.: Child Welfare League of America.

Felsman, J. K. (1989). Risk and resiliency in childhood: The lives of street children. In R. Coles & T. F. Dugan (Eds), *The child in our times: Studies in the development of resiliency* (pp. 56-80). New York: Bruner Mazel.

Festinger, T. (1983). *No one ever asked us: A postscript to foster care.* New York: Columbia University Press.

Fine, M. (1985). Coping with rape: Critical perspectives on consciousness. *Imagination, Cognition, & Personality, 3*(3), 249-267.

Fischer, R. L. (2000). Toward self -sufficiency: Evaluating a transitional housing program for homeless families. *Policy Studies Journal, 28*(2), 402-420.

Fisher, P., & Breakey, W. (1991). The epidemiology of alcohol, drug, and mental disorders among homeless persons. *American Psychologist 45*(11), 1115-1129.

Fogany, P., Steele, M., Steele, H., Higgitt, A., & Target, M. (1994). The 1992 Emanuel Miller Memorial Lecture. The theory and practice of resilience. *Journal of Child Psychology and Psychiatry, 35*(2), 231-257.

Fogel, S. J. (1997). Moving along: An exploratory study of homeless women with children using a transitional housing program. *Journal of Sociology and Social Welfare 25*(3), 113 -133.

Fognani, C. M. (1999). Foster care: Challenges in helping youth live independently: Testimony before the subcommittee on Human resources, Committee on Ways and Means. United States House of Representatives.

Fraenkel, P. (2006). Engaging families as experts: Collaborative family program development. *Family Process, 45*(2), 237-257.

Fram, S.M. (2003). Managing to parent: Social support, social capital, and parenting practices among welfare-participating mothers with young children. Eric document #ED476117. Research report, Institute for Research on Poverty, Madison, WI: Wisconsin University.

Fram, M. S. (2004). Research for progressive change: Bourdieu and social work. *Social Service Review, 78*(4), 553-577.

Fram, M. S., Miller-Cribbs, J. & Farber, N. (2006). Chicks aren't chickens: Women, poverty, and marriage in orthodoxy of conservatism. *Affilia: Journal of Women and Social Work, 21* (3), 256-271.

Friedman, D. H. (2000). *Parenting in public: Family shelter and public assistance.* NY: Columbia University Press.

Garfield, G. (2000). *Knowing what we know: African American women's self-defined experiences of violence.* Unpublished doctoral dissertation, City University of New York, New York.

Garmezy, N. (1987). Stress resistant children: The search for protective factors. In J. Stevenson (Ed.), *Recent research in developmental psychopathology* (pp. 289-303). London: Blackwell Scientific.

Garmezy, N., & Masten, A. S. (1994). Chronic adversities. In M. Rutter, E. Taylor & L. Hersov (Eds), *Child and adolescent psychiatry: Modern approaches. (3rd ed.)* (pp.191-210). London: Blackwell Scientific.

Germain, C. B., & Gitterman, A. (1996). *The life model of social work practice: Advances in theory and practice.* New York: Columbia University Press.

Germain, C. B. (1991). *Human behavior in the social environment: An ecological view.* New York: Columbia University Press.

Gerstel, N., Bogard, C. J., McConnell, J., & Schwartz, M. (1996). The therapeutic incarceration of homeless families. *Social Service Review, 70*(4), 543 -563.

Gilligan, C. (1982). *In a different voice: Psychological theory and women's development.* Cambridge, MA: Harvard University Press.

Golan, N. (1981). *Passing through transitions: A guide for practitioners.* New York: The Free Press.

Goldstein, J., Freud, A., & Solnit, A. J. (1993). *Beyond the best interests of the child.* New York: The Free Press.

Goodman, L. (1991a). The prevalence of abuse among homeless and housed poor mothers: A comparison study. *American Journal of Orthopsychiatry, 61*(4), 469-500.

Goodman, L. A. (1991b). The relationship between social support and family homelessness. A comparative study of homeless and housed mothers. *Journal of Community Psychology, 19*(3), 321-332.

Goodman, L. A., Saxe, L., & Harvey, M. (1992). Homelessness as a psychological trauma: Broadening perspectives. *American Psychologist, 46*(1), 1219-1226.

Gordon, L. (1989). *Heroes of their own lives: The politics and history of family violence.* New York: Penguin Books.

Gore, S. (1995). *The study of homelessness in a prevention research agenda.* Unpublished manuscript. Boston: University of Massachusetts. Dept. Of Sociology.

Gruenberg, J, & Eagle, P. F. (1990). Shelterization: How the homeless adapt to shelter living. *Hospital and Community Psychiatry, 45*(5), 521-525.

Haveman, R., & Knight, B. (1999). *Youth living arrangements, economic independence, and the role of labor market changes: A cohort analysis from the early 70's to the late 80's.* Madison, WI: Univ.of Wisconsin. School of Social Work and Institute for Research on Poverty.

Harris, T., Brown, G. W., & Bifulco, A. (1990). Depression and situational helplessness: Mastery in a sample of women who experienced childhood parental loss. *Journal of Affective Disorders, 20*(9), 27-41.

Hartman, H. (1958). *Ego psychology and problem of adaptation.* New York: International University Press.

Hausman, B. & Hammen, C. (1993). Parenting in homeless families: The double crisis. *The American Journal of Orthopsychiatry, 63*(3), 358- 370.

Herman, J. L. (1997). *Trauma and recovery.* NY: Basic Books.

Hines, A. M., Merdinger, J., & Wyatt, P. (2005). Former foster youth attending college: Resilience and the transition to young adulthood. *American Journal of Orthopsychiatry, 75*(3), 381-394.

Homeless Services United. (2006). *False start—fresh promise. Homeless service providers advocate reform of New York City's Housing Stability Plus.* New York: Homeless Services United.

Institute for Children and Poverty, The. (1993). *Homelessness: The foster care connection.* New York: Author.

Institute for Children and Poverty, The (1998). *Ten Cities: 1997-1998: A snapshot of family homelessness across America.* New York: Author.

Institute for Children and Poverty, The. (2002). *The Hidden Homeless.* New York: Author

Institute for Children and Poverty (2006). *The instabilities of housing stability plus.* New York: Author.

Jahiel, R. I. (1992). The definition and significance of homelessness in the United States. In Rene I. Jahiel (Ed.), *Homelessness: A prevention-oriented approach.* (pp. 11-27). Baltimore: Johns Hopkins University Press.

Johnson, A. K., McChesney, K. Y., Rocha, C., & Butterfield, W. H. (1995). Demographic differences between sheltered homeless families and housed poor families: Im-

plications for policy and practice. *Journal of Sociology and Social welfare 22*(4), 50-57.

Johnson, A. K. & Kreuger, L. W. (1989). Toward a better understanding of homeless women. *Social Work, 34*(6), 537-540.

Johnston, D. (2007). Income gap is widening, data shows. *The New York Times* (March 29), C:1.

Josselson, R. (1996). *The space between us. Exploring the dimensions of human relationships.* Thousand Oaks, CA: Sage Publications.

Jessor, R. (1993). Successful adolescent development among youth in high risk settings. *American Psychologist. 48*(2), *117-126.*

Kaplan, A. G., Klein, R., & Gleason, N. (1991). Women's self-development in late adolescence. In J. V. Jordan, A. G. Kaplan, J. B. Miller, I. P. Stiver & J. L. Surrey (Eds), *Women's growth in connection: Writings from The Stone Center* (pp. 122-142). New York: Guilford Press.

Kasdan, A. & Youdelman, S. (2007). Failure to comply: The disconnection between design and implementation in HRA's We Care Program. NY: Community Voices Heard.

Kates, W. G., Johnson, R. L., Rader, M., & Streider. (1991). Whose child is this? Assessment and treatment of children in foster care. *American Journal of Orthopsychiatry, 61*(4), 504-591.

Katz, L. (1987). An overview of current clinical issues in separation and placement. *Child and Adolescent Social Work, 4*(3 & 4), 209-225.

Kaufman, L. (2007). City vows to improve aid to homeless families. The New York Times (March, 19) .B: 1.

Keenan, E. K. (1997). When you can't afford to leave home: Clinical implications of economic realities. *Child and Adolescent Social Work Journal, 14*(4), 289-303.

Kemp, S. (2001). Environment through a gendered lens: From person-in-environment to woman-in-environment. *Affilia,* 16(1),7-30.

Klein, T., Bittel, C., Calley, M., & Molnar, J. (1993). No place to call home: Supporting the needs of homeless children in the early childhood classroom. *Young Children*, 22-31.

Knickman, J. R., & Weitzman, B. C. (1989). *A study of homeless families in New York. Risk assessment models and strategies for prevention (Vols. 1 & 4).* New York: New York University, Wagner School of Public Service.

Koblinsky, S. A., Morgan, K. & Anderson, E. (1997). Homeless and low-income mothers. Comparison of parenting practices. *American Journal of Orthopsychiatry, 67(1)* (37-47).

Koch, R., Lewis, M., & Quinones, W. (1998). *Homeless mothering: At rock bottom.* In C. Coll-Garcia, J. L. Surrey, & K. Weingarten (Eds.), *Mothering against the odds: Diverse voices of contemporary mothers (*pp 61-85). New York: Guilford Press.

Koegel, P. (1987). Understanding homelessness: An ethnographic approach. In R. I. Jaheil (Ed.), *Homelessness: A prevention-oriented approach* (pp. 127-139). Baltimore, MD: Johns Hopkins University Press.

Koegel, P., Melamid, E., & Burnham, M.A. (1995). Childhood risk factors for homelessness among adults. *American Journal of Public Health*, *85*(2), 1642-1649.

Kohut, H. (1984). *How does analysis cure?* Chicago, IL: The University of Chicago Press.

Kubiak, S. K. (2005). Trauma and cumulative adversity in women of a disadvantaged social location. *American Journal of Orthopsychiatry, 75*(4), 451-466.

Kulkami, S. (2007). Romance narratives, feminine ideals and developmental detours for young mothers. *Affilia:Journal of Women and Social Work, 22*(1), 6-22.

Land, H. (1992). The coming of age in foster care. In A. Maluccio, R. Kreiger & B. Fine (Eds.), *Preparing adolescents for life after foster care* (pp. 35-54). Hawthorne, NY: Aldine de Gruyter.

Lander, B. (2002). *Developing affordable housing in changing neighborhoods*. NY: Hunter College, Department of Urban Affairs.

Laurentis, T., de. (1986). *Feminist studies/critical studies*. Bloomington, Indiana: Indiana University Press.

Leaman, S. & Gee, C. (2006). Abusive romantic relationships among adolescent and young adult mothers. Center for Research on Child Well-Being, working paper #2006-07-FF. Retrieved July 27, 2007, from http://ccrw.princeton.edu.

Lee, M. W. (2006). *Selected findings of the 2005 New York City Housing and Vacancy Survey*. New York City Department of housing preservation and Development.

Lehmann, E. R., Kass, P. H. Drake, C. M. & Nichols, S. B. (2007). Risk factors for first time homelessness in low-income women. *American Journal of Orthopsychiatry*, *77*(1), 20-29.

Leiberman, A. F., Padron, E., Van Horn, P. & Harris,W. W. (2005). The intergenerational transmission of benevolent parental influences. *Infant Mental Health Journal, 25*(6), 504-520.

Leiblich, A., Tuval M. R., & Zilber, T. (1998). *Narrative research: Reading, analysis and interpretation.* Thousand Oaks, CA.: Sage Publications.

Lindsey, E. W. (1997). The process of re-stabilization for mother-headed homeless families: How social workers can help. *Journal of Family Social Work, 2*(3), *9-73.*

Link, B., Schwartz, S., More, R., & P. J. (1995). Public knowledge, attitudes and beliefs about homeless people: Evidence for compassion fatigue? *American Journal of Community Psychology, 23*(4), 533-555.

Mallon, G. (1998). After care, then where? Outcomes of an independent living program. *Child Welfare, (77),* 61-78.

Manguine, S. J., Royse, D., Weihe, V. R., & Neitzel, M.T. (1990). Homelessness among adults raised as foster children: A survey of drop-in center users. *Psychological Reports, 67,* 739-745.

Marcuse, P. (1990). Homelessness and housing policy. In C. L. Caton (Ed.), *Homeless in America*. NY & London: Oxford University Press.

McChesney, K. Y. (1992). Homeless families: Four patterns of poverty. In M. J. Robertson & M. Greenblatt (Eds.),

Homelessness: A national perspective (pp. 245-256). New York: City: Plenum.

McChesney, K. Y. (1995). A review of the empirical literature on contemporary urban homeless families. *Social Service Review, 69*(3), 431-460.

McCubbin, H. I., McCubbin, M. A., Thompson, A. I., Han, S. Y., & Allen, C. (1997). Families under stress: What makes them resilient? *Journal of Family and Consumer Services, 89*(3), 2-12.

McDonald, T., Allen, A., Westerfelt, A., & Piliavin, I. (1996). *Assessing the long-term effects of foster care: A research synthesis.* Edison, New Jersey. Child Welfare League of America/Raritan Press.

McMillan, J. C., & Tucker, J. (1999). The status of older adolescents at exit from out-of-home care. *Child Welfare, 78*(5), 339-60.

McMillan, J. C., & Rideout, G. B. (1996). Breaking intergenerational cycles: Theoretical tools of social workers. *Social Service Review, 70*(3), 378-400.

Mech, E. V., (1994). Foster youth in transition: Research perspectives on preparation for independent living. *Child Welfare, 22*(8), 603-624.

Meier, E. (1965). Current circumstances of former foster children. *Child Welfare, 44*(3), 196-206.

Merves, S. E. (1986). *Conversations with homeless women: A sociological examination.* Unpublished doctoral dissertation. The Ohio State University. Columbus, Ohio.

Metraux, S., & Culhane, D. P. (1999). Family dynamics, housing and recurring homelessness among women in New York City. *Journal of Family Issues, 20*(3), *371-396.*

Milburn, N. & D'Ecrole, N. (1991). Homeless women: Moving toward a comprehensive model. *American Psychologist 46*(1),1161-1169.

Miringoff, M. & Miringoff, M. R. (1999). *The social health of the nation: How America is really doing.* London: Oxford University Press.

Molnar, J. M., Rath, W. R., & Klein, T. (1990). Constantly compromised: The impact of homelessness on children. *Journal of Social Issues 46*(4), *109-133.*

Morse, G. (1992). *Causes of homelessness.* In M. Robertson & M.Greenblatt (Eds.), *Homelessness: A national perspective.* New York: Plenum.

Murphy, J. (2007). The cost of good intentions. *City Limits Investigates, 31*(1), 1-27.

Murphy, L. B. (1974). Coping vulnerability, and resilience in childhood. In G. V. Coehlo, D. A. Hamburg, & J. Adams (Eds.), *Coping and adaptation* (pp. 69-100). New York: Plenum.

Murphy, L. B., & Moriarity, A. E. (1976). *Vulnerability, coping and growth to adolescence.* New Haven, CT: Yale University Press.

National Alliance to End Homelessness. (2007). *A research Agenda for ending homelessness.* Retrieved July 21, 2005 from http://www.endhomelessness.org

National Alliance to End Homelessness. (2006). *Promising strategies to end family homelessness*. Washington, DC: National Alliance to End Homelessness.

National Center on Family Homelessness. (1999). *America's homeless children: New outcasts*. MA: Author.

National Fair Housing Alliance (2007). The crisis of housing segregation. 2007 Fair Housing Trends Report. Retrieved July 7, 2007 from www.nationalfairhousing.org.

National Institute for Mental Health (1996). Basic behavioral science research for mental health. Vulnerability and resilience. *American Psychologist, 51*(1), 22-28.

National Resource Center for Permanency Planning. (1998). *Listening to youth*. New York: Author.

Neiman, L. (1988). A critical review of resiliency literature and its relevance to homeless children. *Children's Environmental Quarterly, 5*(1),17-26.

New York City Commission on the Homeless. (1992). *The way home*. New York City.

New York City Coalition for the Homeless. (2001). *A history of modern homelessness in NYC*.

New York City Coalition for the Homeless. (2007a). *State of the homeless 2007. Falling behind: A midpoint look at the Bloomberg homeless plan*. NY: NYC Coalition for the Homeless.

New York City Coalition for the Homeless.(2007b). *Briefing paper. Reforming New York City's rent subsidy program for homeless families*. NY: NYC Coalition for the Homeless.

New York City Department of Homeless Services. (2000, 2002). *Shelter Census Report.* New York.

New York City Independent Budget Office. (2002). *Fiscal brief. Give 'em shelter: Various city agencies spend over $900 million on homeless services.* New York: Author.

New York City Department of Housing Preservation and Development. (2004). *The New Housing Marketplace: Creating housing for the next generation: 2004-2013.* New York: Author.

New York City Department of Homeless Services. (2005). *Emerging trends in client demographics.* New York: Author.

O'Flaherty B. (1996). *Making room: the economics of homelessness.* Cambridge, MA: Harvard University Press.

Olds, D. L. (2005). The nurse family partnership: Foundations in attachment theory and epidemiology. In L. J. Berlin, Y. Ziv, L. A. Jackson, & M. T. Greenberg (Eds.), *Enhancing early attachments; theory, research, intervention, and policy* (pp. 217-249). New York: Guilford Press.

Norman, E., Turner, S., & Zunz, S. (1994). *Substance abuse prevention: A review of the literature.* NY: New York State Department of Health, Office of Alcohol & Substance Abuse.

Padgett, D. K., Hawkins, R. Adams, C. & Dacos, A. (2006). In their own words: Trauma and substance abuse in the lives of formerly homeless women with mental illness. *American Journal of Orthopsychiatry, 76*(4), 461-469.

Passero, J. M., Zax, M., &, Zozus, R. T. (1991). Social network utilization as related to family history among the homeless. *Journal of Community Psychology,19*(1),70-78.

Patton, M. Q. (1990). *Qualitative evaluation and research methods (2nd ed.).* Beverly Hills, CA: Sage Publications.

Payne, R. K., DeVol, P. & Smith, T. D. (2005). *Bridges out of poverty; Strategies for professionals and communities* (revised edition). Highland, TX: aha!process, inc.

Penzerro, R. M., & Lein, L. (1995). Burning their bridges. Disordered attachment and foster care discharge. *Child Welfare, 74*(2), 351-367.

Pearlin, L., & Schooler, C. (1978). The structure of coping. *Journal of Health & Social Behavior, 19*(1), 1-21.

Picture the Homeless (2007). *Homeless people count vacant properties in Manhattan.* NY: Picture the Homeless.

Piliavin, I., Sosin, M., Westerfelt, A., & Matsuda, R. L. (1991). The duration of homeless careers. An exploratory study. *Social Service Review, 67*(4), 579-598.

Powell, J. B. Witness for justice (2002, May 13). Retrieved 2/18/06. http://www.ucc.org/justicewitness/index.html

Proshansky, H. R., Fabian, A. K., & Kaminoff, R. (1983). Place identity: The physical world socialization of the self. *Journal of Environmental Psychology, 1*(3), 57-83.

Quinton, D., & Rutter, M. (1984). Parents with children in care: I: Current circumstances and parenting. *Journal of Child Psychology and Psychiatry, 25*(2), 211-229.

Quinton. D., & Rutter, M. (1984). Parents with children in care II: Intergenerational continuities. *Journal of Child Psychology and Psychiatry, 25*(2), 231-260.

Rafferty, Y. & Rollins, N. (1989). *Learning in limbo: The educational deprivation of homeless children.* Long Island City, NY: Advocates for Children.

Rafferty, Y., & Shinn, M. (1991). The impact of homelessness on children. *American Psychologist, 46*(1), *1170-1179.*

Reissman, C. K. (1993). *Narrative analysis: Qualitative research method series, 30.* Newbury Park, CA., Sage Publications.

Rog, D., McCombs, T. K., Gilbert-Mongelli, A., Brito, M. C., & Holupka, C. S. (1995). Implementation of The Homeless Families Program: 2. Characteristics, strengths and needs of the participating families. *American Journal of Orthopsychiatry, 65* (4), 514 -528.

Roman, N., & Wolfe, P. (1997). The relationship between foster care and homelessness. *Public Welfare, 53*(11), 4-10.

Rosenbaum, E. & Friedman, S. (2007). *The housing divide: How generations of immigrants fare in New York's housing market.* New York and London: New York University Press.

Rossi, P. H. (1980). *Why families move (2nd ed.).* Beverly Hills, CA: Sage Publications.

Rossi, P. (1994). Troubling families: Family homelessness in America. *American Behavioral Scientist, 73*(3), *342-396.*

Rutter, M. (1981). Stress, coping, and development: Some issues and some questions. *Journal of Child Psychology and Psychiatry and Allied Disciplines, 22*(4), 323-354.

Rutter, M. (1987). Psychosocial resilience and protection measures. *American Journal of Orthopsychiatry, 57*(3), 316-331.

Rutter, M., Liddle, T., & Quinton, D. (1984). Long term follow-up of women institutionalized in childhood: Factors promoting good functioning in adult life. *British Journal of Developmental Psychology, 18,* 225-234.

Saleebey, D. (2001). *Human behavior and social environments: A biopsychosocial approach.* New York: Columbia University Press.

Saleeby, D. (2002). *The strengths perspective in social work practice (3rd ed.).* Boston, MA: Allyn and Bacon.

Sands, R. G. (1996). The elusiveness of identity in social work practice with women: A post-modernist feminist perspective. *Clinical Social Work Journal, 24*(2), 98-103.

Schneider, E. L. (1991). Attachment theory and research: A review of the literature. *Clinical Social Work Journal, 19*(3), 251-266.

Schneiderman, M., Conners, M., Friborg, A., Greis, L., & Gonzales, M. (1998). Mental health services for children in out-of-home care. *Child Welfare, 77*(1), 29-41.

Shinn, M. (1990). Homelessness: What is a psychologist to do? *American Journal of Community Psychology, 20*(1), 1-24.

Shinn, M., Knickman, J. R., Ward, D., Petrovic, N. L., & Muth, B. J. (1990). Alternative models for sheltering homeless families. *Journal of Social Issues, 46*(4), 175-191.

Shinn, M., Knickman, J., & Weitzman, B. C. (1991). Social relationships and vulnerability to becoming homeless among poor families. *American Psychologist, 46*(11), *1180 -1188.*

Shinn, M. B., & Gillespie, C. (1994). The roles of housing and poverty in the origins of homelessness. *American Behavioral Scientist, 37*(4), 505-521.

Shinn, M., Baumohl, J. & Hopper, K. (2001) . The prevention of homelessness revisited. *Annals of Social Issues and Public Policy*, 95-127.

Siefert, K., Finlayson, T. L., Williams, D. R., Delva, J. & Ismail, A. I. (2007). Modifiable risk and protective factors for depressive symptoms in low-income African American mothers. *American Journal of Orthopsychiatry*, 77(1), 113-123.

Slade, A., Sadler, L. S., & Mayes, L.C. (2005). Minding the baby: Enhancing parental reflective functioning in a nurse mental health home visiting program. In L. J. Berlin, Y. Ziv, L. A. Jackson & M. T. Greenberg (Eds.), *Enhancing early attachments: Theory, research, intervention, and policy (*pp. 217-249). New York: Guilford Press.

Smith, E. & North, C. (1994). Not all homeless women are alike: The effect of motherhood and the presence of children. *Community Mental Health Smith Journal, 30*(6), 601-610.

Smith, N., Flores, Z. D., Lin, J., & Markovic, J. (2005). *Understanding family homelessness in New York City: An in - depth study of families' experiences before and after shelter.* New York: Vera Institute of Justice.

Smokawski, P. R. (1998). Prevention intervention strategies for promoting resilience in disadvantaged children. *Social Service Review, 72*(8), 337-386.

Smyth, K. F. , Goodman, L., & Glenn, C. (2006). The full-frame Approach: A new response to marginalized women left behind by specialized services. *American Journal of Orthopsychiatry*, 76*(4),* 489-511.

Snow, D. A., Anderson, L., & Keogel, P. (1994). Distorting tendencies in research on the homeless. *American Behavioral Scientist, 37*(4), 451-476.

Snow, D. A., & Anderson, L. (1987). Identity work among the homeless: The verbal construction and avowal of personal identities. *American Journal of Sociology, 92*(6), 1336-71.

Sroufe, A. (1978). Attachment and the roots of competence. *Human Nature, 1*(10), 50-59.

Stegman, M. A. (1993). *Housing and vacancy report: New York City, 1991.* New York: New York City Department of Housing Preservation and Development.

Stegman, M. S. (1991). Remedies for homelessness: An analysis of potential housing policy and program responses. In J. H. Kryder-Coe, L. M. Salamon & J. M. Molnar (Eds.), *Homeless children and Youth* (255-269). New Brunswick, N J: Transaction Publishers.

Stein, M., & Carey, K. (1986). *Leaving care.* Oxford: Blackwell.

Stern, L. (1990). Conceptions of separation and connection in female adolescents. In C. Gilligan, N. P. Lyons & T. Hammer (Eds.), *Making connections: The relational worlds of adolescent girls at the Emma Willard School.* (pp. 73-67*).* Cambridge, MA: Harvard University Press.

Stern, D. N. (1985). *The interpersonal world of the infant.* N Y: Basic.

Stevens, J. W. (1993). *The Negotiation of adulthood status among a group of* African-American lower class pregnant and non-pregnant female adolescents. Unpublished Doctoral Dissertation: Loyola University. Chicago, Illinois.

Stoner, M. (1995) *The civil rights of homeless people: Law, social policy, and social work practice.* New York: Aldine De Gruyter

Strauss, A., & Corbin, J. (1990). *Basics of qualitative research: Grounded theory procedures and techniques.* Newbury Park, CA.: Sage Publications.

Susser, E., Streuning, E., & Conover, S. (1987). Childhood experiences of homeless men. *American Journal of Psychiatry, 148*(8), 1599-1601.

Taylor, J. M., Gilligan, C. & Sullivan, A.M. (1995). *Between voice and silence: Women and girls, race, and relationships.* Cambridge, MA: Harvard University Press.

Tolpin, M. (1986). *Self-psychology in clinical social work practice.* New York: Norton

The homeless maze. (2007). The New York Times (March 25). A: 25.

Thrasher, S. P. & Mowbry, C. T. (1995). A strengths perspective: An ethnographic study of homeless women and children. *Health and Social Work, 20*(2), 93-102.

U. S. Conference of Mayors. (1999). A status report on hunger and homelessness in America's cities. Washington, D.C.

U.S. Department of Housing and Urban Development, Office of Community Planning. (2007). *The annual homeless assessment report to Congress*. Retrieved March 15, 2007, from www.hud.gov/offices/cpd/homeless/cpd/homeless

United States Conference of Mayors. (2004). *Hunger and Homelessness in American Cities: A Status Report:27 City Survey*. Washington, D.C.

United States Department of Housing and Urban Development. Retrieved March 14, 2006. http://www.hud.gov/offices/ cpd/homeless/library/esg/esgdeskguide/glossary.cfm.

Uniting for solutions beyond shelter: The action plan for New York City. Retrieved Feb. 12, 2006, from http://www.nyc.gov/html/endinghomelessness/html

Usher, C., Rudolph, K., & Gogan, H. (1999). Placement patterns in foster care. *Social Service Review, 73*(1), 22-37.

Vaillant, G. (1993). *The wisdom of the ego: Sources of resilience in adult life*. Cambridge: Harvard Univ. Press.

Van Den Bergh, N. (1995). *Feminist social work practice: Where have we been. Where are we going?* In N. Van Den Bergh (Ed.), *Feminist practice in the 21st century.* (pp, xi-xxxix). Washington, D.C.: NASW Press.

Walsh, F. (1996). The concept of family resilience: Crisis and challenge. *Family Process, 35*(3), 261-281.

Weick, A. (1993). Re-visioning social work education. A social constructionist approach. *Journal of Teaching in Social Work, 8*(1-2).

Weihe, V. (1987). Locus of control in foster and non-foster children. *Journal of Genetic Psychology, 148*(2), 183-187.

Weinreb, L., Nicholson, J., Williams, V. & Anthes, F. (2007). Integrating behavioral health services for homeless mothers and children in primary care. *American Journal of* Orthopsychiatry, *77*(1), 142-152.

Weitzman, B. (1989). Pregnancy and childbirth: Risk factors and homelessness. *Family Planning Perspectives, 21*(4), 175-178.

Weitzman, B. C., Knickman, J. R., & Shinn, M. (1990). Pathways to homelessness among New York City families. *Journal of Social Issues, 46*(4), 125-141.

Werner, E., & Smith, R. C. (1982). *Vulnerable but invincible: A story of resilient children.* NY: McGraw-Hill.

Werner, E. (1989). High-risk children in young adulthood: A longitudinal study from birth to 32 years. *American Journal of Orthopsychiatry,59*(1), 72-81.

Westat, Inc. (1991). *A national evaluation of title IV-E: Foster codependent living programs for youth.* Washington, DC: Dept. of Health & Human Services.

Westerbrooks, K. L. (1998). Spirituality as a form of functional diversity: Activating unconventional family strengths. *Journal of Family Social Work, 2*(4),77-87.

White, A. (2006). I'm afraid of HSP. *How, when, where. Information for homeless and relocated families in New York City.* New York: Information for Families.

White, R. W. (1959). Motivation reconsidered: The concept of competence. *Psychological Review, 66*(5), 297-333.

Wilson, W. (1987). *The truly disadvantaged: The inner city: The underclass and public policy.* Chicago: University of Chicago Press.

Winkleby, M. A. & Boyce, W. T. (2004). Health related risk factors of homeless families and single adults. *Journal of Community Health, 19*(1), 7-23.

Wolkind, S., & Rushton, A. (1994). Residential and foster family care. In M. Rutter, E. Taylor & L. Hersov (Eds.), *Child and adolescent psychiatry: Modern approaches* (3rd ed.) *(*pp. 252-265). London: Blackwell Publications.

Wood, D., Valdez, R. B., Hayashi, T., & Shen, A. (1996). Homeless and housed families in Los Angeles: A study comparing demographic economic, and family function characteristics. *American Journal of Public Health, 80*(9),1049-52.

Zlotnick, C., Robertson, M. J., & Wright, M.A. (1999). The impact of childhood foster care and other out-of-home placement on homeless women and their children. *Child Abuse and Neglect, 23*(11), 1057-1068.

Index

DISNEYANA

A DISNEY MINIATURE

DISNEYANA

CLASSIC COLLECTIBLES 1928–1958

ROBERT HEIDE AND JOHN GILMAN

A WELCOME BOOK

NEW YORK

CONTENTS

INTRODUCTION

The use of the term *Disneyana*, a play on *Americana*, as a catch-word has come to be equated with the zealous collecting of the wide variety of Walt Disney character merchandise manufactured from the 1930s right up to the present era of new "instant" Disney collectibles. The vast array of mass-produced products includes those items that are promoted and distributed today at the theme parks, specialty Disney Stores, collector clubs, department stores, variety stores, souvenir shops, and boutiques of all kinds. Certainly merchandise connected with *The Little Mermaid*, *Beauty and the*

ABOVE: A RECENT DISNEY MEMORABILIA EXHIBIT IN WALT DISNEY WORLD, FLORIDA. OPPOSITE: TIN-LITHO DIME REGISTER BANK (1939).

Beast, *Aladdin*, *The Lion King*, and *Pocahontas* has joined the ranks of desirable new Disneyana collectibles—whether for future

investment or simply for the purpose of collector enjoyment. It is clear from an examination of the yearly merchandise catalogues published during the 1930s and 1940s, and early 1950s by Kay Kamen, Disney's first licensing representative, that the ebullient Mickey Mouse himself and his quacking barnyard pal, Donald Duck, are the perennial leaders of the parade of the cheerful, ongoing Disney merchandising industry.

This book on Disneyana is meant to turn the spotlight on what is now seen as the Golden Era, the late twenties through the fifties, decades when Disney merchandise was regarded only in terms of consumerism and not as rarities to be collected for future generations. Collectors today are thankful for those merchants who took to storing their unsold toys in the basements of their stores or moved them into warehouses. Many of today's fiercely determined collectors recall being deprived of toys when they were children, and readily admit to having become tenacious and

"PRIMITIVE" LEAD MICKEY, ONE OF THE FIRST AMERICAN-MADE METAL FIGURES (EARLY 1930S).

extremely competitive in their ongoing search for undiscovered Mickey Mouse treasures. The hunt for rarity drives these collectors onward; and this is always the key to pricing. At the same time, bona fide Disneyophiles detest price guides, as they often price items either too high or too low, and take the fun out of the bargaining process and the joy out of making what might amount to an "archeological" discovery. Some guides published by collectors deliberately misquote prices so that the publisher/collectors can make better deals for themselves in the marketplace.

Most of the early licensed Disney character merchandise was sold by businesses such as the George Borgfeldt Company of New York, which imported millions of Made-in-Japan bisque figurines; the Ingersoll-Waterbury Clock Company of Waterbury,

TOP: "BABY'S FIRST BIRTHDAY" CARD FROM HALLMARK (1935). BOTTOM: HALL BROTHERS BIRTHDAY CARD (1932).

9

IMPORTED FRENCH CANDY TIN (1930s).

Connecticut, which manufactured the Mickey Mouse watches and other timepieces; or the Lionel Corporation of Irvington, New Jersey, which produced the popular Mickey Mouse handcar, featuring an up-and-down moving Mickey and Minnie. The mass marketing of these original toys has provided ample supplies for Disneyana collectors. Prices have risen dramatically on many items over the years due to the increasing numbers of collectors in the field spurred on by the vast amounts of merchandise in the specialty dealer mail-order collectibles catalogues, Mickey Mouse collector-club newsletters, and "Mickey for Sale" and "Disneyana Wanted" advertisements in periodicals catering to collectors. Mickey and his friends are also constantly on display at antique shows, flea markets, toy sales, and at art auction houses. Today Mickey Mouse and his friends are acknowledged as collectibles by publications like *Life*, *Fortune*, *Business Week*, and by other periodicals as very good "futures" investment. Added to the investment angle, collecting Disneyana can be an exciting hobby that is just plain good fun.

The 1960s Revival

The sixties counterculture hippies began wearing original 1930s Ingersoll Mickey Mouse wristwatches in jest and as a sort of

"new-old" status symbol protest prank in the face of the older establishment who regarded Mickey on a watch as tacky. However, in the wake of the youth revolution, astronauts Walter Schirra and Gene Cernan wore their Mickey Mouse watches proudly aboard the Apollo spacecrafts in 1968 and 1969. The Mickey Mouse image that was preferred by the legions of beginning collectors and beatniks of the sixties was not the more rounded, pink-faced Mickey Mouse so prominent in the forties and fifties, but the Depression-era rodent-like, white-faced, mischievous imp who wore only red shorts held up by two big oval buttons, yellow clown-size shoes, and thick four-fingered gloves. He had black balloon ears, a black stub of a nose, and a long, skinny tail. The more astute collectors of the sixties and seventies, many of whom are still collecting today, particularly seek out the Mickey who gnashes his big teeth in a growling grin as he does in the Dean's Rag Book Company dolls from England or some of the German tin windups or Made-in-Japan bisque figurines.

When flower children began sporting Mickey Mouse watches during the 1967 "summer of love"

MICKEY AND MINNIE MOUSE AUTOMOTIVE RADIATOR CAP OF PAINTED CHROMIUM METAL, MADE IN ENGLAND BY THE DESMO CORPORATION (1934).

A BUTTON-NOSE MICKEY MOUSE GREETING CARD FROM HALL BROTHERS (1934).

in San Francisco, a Mickey fashion trend really began to take hold across the country. Sales for new Mickey character watches tripled in three years, and in a six-month period in 1970 they accounted for over $7 million in sales. *Business Week* reported in their 1975 "Business Investment Outlook" that Disneyana was becoming a standout antiques investment, showing a 50 percent jump in value that year. Windup Mickey Mouse toys were suddenly deemed "investibles" by Wall Street.

In 1977 a grinning litho-on-tin German windup of Mickey Mouse, a toothsome rodent, cranking away on a hurdy-gurdy while a tiny Minnie twirled atop, fetched the then record price for a Mickey toy of $3,105 at Sotheby's in London. There was a startling change in auction prices for Disneyana in the 1990s as well. The hurdy-gurdy that sold for $3,105 in 1977 sold at auction in Byfield, Massachusetts, in 1993 for $18,700, a record-breaking price for this rare animated toy. What was regarded in the seventies as

nostalgia trivia, sentimentalia, or campy is now thought of as classics of the twentieth century.

This pronounced shift in thinking certainly affected the collecting of Disneyana of the thirties, forties, and fifties. Some dealers and inexperienced collectors still confuse the 1950s Mickey or Donald with their 1930s counterparts. However, most items from the pre–World War II period are marked Walt Disney Enterprises, Walter E. Disney, or just W.E.D. By 1940, merchandise was stamped Walt Disney Productions or W.D.P. Pre–World War II items are still considered the classics most sought after, and these are the ones that usually fetch the higher prices in the collectors' marketplace.

The character merchandise produced in the early 1930s is dominated by Mickey Mouse, Minnie Mouse, and that oddball couple Horace Horsecollar and Clarabelle

TOP: PINBACK BUTTON FROM THE 1973 LINCOLN CENTER FESTIVITIES IN NEW YORK CELEBRATING THE FIFTIETH ANNIVERSARY OF THE FOUNDING OF THE WALT DISNEY STUDIOS. BOTTOM: PINBACK BUTTON ISSUED FOR MICKEY'S FIFTIETH BIRTHDAY (1978).

Cow, who went out on country picnics and seashore trips with the mouse couple and their "nephews" Morty and Ferdy. Sometimes even Peg Leg Pete, Pluto, or Goofy would come along on these romps. Donald Duck along with nephews Huey, Dewey, and Louie, and sometimes girlfriend Daisy Duck, were another family that were popular sellers in the 1930s. In 1934, when Donald Duck appeared in his first movie, *The Wise Little Hen*, the obstreperous quacker immediately became a second lead to Mickey and Minnie in the merchandising marketplace, followed by Pluto and Goofy.

By 1938, prior to the release of the animated feature film *Snow White and the Seven Dwarfs*, the film's characters had appeared on every conceivable kind of product. This continued right into the 1940s and was followed by the new 1940 merchandise featuring Pinocchio, his conscience sidekick Jiminy Cricket, and their friends. The 1940s also introduced what is now regarded as top-notch Disneyana from *Dumbo*, *Bambi*, *Saludos Amigos*, *The Three Caballeros* (José Carioca, the parrot; Panchito, the rooster; and Donald Duck), and *Fantasia*.

During the World War II years, Donald Duck seemed to take a lead in popularity over Mickey Mouse. It was Donald who could really spew vitriol and drop bombs onto a common enemy. However, Mickey would regain his lost lead when the Mickey Mouse Club, starring Mickey Mouse and the Mouseketeers, premiered on television in 1955 and took America by storm. Collectible merchandise was also produced in the 1950s to coincide with the animated feature films *Cinderella* (1950); *Alice in Wonderland*

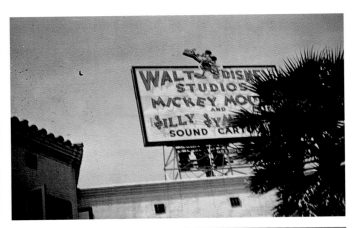

NEON SIGN ATOP THE DISNEY STUDIOS AT 2719 HYPERION AVENUE, HOLLYWOOD, CALIFORNIA (MID-1930S).

(1951); *Peter Pan* (1953); *Lady and the Tramp* (1955); and *Sleeping Beauty* (1959).

Collecting Disneyana has now become a global affair, with an infinite variety of collectible categories to satisfy almost anyone. This book is not meant to be an "everything" or "anything" catalogue; nor is it meant to function as a quick "current" price barometer of the Disneyana marketplace.

Instead, we have chosen to highlight some of the most prized pieces, along with those regarded as having top quality in design and others that are just plain spirited and fun to collect and have around the house.

A MICKEY MOUSE-EUM IN DOWNTOWN NEWARK, NEW JERSEY

One of the world's leading collectors of Disneyana is Mel Birnkrant, who began collecting early Mickey objects in the mid-1960s. During the Christmas season of 1973, Birnkrant installed a portion of his vast collection in a Mickey Mouse-eum at the L. Bamberger's department store in downtown Newark, New Jersey. The store wanted to celebrate Mickey's 45th birthday.

Disney merchandise items orig-inally sold in L. Bamberger's and other leading department stores in the Depression–World War II era—the dolls, games, toys, books, watches, clocks, radios, figurines, Christmas tree lights, and ornaments—were now being

OPPOSITE: LIFE-SIZED PAINTED AND HAND-CARVED WOOD FRENCH CAROUSEL FIGURES OF MICKEY AND MINNIE. RIGHT: CARDBOARD DISPLAY SIGN FOR A SPECIAL CHRISTMAS IN 1973.

presented as if they were *art* for the very first time. The installation was a sight to behold for children and adults alike.

Within the exhibit were the mini-Mouse-Oleums containing dense arrangements of hundreds of hand-painted Made-in-Japan bisques of Mickey Mouse, Minnie, Pluto, Donald Duck, Clarabelle, Goofy, Horace Horsecollar, Snow White and the Seven Dwarfs, Elmer Elephant, the Three Little Pigs, the menacing Big Bad Wolf, Little Red Riding Hood, Pinocchio and his good and ill-begotten friends Geppetto, Jiminy Cricket, Figaro the Cat, Cleo the Goldfish, J. Worthington Foulfellow, Gideon, Stromboli, and Monstro the Whale. Standing on elevated platforms, these figures evoked in the adult spectator a powerful nostalgia for childhood times gone by.

ABOVE: NEON INDUSTRIAL-STYLE CLOCK FEATURING AN ANIMATED "TURN-ABOUT" SOMERSAULTING MICKEY. OPPOSITE: HAND-PAINTED BISQUE FIGURINES AND TOOTHBRUSH HOLDERS, FEATURING MICKEY AND MINNIE MOUSE (1930S).

Early Disneyana collectors who went to this exhibit were astounded at the great variety of objects like the giant, gleaming red-and-blue neon clock in which Mickey did a complete somersault every minute while his hands pointed out the time; giant display figures of Clarabelle the Cow and Horace Horsecollar manufactured by the Old King Cole Company; rare and unusual human-sized Mickey and Minnie Mouse merry-go-round figures in wood, hand-carved and painted in France; and an Austrian bronze Mickey Mouse orchestra, which included ten tiny painted figurines with musical instruments.

The French Bank

The Birnkrant Mouse-eum offered a chance to view what was even then considered a rare Mickey Mouse icon, a cast-iron bank Birnkrant reportedly discovered in a Paris flea market. Some painted aluminum versions of this iron rat-like Mickey turn up today with the imprint "License Exclusive" engraved on the ears or the word "Déposé" across Mickey's back, but even these are scarce and sell into the four figures.

The well-known artist and Disneyana collector John S. Fawcett, in a magazine article he

wrote for *Collectors' Showcase*, called this particular bank the ultimate Mickey Mouse image and collectible. Mr. Fawcett is the owner of several aluminum and iron banks and also has one in brass weighing in at five pounds. He claims it is the only one made of this material known to exist. No collector or dealer up to this point has been able to determine which French company produced these

figural banks, and some confusion exists as to why they were made in three different metals. One theory is that a schoolchildren's molding set existed, but no proof of such a set has been found.

MUSEUM EXHIBITS
AND DISNEY AT AUCTION

everal official museum tributes honoring Disney and Mickey Mouse followed the exhibit at L. Bamberger's. The Bowers Museum in Santa Ana, California, mounted an exhibition in 1978 dedicated to the more serious collector whose "foresight in collecting ensured the preservation of Mickey Mouse art and memorabilia." 1978 was the year the world celebrated Mickey Mouse's fiftieth birthday. A film tribute was held at the Museum of Modern Art in New York, and an exhibition at the Library of Congress in Washington, D.C., entitled "50 Years of Animation—Building a

ABOVE: MICKEY CELEBRATES HIS FIFTIETH BIRTHDAY ON THE COVER OF *LIFE* (NOVEMBER 1978). **OPPOSITE:** MICKEY MOUSE WOOD PULL-TOY FROM FISHER PRICE TOYS (1946).

T-SHIRT FROM THE WHITNEY MUSEUM OF AMERICAN ART "DISNEY ANIMATIONS AND ANIMATORS" SHOW (1981).

vey the processes of animation.

Since 1972, Mickey Mouse at the auction block has been a growing affair, when Kamen's daughter June Gitlin consigned her Disney collection to Sotheby's in Los Angeles. Another such auction was held in New York at Phillips Son & Neale on October 5, 1981, entitled "Disneyana." Animation cels, original art, books and comics, watches and toys, most from the estate of Al Taliaferro, a Disney animator who specialized in Donald Duck, brought in top prices. A one-sheet poster for *Donald's Tire Trouble* (1943) brought $1,100. Donald in a vivid one-sheet for a cartoon called *A Good Time for a Dime* (1941) sold for $750. An animation cel of Donald Duck from *The Band Concert* went for $2,750. A successful bid of just $10 netted one participant at the auction a Donald Duck eggcup made by

Better Mouse" showcased 120 rare and previously unseen examples of Mickey Mouse memorabilia and Disneyana. The Whitney Museum of American Art in New York mounted a fine exhibit of over 1,500 drawings, cels, and original backgrounds in 1981. Various elements of the cinema—movement rhythm, illusion, shadow, light, darkness, and projection—were utilized in the installation to con-

T. W. Hands Fireworks Company of Canada, in the original box; a Donald Duck Popcorn can, unopened, distributed by Popcorn, Inc., Carnarvon, Iowa; two bottle caps from Donald Duck Cola; and a bottle of Donald Duck Grapefruit Juice, unopened, distributed by the Citrus World Corporation, Florida. Oh, Happy Duckiana!

On Sunday, January 17, 1988, Rita Reif announced in a feature article in the *New York Times* that the most comprehensive collection ever assembled of comic character toys from the collection of Robert Lesser, including his remarkable Disneyana pieces, was up for sale at the Alexander Gallery. Early, and rare, German and Spanish litho-on-tin windup Mickey and Minnie Mouse toys as well as celluloids, bisque figurines, Charlotte Clark dolls, animated watches and clocks, and bubble gum cards were among the 4,000-plus items. The asking price for the entire collection, which included a French hand-painted iron Mickey Mouse still bank, was $1,150,000. The collection, practically in its entirety, was purchased by Phillip Samuels. In her Sunday *New York Times* "Antiques" column of July 23, 1989, Rita Reif reported from Clayton, Missouri,

MICKEY "THE ACCORDIONIST." A HAND-PAINTED BISQUE FIGURINE (1930S).

on the newly opened Samuels Museum of Comic Toys. The museum did not last long, however. A year later on October 30, 1990, at Christie's East, the de-accessioning started: A rare German tin-litho Mickey Mouse tap dancer from Samuels's collection sold for $17,600; a celluloid Mickey and Minnie astride a white elephant sold for $7,150; and a Waddle Book sold for $9,550.

Records continued to be set at auction. Christie's East sold a celluloid toy of Mickey riding atop Pluto in December 1988, for $6,600, a set of *Snow White* Seven Dwarfs composition dolls from Knickerbocker for $950, and an Ideal 18 1/2-inch Pinocchio composition doll for $950. Also in 1988, at this same auction house, a cel from *The Mad Doctor* (1933) sold for $63,800! In the summer of 1991, Christie's East and Sotheby's held collectibles sales that included cels and rare Disneyana, realizing a combined total of over $2 million.

Steven Spielberg, a major animation art collector, writing in a recent Christie's animation art catalog, said "In recent years, those of us who love animation have seen its renaissance throughout the world. That is a tribute to those creative talents who have painstakingly sketched and painted the original cels, bringing stories and characters to life. It is also a tribute to the audiences and collectors who have again recognized and appreciated the artistry of classic animation."

Ted Hake's Americana and Collectibles of York, Pennsylvania, held a telephone call-in and catalogue mail-bid auction on February 1 and 2, 1994, offering a variety of over three thousand collectibles. Prices realized for some of the Disneyana include $950 for

a Donald Duck bisque (a scarce figure with a mandolin); $1,236 for an Ingersoll #1 Mickey Mouse wristwatch with die-cut silvered-brass Mickeys that grasp the leather strap (a price that reflected the timepiece's rare wire lug case); $619 for a ceramic Pinocchio figurine by Goebel, which had been estimated around $400 to $700; $400 for a Goebel Dumbo; $300 for a 1937 Mickey Mouse Cookies box (color lithograph cardboard and without the cookies); $288 for a Made-in-Japan china Mickey Mouse ashtray; and $250 for a matching Minnie Mouse ashtray. Treasure-trove auctions are held several times a year by Hake's Americana and Collectibles, and are prime sources for nostalgia collectibles and Disneyana.

PORTION OF THREE-SHEET MOVIE POSTER FOR *HOLLYWOOD PARTY*, A 1934 MGM VARIETY PICTURE.

MICKEY MOUSE: THE ORIGIN

ABOVE: MICKEY MOUSE AS THE CAPTAIN IN *STEAMBOAT WILLIE* (1928). OPPOSITE: MICKEY MOUSE MOVIE PROJECTOR, FROM KEYSTONE MFG. CO. (1935).

When the sound-synchronized animated short film entitled *Steamboat Willie* opened at the Colony Theater on November 18, 1928, in New York City, movie audiences were delighted by the happy cartoon character mouse. Dressed in boys' shorts and big clown shoes, Mickey squeaked and whistled his way into the hearts of viewers.

In 1922 a twenty-year-old Walter Elias Disney formed Laugh-O-Gram Films in Kansas City with his best friend Ub Iwerks. Together these two geniuses created animated silent shorts of fairy tales like *Jack and the Beanstalk*, *Goldilocks*, and *Little Red Riding Hood*. This early experimentation with animated fairy tales did not catch on and soon drove Laugh-O-Gram and its self-starters into

bankruptcy. In 1923, Walt decided to take the train to Hollywood in search of greener pastures and greater cash flow. Disney soon was transfixed by the idea of combining live actors with animated cartoon characters, and the result was the Alice comedies, which featured a real girl named Virginia Davis, brought from Kansas City.

With brother Roy O. Disney acting as business manager, Walt produced fifty-six Alice comedies. In 1927, Disney had become focused on the creation of a character he called Oswald the Lucky Rabbit. In the tradition of the black-and-white cartoons of the day, Oswald had a white face and a black body. Except for his long rabbit ears and bushy tail, we can see from today's perspective that he has a noticeable resemblance to his later incarnation—Mickey Mouse!

Oswald the Lucky Rabbit cartoon shorts became very successful for Disney and his distributor, Universal Pictures. While laboring on twenty-six of these bunny shorts, Disney decided he should

OSWALD THE LUCKY RABBIT BIG LITTLE BOOK FROM WHITMAN (1934).

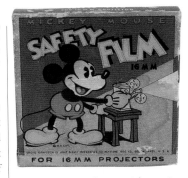

go to New York and request more advance money to meet his cost of production. When he arrived he was not only turned down flat but was informed that because of

the existence of a miniclause in his contract, he did not own the rights to Oswald. Disney was stunned. Depressed and angry, he took the next train home to California with his wife Lillian. Legend has it that it was on this train heading west that Disney, doodling with a pencil and pad, came up with the idea for a new character called Mortimer Mouse. Apparently, Mrs. Disney christened the character with the name "Mickey" because it had more syntax. Thus the cartoon abstraction Mickey Mouse was born.

MICKEY MOUSE AT THE
SATURDAY MOVIE MATINEE

Harry W. Woodin, a manager of the Fox Dome Theater in Ocean Park, California, began the first Mickey Mouse Club for children's Saturday movie matinees. Walt Disney saw the clubs as an outlet for merchandising and reasoned as well that they would help inspire more and more children to go to see Mickey cartoons. Through 1929 there had been fifteen Mickey cartoon shorts released to movie theaters nationwide, and Woodin was hired by Disney as a general manager to organize the kiddie-matinee activities. Mickey Mouse Club bulletins were printed up and sent to theater managers, instructing them on how to develop clubs in their own hometowns. Soon bakeries offered children free Mickey Mouse birthday cakes; dairies offered ice cream to contest winners; banks gave away Mickey savings banks; and department stores gave out free Mickey Mouse toys to help promote sales

ABOVE: PROMOTIONAL GIVEAWAY BUTTON FROM THE ORIGINAL MICKEY MOUSE CLUB (1928–30). OPPOSITE: OFFICIAL MICKEY MOUSE CLUB STORE WINDOW CARD.

for their more expensive toys. By 1930, Mickey Mouse Clubs were established in England, Canada, and other countries as well. Great Britain's Odeon Theater chain alone boasted 160 clubs with 110,000 members. By 1932, the Mickey Mouse Clubs had one million members worldwide.

On Saturday afternoons Mickey Mouse Clubs taught children how to become good boys and girls. Attending Sunday school, doing homework, respecting parents, helping old men or women to cross a street, honesty and honor, were the orders of the day for kids of the Depression era. Mickey Mouse also instructed kids on how to brush their teeth, wash behind their ears, and to make their own beds. Ephemera from the club days of the 1930s includes the $8^{1}/_{2}$" x $8^{1}/_{2}$" orange-and-black store window signs given to shopkeepers that read "Official Mickey Mouse Store," Mickey Mouse birthday cards, club membership cards, paper masks of Mickey and Minnie, the official club bulletin, the club newsletter, and the Mickey Mouse magazine. Original Mickey Mouse Club pinback buttons are also prized by collectors as mementos of more innocent days gone by.

WALT DISNEY MEETS KAY KAMEN IN PRODUCTVILLE

When the stock market crashed in October 1929, Mickey Mouse was only a year old, and already the leading attraction on movie marquees all across America. With eleven Mickey Mouse shorts and *The Skeleton Dance*, the Silly Symphony short, drawing in record crowds, Disney

was sitting on top of the world. Mickey Mouse Clubs were established in small towns and cities, and the brothers Roy and Walt began receiving a great number of requests for merchandise licenses. By the early 1930s unlicensed Disney merchandise began to appear, much of it produced in Germany, France, England, Italy, Czechoslovakia, and Spain.

Walt and Roy became focused on the financial advantages of licensing their creation as a means of creating a larger audience for the Mickey Mouse cartoons. In December 1929, Walt, the vision-

OPPOSITE, CLOCKWISE FROM TOP LEFT: TWO SIZES OF MICKEY AND MINNIE MOUSE PAPIER-MÂCHÉ STORE DISPLAY FIGURES (1933); PERSONALIZED SHEET OF MICKEY MOUSE WRITING STATIONERY FOR RUTH IVENER, KAY KAMEN'S VICE-PRESIDENT (1934); CHILD'S PLAYHOUSE INTERIOR FEATURING TWO LARGE CHARLOTTE CLARK PLUSH DOLLS (1933).

ary and artist, and Roy, the conservative and astute businessman, turned Walt Disney Productions into four subcorporations: a production company, a film recording company, a real estate holding company, and a licensing and merchandising company—the latter known as Walt Disney Enterprises. Roy Disney drafted the first formal contract for the merchandising of Mickey Mouse, which was signed by Walt Disney and the George Borgfeldt Company on February 3, 1930.

Borgfeldt's imported and American products were distributed widely through the toy trade all over the United States. With their exclusive licensing and full distribution rights for the Disney characters, Borgfeldt flooded the dime stores, department stores, and gift shops with bisque and porcelain figurines of Mickey Mouse, made in Japan, as well as fine porcelain tea sets, made in Germany and Czechoslovakia. The very first Mickey Mouse sublicensing rights were granted to a Swiss company called Waldburger, Tanner & Company, which produced a handsome boxed set of Mickey Mouse and Minnie Mouse handkerchiefs.

The Nifty Toy Company created a variety of early toys distributed by Borgfeldt, featuring a Mickey Mouse that tumbled, jumped, danced, squeaked, and clicked, made from lithographed tin, wood, cardboard, and rubber. Other early Borgfeldt toys included a metal sparkler with a Mickey Mouse head, a seven-inch tin-litho Mickey animated drummer, a thirteen-inch metal Mickey and Minnie drum, a Mickey Mouse

shooting game, a felt Mickey Mouse hand doll, a rubber sport ball, and tin-litho spinning tops. The first licensed Mickey Mouse character merchandise was often made from the cheapest available material, such as celluloid or tin.

By 1930 Mickey Mouse cartoons were enjoyed all over the globe. In order to supply the increasing demand for Mickey Mouse merchandise and to protect their merchandising interests in Europe, the Disneys selected William Banks Levy, the manager of the Powers Cinephone in London, which in 1930 was handling Mickey Mouse film distribution, to license manufacturers in England, France, Germany, Italy, and other countries.

The first licensed English product was a cellophane filmstrip mounted under glass to be sold

J. GUIDUCCI, A STUDIO EMPLOYEE, AND WALT DISNEY POSE WITH GIANT-SIZED PLUSH CHARLOTTE CLARK DOLLS (1933).

with a toy lantern projector, made by Johnsons of Hendon, Ltd. Also from England were the eight sizes of Mickey and Minnie dolls produced by the Dean's Rag Book Company, London. Some of these toothy rodent-like Mickey or Minnie dolls had limbs with joints so that their bodies could be twisted into different positions. Other

dolls offered by Dean's Rag include Mickey Mouse and Minnie Mouse "dancer" dolls; a Mickey "skater" on wheels; a "Li-Vo" Mickey puppet controlled through an opening in the back; and a velveteen handpuppet, which was a Mickey Mouse "glove" toy.

Though Borgfeldt was the chief American producer and distributor of Mickey Mouse character merchandise in the United States, Disney was not altogether happy with the quality and design of the toys, games, figurines, and dolls. Mickey Mouse cartoons were often billed right next to the regular features on movie marquees and were certainly gaining all the time in popularity. But nickel, dime, and quarter admissions were not adding up to the dollars Disney needed in order to expand his organization. Film distributors demanded promotional ideas to tie in the cartoons to the Mickey Mouse Clubs and to their local merchants and retailers. During the Depression, when all sales were falling, more manufacturers were taking a good hard look at their products following a poor Christmas season and turning to the sales power of Mickey Mouse and his friends. Disney realized that the future of the studio could become secure only if enough

WALT DISNEY (THIRD FROM LEFT), KAY KAMEN (THIRD FROM RIGHT), AND (FAR RIGHT) ROY DISNEY (1933).

revenue was generated by the character merchandising division.

Walt Disney did not encourage individuality in his artists and staff members, feeling that everyone should contribute as much as they could to the overall product. He also knew that they might jump ship and start their own companies. He made an exception when he tapped Herman "Kay" Kamen to be his licensing representative in the all-important character merchandising division of Walt Disney Productions.

Kay Kamen had already developed a nationally known reputation in merchandise promotion when he joined Disney in 1932. He was known as a gentleman in the grand tradition of the old school. He was polished and charming, forthright and self-taught, tailored and impeccably groomed, a man with a large and imposing frame who sported a part-down-the-middle Vaselined hairstyle. Kamen's brand of showy salesmanship, combined with his luxurious personal lifestyle and elegant eastern manner, helped to seduce many a client into closing a deal. Though the showman in Disney appreciated Kamen's style, it was primarily Kamen's proven abilities in merchandising along with his conservative midwestern views on life and money that coincided with Walt's own philosophy of "putting every penny back into the pot."

The Walt Disney–Kay Kamen alliance was to make the cartoon image of Mickey Mouse into a

first-rate product that in turn could provide the funds Disney needed to continue creating animated movies. Kamen's first real task was the creation of a Mickey Mouse press book. This advertising campaign book was centered around the Mickey Mouse cartoons and suggested advertising art, radio program and contest ideas, as well as tie-ins with manufacturers and their products. The available promotional material included

OFFICIAL MICKEY MOUSE STORE CELLULOID BUTTON.

paper Mickey and Minnie masks, flicker books, balloons, celluloid pinback buttons, posters, pennants, and lobby decorations with written instructions for theater managers, and lists of activities for the Mickey Mouse Clubs.

A suggestion made by a merchandise buyer from Montgomery Ward heralded the turning point in Mickey Mouse merchandising for Kamen. It resulted in the legendary 1933 alliance of the Mickey Mouse image with the Ingersoll-Waterbury Clock Company to manufacture watches and clocks bearing Mickey's likeness. This deal and many others like it, such as the one with the National Dairy Company, which sold well over ten million Mickey Mouse ice-cream cones, and Kamen's successful Globetrotter Bread Campaigns for bakers, which used Disney characters to promote various brands of bread, pushed Mickey Mouse over the top as one of the world's leading supersalesmen.

Kamen became Disney's sole

and exclusive representative for Walt Disney Enterprises in 1933, called by some the worst year of the Depression. Borgfeldt's exclusive licensing contract was canceled in 1933, though the company continued to manufacture and distribute Disney character merchandise until 1941. William Banks Levy's exclusive contract was also nullified in 1933, but as a licensee he persisted in England, beginning the Odhams Press *Mickey Mouse Weekly* in 1936.

Kay Kamen Ltd. created a new standard for the world of Mickey Mouse merchandise by establishing headquarters in prestigious Art Deco–style offices at Rockefeller Center in New York. The West Coast offices were at the Disney Studios in Hollywood. The organization included a network sales office to handle licensed manufac-

POSTER SHOWING THE DISNEY CHARACTERS AVAILABLE FOR LICENSING.

turers and distributors, a department for retail store exploitation, and a production department for advertising, packaging, and promotion. Design and artwork was supplied free of charge to licensees to ensure that the images of Mickey Mouse and his friends

THE SWEETEST MUSIC OF ALL IS THE JINGLE OF YOUR CASH REGISTER

A KAY KAMEN PROMOTIONAL BROADSIDE.

were consistent with the cartoon film characters who might change, sometimes almost imperceptibly, from film to film.

The financial arrangement Kamen had with Disney made him a millionaire, and enabled him to maintain luxuries such as a private railway car home-based in Omaha, which he used in his ceaseless cross-country business travels on behalf of Disney. Kamen set up sales offices in London as well as in Toronto, Lisbon, Milan, and Paris. Offices were also established on the con-

tinents of South America and in Australia. The agreement with Disney, first signed in 1933, structured the profits at 40 percent for Kamen and 60 percent for Disney, up to $100,000. Thereafter it was 50 percent for each.

Christmas 1933 saw America in the grip of the Great Depression, but thanks to Kamen it turned into a bright season for Walt Disney. Mickey Mouse sales topped those of 1932. Every department store in America was demanding Mickey Mouse as the main merchandising theme for Christmas. Some merchandisers and retailers said that Mickey Mouse had taken over Santa Claus in the minds of some children.

Kamen printed a promotional broadside in 1935 stating that "in 1934 Mickey Mouse helped to sell $35 million worth of merchan-

dise"—an astronomical feat in another bad economic year. Mickey and his group of earliest friends—Minnie, Pluto, Horace, Clarabelle, and Goofy—now were obliged to help sell the Three Little Pigs, the Big Bad Wolf, and Donald Duck, a new cast of Disney characters that Kamen was eager to launch in the marketplace.

With the advent of Disney's two greatest animated feature-length films, *Snow White* and *Pinocchio,* the parade of licensed characters multiplied, and graphics on toys and other children's products often featured characters from the two films in various surprising combinations along with many of the other cartoon and Silly Symphony characters: Donald Duck dancing with Dopey, or Snow White patting the head of Figaro the Cat, is a familiar sight to Disneyana enthusiasts today. The artwork on the signs and the waxed bread wrappers from the Kamen campaigns make them desirable as collectibles. Bread

picture cards and bread end-seals are also collected for Disneyana scrapbooks today.

In terms of dating items, it should be noted that in 1939 Walt Disney Studios moved to its new Art Moderne quarters in Burbank and that in the process of reorganization eliminated its ancillary company, Walt Disney Enterprises. After 1939, copyright notices on most items read "Walt Disney Productions" or just "W. D. P."

During World War II and into the postwar years, it became clear that Mickey Mouse had been superseded by Donald Duck, who became the new cartoon superstar at the studio. Donald also dominated the character merchandise market. The Donald Duck Bread campaign was a standout success, featuring waxed bread wrappers with Donald and his nephews Huey, Dewey, and Louie.

Kamen had made successful transitions from the Depression to World War II and then into peacetime. After the war years, he began making business trips by airplane to Stockholm, Copenhagen, London, and Dublin. On October 28, 1949, Kamen (then fifty-six) and his wife Katie died in an Air France plane crash over the Azores. After his untimely passing, many of his better ideas were dropped by the restructured Disney merchandising organizations that followed.

TOP: MICKEY MOUSE GLOBE TROTTERS MEMBER BUTTON (1936). OPPOSITE: *MICKEY MOUSE MAGAZINE*, PUBLISHED BY THE NEW HAVEN DAIRY COMPANY (MAY 1934).

MICKEY MOUSE AT THE FIVE-AND-TEN:
THE MERCHANDISE PHENOMENON

The first deal for the use of the Mickey Mouse image on a product was made in the autumn of 1929, when Walt Disney encountered a man in a hotel lobby in New York City who asked him if he could use Mickey on a child's school note tablet, and offered him $300 on the spot. This event piqued Disney's interest in making other merchandising deals.

In 1930 Charlotte Clark produced her wondrous line of stuffed Mickey Mouse dolls, which captivated both children and adults. These original Mickey dolls were first sold at Bullock's and at May Co. department stores that Depression Christmas. If the five-dollar price tag was a bit much, parents could choose less

Now parents had only to send in ten cents to receive the printed Mickey Mouse pattern #91 in the mail from *McCall's* magazine. The pattern suggested that the doll's pants be made of flannel, and the body made of cotton.

Margarete Steiff & Company created a line of very fine stuffed Mickey dolls in the 1930s. They

expensive Mickey Mouse toys, including the first wood-jointed doll, which was designed by Disney artist Burton Gillett and distributed by Borgfeldt.

Mickey and Minnie Cloth Dolls

Mickey Mouse velvet and cloth dolls were first made in 1930 in California by Charlotte Clark. Minnie was first produced in 1931. Disney authorized the McCall's Company of New York to offer the Clark doll pattern to the public.

often have long black whiskers, a lengthy tail, and are made in velvet, broadcloth, and other better quality materials. A manufacturer's tag is usually found set in one ear; they also sometimes have the orig-

inal orange cardboard tag strung around the collar. The Steiff Mickeys and Minnies, which were produced in Germany, were sold in England and the United States, and are eagerly sought after by doll collectors as well as Disneyana collectors. They range in size from 4 1/2 to 16 3/4 inches.

The Knickerbocker Toy Company manufactured first-rate Mickey and Minnie dolls. Knickerbocker also began adding outfits to their Mickey Mouse dolls, offering Mickey in a Spanish toreador costume, in a polka-dot clown suit, and in a variety of Wild West cowboy gear, including sheepskin chaps, a kerchief, a cowboy hat, guns in holsters, and a rope lariat.

Dean's Rag Book Company, which had made children's ragbooks since 1903, created some unusual Mickey and Minnie cloth dolls in the 1930s. These featured

Mickey Mouse in Toyland: Tin Litho and Trains

Lithographed-on-tin action wind-up comic character toys are considered among the most desirable collectibles in today's Disneyana marketplace. A German tin-litho toy like the Mickey-and-Minnie-Riding-a-Motorcycle depicts two toothy, smiling rodents on a motorbike, complete with Dunlop whitewall tires. This very handsome and rare toy was manufactured by the Tipp Company in 1928 for an English marketplace. The Mickey Mouse Hurdy-Gurdy tin-litho windup features a thin, five-fingered Mickey cranking the organ, while a tiny Minnie sings and dances on top to a plink-plank-plunk tune. Manufactured in 1931 by the Johann Distler Company of Germany, this toy always causes a stir when it is

long spider arms and legs, rat teeth, white saucer eyes with black pupils, flat feet, and baggy shorts. The dolls infuriated Walt Disney when he first saw them, and he instructed William Banks Levy, his London agent, to stop exporting the doll to America. However, collectors today consider them unique and are fascinated by their ratty look.

ABOVE: THE HEADS OF THIS MUSICAL TOY MOVE TO A TUNE WHEN THE HANDLE AT THE BACK IS TURNED (1930). **TOP LEFT:** A RARE TIN WINDUP ACTION TOY (1931). **LEFT:** MICKEY AND MINNIE ON A MOTOR-CYCLE WINDUP TOY (1930S). **BELOW:** THE MICKEY MOUSE CIRCUS TRAIN, PART OF A SET SOLD BY THE LIONEL TRAIN CORPORATION (1935).

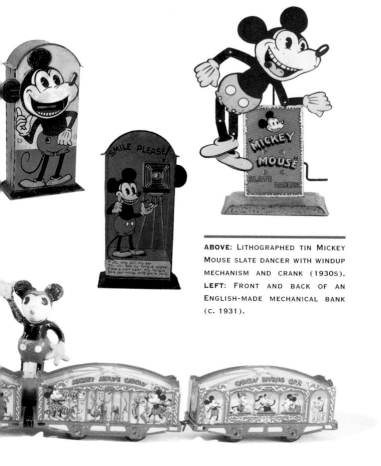

ABOVE: LITHOGRAPHED TIN MICKEY MOUSE SLATE DANCER WITH WINDUP MECHANISM AND CRANK (1930S). **LEFT:** FRONT AND BACK OF AN ENGLISH-MADE MECHANICAL BANK (C. 1931).

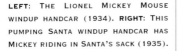

LEFT: THE LIONEL MICKEY MOUSE
WINDUP HANDCAR (1934). RIGHT: THIS
PUMPING SANTA WINDUP HANDCAR HAS
MICKEY RIDING IN SANTA'S SACK (1935).

being offered at a show or put
forth at auction. Made-in-Spain
lithographed tin-action toys manu-
factured by Isla are also consid-
ered rare.

Litho-on-tin toys were manufac-
tured in the millions during the
1930s, mostly in the United States
and England. One of the more
attractive pieces by today's stan-
dards is the Lionel Mickey Mouse
Circus Train set. With a bright
red windup or battery-operated
Commander Vanderbilt stream-
liner engine, and with flashing
headlights and ringing bells, the
toy train was stoked by a swivel-
ing, coal-shoveling Mickey Mouse.
Wells O' London under the
Brimtoy Brand made a version of
this train set featuring a "Silver
Link" engine and a beautifully
executed litho-on-tin circus tent.
Manufactured in 1935 and 1936, it
easily stands alongside the
American Lionel set as among the
best of Disney collectibles.

The most famous Mickey Mouse toy of the thirties is the Mickey Mouse handcar, manufactured by Lionel. With painted wood composition figures of Mickey at one end and Minnie at the other pumping away in a see-saw motion, this bell-ringing car first rode the tracks around the Christmas tree in 1934.

The Bisque Figurines

These Made-in-Japan hand-painted bisque figurines were sometimes mounted on cellophane-wrapped candy containers sold at dime stores. Single bisques were also used as prizes at games of chance at carnivals and amusement parks. Bisque is unglazed porcelain that

TOP: BISQUE TOOTHBRUSH HOLDER (C. 1934). BOTTOM: AT NINE INCHES TALL, THIS MICKEY IS THE LARGEST BISQUE ITEM IMPORTED FROM JAPAN BY THE GEORGE BORGFELDT COMPANY (C. 1934).

has been fired once, after which it can be hand-painted.

Often these bisque figurines came in band sets, with Mickey playing a drum, a banjo, a tuba, an accordion, holding a songbook, or waving a baton. Other sets depicted Mickey with a baseball bat, a mitt, or holding a ball. Collectors prize the sets when they are found in the brightly colored cardboard boxes that feature primitive images of Mickey and Minnie lithographed or silk-screened onto paper label stick-ons. There are toothbrush holders of Mickey and Minnie sitting on a couch, or just a singular standing mouse figurine, or Mickey with Pluto showing Mickey wiping the dog's nose with a rag.

The tiniest and one of the rarest Mickey bisque figurines is just one

LEFT TO RIGHT: HAND-PAINTED BISQUE HORACE HORSECOLLAR, BISQUE PLUTO, AND BISQUE MICKEY MOUSE TOOTHBRUSH HOLDER (1930S).

inch high. The largest Mickey Mouse bisque stands 8 3/4 inches on a fully formed bisque base. Some of the figurines have movable arms and heads, and stand 4, 5, 6, and 7 1/2 inches high. Painted in a variety of color combinations, these characters often have a license number imprinted on them like "Des Pat 8302 by Walter E. Disney" or "W. D. Ent."

Rare bisque or porcelain Mickey Mouse figurines with grinning, toothy rat faces were also produced in Germany. In 1934 Adolf Hitler branded Mickey Mouse "a pest" and proceeded to ban him, reasoning that Disney's cartoon character had a bad influence on Germany's youth.

The Celluloid Toys

Celluloid is a lightweight, thin but fragile, flammable plastic developed in the early years of the twentieth century as a substitute for shell, ivory, bone, and other natural materials. Many excellent figural and action windup Mickey Mouse or Donald Duck celluloid

ABOVE: HAND-PAINTED "BABY MICKEY" BISQUE FIGURINES FLANK A TIN LITHO "LOLLIPOP" PAIL. BELOW: A RARE FIVE-FINGERED CELLULOID MICKEY MOUSE TOY WITH TIN EARS AND WIRE TAIL MADE IN GERMANY BETWEEN 1929 AND 1932.

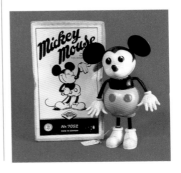

toys were manufactured in Japan during the 1930s. In this material we find Mickey and Minnie doing acrobatic turnabouts on wire stands, or Mickey walking, nodding, shaking, or riding on a flat platform on wheels. There were celluloid baby rattles and bathtub floatables.

Borgfeldt was the chief distributor of celluloid toys. These were often Mickey, Minnie, or Donald figures with movable arms or nodder heads. Examples include a windup carousel with a figure of Mickey beneath a spinning

umbrella. Another version of this whirligig features Donald Duck. Some staunch collectors think that it is most desirable to find such a toy in the original box.

Celluloids are among the most lifelike of all the pieces of Disneyana; and because of their fragility and rarity are among the most prized and expensive Disney collectibles in the marketplace. With fine detailing and imagina-

TOP: HAND-PAINTED MICKEY AND MINNIE CELLULOID FIGURES WITH MOVABLE ARMS. **LEFT:** A CELLULOID MICKEY MOUSE DOLL RIDING A WOODEN HOBBY HORSE. **OPPOSITE:** CELLULOID WINDUP ACTION TOY WITH MICKEY AND TANGLEFOOT.

tive designs, these often sell into the four figures today if they are perfect and still have their paper labels intact, which might read: "Walt E. Disney—Made in Japan."

Mickey Mouse Timepieces

During the Depression, whether at a graduation ceremony, a birthday, or Christmas, a Mickey Mouse comic character wristwatch from Ingersoll-Waterbury was the thing for a boy or girl to receive. With Mickey's yellow-gloved hands pointing to the time, 11,000 of these were sold at Macy's New York store on one day.

Mickey Mouse Ingersolls sold for $2.98 at Macy's and for $2.69 at Sears, Roebuck. Disneyana collectors insist that a "number one" Mickey Mouse Ingersoll watch is something they must own, and they will pay several hundred

MICKEY MOUSE WRISTWATCH NUMBER ONE, MADE BY THE INGERSOLL-WATERBURY CLOCK COMPANY (1933).

dollars to find one in the original box. Teenagers and young adults in the thirties seemed to prefer the Mickey Mouse pocket watch with a Mickey chromium fob to the smaller wristwatch.

By the late 1930s, the Ingersoll watches became rectangular rather than round and featured a less implike, mischievous Mickey than the original. Nevertheless these are still desirable among collectors. In 1933, Ingersoll also produced two table-model Mickey Mouse clocks, one electrical and the other a windup. A Mickey Mouse watch was put into a time-capsule buried in the ground at the New York World's Fair of 1939, giving it the status of a "necessity" in terms of modern living. By 1957 the Walt Disney Company estimated that 25 million Mickey watches had been sold.

A French-made Mickey Mouse alarm clock has a red-gloved, wagging head Mickey who appears to be racing against the concept of

ABOVE: THE FIRST MICKEY MOUSE POCKET WATCH (1933). BELOW: THIS ALARM CLOCK FEATURES A WAGGING HEAD MICKEY MOUSE (1934).

The first Mickey Mouse clock, made by Ingersoll in 1933, was painted Depression green and had a paper band pasted on the side that featured lithographs of Mickey and his friends.

time. These round clocks were produced from 1936 through 1969 by the Bayard Company without changing a single aspect of the design or manufacture.

In the 1960s nostalgia revival, some very attractive production pieces were originally made as prototypes for Ingersoll-Waterbury by artist–toy dealer Al Horen but were never produced in volume. Called "love-in" watches, they are regarded as art pieces that have become rare treasures. Certainly, they are hard to find today.

TOP: Bayard Company's wagging head Mickey Mouse alarm clock. **BOTTOM:** Production model of a Mickey and Minnie "Love-In" pocket watch, which was never mass produced (1960s). **LEFT:** A Celluloid-encased, Art Deco style windup desk clock (1934).

"HOME SWEET HOME" MICKEY

Mickey Mouse for Tots

One of the first things a baby sees is Mickey Mouse on a rattle, as a doll, or in a picture on the nursery wall. Some wonderful tot merchandise from a variety of manufacturers was produced in the thirties, forties, and fifties. Hemco Moulding, a division of the Bryant Electric Company, manufactured children's cocoa mugs, sectioned feeding plates, cereal bowls, and Mickey Mouse dish sets in a sturdy early plastic called Beetleware. Beetleware was produced in red, white, blue, yellow, cream, and green.

ABOVE: BABY'S FIRST DRINKING MUG, MADE OF BEETLEWARE IN DEPRESSION GREEN (1935). OPPOSITE: TOY WASHING MACHINE, FROM OHIO ART (1934).

In 1937 either children or their doting parents could send in a box top from Post-O-Wheat Cereal to General Foods and receive a 5 1/2-inch silver-plated Mickey

67

Mouse cereal spoon. A small child's fork and knife set first produced in 1934 by Fairfield Silver Plate had Mickeys and Minnies embossed on them. The William Rogers & Son sterling silver Mickey Mouse drinking cup, on which a child's name and birth date were often engraved, is considered a fine collectible. The Salem China Company put out a quality line of Mickey Mouse dishware to attend to baby's eating needs.

Blankets, coverlets, bibs, towels, washrags, sheets, pillowcases, and other fabric "useables" with Disney characters imprinted on them were distributed by Smith, Hogg & Company. The Seiberling Latex Rubber Products Company produced Mickey Mouse rubber crib dolls with movable parts, as well as hot-water bottles in the shape of Mickey

TOP: MICKEY AND MINNIE MOUSE "HELPMATE" CHILDREN'S TEA SET (1934). **LEFT:** DIE-EMBOSSED SILVERPLATED SPOON AND CHILD'S DRINKING CUP IN STERLING SILVER, BOTH MADE BY WILLIAM ROGERS & SON (C. 1934).

litho-on-cardboard box, were first produced in 1935 by the Halsom Products Company. These sets came with 9, 16, 20, 30 or 50 blocks featuring Mickey, Minnie, Pluto, Horace, Clarabelle, and other characters.

Eminently collectible in the Disneyana field and found everywhere in America in the 1930s are the Made-in-Japan children's play chinaware tea sets featuring Mickey, Minnie, Donald, and the

Mouse in a sleeping outfit, Mickey Mouse playpen balls, and squeeze-whistle latex Mickey dolls. The American Latex Corporation made a notable contribution to babydom with Mickey baby panties. Celluloid rattles for babies were produced by the Amloid Company. The Mengel Corporation introduced Mickey Mouse playroom rockers, a backyard slide, and a seesaw.

Machine-carved, painted wood Mickey Mouse "safety" alphabet blocks, packaged in a beautiful

A LITHOGRAPHED TIN SPINNING NURSERY TOP FEATURING MICKEY AND FRIENDS (1930s).

69

gang running, jumping, rowing, singing, or playing instruments. Most of the pieces were marked on the bottom "Mickey Mouse—Copyright by Walt E. Disney—Made in Japan."

Limoges of France produced a brilliant line of Disney dishes for children, including complete tea sets, cake plates, cereal bowls, and drinking mugs. Faïencèrie D'Onnaing was another French company whose imported Disney dishware is delicately decorated in fast-action scenes in beautiful colors. The Paragon China Company of Great Britain produced sturdy baby dishware with images of Mickey and fanciful slogans alongside. Mickey Mouse china sets were made in the early 1930s in Bavaria and imported by the Shumann China Company. These fine "ready for use by children" cereal bowls, plates, cups, and saucers were stamped on the bottom "Authorized by Walter E. Disney—Made in Bavaria." Wade, Heath & Company Limited of Burslem, England, also produced tea sets, cups, saucers, creamers, and sugar bowls featuring Mickey Mouse, Minnie Mouse, Pluto, Donald, Horace Horsecollar, and Clarabelle the Cow among others.

Wearables for Boys and Girls

It is hard to walk down the street without seeing children and adults alike wearing Mickey T-shirts or sweatshirts. Mickey wearables were initially considered as fare only for tots and children. Disneyana collectors as well as those who specialize in retro-clothing regard antique Mickey wearables as prize pieces today, when they can find them. Original sweatshirts, pullovers, pajamas, scarves, mittens, or sweaters with Mickey images on them are now

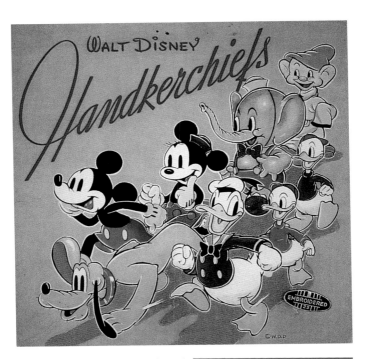

scarce, as much of the clothing has worn out, been discarded, or given away to the ragman. Accessories like ties, kiddy

HANDKERCHIEF BOX FEATURING MICKEY AND THE GANG IN MARCH FORMATION, FROM HERMANN HANDKERCHIEF (1940).

umbrellas, children's jewelry, handkerchiefs, and pocketbooks can be found more often, while shirts, galoshes, socks, or belts are less apt to show up in the markets. Colorful litho-on-cardboard boxes such as the ones for Mickey Mouse "undies" are thought of as very desirable by collectors because of their unusually strong graphics and colors.

Among the great variety of early children's wearables are all-wool sweaters (with a character, usually Mickey, centered on the front), boys' ties, boxed sets of handkerchiefs, boys' belts, suspenders, slippers or moccasins, rubber boots, jumpsuits, girls' pocket purses, boys' and girls' hats, pajamas with repeat patterns of Mickey Mouse and his friends, umbrellas with composition or Bakelite Mickey or Minnie figurine handles, raincoats, jewelry, and hair barrettes.

Mickey Mouse All Over the House

A child growing up in the Depression could have his or her entire room decorated with Mickey and the gang. The centerpiece of such a room might be the tabletop desk from the Kroehler Manufacturing Company, which specialized in producing fine children's furniture in the 1930s.

A child's room might also have sun-tested and waterproof Mickey Mouse wallpaper and trim from the United Wallpaper Factory. A

toy chest manufactured by the Odora Company, made of cardboard and wood with a fabric cover, could also serve as a child's windowseat.

Lucky lads and lasses in the Depression could tune into their

favorite radio programs on a square, boxlike, four-tube "Baby" Emerson radio made of a pressed wood called Syroco. Alongside a child's bed on a night table might be a painted plaster lamp of Mickey sitting in an overstuffed chair from the Soreng Manegold Company. A figural bisque Mickey

BRISTLE HAIRBRUSH WITH AN ENAMELED METAL BAND (1938).

available at drugstores from the Lightfoot Schultz Company, and Mickey Mouse toothpaste came from the Kent Dental Laboratories. Boys and girls could brush their hair with fine Mickey Mouse hairbrushes, which came in sturdy decorated cardboard boxes from the Hughes-Autograf Brush Company. On the floor of the room could be one of the colorful Mickey-in-action-adventure rugs from the Alexander Smith Company. Mickey Mouse linoleum with all the characters was produced by several American firms.

In the kitchen Mickey Mouse turned up on tablecloths, napkins, tea towels, colorful Catalin napkin rings, cookie jars, hot-dish holders, dishware, ceramic planters, glass tumblers, and as salt and pepper shakers. The living room or parlor seldom went Mickey Mouse, but an occasional Mickey chalk or composition amusement

Mouse toothbrush holder with a Mickey Mouse toothbrush held in one arm would sit on the dresser.

For the bathroom, boxed Mickey Mouse figural soap was

park figure might be found standing atop a mantle or the family console radio. Glazed ceramic figurines of Disney characters and painted-on-metal, porcelain, or glass figurine ashtrays were popular souvenirs that were proudly displayed on blue-mirrored end tables or on small glass or Lucite knickknack shelves. These novelties also served as decoratives for a post-Prohibition barroom, game room, or den.

ABOVE: ENGLISH-MADE PAINTED LEAD FIGURINE WITH MATCH HOLDER AND ASHTRAY (C. 1930). BELOW: MICKEY AND MINNIE HAND-PAINTED PORCELAIN ASHTRAYS (EARLY 1930S).

MICKEY MOUSE TARGET

FUNTIME MICKEY

Merchandise in the toy industry is not just seasonal but usually geared to specific time points. Certainly back-to-school in autumn leads into Halloween and then to Thanksgiving and the Christmas season, when many stores in the United States do more than one-third of their total yearly business. Easter awakens the spring buying season, while summer, when kids are on vacation, presents other opportunities in the sales marketplace.

Games and Targets

The best in Disneyana graphics are found on the boxes and

ABOVE: MICKEY MOUSE BAGATELLE GAME, COLOR-LITHOGRAPHED PAPER ON CARDBOARD, WOOD, AND METAL (1934). **OPPOSITE:** MICKEY MOUSE TARGET GAME FROM MARKS BROTHERS (1934).

MICKEY MOUSE PAINT SET (1930S).

boards of games. The Mickey Mouse Target manufactured by Marks Brothers of Boston is a first-rate example of the design and excellent color lithography that attracts collectors to these original Pop Art works. It came with a black metal gun, six wood and rubber suction darts, and a rubber-tipped three-legged stand. The Quoits Gameboard made by Chad Valley of Birmingham, England, has exactly the same straightforward Mickey Mouse image as the American dart set.

The Mickey Mouse Bagatelle Game shows Mickey with one gloved hand lowered and one held up high as if he were playing catch. This image was repeated on the Mickey Mouse Hoop-La Game and is a ubiquitous stance for Mickey on all sorts of toys, games, and graphics.

The games produced in the 1930s by Marks Brothers are prized items in the world of Disneyana. Other collectibles include a circus game, a topple Mickey in which children could shoot down Mickey and Minnie, a Mickey Mouse kite, a squeeze toy, and a Mickey Mouse Rollem' Game. The splendid Scatter Ball Game shows eight repetitions of Mickey with images of Minnie,

ABOVE: THIS OIL-CLOTH PIN THE TAIL ON
MICKEY WAS PART OF THE MICKEY MOUSE
PARTY GAME SET (1935).

Pluto, Clarabelle, and Horace on the box and board.

Other producers of Disney games for the children's market of the 1930s include the Einson-Freeman Publishing Corporation, which made Mickey Mouse puzzles, and the Fulton Specialty Company, which made Be Your Own Printer sets. American Toy

ABOVE: BOX FOR A FOUR-PUZZLE SET FEATURING MICKEY AND THE GANG (1933). **OPPOSITE:** MICKEY MOUSE SCATTER BALL GAME (1934).

Works, Parker Brothers, and the Milton Bradley Company also produced games featuring Mickey and the original gang.

If these games and toys were wrapped in Mickey Mouse Christmas or birthday paper, they would often be accompanied by a Mickey Mouse greeting card from Hall Brothers (Hallmark Cards). These fine Disney graphics of Mickey or one of his pals are collected with zest.

Seaside Play

Summer sand pails, sand-sifters, toy water pumps, and sand shovels in Technicolor litho-on-tin from the Ohio Art Company were extremely familiar items at the beaches during the thirties and forties. Collectors enjoy them today for their cartoon-art style, showing Mickey and Minnie, Horace, Clarabelle, and Pluto at play on the beach or in the water, on a picnic outing, in a parade, or selling lemonade. Ohio Art also produced wonderfully crafted children's playtime tea sets, snow shovels, drums, carpet sweepers, and other play items in tin-litho. The Paton Calvert Company of London produced similar and equally beautiful litho-on-metal seaside pails, children's tea sets, money boxes, and tin drums with the marking "By Permission of Walt Disney (Mickey Mouse) Ltd."

ABOVE: LITHOGRAPHED TIN AND WIRE-SCREEN SAND SIFTERS (1934). LEFT: LITHO-ON-TIN SAND PAIL SHOWING MICKEY WITH A DONALD DUCK SAND PAIL. OPPOSITE TOP: COLOR LITHOGRAPHED TIN SAND PAIL WITH MICKEY AND MINNIE ON THE ATLANTIC CITY BOARDWALK. OPPOSITE BOTTOM: CHILD'S LITHOGRAPHED TIN WATERING CAN (1933).

Merry Christmas with Mickey and Minnie

The Mickey Christmas specialty items on many Disneyana collectors' "most wanted" lists would include a good selection of Disney greeting cards from Hall Brothers and the spectacular Mickey Mouse light sets from the Noma Electric Corporation. These Mazda tree lights have varicolored Beetleware shades featuring decal appliqués of the early Disney characters engaged in Christmas pursuits.

Mickey Mouse was a perennial giant balloon in the Macy's Thanksgiving Day Parade bringing cheer to children and their

ABOVE: HALL BROTHERS GREETING CARD (1934). **RIGHT TOP:** R.H. MACY & COMPANY HANDED OUT COPIES OF *MICKEY MOUSE AND MINNIE AT MACY'S* TO CHILDREN DURING CHRISTMAS IN 1934. KAY KAMEN INSTIGATED THIS PROMOTIONAL GIVEAWAY, WHICH WAS SO POPULAR THAT ANOTHER BOOK, ENTITLED *MICKEY MOUSE AND MINNIE MARCH TO MACY'S* (**RIGHT**), WAS GIVEN OUT AT THE STORE DURING CHRISTMAS 1935. **OPPOSITE TOP:** BETTLEWARE-SHADE DECAL TRANSFER (1936). **OPPOSITE BOTTOM:** NOMA CHRISTMAS TREE LIGHT SET, WITH COLORFUL BEETLEWARE LIGHT SHADES AND DECAL TRANSFERS OF THE DISNEY CHARACTERS (1936).

families during the Depression. During the Christmas season of 1934, R.H. Macy had Santa Claus present children with a giveaway Big Little–type book entitled *Mickey Mouse and Minnie at Macy's*. Another tiny book, *Mickey Mouse and Minnie March to Macy's*, was given out in 1935.

LEFT: DIE-CUT *MICKEY MOUSE BOOK FOR COLORING* (1936). **BELOW:** "COME ON EVERYBODY, LET'S GO SLEDDING," SAYS MICKEY ON THIS PAMPHLET FOR A MICKEY MOUSE SLED (1935).

Both of these books tell the story, in words and ink drawings, of Macy's huge Thanksgiving Day Parade.

Fun in the Snow

A child could romp about in style and warmth if his or her gifts for Christmas included a Mickey Mouse snowsuit from Mayfair Togs, Mickey Mouse mittens, Mickey Mouse rubber boots, or a Mickey Mouse scarf. Children could venture out on the frozen iceponds wearing Mickey Mouse ice skates. And, for gliding down a snow bank, there was a Mickey Mouse or Donald Duck sled from S.L. Allen and Company. The Mickey Mouse sled came in 30" and 32" sizes, and the Donald Duck model was 36" long. Later, a

S.L. ALLEN AND COMPANY'S MICKEY MOUSE SLED, MADE OF WOOD AND METAL AND MEASURING 30 INCHES (1935).

40-inch-long Snow White and the Seven Dwarfs model was added for bigger children. In stories, coloring books, games, and as illustration on children's winter outdoor toggery—scarves, mittens, hats, sweaters, or snowsuits—Disney characters were often engaged in winter play.

A Spooky Mouse

Halloween is always a wondrous time for children; and during trick-or-treating in the thirties, boys and girls came dressed up as Mickey and Minnie. The painted black-and-white face masks made of stiff, molded cheesecloth by the Wornova Manufacturing Company were indeed scary to many. Mickey Mouse had a big rat-face, while Minnie bore a full set of rat-like choppers. Collectors prize these wonderful masks; and if they can find a vintage thirties outfit in the original box with the full costume intact, that is a real plus. Sometimes these masks are squashed or torn in places; but they can be artfully restored with a bit of paste, water, and extra cheesecloth or burlap.

TOP LEFT : MICKEY MOUSE HALLOWEEN MASK (1934). TOP RIGHT: HALLOWEEN PAPER SEAL (1935). RIGHT: KIDS OF THE DEPRESSION DRESSED UP IN THEIR FAVORITE COMIC STRIP CARTOON CHARACTER OUTFITS, INCLUDING DONALD DUCK, MICKEY MOUSE, AND MINNIE MOUSE.

Valentine's Day and Eastertime

On Valentine's Day there were many Mickey Mouse or Minnie Mouse greeting cards produced by the indomitable Hall Brothers. A Charlotte Clark Mickey or Minnie doll was a popular favorite at Easter, in case a Depression kid had missed out on one at Christmas. The Paas Dye Company sold attractive packages of Mickey Mouse transfers for Easter eggs, with a bright graphic of Mickey, the Funny Little Bunnies, and Donald Duck, who as a duck could easily enter the Easter markets at the dime store.

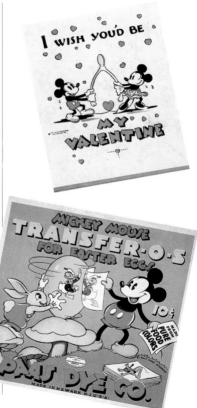

TOP RIGHT: HALL BROTHERS VALENTINE'S DAY GREETING CARD (1932). RIGHT: MICKEY MOUSE "TRANSFER-O-S FOR EASTER EGGS" (1935).

BUY THIS BREAD

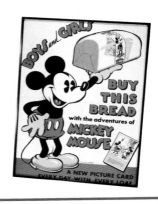

The merchandising campaigns created by Kay Kamen for retail-store exploitation of Mickey Mouse products are seen as important aspects of collecting Disneyana. Particularly collectible are some of the food products and their packaging. The Glaser Crandell Company manufactured a now rare piece—the Mickey Mouse Jam jar. After the the jar was washed, it could be reused as a bank. When found in good condition with the label intact, it can sell well into the hundreds of dollars. Action Mickey Mouse store displays selling this jam product were produced by the Old King

ABOVE: MICKEY MOUSE "BUY THIS BREAD" STORE WINDOW POSTER (C. 1934). OPPOSITE: WRAPPER OF A MICKEY MOUSE TOASTED NUT CHOCOLATE BAR (1934).

Cole Company and sold to retail stores through Kamen. Mickey Mouse Bubble Gum picture insert cards, from Gum, Inc., were traded

Mickey Mouse bread insert-picture cards. Post Toasties (General Foods) lithographed cardboard store display signs are sought after today. Original Post Toasties Disney character cutouts are plentiful in the marketplace and still reasonably priced items for collectors; but an entire, uncut Post Toasties box is a rare find. Mickey

eagerly during the 1930s and are again collected today. There are two series, one from 1933 to 1935, numbered 1 to 96 (with two albums) and the other, "Mickey Mouse with the Movie Stars," numbered 97 to 120.

The first of the successful promotional campaigns produced by Kamen, in 1934–1935, featured Mickey Mouse "Buy This Bread" posters, themselves artfully executed lithographs. There were other litho store pieces, including cardboard display signs and free Globetrotter Bread Campaign Scrapbooks in which to paste your

ABOVE: The back and two side panels from a Post Toasties box (1934). **LEFT AND RIGHT:** Post Toasties cut-out toy figures.

Mouse litho candy tins are prized items; so is a paper wrapper from a Mickey Mouse Toasted Nut Chocolate Bar made in 1934 by the Wilbur-Suchard Chocolate Company.

Beginning in 1937, the National Biscuit Company packaged Mickey

TOP: CELLULOID PINBACK BUTTON. LEFT: MICKEY MOUSE MILK OF MAGNESIA TOOTHPASTE (1936). BELOW: AN INK BLOTTER FROM SUNHEAT FURNACE OIL.

96

Mouse Cookies in colorful boxes. The retail store cookie posters, which show Mickey holding up a sign stating "We're At The Grocery Now!", are excellent lithographs. The paper Mickey Mouse Comic Cookie Hat from an early 1930s cookie campaign is a choice item. So is a jar of Crosse & Blackwell's Mickey Mouse Marmalade.

Mickey Mouse has been a spon-

MICKEY, DONALD, PLUTO, MAX HARE, AND CLARA CLUCK RACING AROUND A NABISCO COOKIE BOX (1936).

sor for the "more wholesome" milk of the National Dairy Products Company. Milk and cheese sales skyrocketed when National Dairy and an affiliate called Southern Dairies used Mickey Mouse to sell their product.

BACK TO SCHOOL MICKEY

A schoolchild returning to class in September could bring along Mickey items available from the dime store or department store in the Depression, the forties, or the fifties. You could choose from a selection of silk-screened and lithographed Disney cartoon character cardboard pencil boxes manufactured by the Joseph Dixon Crucible Company. These rectangular or sometimes figural Mickey Mouse snap-shut boxes were marked "A Dixon Product" or "Dixon U.S.A.," and "Walt Disney Enterprises," and

OPPOSITE: CARDBOARD DIE-CUT DISPLAY SIGN USED AS PART OF A "BACK TO SCHOOL" AD CAMPAIGN. **LEFT:** PENCIL BOX (1936). **RIGHT:** PENCIL BOX MADE OF SIMULATED-COWHIDE CARDBOARD IN BLUE, GOLD, AND BLACK.

included Mickey Mouse pencils, a pen, a Mickey Mouse ruler, a Mickey Mouse eraser, crayons, a tin penny bank, a compass, and sometimes a Dixon Mickey Mouse Map of the United States.

Mickey Mouse easel blackboards in several styles and sizes were produced by the Barricks Manufacturing Company and by the Richmond School Furniture Company. The InkoGraph Company Ink-D-Cator fountain pens featured a Mickey head at the top of the pen. Retractable pencils with a Mickey head were produced by InkoGraph as well. The Geuder Paeschke and Frey Company manufactured litho-on-tin or sheet metal wastepaper baskets, flower pots, bread boxes, and cake covers. A Geuder Paeschke and Frey Mickey Mouse lunch kit had a removable eating tray insert. Hinged tin-litho boxes for crayon sets made by the Transogram

ABOVE: MICKEY MOUSE COMPOSITION BOOK (1935). **RIGHT:** PAINTED AND VARNISHED PAPIER-MÂCHÉ FIGURAL PENCIL BOX (1934). **BELOW:** MICKEY MOUSE SCHOOL RULER (1934). **OPPOSITE:** PENCIL BOX INTERIOR LINING.

Company and stamp pads made by the Fulton Specialty Company also had a Mickey Mouse image on them. School note tablets, such as those produced by the Powers Paper Company, showed Mickey and his friends in school activities or at playtime games.

RIGHT AND OPPOSITE:
THIS PAINTED PLYWOOD
DESK FOR STUDYING AT
HOME HAS MICKEY MOUSE
HOLDING UP ONE SIDE OF
THE DESK TOP AND MINNIE
THE OTHER (1935).

103

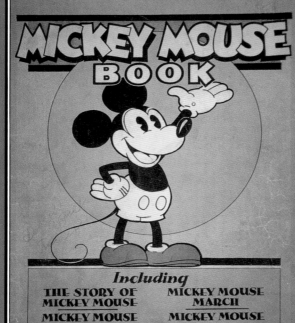

MICKEY MOUSE
BOOK

Including

THE STORY OF
MICKEY MOUSE

MICKEY MOUSE
MARCH

MICKEY MOUSE
GAME

MICKEY MOUSE
SONG

Printed in U. S. A.

MICKEY MOUSE BOOKS

Mickey Mouse storybooks from the 1930s, 1940s, and 1950s, with their brightly colored covers, were usually profusely illustrated, and are enthusiastically collected by Disneyophiles. The "Mickey Mouse Book," considered by connoisseurs to be the first Mickey Mouse book, is actually in a magazine format. Published in 1930 by Bibo and Lang and written by Bobette Bibo, the publisher's eleven-year-old daughter,

"Mickey Mouse Book" is only fifteen pages long and includes a Mickey Mouse game, a march, and a song. This "book" had a print run of 100,000 and was first sold at dime stores. Of special interest to Disneyana collectors is the fact that the cover of this book was drawn by Ub Iwerks.

In the early years of the creation of Mickey Mouse, Walt Disney had problems finding a publisher who could distribute Mickey books nationally. The David McKay Company of Philadelphia and New York was the one to finally agree to Disney's demands and eccentricities. McKay

OPPOSITE: "MICKEY MOUSE BOOK" (ACTUALLY IN MAGAZINE FORMAT) WAS THE FIRST BOOK PUBLISHED ABOUT MICKEY MOUSE (1930).

published the first commercial book, *The Adventures of Mickey Mouse*, which arrived at bookstores in 1931.

In 1931, McKay also published *Mickey Mouse Series #1*, an album of newspaper comic strip reprints, and *The Mickey Mouse Storybook*, illustrated with stills from the cartoon shorts. *Mickey Mouse Series #2* was issued in 1932; *Series #3*, from the Sunday color strips, in 1933; and *Series #4* in 1934, all published by McKay. Sold originally in bookstores for 50¢ were McKay's *Mickey Mouse Illustrated Movie-Stories*; *The Adventures of Mickey Mouse Book #2*, both published in 1932; and *Mickey Mouse Stories Book #2*, published in 1934.

In 1978, McKay published *Walt Disney's Mickey Mouse Story Book Album*, featuring stories from the 1931–1934 cartoons, and the "all-in-color" 50th Anniversary Edition of *Walt Disney's Adventures of*

FRONT AND BACK COVERS OF *THE ADVENTURES OF MICKEY MOUSE BOOK #1.* THIS ILLUSTRATED BOOK TELLS THE STORY OF THE ORIGINAL BARNYARD CHARACTERS.

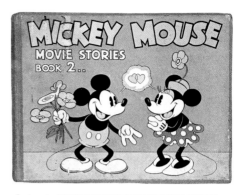

Mickey Mouse, a reprint of the original *Adventures of Mickey Mouse Book #1*, *Adventures of Mickey Mouse Book #2*, and *Mickey Mouse and His Horse Tanglefoot*.

Dean and Sons Ltd., in London, published the first *Mickey Mouse Annual for Boys and Girls* in 1931. The colorful, cardboard-covered books, chock full of stories, comics, poems, games, and crosswords, delighted the children of Great Britain. William Collins published storybooks in England as

LEFT: *MICKEY MOUSE ILLUSTRATED MOVIE STORIES*, A HARDCOVER BOOK WITH 190 PAGES OF CARTOON STILLS. RIGHT: *MICKEY MOUSE MOVIE STORIES*, BOOK 2, A HARDCOVER BOOK WITH STORIES AND MOVIE STILLS.

well, including *Mickey Mouse and Mother Goose*, *Mickey Mouse in Giant Land*, *Mickey Mouse Nursery Stories*, and *Mickey Mouse Bedtime Stories*.

Blue Ribbon Books, Inc., of New York published *The Pop-Up Mickey Mouse* and *The Pop-Up Minnie Mouse* in 1933, each with

three beautiful Pop-Ups. Blue Ribbon Books coined the term "pop-up" in the 1920s, registering the phrase in 1933 as their official trademark. A large-sized Pop-Up storybook format included *Mickey Mouse in King Arthur's Court*, *Mickey Mouse in Ye Olden Days*, and *The Pop-Up Silly Symphonies*. In 1934, Blue Ribbon published *Mickey Mouse Waddle Book*, which featured cutouts of Mickey, Minnie, Pluto, and Tanglefoot "walking" right out of the book on a slanted ramp. It is rare to find the Disney character "waddles" intact or unpunched. However, even without the waddles walking, the book is still a desirable collector's item.

Disney educational books were

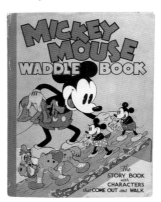

ABOVE: THE *POP-UP MICKEY MOUSE* FEATURES THREE COLOR POP-UPS. **RIGHT:** *MICKEY MOUSE WADDLE BOOK* FEATURES A STORY AS WELL AS CUT-OUT FIGURES.

welcomed by parents and teachers because they helped children to learn to read. "Readers" like *Mickey Mouse and His Friends* by Walt Disney and Jean Ayer, published in 1937 by Thomas Nelson and Sons, and the schoolbook series from D. C. Heath and Company of Boston, which included titles like *School Days in Disneyville, Mickey Never Fails,* and *Mickey Sees the U.S.A.,* were favorites of schoolchildren of the thirties and forties. Kamen licensed the Whitman Publishing Company of Racine, Wisconsin, to publish hundreds of books, usually printed on pulp paper and sold at J. J.

TOP: *MICKEY MOUSE HAS A PARTY*, A SCHOOL READER (1938). **BOTTOM:** *MICKEY MOUSE AND HIS FRIENDS*, A HARDCOVER STORYBOOK (1937). **OVER-LEAF:** CIRCUS SCENE POP-UP, FROM THE *POP-UP MICKEY MOUSE* ILLUSTRATED STORYBOOK PUBLISHED BY BLUE RIBBON BOOKS (1933).

Newberry's, Woolworth's, and other dime stores.

For ten cents, the Big Little Books featured Mickey Mouse acting the role of a mail pilot, a detective, a newspaper editor, a cowboy, or a hunter searching for hidden treasures. In 1934, Whitman published a set of six Wee Little Books (3 x 3 1/2 inches), which were only 40 pages long and attractively packaged in a sturdy cardboard Mickey Mouse Library container.

A Big Big Book (9 1/2 x 7 3/4 inches), 316 pages, and entitled *The Story of Mickey Mouse,* was published by Whitman in 1935 and reprinted the following year with a different cover featuring Mickey and Minnie on a boat wearing nautical garb. In 1938, Whitman also published a series of 5 1/2 x 5 1/2-inch Better Little Books featuring Mickey Mouse.

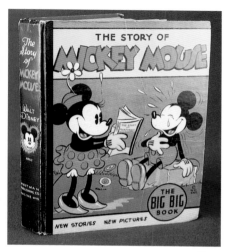

LEFT: *THE STORY OF MICKEY MOUSE* WAS PUB-LISHED AS A BIG BIG BOOK IN 1935 BY WHITMAN. **BELOW LEFT AND RIGHT:** WALT DISNEY'S *STORY OF CLARABELLE COW* AND *STORY OF PLUTO THE PUP*, BOTH PUBLISHED IN 1938 BY WHITMAN.

MICKEY MOUSE MAGAZINE

SUMMER QUARTERLY

5¢

A Fun-Book for Boys and Girls to Read to Grown-ups

MICKEY MOUSE MAGAZINES

Kamen produced the first *Mickey Mouse Magazine* for Walt Disney Enterprises in January 1933. Volume 1, No. 1, features stories along with Disney illustrations, games, jokes, and puzzles. Kamen created this magazine as a promotional giveaway at department stores and movie theaters. The ninth issue, dated September 1933, is the last of this first series. They are among today's hard-to-find magazines. An advertising director at United Artists named Hal Horne produced the second *Mickey Mouse Magazine*, as part of Kamen's national campaign for dairies to get kids to

ABOVE: *RADIO MIRROR* MAGAZINE, (APRIL 1938). **OPPOSITE:** *MICKEY MOUSE MAGAZINE* (JUNE–AUGUST 1935), THE PREMIERE ISSUE OF THE THIRD SERIES. **OVERLEAF:** FROM *MICKEY MOUSE MAGAZINE* (SUMMER QUARTERLY 1935).

ROLICS
OF CEREMONIES"

...IDEA

HEY! WHAT'S THE IDEA!

GIVE ME BACK MY CANDY!

YOUR CANDY! I DON'T KNOW WHAT YOU MEAN!

WHY YOU JUST TOOK THAT BOX OF CANDY AWAY FROM ME!

...IN, HORACE. I'M NOT IN JAPAN OR CHINA ~ AM I?

NO, YOU'RE NOT IN JAPAN OR CHINA!

THEN I MUST BE SOME PLACE ELSE, AND IF I'M SOME PLACE ELSE I'M NOT HERE!

WELL ~ WHAT OF IT?

IF I'M NOT HERE ~ HOW COULD I TAKE YOUR BOX OF CANDY?

POW!

HOW COMIC CARTOONS MAKE FORTUNES
World Celebrates The Airplane's 30th Birthday

SEE PAGE 32

The final issue, Volume 5, No. 12, was printed in September 1940.

In October 1940, the first *Walt Disney's Comics and Stories* was published. Much cheaper to produce and easy to distribute, comic books by that year were becoming a rage. *Walt Disney's Comics and Stories* was selling one million copies per issue within months, and became the best-selling comic book around the world.

The *Mickey Mouse Weekly* put out by William Banks Levy in London had a large format (11 x 15 inches). *Le Journal de Mickey*, from Hachette Publishers in Paris, published its first volume on October 21, 1934. *Topolino*, the Italian magazine, first appeared in December of 1932.

drink milk. The 24 issues, Volume 1, No. 1 (November 1933), through Volume 2, No. 2 (October 1935), are highly desirable as collectibles.

Hal Horne created the *Mickey Mouse Magazine* again in May 1935. Unfortunately, at 25¢ per copy parents considered them too expensive in the hard times of the thirties. Subsequent editions were reduced to 10¢ as well as in size.

MICKEY MOUSE
MUSIC IN THE AIR

In the 1930s, many homes had upright pianos in the parlor or living room on which sheet music and Disney song folios were perched, such as "Minnie's Yoo Hoo." Copies of this sheet music—Mickey Mouse's theme song, first introduced in the 1929 cartoon *Mickey's Follies*—were given to lucky members of the first Mickey Mouse Clubs. Other Mickey Mouse songs include: "Mickey Mouse's Birthday Party," "Mickey Mouse and Minnie's in Town," "The Wedding of Mister Mickey Mouse," and "What! No Mickey Mouse? What Kind of a Party Is This?"

The Disney music publishers

RCA VICTOR 78 RPM "ORTHOPHONIC" RECORDING OF "MICKEY MOUSE AND MINNIE'S IN TOWN." OPPOSITE: "MICKEY MOUSE'S BIRTHDAY PARTY" SHEET MUSIC.

included Villa Moret, Inc., Music Publishers from San Francisco, Irving Caesar, Inc., and Irving Berlin, Inc., the major publisher of

the 1930s and later known as Bourne Music Publishers. A variety of publishers have been used by Disney since 1940 up to the present. The most popular all-time favorite songs from Walt Disney films include: "Some Day My Prince Will Come," "Whistle While You Work," and "Heigh Ho" from *Snow White and the Seven Dwarfs*; "When You Wish Upon a Star," "Give a Little Whistle," and "Hi Diddle Dee Dee" from *Pinocchio*; "Der Fuehrer's Face" from the short *Der Fuehrer's Face*; "You Belong to My Heart" from *The Three Caballeros*; "Zip-a-Dee-Doo-Dah" from *Song of the South*; and "Bibbidi-Bobbidi-Boo" and "A Dream Is a Wish Your Heart Makes" from *Cinderella*.

TOP: "WHAT! NO MICKEY MOUSE? WHAT KIND OF A PARTY IS THIS?" SHEET MUSIC (1932). **BOTTOM:** MICKEY MOUSE PARTYTIME MUSICAL HORN IN BRIGHT LITHOGRAPHED CARDBOARD (1934).

ABOVE: WINDUP TOYS (1940s). RIGHT: "THE WEDDING PARTY OF MICKEY MOUSE" SHEET MUSIC (1931).

Three songs that won Academy Awards were "When You Wish Upon a Star" (1940), "Zip-a-Dee-Doo-Dah" (1946), and "Chim Chim Cher-ee" (*Mary Poppins*, 1964). Sheet music falls into the category of ephemera and is to be found today at paper collectibles shows, antique shows, flea markets, nostalgia conventions, and antiquarian book sales.

Record collectors search with great intensity for the early Disney 78 rpm records. In 1934, the RCA Victor Company, Inc., of Camden, New Jersey, produced one of the first Disney records, using Frank Luther and his Orchestra to perform the Mickey hits. Many dance bands performed songs recorded from Disney movies. Original 78 rpm record albums of film music are very desirable, particularly those from *Snow White and the Seven Dwarfs*, *Pinocchio*, *The Three Caballeros*, *Dumbo*, *Saludos Amigos*, and *Song of the South*.

DONALD DUCK RAGE

Donald Duck is mentioned by name in *The Adventures of Mickey Mouse Book #1*, published by David McKay in 1931; but he did not actually take on his cartoon persona until June 9, 1934, the date the Silly Symphony cartoon *The Wise Little Hen* was released to movie theaters. So endearing to the public was this agitated, quacking duck that he stole the picture from the cooing Wise Little Hen. Weary of a country in the grip of the Great Depression, angry moviegoers identified with Donald Duck, particularly when he twisted his bulbous feathery form into a rotating white, orange, and blue ball while emitting a series of vitriolic

quacks. These honking, quivering vocalizations were made by the voice of Clarence Nash.

Dime Store Donald: Merchandising the Duck

After Donald's triumph in *The Wise Little Hen*, Kamen licensed Donald Duck to eager manufacturers and merchandisers. By 1935, Donald Duck soap, Donald Duck ties and handkerchiefs, and other merchandise began to appear at dry goods stores and dime stores. Disneyana collectors seek out Donald Duck memorabilia from the 1930s, 1940s, and 1950s with the same attention they give to Mickey Mouse merchandise.

Donald Duck as a comic-strip character began on Sunday, September 16, 1935, with the Silly Symphony version of *The Little Red Hen*, written by Ted Osborne and drawn by Al Taliaferro. But it wasn't until February 7, 1939, that

DONALD DUCK MODELED IN CASTILE SOAP, SHOWN WITH THE ORIGINAL BOX (1938).

Donald took the lead in his own strip. Donald Duck took hold as a comic-book character in a profound way from 1942 through the 1960s, with Carl Barks operating as the top Donald Duck artist and writer for Dell Comic Book Publications.

Borgfeldt distributed a great number of Made-in-Japan Donald Duck painted bisque figurines and toothbrush holders in several sizes, from tiny to medium to large (5¾ inches). Larger painted

TOP: LONG-BILLED DONALD DUCK BISQUE TOOTHBRUSH HOLDER (1930S). MIDDLE: DONALD DUCK BISQUE FIGURINE WITH MOVABLE ARMS (1935). BOTTOM: "SIAMESE-TWIN" DONALD DUCK BISQUE TOOTHBRUSH HOLDER (1935).

Donald Duck bisque figurines with movable arms are the most exquisitely sculptured of these pieces. One Donald Duck toothbrush holder, which features two likenesses of Donald, is sometimes referred to as the "Siamese-twin" Donald by collectors, many of whom regard it as tops in the design category.

Like Mickey, Donald Duck also was marketed in celluloid as a windup action toy. A whirligig toy features a large Donald under a spinning canopy of miniature celluloid Mickeys and Donalds, while the Donald Duck Carousel, a smaller piece, has simple celluloid balls rotating over his head when wound up. These celluloids were

distributed by Borgfeldt and came in boxes with interesting graphics. Small Catalin pencil sharpeners, Catalin napkin rings with Donald Duck decals, and small celluloid tape measures were also in the marketplace in the 1930s.

Also in the Donald Duck line are children's porcelain tea sets, Roly-Poly banks, action and pull toys from the Fisher-Price Company featuring Donald banging drums or playing the xylophone, a Donald Duck toy phone by N. N. Hill Brass, a Seiberling latex Donald Duck with a movable head, Donald Duck lithographed tin sand pails and shovels from the Ohio Art Company, a Donald Duck sled, lamps, bookends, and a host of other items.

Knickerbocker created some

ABOVE: WINDUP CELLULOID DONALD DUCK TOY WITH METAL FEET (1930S). **RIGHT:** THIS DONALD DUCK METAL WINDUP TOY, MADE BY SCHUCO, WALKS AND OPENS AND CLOSES ITS BILL (1935).

THE DONALD DUCK RAIL CAR, FROM THE
LIONEL CORPORATION, FEATURED A COM-
POSITION DUCK WITH PLUTO THE PUP IN A
METAL DOGHOUSE (1936).

excellent cloth Donald Duck dolls and painted wood-composition dolls. Charlotte Clark designed Donald Duck dolls for several manufacturers, and the Richard G. Krueger Company of New York made a variety of Donald dolls, some in velvet, as did the Character Novelty Company.

The tin-litho windup parade of moving Donald Ducks is led by the Schuco toy, manufactured in Germany in 1935. Windups by Marx and LineMar have Donald in action, like playing a drum or rid-ing a Disney "Dipsy" car. One toy that caused a great deal of excite-ment in the 1936 Christmas season was the Lionel Corporation's Donald Duck Rail Car.

The first Donald Duck watch was produced in 1936 by Ingersoll-Waterbury, which also made a fine pocket watch with Donald in 1939. A later Donald

Duck wristwatch appeared in 1947, a Daisy Duck in 1948, and a Huey Duck in 1949.

The first storybook to portray Donald Duck in pictures and text was *The Wise Little Hen*, published by David McKay in 1934. The first all–Donald Duck book was entitled simply *Donald Duck* and has sixteen linen-like pages with color illustrations. Marketed in 1935 by Whitman Publishing, it is seen as an essential item for collectors of Donald Duck–Disneyana. Donald first appeared in a Whitman Big Little Book jn 1933, in a collection entitled "Mickey Mouse Presents Walt Disney's Silly Symphony Stories." Donald went on as a stellar attraction in over a dozen Whitman Big Little Books from 1939 to 1949. Dell Publishing's Fast Action Books had Donald Duck appearing

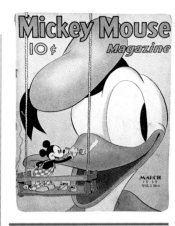

ABOVE: DONALD ON THE COVER OF *MICKEY MOUSE MAGAZINE* **(MARCH 1938). BELOW: AN ENGLISH-MADE CANDY TIN (C. 1948).**

in at least four titles, and D. C. Heath published three Donald titles in their 1940s schoolbook-reader series.

Donald Duck's march into the stores included Ohio Art paint sets, Parker Brothers' games, and salt and pepper shakers, planters, cookie jars, and baby dishes pro-

TOP: A VARIETY OF PRODUCTS CARRIED DONALD DUCK'S OFFICIAL ENDORSEMENT. **MIDDLE:** STORE SIGN FOR DONALD DUCK ICY-FROST TWIN POPSICLES (1940S). **BOTTOM:** SIGN FOR DONALD DUCK BREAD (C. 1948).

duced by the American Pottery Company of Los Angeles and the Leeds China Company of Chicago. The Kamen campaigns included Donald Duck Bread, Donald Duck Chocolate Syrup, Donald Duck Mayonnaise, Donald Duck Peanut Butter, and, his most popular, Donald Duck Grapefruit and Orange Juice. Other ephemera like store signs, cardboard displays, and window stickers from product campaigns featuring Donald are collected today by serious Disneyana collectors.

THREE LITTLE PIGS, THE BIG BAD WOLF, AND THE GREAT DEPRESSION

The *Three Little Pigs* Silly Symphony cartoon, based on the famous tale by the Brothers Grimm, opened in New York in 1933 at Radio City Music Hall. The film, all in color and featuring the three little pigs in their frantic attempts to outwit the hungry wolf, captivated adults and children. Merrily and defiantly the pigs sang "Who's Afraid of the Big Bad Wolf." The jolly theme song, written by Frank Churchill, in effect became the theme song of the Depression, with the Big Bad Wolf serving as a euphemism for the landlord, the mortgage company, or the bill collector. *Three Little Pigs* won an Academy Award for Walt Disney as Best Cartoon Short Subject of 1932–1933.

RIGHT: "WHO'S AFRAID OF THE BIG BAD WOLF" SHEET MUSIC (1933). **OPPOSITE:** THREE LITTLE PIGS GAME, MADE BY EINSON-FREEMAN (1933).

Kamen lost no time marketing the Three Little Pigs, the Big Bad Wolf, and Little Red Riding Hood to product manufacturers and merchandisers. Children in the Depression were lucky indeed when given a hardback edition of *Three Little Pigs* from Blue Ribbon Books, with illustrations from the Disney Studio staff of artists. This book was also printed in 1934 in England by John Lane, The Bodley Head Ltd., London.

Post Toasties Cornflakes featured colorful cut-out figures of the Three Little Pigs and the Big Bad Wolf on the backs of cereal packages. These cut-out collectibles are eagerly sought after by today's collectors.

Ingersoll-Waterbury issued a

Three Little Pigs and Big Bad Wolf alarm clock in 1934. Boys in particular wanted the Three Little Pigs pocket watch, a striking timepiece that collectors covet. A Big Bad Wolf wristwatch with the Wolf and the Pigs on the links was also available from Ingersoll in 1934. Today, these timepieces command high prices in the Disneyana collectors' arena.

Borgfeldt bisque novelties produced in Japan featured the Three Little Pigs. The most common hand-painted Japanese bisque toothbrush holder has the three standing Pigs all connected in one form. A single, menacing Big Bad Wolf was produced in bisque in medium and small sizes. Three Little Pigs celluloid novelties and action toys were also part of the Borgfeldt product line.

Seiberling made a

with the Three Little Pigs. Colorful Beetleware shades with decal appliqués of all the Silly Symphony characters could be put over each tiny Mazda Christmas tree light bulb.

handsome hard-rubber Big Bad Wolf and three separate Pig dolls. The Knickerbocker Toy Company and Krueger produced stuffed Pigs, a Big Bad Wolf, and Little Red Riding Hood dolls. Borgfeldt also manufactured a plush Red Riding Hood doll; and Madame Alexander produced outfitted Pig dolls. Borgfeldt also distributed Schuco Toy Company's three felt-on-metal windups.

A stunning Silly Symphony Christmas tree light set from the Noma Electric Company features the Big Bad Wolf on the box along

Other Disneyana collector pieces featuring the Three Pigs and the Wolf that are desirable include: Pencil boxes with the Three Little Pigs and the Big Bad Wolf from the Joseph Dixon Crucible Company; Three Little Pigs litho-on-metal children's play sets from the Ohio Art Company; Three Little Pigs notepads from the Powers Paper Company; and a very rare Emerson Company Three Little Pigs table radio made of Syroco (pressed sawdust).

Appearing in many household kitchens in the Depression were the Three Little Pigs and Big Bad Wolf drinking tumblers put out by Sheffield Farms. Salem China

NOMA CHRISTMAS TREE LIGHT SET WITH MAZDA LAMPS AND SHADE DECALS (1936).

Company provided beautiful chinaware sets for the children. William Rogers International Silver Company made silverware and drinking cups for toddlers. In the nursery might be a Three Little Pigs windup lamp complete with a matching paper shade, which played "Who's Afraid of the Big Bad Wolf."

Girls put Three Little Pigs handkerchiefs from the Hermann Handkerchief Company of New York in their lithographed leatherette Three Little Pigs handbags from King Innovations, New York. Boys wore D. H. Neumann Company Three Little Pigs ties to school and could play the Who's Afraid of the Big Bad Wolf game, from Marks Brothers, or Walt Disney's Who's Afraid of the Big Bad Wolf or The Red Riding Hood–Big Bad Wolf games, both produced by Parker Brothers. Full costume sets with masks for Halloween were made by A. S. Fischback, Sarkman Brothers Company, and Wornova.

Under the Christmas tree for boys in the Depression might be a Three Little Pigs flashlight from the U. S. Electric Manufacturing Company of New York and a Who's Afraid of the Big Bad Wolf toy printing set from the Fulton

Specialty Company. Ensign Ltd. of London produced a slide projector that came with hand-painted glass lantern slides that told the story of *Three Little Pigs* in visuals.

RIGHT: PROHIBITION "REPEAL" BEER-TRAY FEATURING THREE DRINKING PIGS (1933). BELOW: COLOR LITHOGRAPHED METAL WINDUP JUMPER TOYS OF FIDDLER PIG AND THE BIG BAD WOLF (C. 1949).

SILLY SYMPHONY PARADE

The Silly Symphonies introduced a number of appealing Disney characters into the world of cartoon merchandising. These seventy-five short films, starting with *The Skeleton Dance* (1929) and ending with a remake of *The Ugly Duckling* (1939), won seven Academy Awards. There were enough characters in the series to provide an army of products for the merchandise markets.

Of special interest to merchandisers were Elmer Elephant, the cartoon star of *Elmer Elephant*, a 1936 Silly Symphony, and his girlfriend, Tillie Tiger. Elmer and Tillie appear on N. N. Hill Brass and Fisher-Price action-pull toys, on drinking tumblers, handker-

chiefs, paint boxes, as bisque figurines and toothbrush holders, as dolls, and in books. Richard G. Krueger produced now rare dolls of the Robber Kitten, the Three Orphan Kittens, Elmer Elephant, Miss Cottontail, and Toby Tortoise.

David McKay published beautiful books of the Silly Symphonies, including the first *Elmer Elephant*

book in 1936, *The Wise Little Hen* (1934), *Peculiar Penguins* (1936), and *The Country Cousin* (1938). The Walt Disney Studios wrote and illustrated hardcover books published by Whitman in 1935 of *The Three Orphan Kittens*, *The Robber Kitten*, and *The Tortoise and the Hare*. In 1938, Whitman published *Timid Elmer*, as well as similar editions featuring Practical Pig, the Ugly Duckling, and "Mother Pluto." Whitman also put out four Silly Symphony Big Little Books. In 1933, Blue Ribbon Books published a handsome hardback storybook with Pop-Up

illustrations of the 1932 Silly Symphonies *King Neptune* and *Babes in the Woods*.

In 1938, a special short, *Ferdinand the Bull*, won Walt Disney another Academy Award. Ferdinand was produced as a "glazed leatherette fabric" stuffed doll manufactured by Richard G. Krueger; as a Knickerbocker painted composition doll; as an attractive painted bisque figurine; and as a Louis Marx Company tin-litho windup toy with a spinning tail.

Another Silly Symphony character, Clara Cluck, was part of a set of 1936 Fisher-Price pull-toys, but the extent of the operatic hen in toy merchandise is scarce.

Collectors may never enjoy, alas, a Clara Cluck watch or clock that made operatic hen noises on the hour or half hour.

Silly Symphony characters are very rare, and collectors seek them out for that reason. Also, it is not at all unusual to find Donald, Mickey, or Pluto on various Silly Symphony products and toys.

ABOVE: 1936 PULL-TOY OF CLARA CLUCK, STAR OF *ORPHAN'S BENEFIT*. BELOW: CAPITOL RECORDS RECORDING BASED ON THE 1938 SILLY SYMPHONY *FERDINAND THE BULL*.

movie
MIRROR

10¢

A MACFADDEN
PUBLICATION

MAY

SNOW WHITE
AND THE
SEVEN DWARFS

HAS GARY COOPER BEEN FOOLING HOLLYWOOD?
THE DRAMATIC LIFE AND DEATH OF
DOPEY of "SNOW WHITE"

DISNEY'S MASTERPIECE: SNOW WHITE AND THE SEVEN DWARFS

The preparation for *Snow White and the Seven Dwarfs*, generally acknowledged to be Walt Disney's masterpiece, was begun in 1934 when Disney explained his dream of a feature-length animated film to a group of studio artists. The Disney story department began to develop the Grimms' fairy tale into a full concept, but actual work in animation did not start until 1936. The production cost, which was estimated to be $150,000, eventually soared to $1.5 million. Word around Hollywood in the mid-1930s had it that *Snow White* would be "Disney's Folly." But with the profits from *Snow White*, Walt built the new Disney Studios in Burbank.

Snow White and the Seven Dwarfs premiered December 21, 1937, at the Carthay Circle Theater in Los Angeles. During its first three months of national release an estimated twenty million people flocked to see it, and it grossed $8.5 million. The great success of *Snow White* was capped off on February 23, 1939, when Shirley Temple presented Walt Disney

OPPOSITE: SNOW WHITE, THE PRINCE, AND ALL SEVEN DWARFS ARE FEATURED ON THE COVER OF *MOVIE MIRROR* MAGAZINE (MAY 1938).

with an Academy Award consisting of one large Oscar for Snow White and seven miniature ones for each of the dwarfs.

Snow White, Grumpy, Bashful, Sleepy, Sneezy, Dopey, Happy, and Doc Character Merchandise

Kamen made preparations early in 1936 to saturate the marketplace with mass-produced Snow White character merchandise. This is one reason why certain Snow White items may be dated 1937, though the bulk is dated 1938. Comic books, paint and coloring books, and picture books were distributed well in advance of the film's release. Kamen's Rockefeller Center headquarters issued a pin-back button giveaway for the Snow White Jingle Clubs and litho-on-paper masks of Snow White, all Seven Dwarfs, and the Wicked Witch, made by Einson-Freeman.

JANE WITHERS AT HOME IN 1938 HOLD-ING A DOPEY DOLL IN FRONT OF HER COL-LECTION OF SNOW WHITE AND THE SEVEN DWARFS CHARACTER DOLLS.

Hand-painted bisque sets of Snow White and all Seven Dwarfs were produced in Japan for Borgfeldt in small, medium, and large sizes. Some unique sets had the Seven Dwarfs playing instruments. Seiberling made painted hard-rubber figures of Snow White, which are quite rare, as

well as the Seven Dwarfs, all having excellent detail. A painted white-metal set of Snow White and the Seven Dwarfs from J. L. Wright, Inc., of Chicago sold for twenty-five cents each in 1938. Several glass pottery companies made very good eight-piece sets that are regarded as fine collectibles.

Twenty-inch-high Snow White stuffed dolls were produced by Richard G. Krueger. The Knickerbocker Toy Company and the Chad Valley Company produced Snow White doll sets. Madame Alexander created Snow White and the Seven Dwarfs dolls and marionettes. The Ideal Novelty and Toy Company of New York made a stuffed set of Snow White and the Seven Dwarfs and a composition Snow White doll, which used a face mold from a Shirley Temple doll.

TIN PLATE FROM A SNOW WHITE TEA SET (1937).

Storybooks from Grosset & Dunlap, the David McKay Company, and other publishers were produced in several editions. Whitman produced at least five linen-like books, cut-out doll books, coloring books, boxed book sets, and a Big Little Book. William Collins of Great Britain published a number of books for the British trade. RCA Victor produced the soundtrack recording, Decca records produced a 78 rpm record-album set of the songs recorded by Lyn Murray and His Orchestra, and Irving Berlin published the sheet music from *Snow White*.

Collectors' items avidly sought after include both a square and a rectangular Snow White radio produced by the

Emerson Radio Corporation of New York. There was an "animated" Snow White music box and a beautiful "animated Snow White Toy Piano" made by Marks Brothers. An album of famous songs from *Snow White* and a ten-note "carefully tuned" dulcimer was produced by J. W. Spear & Sons.

Juvenile hand-painted Modeware (plastic composition) figural lamps came with Disney illustrated parchment shades. La Mode Studios also offered figural wall lamps, bookends, and night lights. Boxed sets of Mazda Christmas tree lights were made by the Thompson-Houston Company Ltd. of London. Storkline Furniture Corporation of Chicago sold a complete line of wood furniture made to scale for a child's small room. For outdoor wintertime play, S. L. Allen made a Snow White and the Seven Dwarfs sled.

ABOVE LEFT AND RIGHT: THESE EINSON-FREEMAN PAPER PAR-T-MASKS OF SNOW WHITE AND THE WICKED WITCH WERE OFFERED BY PROCTER & GAMBLE AS PART OF A PROMOTIONAL CAMPAIGN FOR CAMAY SOAP (1937). **LEFT:** JAPANESE MADE HAND-PAINTED BISQUE FIGURINES (1938).

Borgfeldt offered boxed porcelain Snow White tea sets; and colorful Beetleware "meal-time" sets came from Bryant Electric. Ohio Art produced litho-on-metal Snow White boxed children's tea sets.

Ohio Art also made lithographed tin musical instruments, beach pails, and watering cans. A tin-litho paint box came from Charles G. Page Ltd. of London. The Libbey-Owens Glass Company produced a lithographed metal Snow White tray, a decorated lunch box, and a set of glass drinking tumblers. Louis Marx manufactured a wonderful tin-litho "shaking" and "wobbling" Dopey the Dwarf windup toy with rolling eyes.

There was a Snow White hand-

ABOVE: RUBBER DOPEY DOLL WITH A PAINTED YELLOW SUIT AND PURPLE HAT AND SHOES (1938). **RIGHT:** *SNOW WHITE AND THE SEVEN DWARFS* BIG LITTLE BOOK FROM WHITMAN (1938).

bag from W. Wood Ltd., and a girl's leatherette purse manufactured by King Innovations. A Snow White wristwatch was produced by Ingersoll-Waterbury in 1949, and in 1952 one was sold with a plastic figurine of Snow White by U. S. Time.

Cartier offered beautiful Snow White–Seven Dwarfs charm bracelets and pins. Brier Manufacturing produced large quantities of

affordable five-and-dime novelty jewelry. Attractive Snow White plastic barrettes were made by Lapin-Kurley Kew Company. Prized by collectors today are the Catalin novelty pencil sharpeners and napkin holders. In dry goods

stores across the country, cotton prints for fabrics depicting Snow White scenes were available from Arthur Beir & Company; Colcombet-Werk, Inc., of New York and Paris created similar "pure silk" fabrics. Hand-loomed Snow White linen tablecloths, napkins, and towels were made by Louis Nessel & Company.

For younger children there were "Laxteen" baby pants in a pretty Snow White box from American Latex. Framed Snow White prints from Aristo, Inc., decorated the nursery. Celluloid rattles came from Amloid. For older children, Powers Paper produced notepads and stationery. Women could choose from ten different Snow White print corsets offered

LEATHERETTE PURSE FOR YOUNG LADIES, MADE BY KING INNOVATIONS (1938).

by Miller Corsets, Inc., of Canandaigua, New York. Figural Snow White and the Seven Dwarfs soaps came in sets boxed by Lightfoot Schultz.

Character socks were manufactured by the Herbert Hosiery Mills Company of Jersey City. Hermann Handkerchief created embroidered hankies of Snow White and all Seven Dwarfs. Snow White rubber boots and canvas sneakers were manufactured by the Converse Rubber Company of Malden, Massachusetts. There were Snow White print pajamas and snowsuits from Mayfair Togs. Boys' and girls' accessories were made by D. H. Neumann.

The Odora Company manufactured a lithographed cardboard wood and print-fabric-covered Snow White Treasure Chest to store all the new Snow White toys and games. The treasure chest of Snow White collectibles today

ABOVE: DAYLEE SNOW WHITE AND THE SEVEN DWARFS "SLICED BREAD" WAX PAPER BREAD WRAPPER (1938). OPPOSITE: LADIES' RAYON SNOW WHITE PRINT KERCHIEF (C. 1938).

includes animated Snow White Valentine cards made by the Paper Novelty Company, the Tap-A-Way Game (with new "electric" tappers) offered by the Naylor Corporation, and the litho-on-metal Snow White Bagatelle and Pinball Game manufactured by Chad Valley Company. There were target games from American Toy Works, Snow White card games from Pepy's Series Games of London, and jigsaw puzzles from Williams, Ellis Company and the Whitman Company.

Kamen's food products division went into full gear. Snow White sliced bread came in a colorful wrapper. Picture-card inserts and the end-paper stickers, along with the store window signs, cardboard

display boards, streamers, and pennants issued by Kamen are now Disneyana collectibles. Original artwork and cels from this Disney masterpiece are now in the category of original Disney Studio art works and sell accordingly as "high art."

THE FORTIES FEATURE FILMS

PINOCCHIO

The Disney Studio's second masterful feature-length animated movie was *Pinocchio*, based on the famous children's book *Pinocchio, The Story of a Marionette*. The film premiered on February 7, 1940. In *The Art of Walt Disney*, author Christopher Finch states that *Snow White* may have given Disney his finest moment, but *Pinocchio* is his greatest achievement.

RIGHT: PAINTED PLASTER STATUETTE OF PINOCCHIO (1940). **OPPOSITE:** COVER OF *MICKEY MOUSE MAGAZINE* (DECEMBER 1939).

Pinocchio: The Product

Baking concerns across the country lined up for Pinocchio wax-paper wrappers, end stickers, and the sixty different picture-card inserts to promote their bread products. This bread campaign also produced a variety of cardboard display signs, window stickers, streamers, and pennants. National Dairy offered giveaway prizes, including Pinocchio hand puppets, note tablets, paper masks, and other manufactured character items.

LEFT: DECCA RECORDS 78 RPM RECORD ALBUM, FEATURING THE SONG HITS FROM *PINOCCHIO*. RIGHT: SHEET MUSIC FOR "GIVE A LITTLE WHISTLE."

Pinocchio and his friends were licensed to a number of firms, including Calox Antiseptic Mouthwash from McKesson & Robbins, Inc. For three empty bottles of this product you could get a set of six glass tumblers manufactured by Libbey-Owens. Other product tie-ins were from the Gillette Safety Razor Company, which gave away

paper masks from Einson-Freeman; Jiminy Cricket Bubble Gum; Pinocchio Stick Chewing Gum; and other character candies made by the Overland Candy Corporation and Sunlight Butter Company. Post Toasties boxes with Pinocchio cardboard cutouts appeared on the kitchen table.

Borgfeldt imported Japanese bisque pieces in a number of sizes and made a composition toy "Walker" Pinocchio as well as a

Pinocchio wooden puppet. Louis Marx produced handsome litho-on-tin windup toys. Transogram Company made Pinocchio litho-on-metal paintbox sets.

Small molded wood fiber (Syroco) figurines of all the characters were sent to stores and carnival supply houses from Multi-Products Company of Chicago. Painted metal figurines from

ABOVE: AN ICE-CREAM DIXIE-CUP LID WAS WORTH FREE PINOCCHIO MERCHANDISE FROM NATIONAL DAIRY PRODUCTS (1940S). LEFT: PINOCCHIO MASK USED AS A PROMOTIONAL GIVEAWAY FROM GILLETTE BLUE BLADES (1939).

Lincoln Logs, Halsam Company, Chicago, and John Wright, Inc., of Wrightsville, Pennsylvania, were dated as early as 1938. Schoolchildren wanted the pencil boxes featuring Pinocchio and Jiminy Cricket, as well as the brightly colored Catalin pencil sharpeners and thermometers made by Plastic Novelties, Inc., of New York. At bedtime they could read a Better Little Book (1940) from Whitman called *Pinocchio and Jiminy Cricket.* Whitman published various paint books, coloring books, scrapbooks, and cut-out books. A top collector book is *Pinocchio*, published by Grosset & Dunlap and copyrighted W. D. Ent., 1939.

The largest Pinocchio doll, at twenty inches, is from the Ideal Novelty and Toy Company and is made of wood composition with flexible joints. In 1940, Knickerbocker Toy released Pinocchio composition dolls with wood-jointed "flexy" legs and arms, as well as a Jiminy Cricket and a Figaro doll. Richard G. Krueger made stuffed Pinocchio dolls; and Crown Toy Manufacturing Company of Brooklyn made three composition doll versions of Pinocchio, a hand puppet, and a composition bank. Seiberling made hard rubber figurine dolls.

The Relaxon Products Company of Chicago produced a line of

washable Pinocchio nursery furniture. William Rogers made children's silverware. Ohio Art made a play tea set. The Flexo Corporation of Chicago produced Pinocchio and Jiminy Cricket lamps of thermo-plastic and woodfiber, meant to resemble the wood featured in Geppetto's magical toy shop.

N. N. Hill Brass and Fisher-Price made Pinocchio and Jiminy Cricket pull-toys for nursery tots, now regarded as prized pieces. Parker Brothers put out a Pinocchio Game set, and The Ring-Toss Game from DeWard Novelty Company, Inc., of Angola, New York, has excellent graphics.

For at-home use there was also the brightly colored plastic Beetle-ware sets of dishware from Bryant Electric Company. Pottery companies that produced Pinocchio character figurines and planters include the National Porcelain Company of Trenton, New Jersey, the Laguna-Brayton Pottery Company, The American Pottery Company, the Evan K. Shaw Company, and even a small firm called Geppetto Pottery. The Goebel sets of Pinocchio and his pals are very desirable collectors' items, though produced in the 1950s. For Halloween the Fishbach

Company and Ben Cooper produced boxed sets of masks and costumes of Pinocchio characters.

Pinocchio jewelry, manufactured by Brier, included plastic pins and charm bracelets. Cartier made Pinocchio pins and charms. Fancy millinery shops featured a better-quality hat inspired by *Pinocchio*, manufactured by the Philbert Hat Company of New York. Children's Pinocchio hats were manufactured by the Newark Felt Novelty Company, or by L. Lewis & Son. In 1948, wristwatches of Pinocchio and of Jiminy Cricket were produced by Ingersoll-Waterbury.

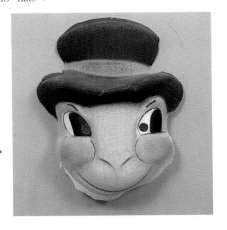

TOP: PROMOTIONAL PINBACK BUTTON GIVEN AWAY AT MOVIE THEATRES IN 1940 AND 1941. BOTTOM: JIMINY CRICKET HALLOWEEN MASK (1940).

163

FANTASIA

Fantasia is Disney's great experiment in animation. The film initially grew out of Walt Disney's desire to find a suitable vehicle for Mickey Mouse, whose popularity by 1940 had been eclipsed by that of the feisty Donald Duck. Walt Disney asked Leopold Stokowski to conduct the Philadelphia Symphony Orchestra in a symphonic musical score. *Fantasia* opened on November 13, 1940, but was not a box-office success. Like a bottle of vintage wine, the film garnered more success as time went by. The many *Fantasia* characters did not inspire a great

LEFT: RKO INSERT POSTER FOR *FANTASIA* FEATURING MAESTRO LEOPOLD STOKOWSKI AND MICKEY MOUSE IN HIS FIRST FEATURE-LENGTH FILM. **OPPOSITE:** *WALT DISNEY'S FANTASIA* HAS BLACK-AND-WHITE STORY SKETCHES AND TIPPED-IN COLOR PRINTS FROM THE ANIMATED FEATURE FILM (1940).

and Brothers, and *The Sorcerer's Apprentice*, from Grosset & Dunlap. Random House also published *Walt Disney's Fantasia*, a large-format, hardcover children's book. *Fantasia* movie programs, first-run and subsequent rerelease movie posters and lobby cards are collected with fervor.

Vernon Potteries, Ltd., of Los

number of objects in the merchandise market, but ones that were produced are eagerly sought after by Disneyana collectors.

In the field of rare antiquarian books there is *Walt Disney's Fantasia* by Deems Taylor, a large-size fine-art book published by Simon & Schuster in 1940. There is an array of coloring and cut-out books and children's storybooks, such as *Dance of the Hours* and *Pastoral*, published by Harper

Angeles produced 36 different figurines, five bowls, and an assortment of vases using characters from *Fantasia*. These are of extremely high quality and reminiscent of the production models used in the making of the film itself. Studio production models are scarce and are regarded as art objects by Disneyophiles. Vases, bowls, and figurines are often marked "Disney Copyright 1940—Vernon Kilns." Stunning Art Deco–style vases were also made.

THE RELUCTANT DRAGON

The Reluctant Dragon, filmed in black and white and color, opened on June 20, 1941. It is the inside story of how animated cartoons were produced at Walt Disney Studios. The two chief characters to come out of this film were the Reluctant Dragon and a

LEFT: WALT DISNEY'S STORY OF *THE RELUCTANT DRAGON* (1941). BELOW: *BABY WEEMS* HARDCOVER BOOK BY JOE GRANT AND DICK HUEMER.

baby boy in diapers with a high I.Q. named Baby Weems. *The Reluctant Dragon* was a four-color Walt Disney Dell Comic Book in 1941. Original children's storybooks of *The Reluctant Dragon* and *Baby Weems* were published by Doubleday.

DUMBO

Dumbo is thought of today as one of the best of the Disney animated feature films. Bearing some resem-

blance to Elmer Elephant, the Silly Symphony character of the 1930s, Dumbo captivated audiences of the early 1940s. *Dumbo* premiered on October 23, 1941.

Dumbo character merchandise quickly became a popular commodity in the marketplace. These included ceramic planters, salt and pepper shakers, and cookie jars from Leeds China. Multi-Products produced painted plaster and chalk figures of Dumbo to serve as amusement park prizes. Evan K. Shaw and Vernon Kilns featured Dumbo in their line of

TOP: DUMBO PINBACK BUTTON GIVEAWAY. LEFT: WALT DISNEY'S *DUMBO* "ONLY HIS EARS GREW!" BETTER LITTLE BOOK WITH "SEE 'EM MOVE FLIP PICTURES," FROM WHITMAN PUBLISHING (1941).

Disney figurines. Knickerbocker produced big-eared Dumbo dolls in the early forties; and Gund produced one in 1949. Walt Disney's *Dumbo*, a Better Little Book published by Whitman, was a popular schoolchildren's treasure in the 1940s. *Dumbo* is also the subject of many children's storybooks, such as those from D. C. Heath and Simon & Schuster's Little Golden Book series. Dumbo was the star of comic books and an RCA Victor "Little Nipper" Series 78 rpm record album. There are as well colorful Dumbo songbooks and sheet music.

BAMBI

Bambi the fawn has become one of Disney's most appealing and beloved characters. *Bambi* premiered on August 9, 1942, in London and on August 13 at Radio City Music Hall, New York, where it attracted record crowds of mothers with their children looking for escape from the pressures of war.

Popular as decoratives in homes of the forties were the fine glazed ceramic figurines of Thumper and Flower from American Pottery, which included in its line at least five Bambis. Bambi dinnerware was made by this same company in 1949. Bambi

ceramic planters and Bambi salt and pepper shakers were produced by Leeds China. In 1946, Evan K. Shaw produced wonderful figurines of Bambi characters.

Ingersoll-Waterbury produced a Bambi children's wristwatch in 1948. Movie posters and lobby cards from the original release are good investments today; and certainly the cels or any of the original artwork command higher and higher competitive prices in the art-auction market.

Disney's *Bambi*, from an original story by Felix Salten, was published in 1942 by Grosset & Dunlap, which also published a *Thumper* storybook. Disney's *Bambi* was retold by Idella Purnell in a child's reader published by Heath in 1944. Whitman published *The Bambi Story Book* and two Better Little Books, as well as cut-out books, scrapbooks, puzzles, and games. Simon & Schuster published *Bambi* in several formats in its Golden Book series. Kamen published a *Bambi* comic book with Whitman Publishing in 1941 and 1942, and this is now a top comic to collect.

Novel merchandise featuring *Bambi* tie-ins includes Einson-Freeman Bambi and Thumper premium masks from Wheaties; and

Donald Duck Rice boxes that feature Bambi and Faline cutouts on the back of the packages. There was a Sun Rubber Company Thumper squeeze toy and Catalin Bambi pencil sharpeners. Framed color prints of *Bambi* from Courvoisier Galleries joined *Snow White* and *Pinocchio* sets that were already on the walls of the playroom or den. On the family knickknack shelf you might find fine porcelain Hummel figurines of Disney characters produced by the German Goebel Company,

particularly the figurines from *Bambi*, which comprised the majority of the "first series" of 220 pieces produced in the 1950s. Though they were produced through 1967 and are not from the so-called golden period, these overglazed pieces are desirable to collect but for some reason are difficult to find in the Disneyana marketplace.

CERAMIC FIGURES OF THUMPER'S GIRLFRIEND (LEFT), FLOWER THE SKUNK, AND THUMPER.

A DISNEY VICTORY PARADE

During the World War II years, the Walt Disney Studios in Burbank, California, virtually became an extension of the War Department. Mickey Mouse, Donald Duck, Pluto, and the other well-known Disney cartoon characters became important icons that symbolized America and were used by the military for propaganda purposes abroad as well as on the American homefront. The idea of an angry, writhing duck throwing a ripe tomato at a caricature of Adolf Hitler somehow helped to inspire servicemen to go bravely to war.

The U. S. Navy became Disney's

ABOVE: HOMEFRONT DISNEY WINDOW STICKER FOR WORLD WAR II FACTORIES. **OPPOSITE:** DONALD DUCK INSIGNIA PATCH FOR 47-3 (AW) BATTALION BATTERY "A," NEW YORK, NY.

biggest customer, and it preempted an entire studio wing to produce films aimed specifically at the instruction of Naval flyers. The

ABOVE LEFT: DONALD DUCK FLYBOY INSIGNIA ON A MATCHBOOK (1940S). **ABOVE RIGHT:** UNITED STATES TREASURY WAR FINANCE COMMITTEE SPECIAL DISNEY CERTIFICATE (1944). **BELOW:** CARDBOARD "DIMENSIONAL" COLORING PLAQUE MADE FROM A DO-IT-YOURSELF KIT (1942–43).

90 percent of its production during the war years to the output of films made especially for the Navy, the Army, and other government agencies. In 1944, the Treasury Department, under Secretary Morgenthau's order,

Navy requested twenty short subjects using photography in conjunction with models, live action, and animated drawing. Some of them were highly confidential and restricted by the War Department for military reasons.

The Disney Studio devoted over

issued a special Disney character "War Bond" certificate designed for schoolchildren.

After the Japanese attack on Pearl Harbor, the intrepid pilots of the A. V. G. (American Volunteer Group, called Flying Tigers) flew over the Burma Route to China in planes decorated with Disney insignia. The demand for Disney insignia was so intense from America's fighting units that there were long waiting lists which kept the special crew of five Disney artists busy around the clock. Donald Duck was used more frequently than Mickey Mouse on insignia as Donald naturally conveyed more wrath toward an enemy. These wartime insignia, including patches, posters, matchbooks, and instruction booklets, have entered the realm of Disneyana ephemera.

The most popular of all war

cartoons, and the one that won an Academy Award in 1943, was *Der Fuehrer's Face*, originally planned to be called *Donald Duck in Nutziland*.

South of the Border: Caballeros y Amigos

Nelson Rockefeller, the coordinator of Inter-American Affairs in 1941, asked Walt Disney to go to South America to make movies that would encourage a better "good neighbor" policy. He also wanted Disney to help check the rise of the Nazi propaganda machine moving into Latin American countries.

Disney, with his staff of animators, went to work on the first of four pictures, *Saludos Amigos*, which was released in the U.S. in February 1943. *Saludos Amigos* was such a smash hit that Disney pushed full speed ahead with *The Three Caballeros*, which cost $2 million to produce. For this film, Disney Studio artists went on a special trip to Mexico. The result of their research was a wild pistol packin' Mexican Charro rooster named Panchito who joined caballeros José Carioca of Brazil and Donald Duck, the north-of-the-border quacker. A world premier for *The Three Caballeros* was held in Mexico City on December 21, 1944, with a North American opening at movie theaters across the country on February 3, 1945.

The green parrot José Carioca appears on one side of a "turn-about" cookie jar produced by Leeds China in 1947. When reversed, the other side is his caballero sidekick Donald Duck. In 1946, Donald, Panchito, and José were favorites as glazed ceramic figurines from Evan K. Shaw. Plastic Novelties produced Catalin pencil sharpeners with Donald, Panchito, and José

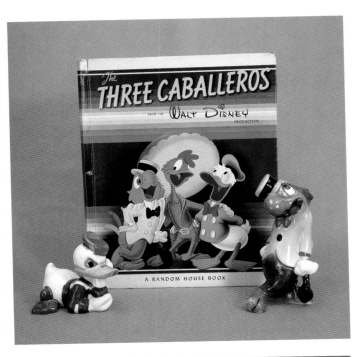

appliqued on them; and Alladin Color Plastic made charms of Donald, Panchito, and José Carioca for their jewelry line.

THE THREE CABALLEROS BOOK (1944) AND FIGURINES OF DONALD DUCK (BRAYTON-LAGUNA) AND JOSÉ CARIOCA (EVAN K. SHAW) (1946).

Bread campaigns used José Carioca, Panchito, and Pedro, the plane, as end-paper seals, which are now collectible Disneyana ephemera. Attractively packaged 78 rpm record album sets from RCA Victor of songs from both *Saludos Amigos* and *The Three Caballeros* are sought by record collectors and Disneyophiles alike. A 1942 Dell four-color comic book by Carl Barks and Jack Hannah entitled *Donald*

Duck Finds Pirate's Gold features a pre–*Three Caballeros* José Carioca–type parrot in the role of a one-legged pirate.

The postwar demand for stories featuring the popular South American parrot was such that Whitman issued the comic book in 1946 as a Better Little Book.

Random House published *The Three Caballeros*, told in story form by H. Marion Palmer and illustrated by the Walt Disney Studios. The José Carioca wristwatch, manufactured in 1948 by Ingersoll, sold for $6.95, and this timepiece is now regarded as a rare but choice item among Disneyana collectors.

ABOVE: WALT DISNEY JIGSAW PUZZLE FEATURING THE PEDRO AND GAUCHITO SEGMENTS OF *THE THREE CABALLEROS*. **LEFT:** PANCHITO, THE GUN-TOTIN' MEXICAN BANDITO CHICKEN FROM *THE THREE CABALLEROS*. **BELOW:** *THE COLD BLOODED PENGUIN* STORYBOOK FROM *THE THREE CABALLEROS* (1944).

POSTWAR TRAILBLAZERS

Song of the South

Song of the South was Disney's first motion picture in which live actors were used for dramatic impact. Three of the Joel Chandler Harris Uncle Remus tales were brilliantly produced in animation. "Zip-a-Dee-Doo-Dah," happily sung by James Baskett, won an Academy Award for its writers Allie Wrubel and Ray Gilbert. James Baskett won an

Oscar as well for his portrayal of Uncle Remus. Song of the South was a success for Walt Disney on November 12, 1946, when it opened, and in the 1956 rerelease.

Products connected to the film include a Walt Disney's Uncle Remus Game—ZIP from Parker

RIGHT: WALT DISNEY'S *BRER RABBIT*, A BETTER LITTLE BOOK ADAPTED FROM *SONG OF THE SOUTH* (1947). **OPPOSITE:** "ZIP-A-DEE-DOO-DAH" SHEET MUSIC FROM *SONG OF THE SOUTH*.

Brothers, school pencil sharpeners of Brer Rabbit, Brer Fox, and Brer Bear, as well as collectible bread paper end seals. Alladin Color Plastic offered novelty Brer Rabbit jewelry. Ben Cooper, Inc., offered masquerade costumes of Disney's Brer Rabbit for Halloween. American Pottery produced glazed ceramic planter and figurines of Brer Rabbit that are desirable pieces of Disneyana today.

The Wonderful Tar Baby was adapted by Marion Palmer from the original Harris story and published in 1946 by Grosset & Dunlap. *Brer Rabbit* is a Better Little Book title published in 1947 by Whitman, which reissued the book in 1949, adding an overlay of red ink to the black and white illustrations inside. A giveaway *Brer Rabbit's Secret* premium comic book was issued by K. K. Publications, and there was an *Uncle Remus Stories* Giant Golden Book as well as an *Uncle Remus* Little Golden Book. The attractive collector album *Song of the South* on 78 rpm records is from RCA Victor. There was also Brer Fox and Brer Rabbit stuffed dolls on the marketplace. The handsome, colorful 1946 program from the opening in Atlanta, Georgia, following in the footsteps of that other spectacle, *Gone With the Wind*, is among the prized collectibles from this film.

MAKE MINE MUSIC

Three other Disney films of the postwar era were fundamentally "package" films. Disney had learned that he could integrate short sequences at a low cost and present them in one feature film. *Make Mine Music* opened just prior to *Song of the South* on August 15, 1946. The picture featured a delightful new animated character called Willie the Whale,

"the Whale who wanted to sing at the Met," vocalized by Nelson Eddy, and included the sounds of the Andrews Sisters, Benny Goodman and his orchestra, and Dinah Shore. The "Blue Bayou" section utilized animation originally to have been included in *Fantasia* with Debussy's "Claire de Lune." "The Peter and the Wolf" sequence has music by Sergei Prokofiev.

FUN AND FANCY FREE

Fun and Fancy Free is a live-action and animation picture consisting of "Mickey and the Beanstalk" and "Bongo." It opened September 27, 1947. "Mickey and the Beanstalk" is a first-rate animated segment with participation from Donald Duck and Goofy.

The character of Bongo, the wonder bear, introduced by Jiminy Cricket, was licensed to a number of manufacturers. Bongo

CHILDREN'S STORYBOOK *MICKEY AND THE BEANSTALK*, BASED ON THE DISNEY FILM *FUN AND FANCY FREE* (1947).

storybooks and paintbooks and an Ingersoll watch manufactured in 1948 were topped off by the Bongo and Lulubelle (his girlfriend) free-standing stuffed dolls from the Gund Manufacturing Company of New York. There was also a Bongo Columbia Records 78 rpm album. "Mickey and the Beanstalk" was published as a storybook, with picture illustrations

Bobby Driscoll and Roy Rogers and the Sons of the Pioneers in introducing the "Pecos Bill" segment, and the voices of the Andrews Sisters were heard in "Little Toot." Dennis Day was the voice of Johnny Appleseed, and the voices and music of Buddy Clark, Frances Langford, Fred Waring and His Pennsylvanians, and Freddy Martin and His Orchestra were heard in other segments. A particularly happy live-action "Blame It on the Samba" has Ethel Smith, the amazing organist, dancing frenetically in her 1940s platform "wedgies" with those two south-of-the-border animated caballeros, José Carioca and Donald Duck.

by Campbell Grant, by Grosset & Dunlap in 1947 and by Whitman in their Story Hour series in 1948.

Melody Time

Opening on May 27, 1948, *Melody Time* was a film with seven live-action and/or animated segments. Luana Patten starred again with

78 RPM FOUR-RECORD ALBUM OF *SO DEAR TO MY HEART* (1949).

SO DEAR TO MY HEART

So Dear To My Heart opened on January 19, 1949, starring Burl Ives, Bobby Driscoll, Luana Patten, Beulah Bondi, and Harry Carey. This dramatic and sentimental picture, unlike previous postwar Disney features, is live-action with only a minimum of animation. Walt Disney loved this film, which reminded him of his own boyhood years on the farm. Though *So Dear To My Heart* did not make a lot of money, it did have a nostalgic charm similar to other family pictures of the 1940s like *State Fair* and *Meet Me in St. Louis*. Musical highlights in the film include Burl Ives singing "Lavender Blue" and, in a duet with Beulah Bondi, "Billy Boy." Critically well received, *So Dear To My Heart* helped pave the way for more live-action Disney pictures.

THE ADVENTURES OF ICHABOD AND MR. TOAD

The Adventures of Ichabod and Mr. Toad was released on October 5, 1949, and is the last of the all-animation feature films made in the 1940s. The "Mr. Toad" section is based on Kenneth Grahame's *The Wind in the Willows*, and the "Ichabod" section comes from Washington Irving's *The Legend of Sleepy Hollow*. Merchandise from this film is scant, but song sheets, storybooks, movie posters, and other ephemera are always desirable to those who seek oddities in the field of Disneyana.

BABY-BOOMER DISNEYANA (THE 1950s)

On February 15, 1950, Disney's *Cinderella* was released to great acclaim, earning the studio over $4 million in its first run. The last of Kay Kamen's great character merchandise catalogs, 1949–1950, helped sell *Cinderella* and the cast of characters to the merchants. Following Kamen's untimely death, the Character Merchandise Division developed by Walt Disney Productions quickly licensed new products for *Alice in Wonderland*, which premiered on July 28, 1951, and *Peter Pan*, released on February 5, 1953.

The 1955 release of the feature-length film *Davy Crockett, King of the Wild Frontier*, sparked Disney's first mass-market character merchandising campaign for live-action films. This film resulted from the popular series that had

RIGHT: SHEET MUSIC FOR "A DREAM IS A WISH YOUR HEART MAKES," FROM DISNEY'S *CINDERELLA* (MUSIC COPYRIGHT 1948). OPPOSITE: MICKEY MOUSE CLUB NEWSREEL TOY PROJECTOR (1956).

187

appeared on television in late 1954. Davy Crockett merchandise included toy guns and rifles, fur hats with raccoon tails, suede fringe frontier jackets and pants, litho-on-metal lunch boxes with thermoses, Davy guitars, penknife sets, toys, games, children's night lamps, storybooks, pull-wagons, camper tents, schoolbags, cookie jars, mugs, pinback buttons, watches, and clocks.

Lady and the Tramp, the first Disney film to be made in Cinemascope, was released on June 16, 1955. Character merchandise was lined up well in advance. Work on *Sleeping Beauty* had begun in 1952, and the film was

released on January 29, 1959. Collectibles from *Sleeping Beauty* are sought after today, but not with the enthusiasm for earlier Disneyana. This also holds true for *101 Dalmatians*, released on January 25, 1961; it also has an appreciable number of collectibles.

Much of the best merchandise of the 1950s, avidly collected by baby boomers, was inspired by

the second *Mickey Mouse Club*, which premiered on television on October 3, 1955, on ABC. Disney issued a quarterly periodical called *Walt Disney's Mickey Mouse Club Magazine*, which was changed to *Walt Disney Magazine* in 1957 when it became bimonthly.

Mickey Mouse Club merchandise abounded in the five-and-dimes and department stores. In addition, there were several Mickey Mouse Club coloring books, a *Mickey Mouse Club Scrap Book*, *Walt Disney's Mickey Mouse Club Annual*, and *Walt Disney's Big Book*. Annette Funicello was the most popular Mouseketeer, and a number of books featured her on the cover. These included Annette coloring books, cut-out doll portfolios, comics, and boxed paper dolls, all promoted between 1956 and 1967.

Some of the multitudinous items that featured the jovial fifties-style Mickey Mouse included the Mousegetar (23 inches) and the Mousegetar Jr. (14 inches) from Mattel, Inc.; Mickey Mouse Club white plastic dinner sets, cups, plates, and bowls manufactured by Molded Plastics, Inc., of Cleveland, Ohio; a Mouseketeer

Western outfit by L. M. Eddy Manufacturing Company, Inc., of Framingham, Massachusetts; a Mickey Mouse Club Explorer's Club outfit; and a Mickey Mouse

ABOVE: THE MOUSEGETAR JR. HAS A WINDUP MUSICAL BOX THAT PLAYS THE MOUSEKETEER THEME SONG (1955). **TOP:** MICKEY MOUSE SCHOOL LUNCHBOX MADE OF COLOR LITHOGRAPHED METAL (1958). **RIGHT:** "DISNEYLAND" TEA SET (1955).

bandleader outfit. An attractive Mickey Mouse Club tool chest was manufactured by the American Toy and Furniture Company of Chicago. The famous black "Mouseketeer Ears" in hard-cotton felt and set on a plastic earmuff-type band were stamped on each ear with "Walt Disney Prod. Mouseketeers" and made by the Empire Plastic Corporation of Tarboro, North Carolina.

Disneyland opened July 17, 1955, in Anaheim, California. Toys from Disneyland include a Disneyland Ferris Wheel made by J. Chien Company of Newark, New Jersey. A Disneyland Melody Player Music Box with musical wheels is a fine Disneyland collectible. Strombecker Company wooden toys sold at Disneyland include a Casey Jr. train set and a Mickey Mouse bus with Donald Duck.

With the advent of television, Davy Crockett, the Mickey Mouse

DISNEYLAND FERRIS WHEEL WINDUP TOY WITH A MECHANICAL BELL (1955).

Club, and the accompanying merchandising in full swing—and Disneyland opening to resounding success—the Disney Studios were on the way to becoming an empire. There would be no limit to their success, and it was all due to M-i-c-k-e-y M-o-u-s-e!

191

Credits:
Principal photography by John Gilman. Photographs courtesy of Ted Hake, York, PA: pages 52, 53, 57 (top), 73 (bottom), 96 (top), 135 (top), 136 (all), 162, and 191. Photographs courtesy of Ivy Wharton: pages 36 (all), 39, 40, and 43.

ISBN: 0-7868-6186-x
"A Disney Miniature" Edition

For information address:
HYPERION
114 Fifth Avenue
New York, NY 10011

Produced by:
WELCOME ENTERPRISES, INC.
575 Broadway
New York, NY 10012

Printed and bound in Singapore by Tien Wah Press
10 9 8 7 6 5 4 3 2 1